A Visual Guide to Drink

AVERY

an imprint of Penguin Random House LLC

375 Hudson Street

New York, New York 10014

Most Avery books are available at special quantity discounts for bulk purchase for sales promotions,

premiums, fund-raising, and educational needs. Special books or book excerpts also can be created to fit

specific needs. For details, write SpecialMarkets@penguinrandomhouse.com.

ISBN 978-1-59240-930-3

Printed in the United States of America

1 3 5 7 9 10 8 6 4 2

Book design by Pop Chart Lab

Neither the publisher nor the author is engaged in rendering professional advice or services to the

individual reader. The ideas, procedures, and suggestions contained in this book are not intended as

a substitute for consulting with your physician. All matters regarding your health require medical

supervision. Neither the author nor the publisher shall be liable or responsible for any loss or damage

allegedly arising from any information or suggestion in this book.

The recipes contained in this book have been created for the ingredients and techniques indicated. The

publisher is not responsible for your specific health or allergy needs that may require supervision. Nor

is the publisher responsible for any adverse reactions you may have to the recipes contained in the book,

whether you follow them as written or modify them to suit your personal dietary needs or tastes.

A VISUAL 2015
GUIDE TO
DRINK

BKLYN

v 1.0

A

VISUAL GUIDE

to

DRINK

Ben Gibson, Patrick Mulligan, and

POP CHART LAB

AVERY

an imprint of
Penguin Random House
New York

Preface

Pop Chart Lab's very first project was a taxonomy of beer styles, and we've been charting alcohol and other topics for five years now. In putting together this book we've tried, as always, to be as true to the data as possible, which has required some variation in approach from beverage to beverage. We've stayed away from some areas that are typical in alcohol primers—such as taste or pairing recommendations—that can't be empirically quantified. We have tried, though, to incorporate taste in those cases where there is an agreed-upon measure of flavor, such as IBU (International Bittering Units) as a metric of beer bitterness or, of course, ABV (alcohol by volume) as a measure of alcoholic strength.

Beer is most easily understood as a function of style, and most beer drinkers are familiar with particular beer brands, so we've structured our beer section around the main varieties, using example beers as benchmarks, but primarily focusing on craft selections. Wine, on the other hand, depends greatly on *terroir*—where a wine is from—so that section is based largely in geography. There are hundreds of thousands of individual wines, so we've tried to present more of an overview of countries and grapes rather than drilling down to individual vintages. Spirits are grouped according to production process, with some nods to particular regions in the case of liquors like whiskey, and we've also examined how spirits combine into mixed drinks.

From the outset, Pop Chart Lab has sought to unify data, design, and delight. We hope we've presented here a true (and pleasing) visual register of the data behind drink.

POP
CHART
LAB

Introduction

How Yeast Makes Alcohol

For most of history, humans had no idea that a microorganism is responsible for creating alcohol. Yeasts consume sugar, and alcohol is a by-product of that chemical process, which is sketched out below.

ALCOHOLIC FERMENTATION

YEAST + GRAPES = *WINE*

YEAST + MALTED GRAIN + HOPS = *BEER*

YEAST + MALTED RICE = *SAKE*

YEAST + STARCH/UNMALTED GRAIN X *Distilled* = *VODKA/WHISKEY*

YEAST + SUGARCANE X *Distilled* = *RUM*

YEAST + STARCH/UNMALTED GRAIN X *Distilled* + *Flavoring* = *GIN*

YEAST-INDUCED TRANSFORMATION OF GLUCOSE INTO ETHANOL

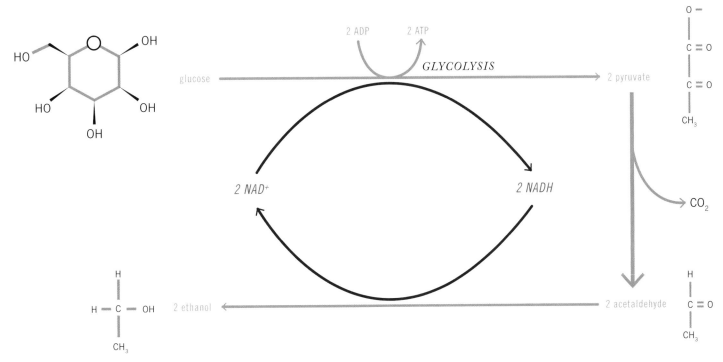

glucose — *GLYCOLYSIS* → 2 pyruvate

2 ADP → 2 ATP

2 NAD+ → 2 NADH

2 ethanol ← 2 acetaldehyde

CO_2

Varieties of Alcohol

All alcoholic beverages are fermented—the aforementioned process whereby yeast creates alcohol—but fermented beverages can then be distilled, which concentrates the alcohol. The chart below broadly breaks down drinks by fermented versus fermented and distilled, and then further categorizes by ingredients.

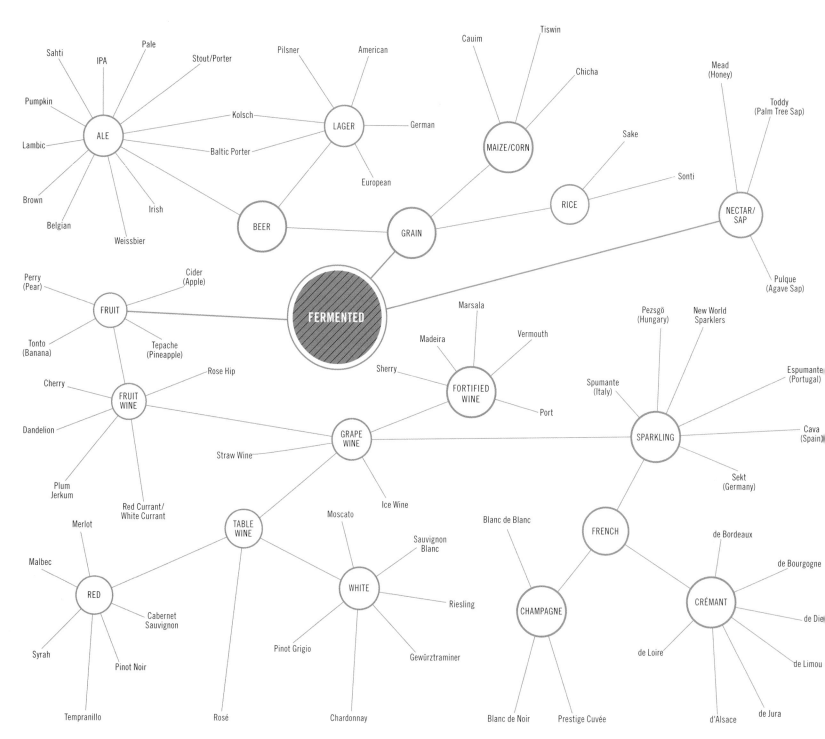

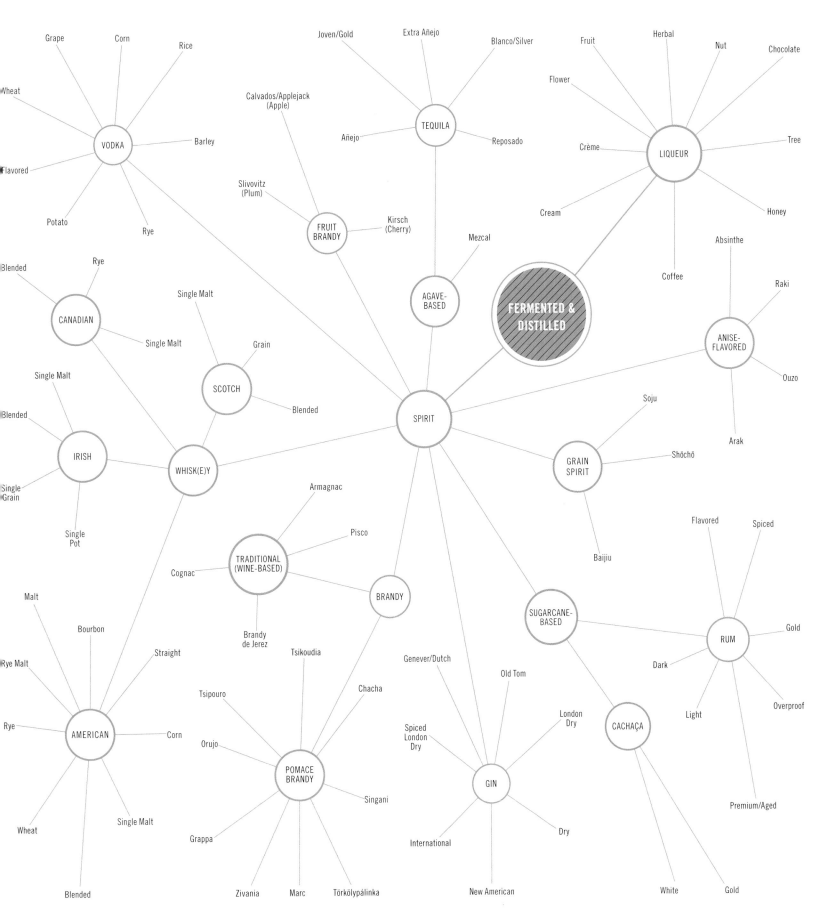

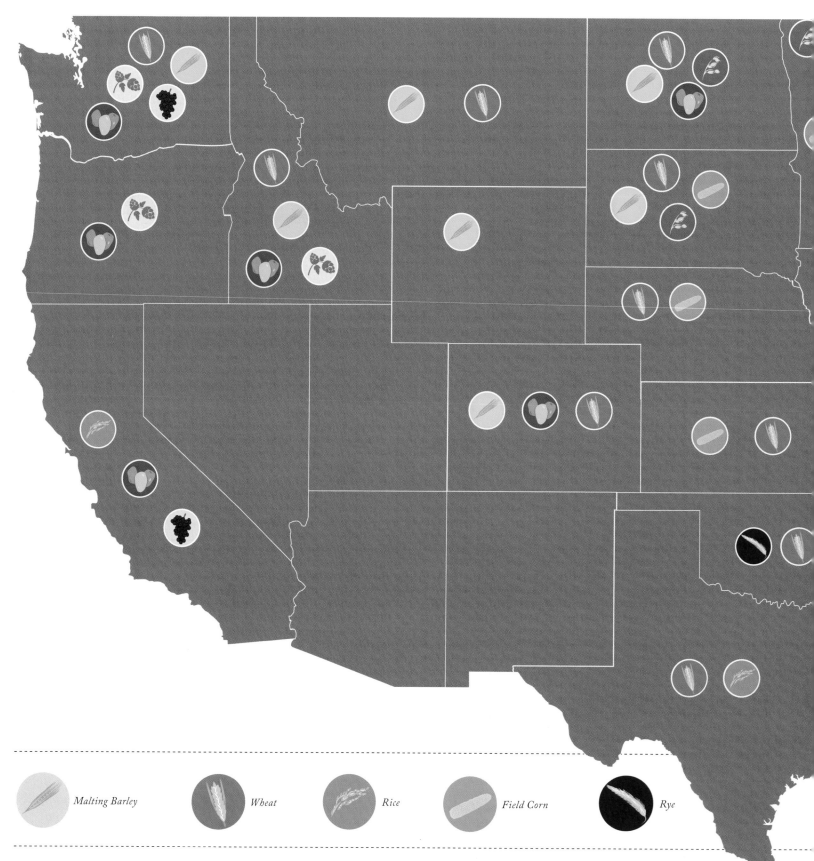

Malting Barley Wheat Rice Field Corn Rye

U.S. Crop Map

The main ingredients and flavoring agents employed in the production of beer, wine, and spirits are grown in a number of different states. There are few surprises here—grain production is concentrated in the Midwest, and California produces the vast majority of the country's grapes. Interestingly, juniper berries, the essential flavoring base of most gins, are still picked wild rather than in any sort of mechanized harvest.

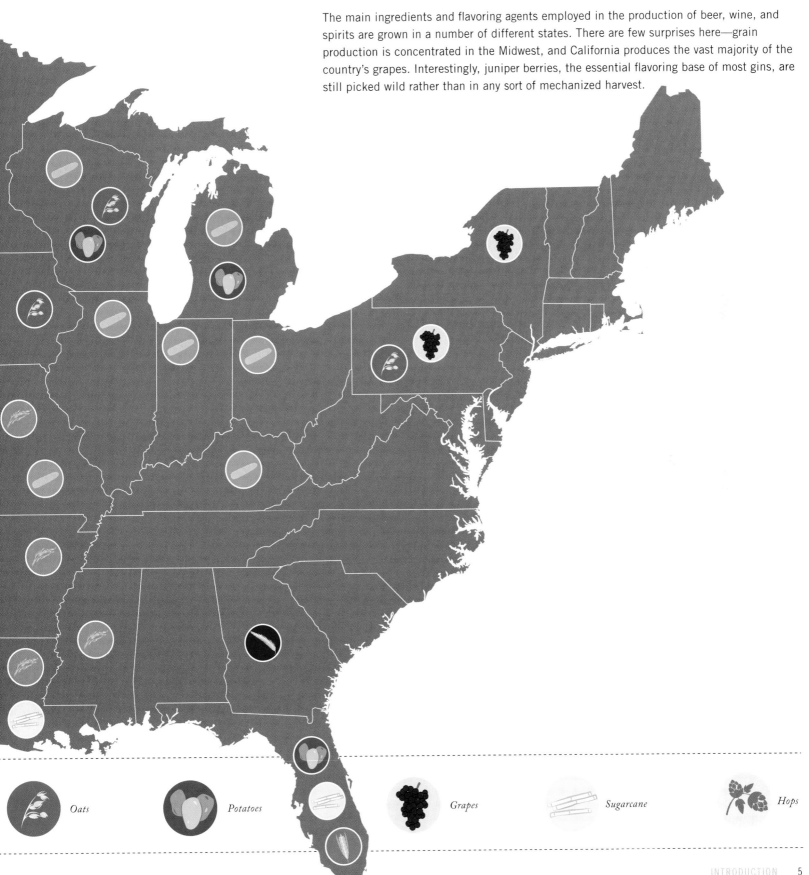

Oats Potatoes Grapes Sugarcane Hops

Ingredients x Processes = Drinks

Throughout history, people have figured out how to make alcohol out of just about anything. By using the two processes of fermentation and distillation, many different ingredients can be combined and recombined into alcoholic beverages. Many fermented beverages can be distilled into a stronger drink, as with wine into brandy, and stronger drinks can themselves be diluted or flavored with all manner of fruits and herbs.

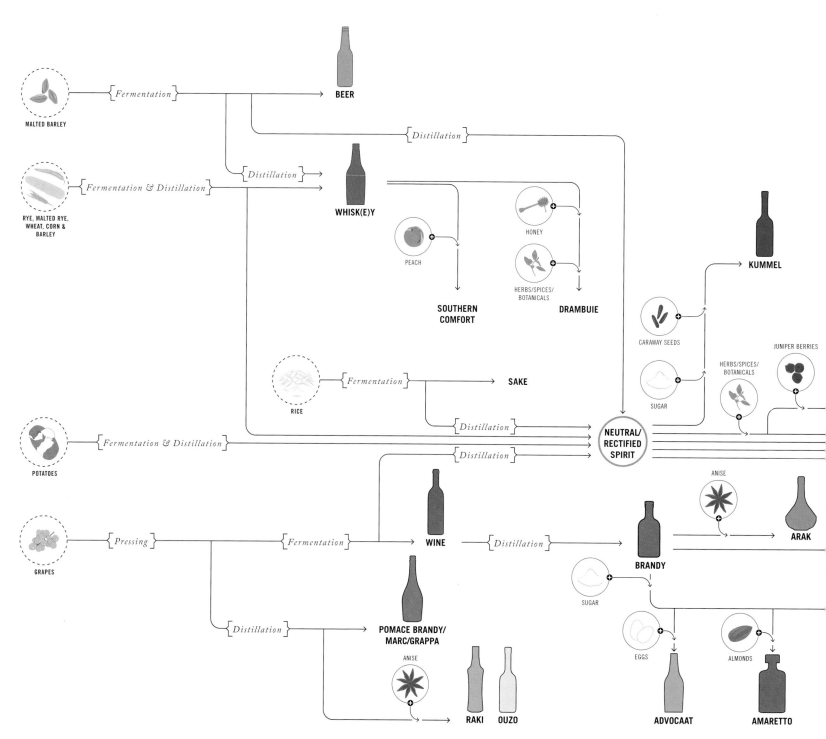

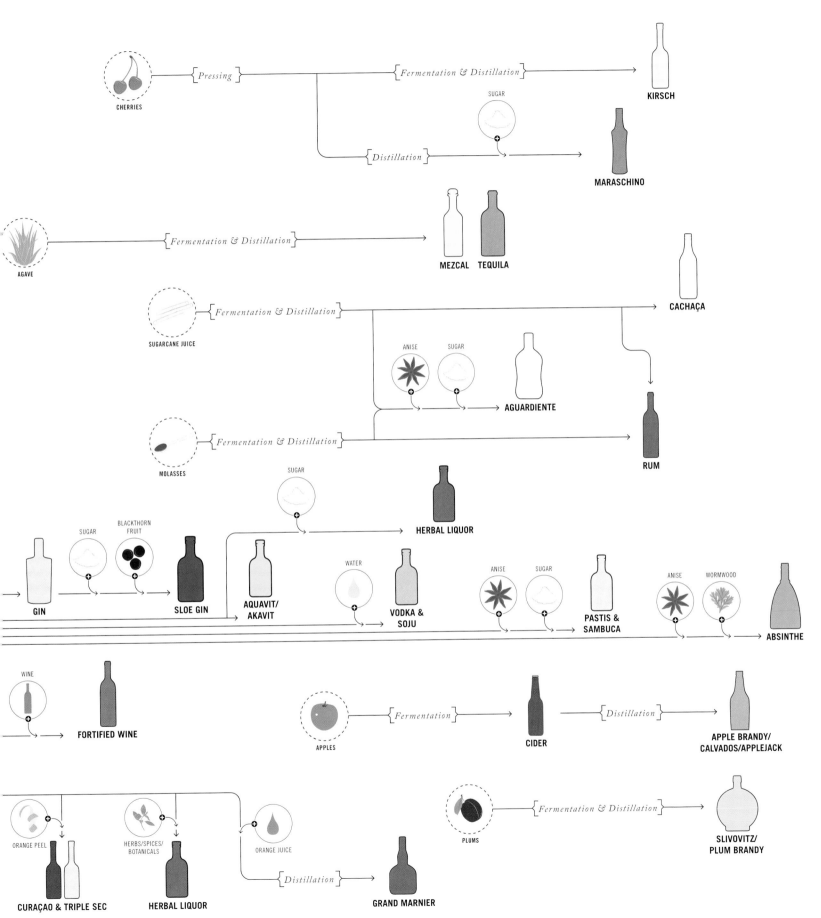

CHERRIES
{Pressing}
{Fermentation & Distillation}
KIRSCH

SUGAR
{Distillation}
MARASCHINO

AGAVE
{Fermentation & Distillation}
MEZCAL TEQUILA

CACHAÇA

SUGARCANE JUICE
{Fermentation & Distillation}

ANISE SUGAR
AGUARDIENTE

MOLASSES
{Fermentation & Distillation}
RUM

SUGAR
HERBAL LIQUOR

SUGAR BLACKTHORN FRUIT
GIN SLOE GIN

AQUAVIT/ AKAVIT

WATER
VODKA & SOJU

ANISE SUGAR
PASTIS & SAMBUCA

ANISE WORMWOOD
ABSINTHE

WINE
FORTIFIED WINE

APPLES
{Fermentation}
CIDER
{Distillation}
APPLE BRANDY/ CALVADOS/APPLEJACK

PLUMS
{Fermentation & Distillation}
SLIVOVITZ/ PLUM BRANDY

ORANGE PEEL
CURAÇAO & TRIPLE SEC

HERBS/SPICES/ BOTANICALS
HERBAL LIQUOR

ORANGE JUICE
{Distillation}
GRAND MARNIER

The ABV of All Manner of Drinks

In general, beverages that are first fermented and then distilled have a higher alcohol content than those that are only fermented, as distillation removes water and concentrates alcohol. Only soju, the world's most popular spirit, is in the range of higher-ABV fermented beverages such as wine. This graph notes the average range for each beverage group, but it should be noted that there are always outliers, such as small-batch craft beers with alcohol contents approaching 40%.

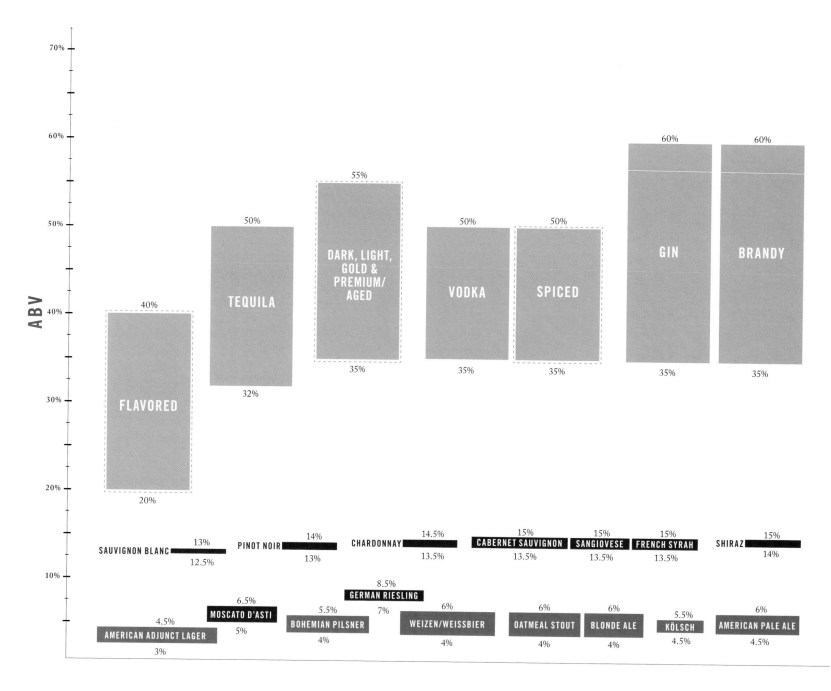

ABV

FLAVORED — 40% / 20%

TEQUILA — 50% / 32%

DARK, LIGHT, GOLD & PREMIUM/AGED — 55% / 35%

VODKA — 50% / 35%

SPICED — 50% / 35%

GIN — 60% / 35%

BRANDY — 60% / 35%

SAUVIGNON BLANC — 13% / 12.5%

PINOT NOIR — 14% / 13%

CHARDONNAY — 14.5% / 13.5%

CABERNET SAUVIGNON — 15% / 13.5%

SANGIOVESE — 15% / 13.5%

FRENCH SYRAH — 15% / 13.5%

SHIRAZ — 15% / 14%

GERMAN RIESLING — 8.5% / 7%

MOSCATO D'ASTI — 6.5% / 5%

BOHEMIAN PILSNER — 5.5% / 4%

WEIZEN/WEISSBIER — 6% / 4%

OATMEAL STOUT — 6% / 4%

BLONDE ALE — 6% / 4%

KÖLSCH — 5.5% / 4.5%

AMERICAN PALE ALE — 6% / 4.5%

AMERICAN ADJUNCT LAGER — 4.5% / 3%

FERMENTED ALCOHOL BEER WINE FORTIFIED WINE OTHER

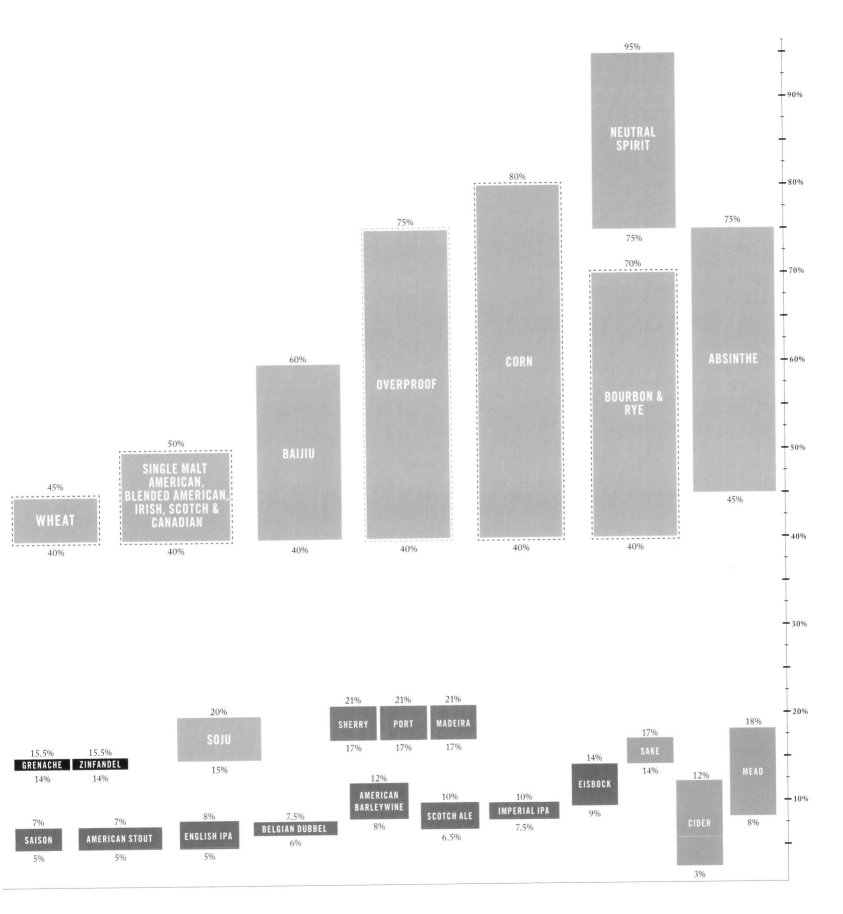

95%

NEUTRAL
SPIRIT

75%

80%

CORN

75%

70%

ABSINTHE

BOURBON &
RYE

75%

OVERPROOF

60%

BAIJIU

50%

SINGLE MALT
AMERICAN,
BLENDED AMERICAN,
IRISH, SCOTCH &
CANADIAN

45%

WHEAT

40%

40%

40%

40%

40%

40%

45%

21% 21% 21%

SHERRY PORT MADEIRA

17% 17% 17%

20%

SOJU

15%

15.5% 15.5%

GRENACHE ZINFANDEL

14% 14%

12%

AMERICAN
BARLEYWINE

8%

10%

SCOTCH ALE

6.5%

10%

IMPERIAL IPA

7.5%

14%

EISBOCK

9%

17%

SAKE

14%

18%

MEAD

8%

12%

CIDER

3%

7% 7% 8%

SAISON AMERICAN STOUT ENGLISH IPA

5% 5% 5%

7.5%

BELGIAN DUBBEL

6%

90%
80%
70%
60%
50%
40%
30%
20%
10%

DISTILLED ALCOHOL 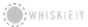 SPIRITS 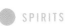 RUM 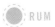 WHISK(E)Y

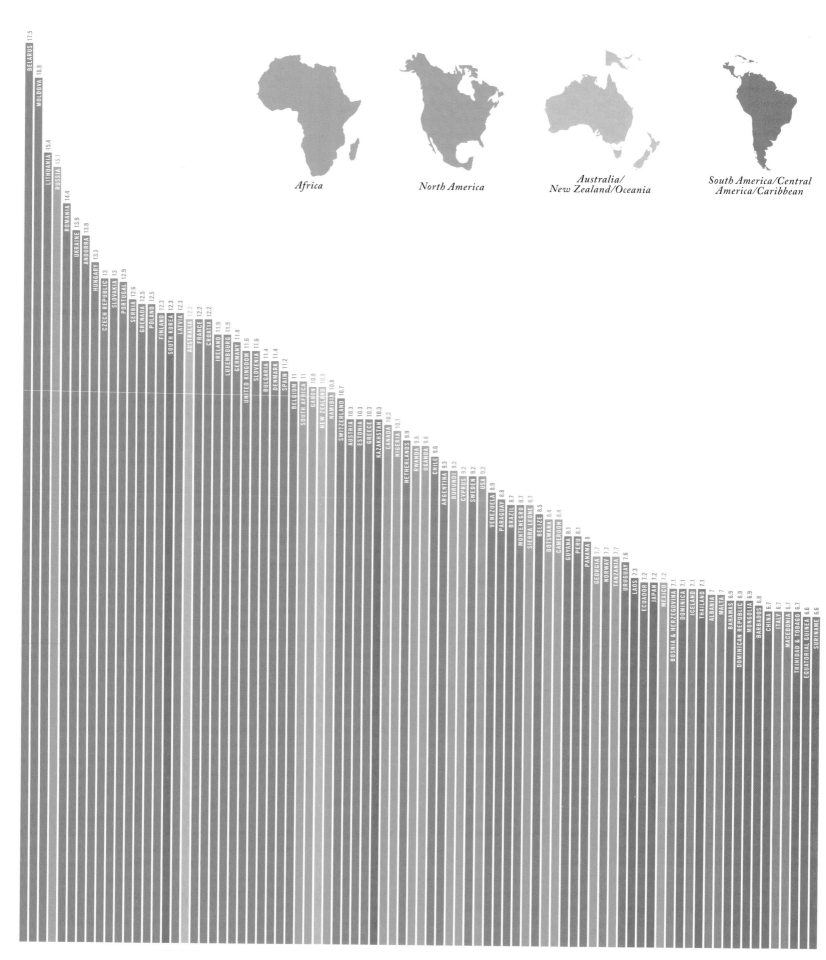

Africa

North America

Australia/
New Zealand/Oceania

South America/Central
America/Caribbean

BELARUS 17.5
MOLDOVA 16.8
LITHUANIA 15.4
RUSSIA 15.1
ROMANIA 14.4
UKRAINE 13.9
ANDORRA 13.8
HUNGARY 13.3
CZECH REPUBLIC 13
SLOVAKIA 13
PORTUGAL 12.9
SERBIA 12.6
GRENADA 12.5
POLAND 12.5
FINLAND 12.3
SOUTH KOREA 12.3
LATVIA 12.3
AUSTRALIA 12.2
FRANCE 12.2
CROATIA 12.2
IRELAND 11.9
LUXEMBOURG 11.9
GERMANY 11.8
UNITED KINGDOM 11.6
SLOVENIA 11.6
BULGARIA 11.4
DENMARK 11.4
SPAIN 11.2
BELGIUM 11
SOUTH AFRICA 11
GABON 10.9
NEW ZEALAND 10.9
NAMIBIA 10.8
SWITZERLAND 10.7
AUSTRIA 10.3
ESTONIA 10.3
GREECE 10.3
KAZAKHSTAN 10.3
CANADA 10.2
NIGERIA 10.1
NETHERLANDS 9.9
RWANDA 9.8
UGANDA 9.8
CHILE 9.6
ARGENTINA 9.3
BURUNDI 9.3
CYPRUS 9.2
SWEDEN 9.2
USA 9.2
VENEZUELA 8.9
PARAGUAY 8.8
BRAZIL 8.7
MONTENEGRO 8.7
SIERRA LEONE 8.7
BELIZE 8.5
BOTSWANA 8.4
CAMEROON 8.4
GUYANA 8.1
PERU 8.1
PANAMA 8
GEORGIA 7.7
NORWAY 7.7
TANZANIA 7.7
URUGUAY 7.6
LAOS 7.3
ECUADOR 7.2
JAPAN 7.2
MEXICO 7.2
BOSNIA & HERZEGOVINA 7.1
DOMINICA 7.1
ICELAND 7.1
THAILAND 7.1
ALBANIA 7
MALTA 7
BAHAMAS 6.9
DOMINICAN REPUBLIC 6.9
MONGOLIA 6.9
BARBADOS 6.8
CHINA 6.7
ITALY 6.7
MACEDONIA 6.7
TRINIDAD & TOBAGO 6.7
EQUATORIAL GUINEA 6.6
SURINAME 6.6

Alcohol Consumption by Country

Eurasia *Europe* *Asia*

Measured by liters of pure alcohol consumed per year, eastern Europe dominates the rankings, whereas in countries where the majority of the population is Muslim and alcohol is restricted or banned outright, consumption can be 1,000 times lower.

ALCOHOL GODS

The conversion of starch and water into alcohol is such a miraculous process that many ancient cultures throughout the world worshipped gods of drink.

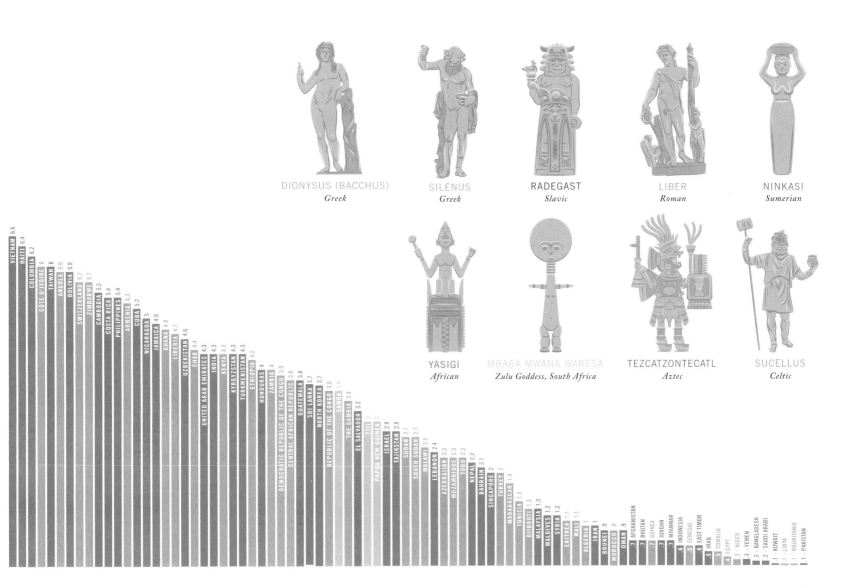

DIONYSUS (BACCHUS)
Greek

SILENUS
Greek

RADEGAST
Slavic

LIBER
Roman

NINKASI
Sumerian

YASIGI
African

MBABA MWANA WARESA
Zulu Goddess, South Africa

TEZCATZONTECATL
Aztec

SUCELLUS
Celtic

VIETNAM 6.6
HAITI 6.4
COLOMBIA 6.2
CÔTE D'IVOIRE 6
TAIWAN 6
ANGOLA 5.9
BOLIVIA 5.9
SWITZERLAND 5.7
ZIMBABWE 5.7
CAMBODIA 5.5
COSTA RICA 5.4
PHILIPPINES 5.4
ARMENIA 5.3
CUBA 5.2
NICARAGUA 5
JAMAICA 4.9
GHANA 4.8
LIBERIA 4.7
UZBEKISTAN 4.6
CHAD 4.4
UNITED ARAB EMIRATES 4.3
INDIA 4.3
KENYA 4.3
KYRGYZSTAN 4.3
TURKMENISTAN 4.3
ETHIOPIA 4.2
HONDURAS 4
ZAMBIA 4
DEMOCRATIC REPUBLIC OF THE CONGO 3.9
CENTRAL AFRICAN REPUBLIC 3.8
GUATEMALA 3.8
SRI LANKA 3.7
NORTH KOREA 3.7
REPUBLIC OF THE CONGO 3.6
SAMOA 3.6
THE GAMBIA 3.4
EL SALVADOR 3.2
FIJI 3
PAPUA NEW GUINEA 3
ISRAEL 2.8
TAJIKSTAN 2.8
SUDAN 2.7
SOUTH SUDAN 2.7
MALAWI 2.5
LEBANON 2.4
AZERBAIJAN 2.3
MOZAMBIQUE 2.3
TOGO 2.3
NEPAL 2.2
BAHRAIN 2.1
SINGAPORE 2
TURKEY 2
MADAGASCAR 1.8
TUNISIA 1.5
DJIBOUTI 1.3
MALAYSIA 1.3
MALDIVES 1.3
SYRIA 1.2
ERITREA 1.1
MALI 1.1
ALGERIA 1
IRAN 1
BRUNEI .9
MOROCCO .9
OMAN .9
AFGHANISTAN .7
BHUTAN .7
GUINEA .7
JORDAN .7
MYANMAR .7
INDONESIA .6
SENEGAL .6
EAST TIMOR .6
IRAQ .5
EGYPT .4
SOMALIA .4
NIGER .3
YEMEN .3
BANGLADESH .2
SAUDI ARABIA .2
KUWAIT .1
LIBYA .1
MAURITANIA .1
PAKISTAN .1

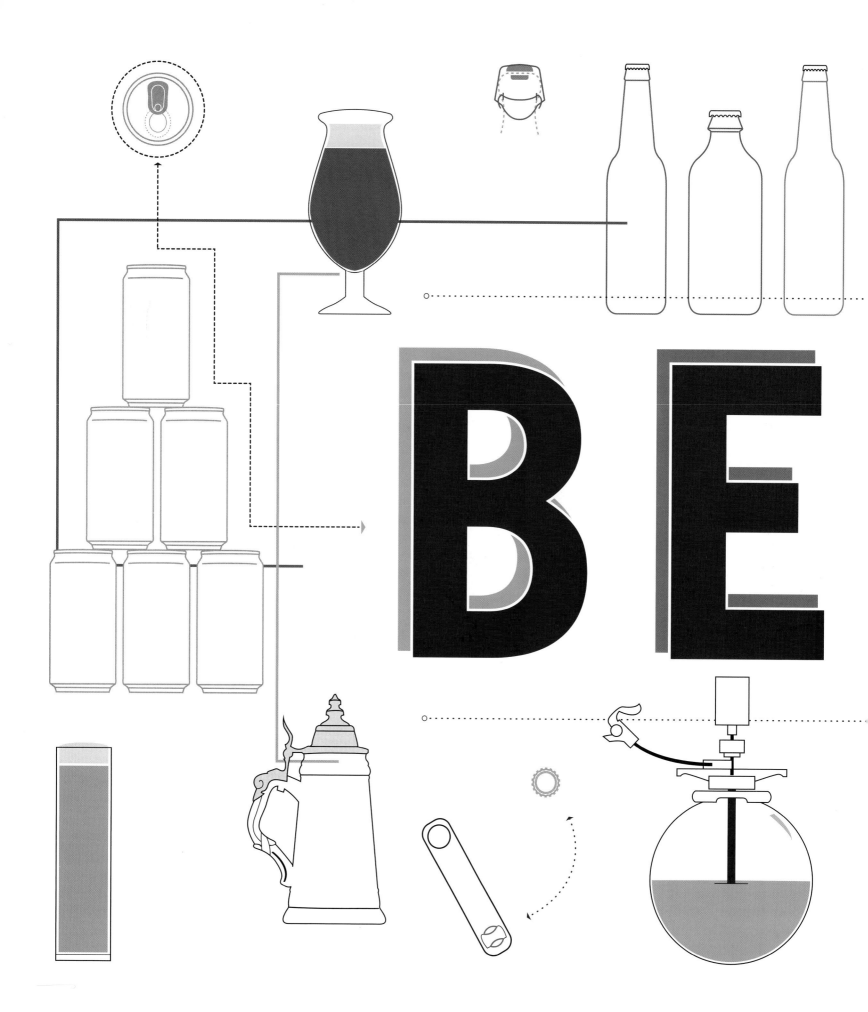

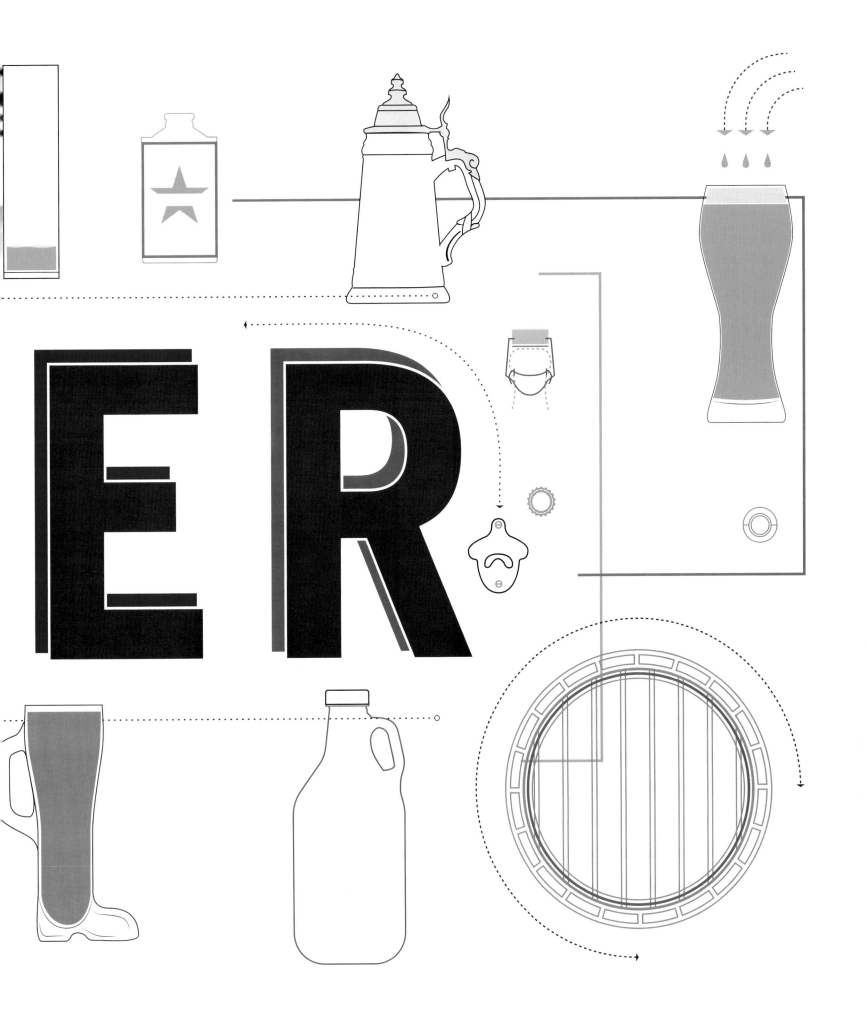

The Brewing Process

Here is a generalization of the steps needed to convert grain into a drinkable brew. Not every brewery follows every step: very few malt their own grains, for instance; many breweries combine two steps or devices into one, such as a mash/lauter tun; and many breweries add additional steps, such as using a hopback device to infuse extra hops flavor. Home-brewing also varies quite a bit from commercial brewing due to the type of equipment and scale available for larger production runs.

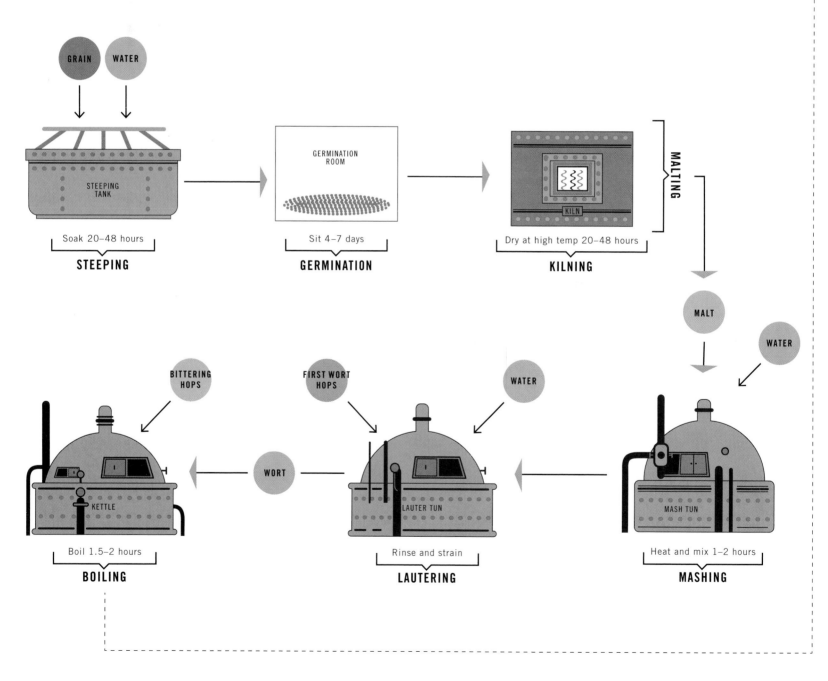

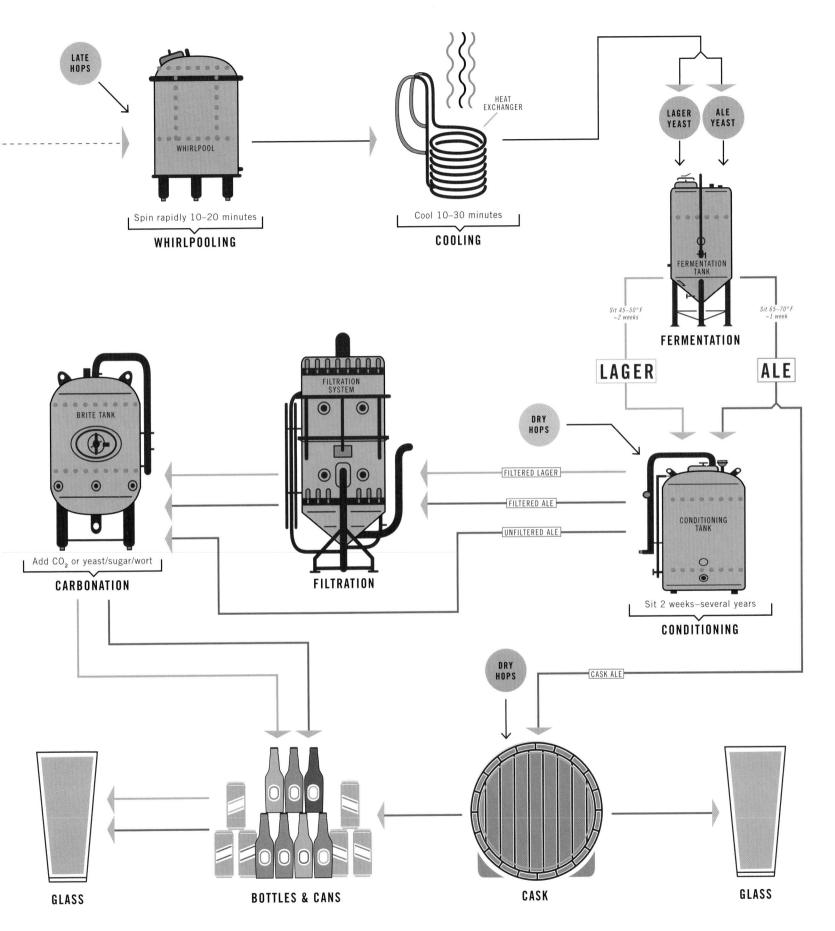

LATE HOPS

WHIRLPOOL

Spin rapidly 10–20 minutes

WHIRLPOOLING

HEAT EXCHANGER

Cool 10–30 minutes

COOLING

LAGER YEAST

ALE YEAST

FERMENTATION TANK

Sit 45–50°F ~2 weeks

Sit 65–70°F ~1 week

FERMENTATION

LAGER

ALE

DRY HOPS

BRITE TANK

FILTRATION SYSTEM

FILTERED LAGER

FILTERED ALE

UNFILTERED ALE

CONDITIONING TANK

Sit 2 weeks–several years

CONDITIONING

Add CO$_2$ or yeast/sugar/wort

CARBONATION

FILTRATION

DRY HOPS

CASK ALE

GLASS

BOTTLES & CANS

CASK

GLASS

Ingredients Used in Beer-Making

The central ingredient in beer is grain, usually barley. The malting and kilning process converts raw grains into a form that can readily convert into alcohol. Any unmalted grain is considered an "adjunct," and in the case of corn and rice, adjuncts are usually associated with weak, lower-quality quaffs. Hops is the most famous beer additive—it is nearly impossible to find a beer with no hops—but fruits, vegetables, and even oysters have also been utilized to spice up brews.

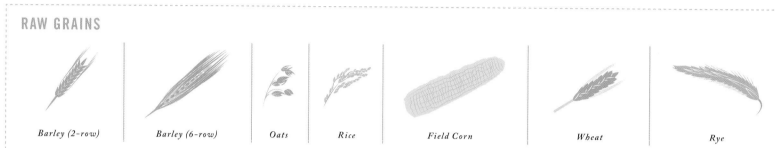

RAW GRAINS

| Barley (2-row) | Barley (6-row) | Oats | Rice | Field Corn | Wheat | Rye |

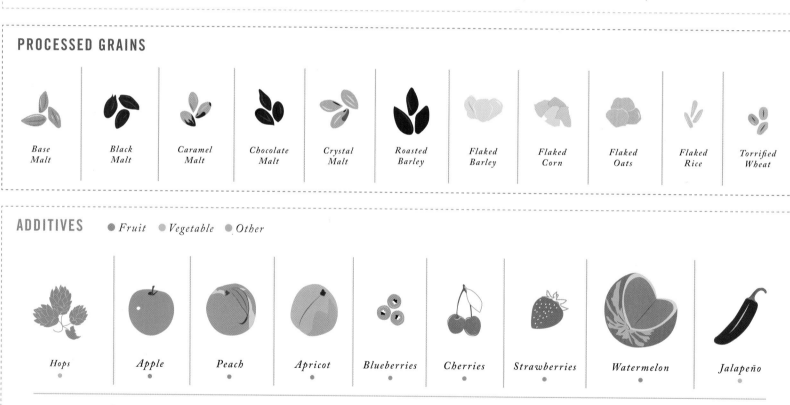

PROCESSED GRAINS

| Base Malt | Black Malt | Caramel Malt | Chocolate Malt | Crystal Malt | Roasted Barley | Flaked Barley | Flaked Corn | Flaked Oats | Flaked Rice | Torrified Wheat |

ADDITIVES ● *Fruit* ● *Vegetable* ● *Other*

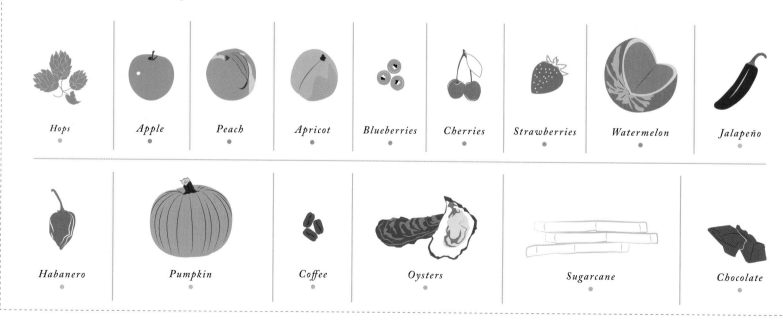

| Hops | Apple | Peach | Apricot | Blueberries | Cherries | Strawberries | Watermelon | Jalapeño |

| Habanero | Pumpkin | Coffee | Oysters | Sugarcane | Chocolate |

The Magic of Yeast

Two species of yeast are largely responsible for beer. *Saccharomyces cerevisiae* ferments at warmer temperatures and makes all ales. *Saccharomyces pastorianus* works its magic at lower temperatures and is responsible for all lagers. Beyond the two main yeasts, "Brett" yeasts are utilized by certain brewers to create sour beers. There is a great mystery concerning lager yeast, however. DNA analysis has confirmed that one parent of lager yeast is ale yeast, but the other parent, *Saccharomyces eubayanus,* is found only in Patagonia. Bavarians have been brewing lagers since the 1300s—before Europeans made it to the New World, and at this time it's unknown how the Patagonian yeast met the ale yeast to produce the lager yeast.

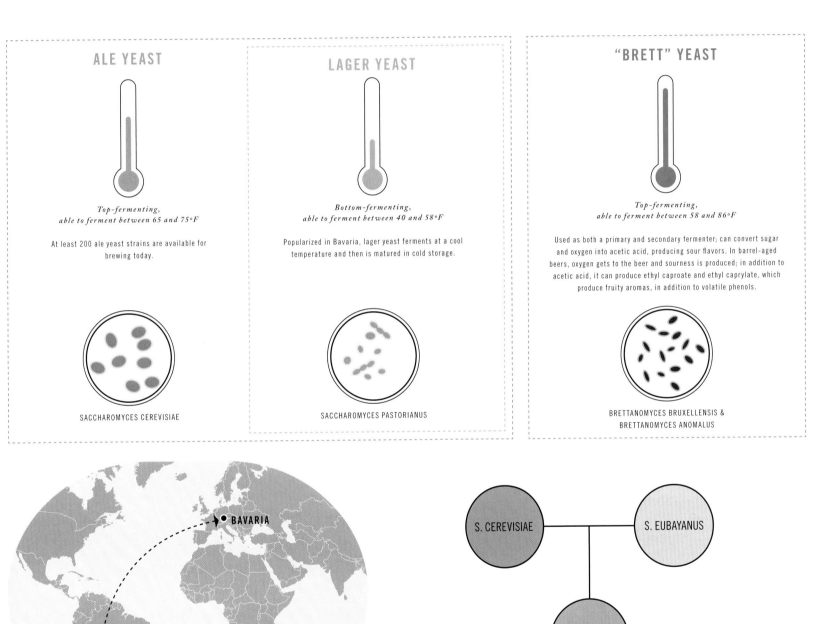

ALE YEAST

*Top-fermenting,
able to ferment between 65 and 75°F*

At least 200 ale yeast strains are available for brewing today.

SACCHAROMYCES CEREVISIAE

LAGER YEAST

*Bottom-fermenting,
able to ferment between 40 and 58°F*

Popularized in Bavaria, lager yeast ferments at a cool temperature and then is matured in cold storage.

SACCHAROMYCES PASTORIANUS

"BRETT" YEAST

*Top-fermenting,
able to ferment between 58 and 86°F*

Used as both a primary and secondary fermenter; can convert sugar and oxygen into acetic acid, producing sour flavors. In barrel-aged beers, oxygen gets to the beer and sourness is produced; in addition to acetic acid, it can produce ethyl caproate and ethyl caprylate, which produce fruity aromas, in addition to volatile phenols.

BRETTANOMYCES BRUXELLENSIS &
BRETTANOMYCES ANOMALUS

BAVARIA

PATAGONIA

S. CEREVISIAE

S. EUBAYANUS

S. PASTORIANUS

Equations

Brewers use two different scales to measure the amount of extract (fermentable sugars plus other grain by-products) versus water in their product. The older Plato scale, still used in Central Europe, expresses the ratio of extract to water as "degrees Plato"—10 degrees Plato means that if the extract were pure sucrose (which it's not), sucrose would make up 10 percent of the weight of the mixture. The more common Specific Gravity scale simply measures the density of a mixture versus the density of water. Pure water has a Specific Gravity of 1.00. A mixture coming in at a specific gravity of 1.16 is 16 percent denser than a mixture of pure water. Brewers will test the wort (that is, the beer mixture before boiling, cooling, and fermentation) using a hydrometer to obtain the Original Gravity. After fermentation is complete, the beer is tested again to obtain the Final Gravity. The Original Gravity can be compared to the Final Gravity to determine how much sugar has been converted into alcohol.

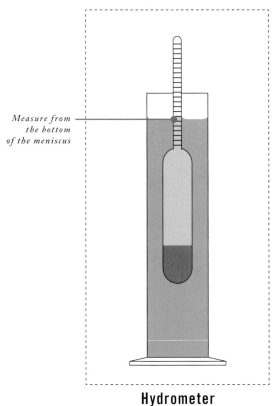

Measure from the bottom of the meniscus

Hydrometer
Used to calculate alcohol percentage and fermentation status

Specific Gravity
$$= 1 + (Plato / (258.6 - ((Plato/258.2) \times 227.1)))$$

Plato
$$= -616.868 + (1111.14 \times sg) - (630.272 \times sg^2) + (135.997 \times sg^3)$$

INTERNATIONAL BITTERING UNITS BREAKDOWN

The International Bittering Units (IBU) scale was developed to measure the bitterness of beers. Using a spectrometer, the amount of alpha acid compounds (which are the bitter flavors imparted by hops) can be measured. The least hoppy beer will score around 10 on the IBU scale, with the hoppiest IPAs approaching 100. It is important to note that IBU tells you how many of the bitter compounds are in a beer, but not necessarily how bitter a beer will taste, because high amounts of maltiness can ameliorate bitterness on the palate.

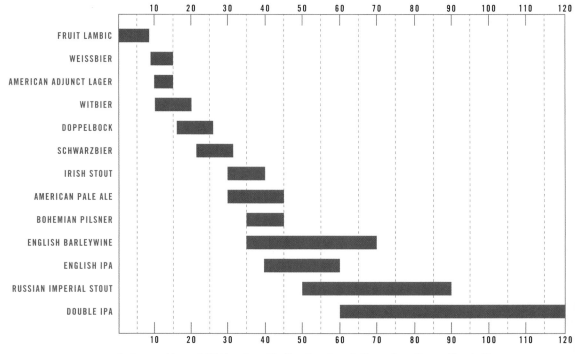

International Bittering Units Scale of Popular Beer Varieties

SRM Scale

The Standard Reference Method (SRM) scale measures the color of beer. Specifically, it measures the attenuation of light when passed through beer. The formula is given at left; below is a chart of where various styles of beer fall on the SRM scale.

$$SRM = 12.7 \times D \times A_{430}$$

Where **D** is the dilution factor (**D** = 1 for undiluted samples, **D** = 2 for 1:1 dilution, etc.) and A_{430} is the absorbance at 430 m in 1 cm.

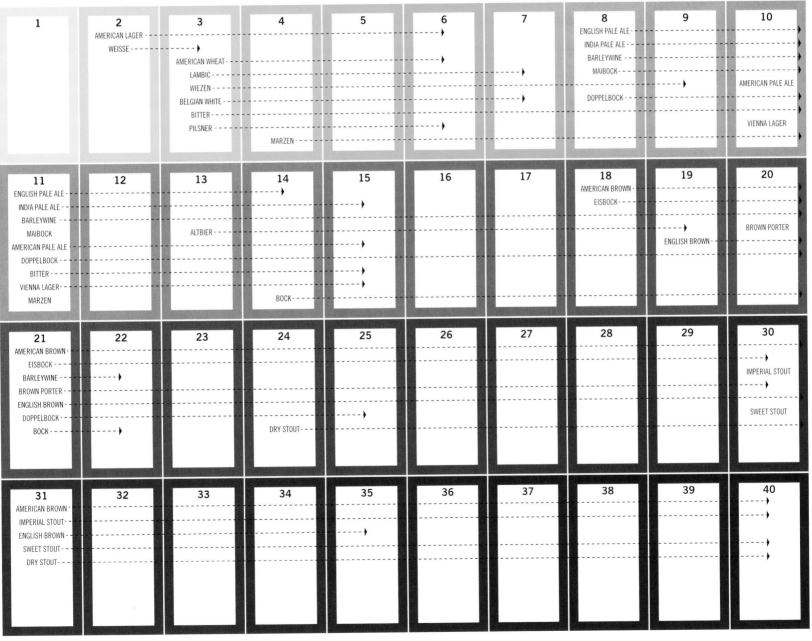

1	2	3	4	5	6	7	8	9	10
	AMERICAN LAGER						ENGLISH PALE ALE		
	WEISSE						INDIA PALE ALE		
		AMERICAN WHEAT					BARLEYWINE		
		LAMBIC					MAIBOCK		AMERICAN PALE ALE
		WIEZEN							
		BELGIAN WHITE					DOPPELBOCK		
		BITTER							
		PILSNER							VIENNA LAGER
			MARZEN						

11	12	13	14	15	16	17	18	19	20
ENGLISH PALE ALE							AMERICAN BROWN		
INDIA PALE ALE							EISBOCK		
BARLEYWINE									BROWN PORTER
MAIBOCK		ALTBIER							
AMERICAN PALE ALE								ENGLISH BROWN	
DOPPELBOCK									
BITTER									
VIENNA LAGER									
MARZEN				BOCK					

21	22	23	24	25	26	27	28	29	30
AMERICAN BROWN									
EISBOCK									IMPERIAL STOUT
BARLEYWINE									
BROWN PORTER									
ENGLISH BROWN									SWEET STOUT
DOPPELBOCK									
BOCK			DRY STOUT						

31	32	33	34	35	36	37	38	39	40
AMERICAN BROWN									
IMPERIAL STOUT									
ENGLISH BROWN									
SWEET STOUT									
DRY STOUT									

The Hop Family Tree

The varieties of hops have greatly increased in the past forty years due to the USDA's hop breeding program in the Pacific Northwest. Through thousands of breedings, Old World hops such as Hallertau and Brewer's Gold produced American originals such as Cascade and Chinook, paving the way for the craft brewing industry to resurrect hop-forward styles such as IPA.

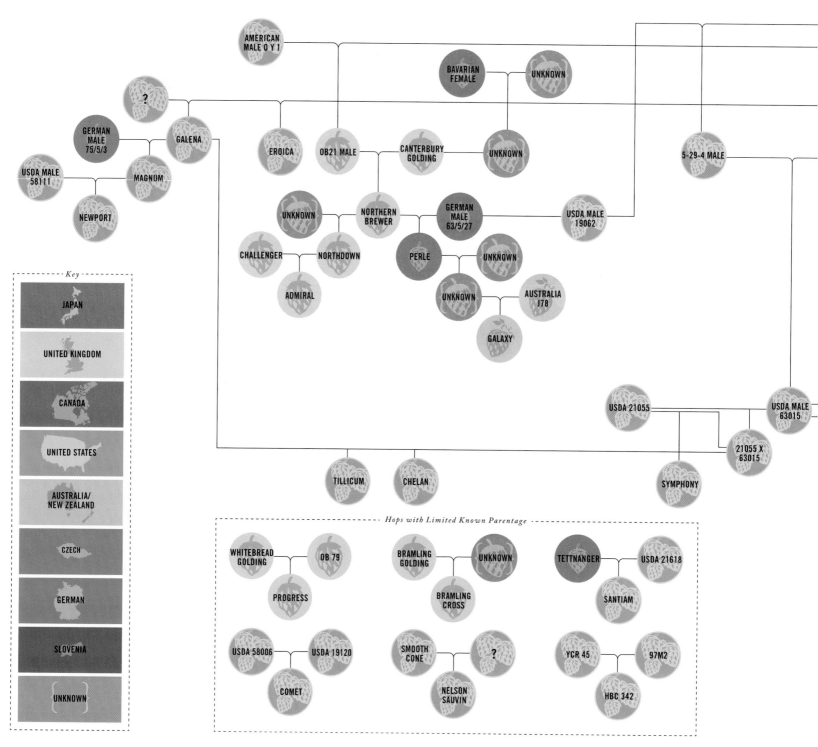

Key

JAPAN

UNITED KINGDOM

CANADA

UNITED STATES

AUSTRALIA/
NEW ZEALAND

CZECH

GERMAN

SLOVENIA

UNKNOWN

AMERICAN MALE 0 Y 1

BAVARIAN FEMALE

UNKNOWN

?

GERMAN MALE 75/5/3

GALENA

EROICA

OB21 MALE

CANTERBURY GOLDING

UNKNOWN

5-29-4 MALE

USDA MALE 58111

MAGNUM

UNKNOWN

NORTHERN BREWER

GERMAN MALE 63/5/27

USDA MALE 19062

NEWPORT

CHALLENGER

NORTHDOWN

PERLE

UNKNOWN

ADMIRAL

UNKNOWN

AUSTRALIA J78

GALAXY

USDA 21055

USDA MALE 63015

21055 X 63015

TILLICUM

CHELAN

SYMPHONY

Hops with Limited Known Parentage

WHITEBREAD GOLDING

OB 79

BRAMLING GOLDING

UNKNOWN

TETTNANGER

USDA 21618

PROGRESS

BRAMLING CROSS

SANTIAM

USDA 58006

USDA 19120

SMOOTH CONE

?

YCR 45

97M2

COMET

NELSON SAUVIN

HBC 342

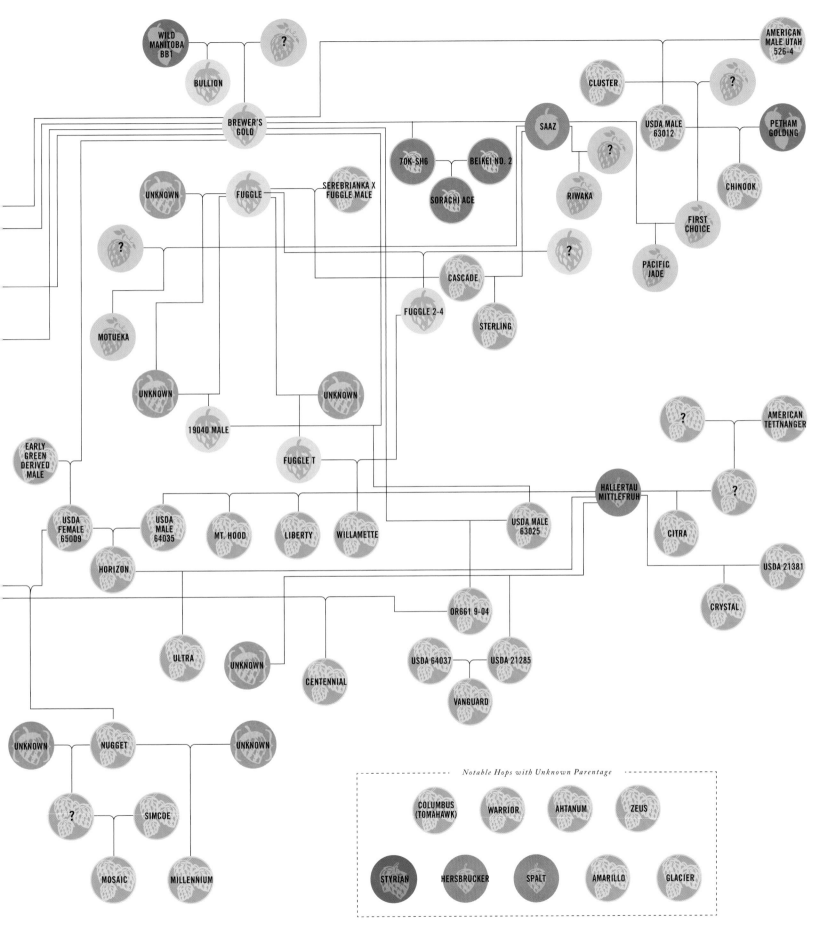

The AB InBev Behemoth

The result of a series of mergers and acquisitions by macrobrewing giants, the Dutch-Brazilian-American conglomerate Anheuser-Busch InBev is the world's largest brewing company, with more than two hundred brands and a market share of 46 percent in the United States and 22 percent worldwide.

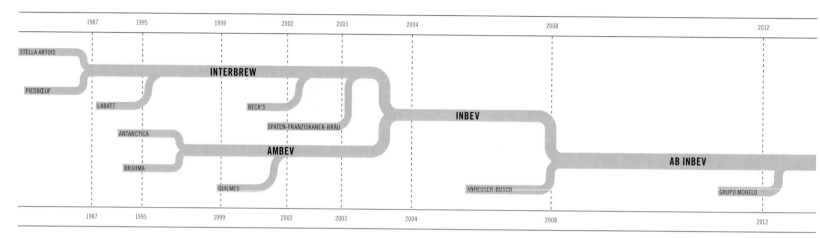

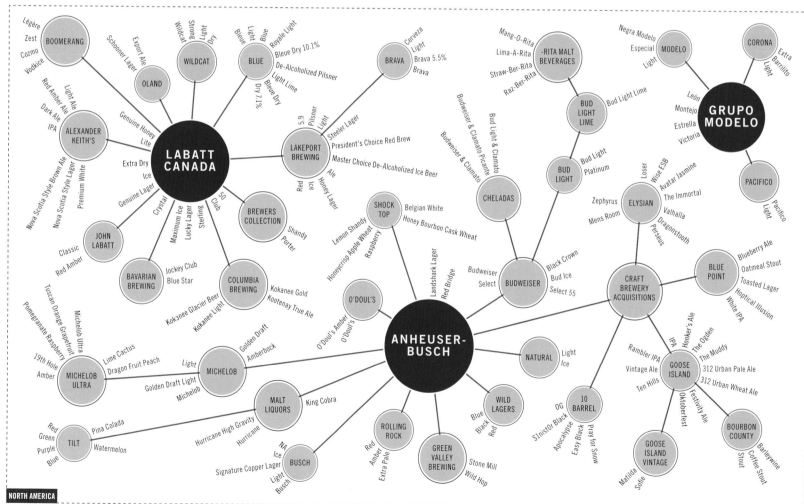

NORTH AMERICA

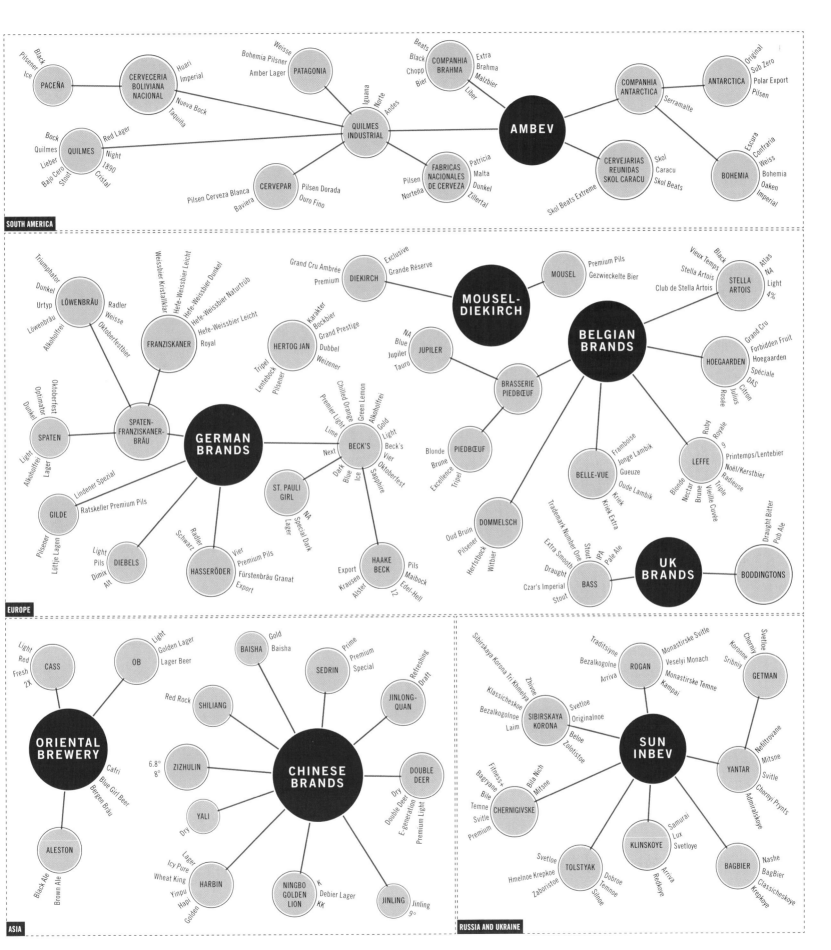

SOUTH AMERICA

EUROPE

ASIA

RUSSIA AND UKRAINE

The Rise of Craft Beer

While the major multinational conglomerates sell most of the world's beer, it is the craft brewers who make the best beer, and who have pushed forward the industry by inventing new styles and rediscovering old ones. In the United States, the passage of a law in 1979 legalizing home-brewing allowed amateur brewers to experiment with beer-making, and by the mid-eighties new breweries were opening across the country.

SIERRA NEVADA — 1979

1980

1981

1982

1983

SAMUEL ADAMS — 1984

BELL'S — 1985

HARPOON, ABITA — 1986

BROOKLYN BREWERY — 1987

ROGUE ALES, DESCHUTES, GREAT LAKES — 1988

1989

FLYING DOG, BRECKENRIDGE — 1990

NEW BELGIUM — 1991

1992

AVERY, LAGUNITAS, NEW GLARUS, LEFT HAND — 1993

SMUTTYNOSE — 1994

DOGFISH HEAD, BEAR REPUBLIC — 1995

BALLAST POINT, STONE, FIRESTONE WALKER, FOUNDERS, VICTORY — 1996

SWEETWATER, OSKAR BLUES — 1997

1998

1999

2000

2001

SOUTHERN TIER, GREEN FLASH — 2002

BREWERIES IN U.S. BY YEAR

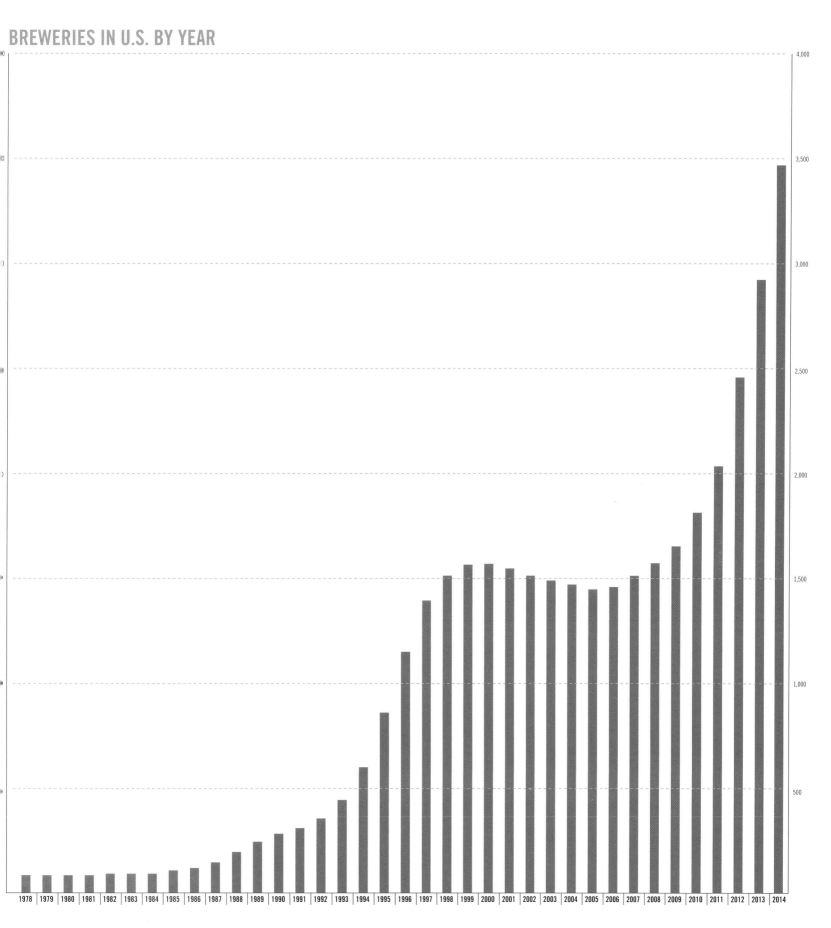

Beer Styles—The Many Varieties of Beer

There are more than one hundred varieties of beer, but except for a handful of hybrid styles, all beer is either ale or lager. Beyond this dichotomy, beer can be grouped by place of origin or production process. As with most things beer-related, the craft brewing revolution of the past thirty years has greatly expanded matters, especially among the ales, which require less time and investment to produce and thus are more accommodating to experimentation than lagers.

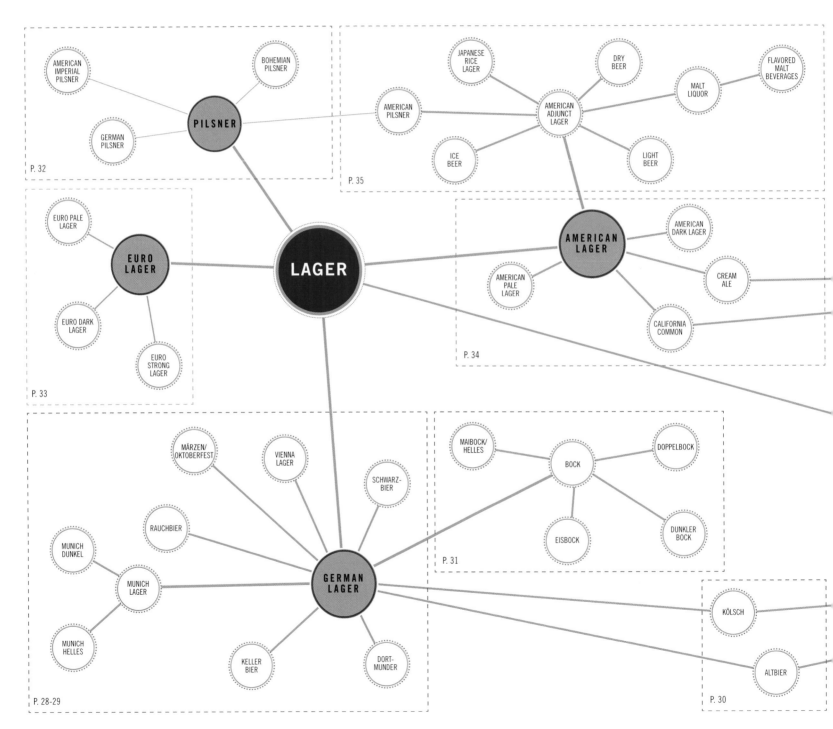

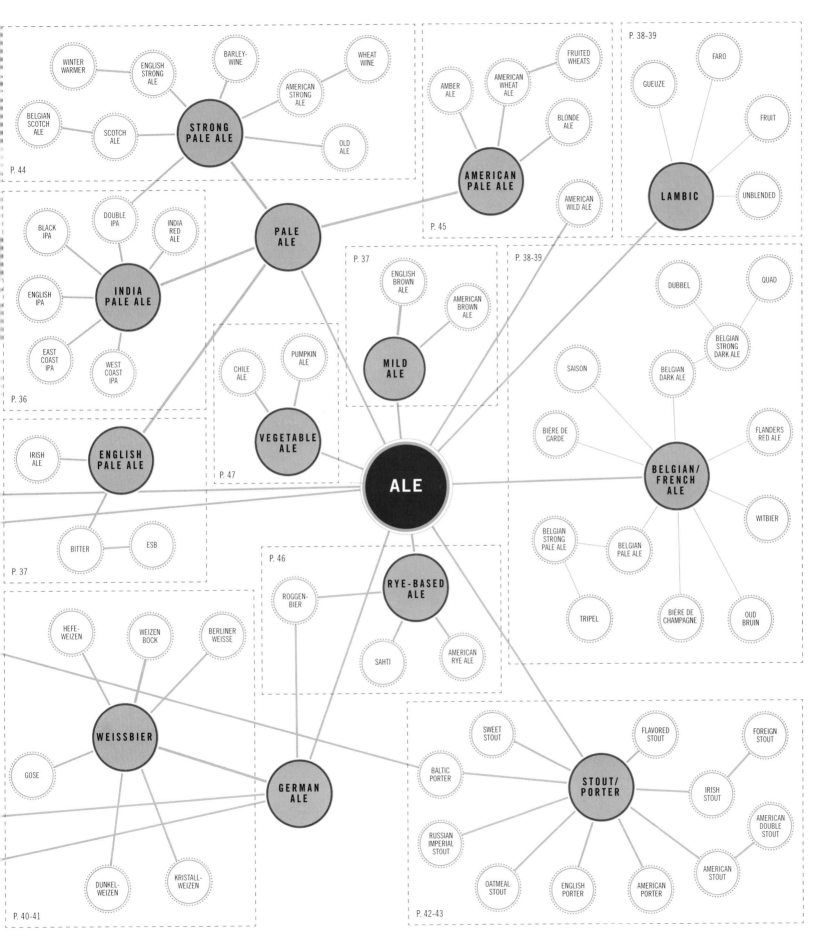

P. 44

P. 38-39

P. 45

P. 36

P. 37

P. 38-39

P. 47

P. 37

P. 46

P. 40-41

P. 42-43

WINTER WARMER

ENGLISH STRONG ALE

BARLEY-WINE

WHEAT WINE

AMERICAN STRONG ALE

BELGIAN SCOTCH ALE

SCOTCH ALE

STRONG PALE ALE

OLD ALE

AMBER ALE

AMERICAN WHEAT ALE

FRUITED WHEATS

BLONDE ALE

AMERICAN PALE ALE

AMERICAN WILD ALE

FARO

GUEUZE

FRUIT

LAMBIC

UNBLENDED

BLACK IPA

DOUBLE IPA

INDIA RED ALE

ENGLISH IPA

INDIA PALE ALE

PALE ALE

EAST COAST IPA

WEST COAST IPA

ENGLISH BROWN ALE

AMERICAN BROWN ALE

MILD ALE

DUBBEL

QUAD

BELGIAN STRONG DARK ALE

BELGIAN DARK ALE

SAISON

IRISH ALE

ENGLISH PALE ALE

CHILE ALE

PUMPKIN ALE

VEGETABLE ALE

ALE

BIÈRE DE GARDE

FLANDERS RED ALE

BELGIAN/ FRENCH ALE

WITBIER

BITTER

ESB

BELGIAN STRONG PALE ALE

BELGIAN PALE ALE

TRIPEL

BIÈRE DE CHAMPAGNE

OUD BRUIN

ROGGEN-BIER

RYE-BASED ALE

SAHTI

AMERICAN RYE ALE

HEFE-WEIZEN

WEIZEN BOCK

BERLINER WEISSE

WEISSBIER

GOSE

GERMAN ALE

DUNKEL-WEIZEN

KRISTALL-WEIZEN

SWEET STOUT

BALTIC PORTER

FLAVORED STOUT

FOREIGN STOUT

STOUT/ PORTER

IRISH STOUT

AMERICAN DOUBLE STOUT

RUSSIAN IMPERIAL STOUT

OATMEAL STOUT

ENGLISH PORTER

AMERICAN PORTER

AMERICAN STOUT

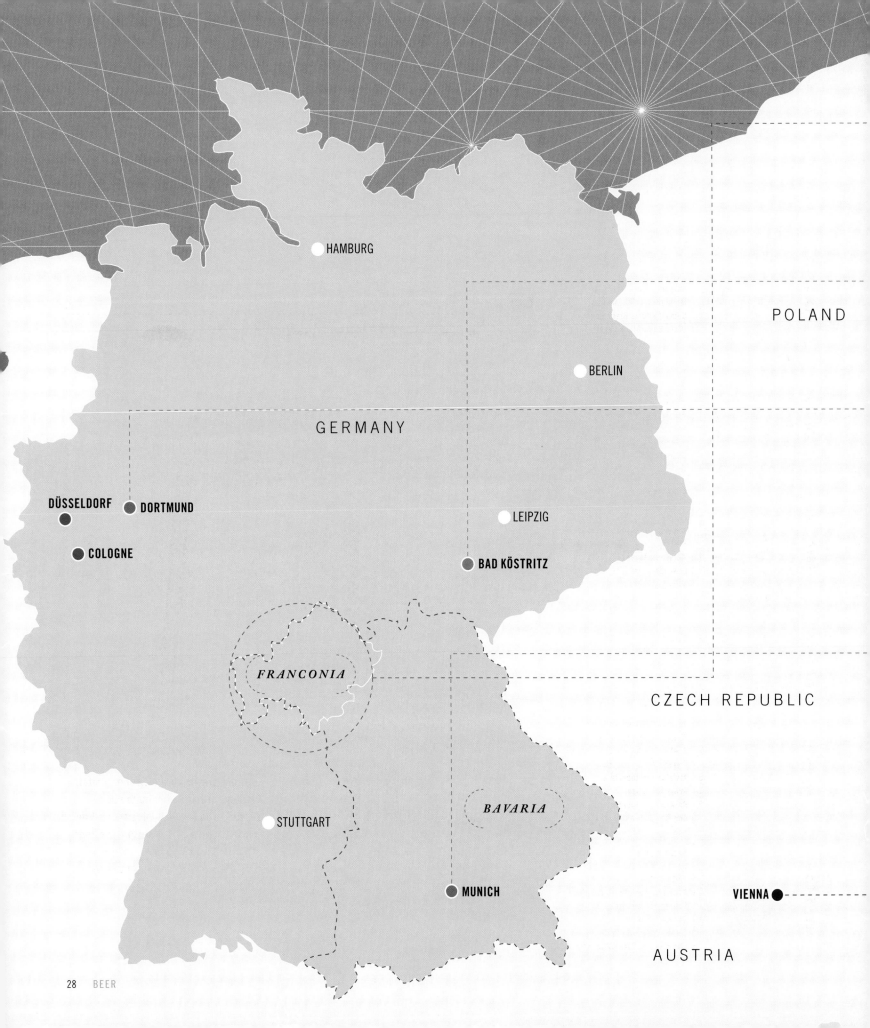

HAMBURG

POLAND

BERLIN

GERMANY

DÜSSELDORF ● ● DORTMUND

LEIPZIG

COLOGNE ●

● BAD KÖSTRITZ

FRANCONIA

CZECH REPUBLIC

BAVARIA

STUTTGART

MUNICH ●

VIENNA ●

AUSTRIA

The first lagers were developed in Bavaria, when a new type of yeast that fermented on the bottom of the vessel at cooler temperatures allowed for a totally new style of beer to develop. The older German lagers are all dark; it wasn't until pale malt was brought over from England in the nineteenth century that popular light-colored lagers such as Helles were developed. These light, drinkable lagers would then be brought to the United States by German immigrants.

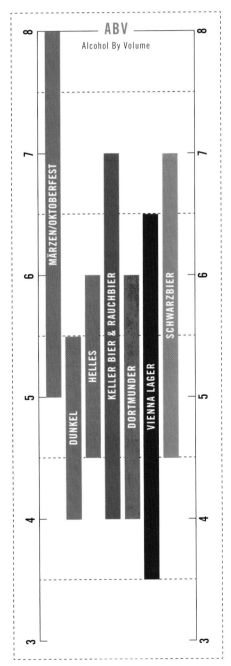

From Franconia

KELLER BIER / RAUCHBIER
ABV 4–7%

Notable Examples
- Aecht Schlenkerla Rauchbier Märzen
- Spezial Rauchbier Lager
- Jack's Abby Fire in the Ham
- NOLA Smoky Mary
- Sam Adams Cinder Bock

- St. Georgenbräu Keller Bier
- Creemore Springs Kellerbier
- Columbus Summer Teeth
- Mahrs-Bräu Mastodon
- Voodoo PILZILLA
- Tuppers' Hop Pocket Pils

From Bad Köstritz

SCHWARZBIER
ABV 4.5–7%

Notable Examples
- Köstritzer Schwarzbier
- Choc Beer Miner Mishap
- Mönchshof Schwarzbier
- Saranac Black Forest
- Sprecher Black Bavarian
- Midnight Sun BREWtality
- Samuel Adams Black Lager
- Uinta Baba Black Lager

From Dortmund

DORTMUNDER
ABV 4–6%

Notable Examples
- Ayinger Jahrhundert Bier
- Appalachian Mountain Lager
- Three Floyds Jinx Proof
- DAB Original
- Great Lakes Dortmunder Gold
- Thirsty Dog Labrador Lager
- Flensburger Gold
- Depot Street Loose Caboose Lager

HELLES
ABV 4.5–6%

Notable Examples
- Odd Side Hells Yes!
- Lancaster Lager
- Penn Brewing Penn Gold
- Terrapin Pineapple Express
- Stoudt's Gold Lager
- Weihenstephaner Original
- Löwenbräu Original
- Maui Bikini Blonde

From Munich

DUNKEL
ABV 4–5.5%

Notable Examples
- Warsteiner Premium Dunkel
- Lakefront Eastside Dark
- Surly Schadenfreude
- Spaten Dunkel
- Karbach Mother in Lager
- Trapp Dunkel Lager
- Tempo Gold Star
- Capital Dark

MÄRZEN/OKTOBERFEST
ABV 5–8%

Notable Examples
- Paulaner Oktoberfest
- Flying Dog Dogtoberfest
- Spaten Oktoberfestbier Ur-Märzen
- Flying Fish OktoberFish
- Atwater Bloktoberfest
- Avery The Kaiser
- Berkshire Oktoberfest
- Augustiner Bräu Märzen Bier

From Vienna

VIENNA LAGER
ABV 3.5–6.5%

Notable Examples
- Negra Modelo
- Dos Equis Amber Lager
- Abita Amber
- Millstream Schild Brau Amber
- Schwelmer Bernstein
- Bohemia Obscura
- Gigantic Dark Meddle
- Live Oak Big Bark Amber Lager

ABV
Alcohol By Volume

- MÄRZEN/OKTOBERFEST
- DUNKEL
- HELLES
- KELLER BIER & RAUCHBIER
- DORTMUNDER
- VIENNA LAGER
- SCHWARZBIER

German brewer Anton Dreher visited England in the early nineteenth century, and legend holds that while visiting a brewery in Burton-on-Trent he furtively sucked up a sample of pale ale into a hollowed-out cane in order to unlock the secrets of pale beer.

Kölsch & Altbier

Cologne and Düsseldorf are separated by just 25 miles along the Rhine, and each is home to a unique hybrid of an ale and a lager. Cologne's *kölsch* ("from Cologne") is a light, easy-drinking pale beer that's top-fermented like an ale but aged like a lager. Düsseldorf's *altbier* ("old beer"), on the other hand, while also brewed via both top fermentation and lagering, is a copper-colored and bitter beer. While Kölners and Düsseldorfers have a friendly rivalry over whose beer is superior, they do agree on one thing: The proper serving vessel is the small, cylindrical cup known as a *stange*.

Stange

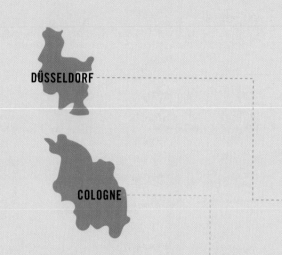

DÜSSELDORF

COLOGNE

From Düsseldorf **ALTBIER**

Uerige Altbier
Uerige Doppelsticke
Frankenheim Alt
Alaskan Amber
Long Trail Double Bag
Off Color Scurry
OMB Copper
Rising Tide Ishmael
Pinkus Mueller Münster Alt
Fordham Copperhead Ale
Tuckerman Headwall Alt
Hops and Grain Alt-eration Ale
Füchschen Alt
Schlösser Alt
Hopfenstark Ostalgia Rousse

From Cologne **KÖLSCH**

Sünner Kölsch
Mother Earth Endless River
Ballast Point Yellowtail
Gaffel Kölsch
Reissdorf Kölsch
Pyramid Curve Ball Kölsch
Saint Arnold Santo
Coast 32°/50°
Früh Kölsch
Braustelle Freigeist Ottekolong
Zunft Kölsch
Dom Kölsch
Trillium Big Sprang
Fate Coffee Kölsch
Saddleback Dirty Blonde

	ALE-LIKE	LAGER-LIKE
YEAST	✓	
FERMENTATION	✓	
AGED		✓

Bock

Bock beers are strong, dark lagers that originated in the German city of Einbeck in the fourteenth century. Eventually Munich brewers caught on and started creating bocks of their own. Bocks are full-bodied but usually very low in bitterness, and often have fruit and malt notes. The word *bock* derives from "Einbeck," but *bock* also means "billy goat" in German, which is why many bocks feature goats on their labels.

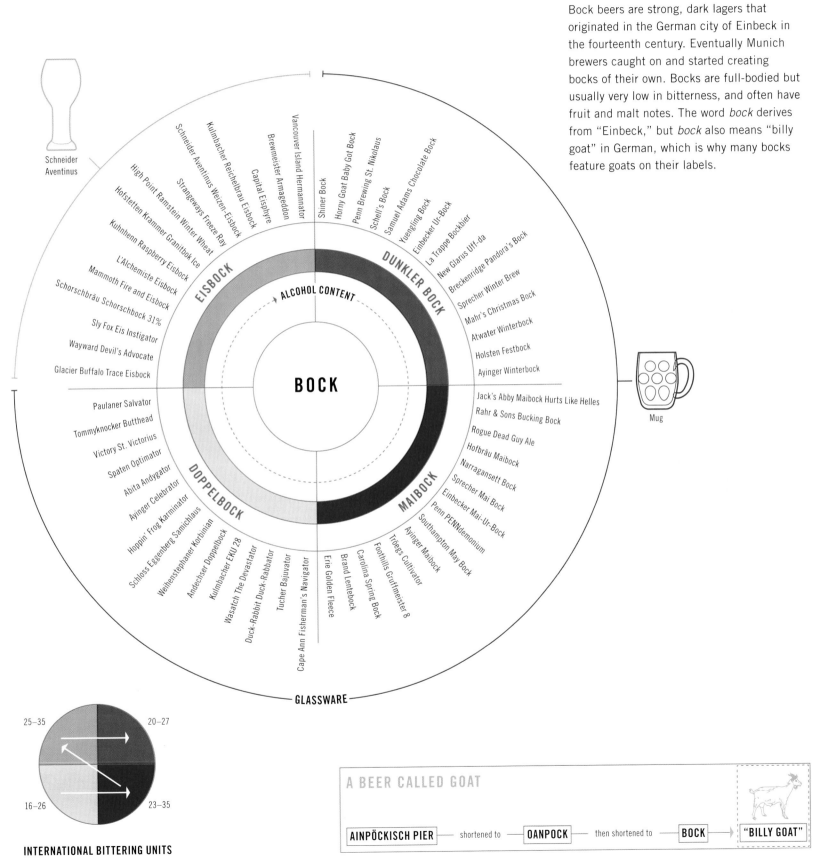

Schneider Aventinus

ALCOHOL CONTENT

BOCK

Mug

GLASSWARE

EISBOCK

Vancouver Island Hermannator
Brewmeister Armageddon
Capital Eisphyre
Kulmbacher Reichelbräu Eisbock
Schneider Aventinus Weizen-Eisbock
Strangeways Freeze Ray
High Point Ramstein Winter Wheat
Hofstetten Krammer Granitbok Ice
Kuhnhenn Raspberry Eisbock
L'Alchemiste Eisbock
Mammoth Fire and Eisbock
Schorschbräu Schorschbock 31%
Sly Fox Eis Instigator
Wayward Devil's Advocate
Glacier Buffalo Trace Eisbock

DUNKLER BOCK

Shiner Bock
Horny Goat Baby Got Bock
Penn Brewing St. Nikolaus
Schell's Bock
Samuel Adams Chocolate Bock
Yuengling Bock
Einbecker Ur-Bock
La Trappe Bockbier
New Glarus Uff-da
Breckenridge Pandora's Bock
Sprecher Winter Brew
Mahr's Christmas Bock
Atwater Winterbock
Holsten Festbock
Ayinger Winterbock

DOPPELBOCK

Paulaner Salvator
Tommyknocker Butthead
Victory St. Victorius
Spaten Optimator
Abita Andygator
Ayinger Celebrator
Hoppin' Frog Karminator
Schloss Eggenberg Samichlaus
Weihenstephaner Korbinian
Andechser Doppelbock
Kulmbacher EKU 28
Wasatch The Devastator
Duck-Rabbit Duck-Rabbator
Tucher Bajuvator
Cape Ann Fisherman's Navigator

MAIBOCK

Jack's Abby Maibock Hurts Like Helles
Rahr & Sons Bucking Bock
Rogue Dead Guy Ale
Hofbräu Maibock
Narragansett Bock
Sprecher Mai Bock
Einbecker Mai-Ur-Bock
Penn PENNdemonium
Southampton May Bock
Ayinger Maibock
Tröegs Cultivator
Foothills Gruffmeister 8
Carolina Spring Bock
Brand Lentebock
Erie Golden Fleece

25–35 20–27

16–26 23–35

INTERNATIONAL BITTERING UNITS

A BEER CALLED GOAT

AINPÖCKISCH PIER — shortened to — OANPOCK — then shortened to — BOCK → "BILLY GOAT"

Pilsner

Pilsner was born in the town of Plzeň, in what is today the Czech Republic, in 1842. The town commissioned the construction of a new brewery, the Bürger Brauerei, and sent its brewmaster into Bavaria to learn about the new light-colored lager that was sweeping the continent. The combination of Bohemian barley and hops with Bavarian techniques produced a miraculous lager with a sharp, assertive hop character. Pilsner today is among the most popular styles of beer, even if many of the mass-produced beers labeled as such are pale imitations of the Bohemian original.

HANA BARLEY + **SAAZ HOPS** x **BAVARIAN LAGERING** = **!**
(Original Pilsner Hop)

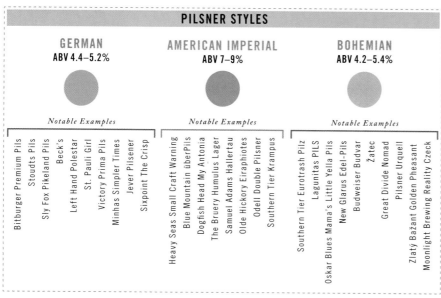

PILSNER STYLES

GERMAN
ABV 4.4–5.2%

Notable Examples

Bitburger Premium Pils
Stoudts Pils
Sly Fox Pikeland Pils
Beck's
Left Hand Polestar
St. Pauli Girl
Victory Prima Pils
Minhas Simpler Times
Jever Pilsener
Sixpoint The Crisp

AMERICAN IMPERIAL
ABV 7–9%

Notable Examples

Heavy Seas Small Craft Warning
Blue Mountain überPils
Dogfish Head My Antonia
The Bruery Humulus Lager
Samuel Adams Hallertau
Olde Hickory Eiraphiotes
Odell Double Pilsner
Southern Tier Krampus

BOHEMIAN
ABV 4.2–5.4%

Notable Examples

Southern Tier Eurotrash Pilz
Lagunitas PILS
Oskar Blues Mama's Little Yella Pils
New Glarus Edel-Pils
Budweiser Budvar
Žatec
Great Divide Nomad
Pilsner Urquell
Zlatý Bažant Golden Pheasant
Moonlight Brewing Reality Czeck

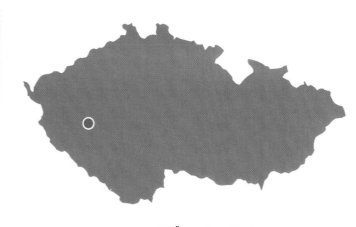

PLZEŇ, CZECH REPUBLIC
The city known for pilsner beer

PILSNER GLASSWARE VARIETIES

Euro Lager

As German lagers and Bohemian pilsners flooded the continent in the late nineteenth century, brewers across Europe came up with their own variations, now generally known as Euro lagers. In addition to the dark and pale variants, many breweries produce higher-alcohol strong versions.

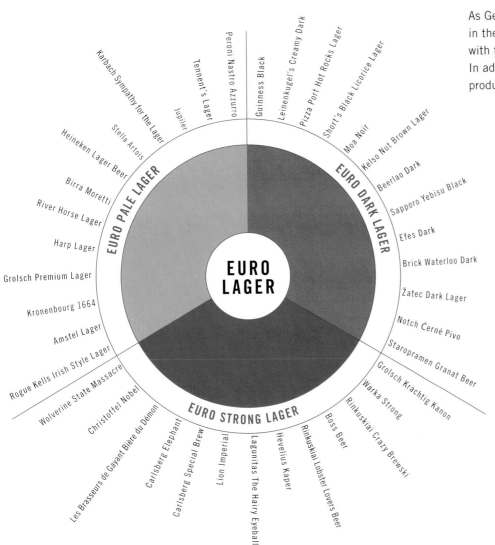

EURO PALE LAGER

- Karbach Sympathy for the Lager
- Heineken Lager Beer
- Stella Artois
- Jupiler
- Tennent's Lager
- Peroni Nastro Azzurro
- Birra Moretti
- River Horse Lager
- Harp Lager
- Grolsch Premium Lager
- Kronenbourg 1664
- Amstel Lager
- Rogue Kells Irish Style Lager

EURO DARK LAGER

- Guinness Black
- Leinenkugel's Creamy Dark
- Pizza Port Hot Rocks Lager
- Short's Black Licorice Lager
- Moa Noir
- Kelso Nut Brown Lager
- Beerlao Dark
- Sapporo Yebisu Black
- Efes Dark
- Brick Waterloo Dark
- Žatec Dark Lager
- Notch Černé Pivo

EURO STRONG LAGER

- Wolverine State Massacre
- Christoffel Nobel
- Les Brasseurs de Gayant Bière du Démon
- Carlsberg Elephant
- Carlsberg Special Brew
- Lion Imperial
- Lagunitas The Hairy Eyeball
- Hevelius Kaper
- Rinkuskiai Lobster Lovers Beer
- Boss Beer
- Rinkuskiai Crazy Brewski
- Warka Strong
- Grolsch Krachtig Kanon
- Staropramen Granat Beer

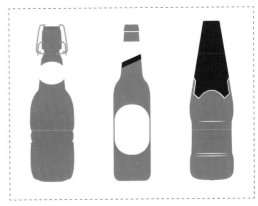

For unknown reasons, many Euro lagers are packaged in flavor-killing green bottles.

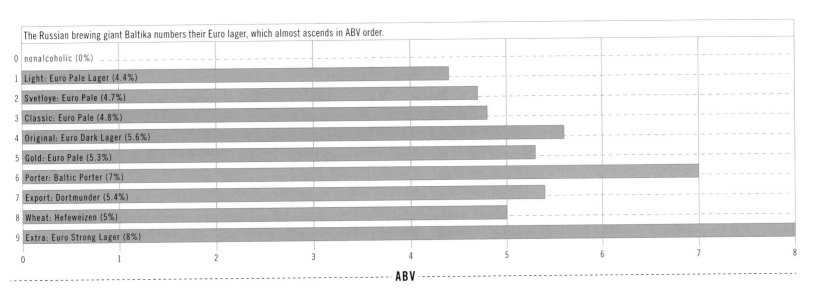

The Russian brewing giant Baltika numbers their Euro lager, which almost ascends in ABV order.

		ABV
0	nonalcoholic (0%)	
1	Light: Euro Pale Lager (4.4%)	
2	Svetloye: Euro Pale (4.7%)	
3	Classic: Euro Pale (4.8%)	
4	Original: Euro Dark Lager (5.6%)	
5	Gold: Euro Pale (5.3%)	
6	Porter: Baltic Porter (7%)	
7	Export: Dortmunder (5.4%)	
8	Wheat: Hefeweizen (5%)	
9	Extra: Euro Strong Lager (8%)	

American Lager

As is the case with all lagers, American lagers are influenced by their Bavarian ancestors. The terms *pale* and *amber* are largely color descriptors, although amber lagers tend to be maltier and fuller bodied. Steam beer and cream ale are American innovations, each combining ale and lager into one. Steam beer (a term now aggressively trademarked by Anchor Brewing, which has given rise to the "California Common" sobriquet) uses lager yeast fermented at a temperature closer to that used for ale yeast. Cream ales can be made with lager yeast, ale yeast, or both, and were developed to stand as a stronger, more fully flavored lager.

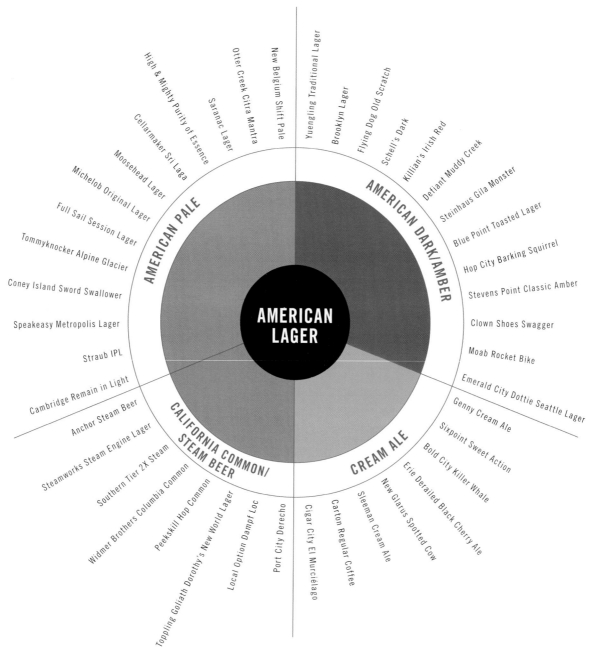

American Adjunct Lager

More than 90 percent of beer sold in the United States is American adjunct lager. Strictly speaking, an "adjunct" is simply an unmalted grain, which can be added to the brewing process for any number of reasons, but in the case of American adjunct lager it is often rice or corn added to the beer to lighten both color and flavor. Due to a rubric that taxes beers based on malt content, Japanese brewers developed Happoshu, a rice-based lager, which usually contains less than 25 percent malted grains.

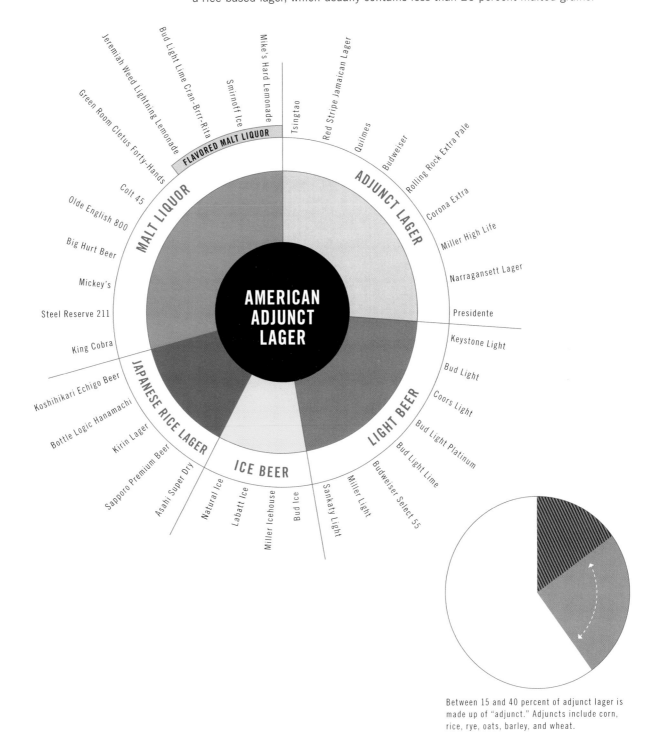

AMERICAN ADJUNCT LAGER

FLAVORED MALT LIQUOR
- Jeremiah Weed Lightning Lemonade
- Bud Light Lime Cran-Brrr-Rita
- Smirnoff Ice
- Mike's Hard Lemonade

MALT LIQUOR
- Green Room Cletus Forty-Hands
- Colt 45
- Olde English 800
- Big Hurt Beer
- Mickey's
- Steel Reserve 211
- King Cobra

ADJUNCT LAGER
- Tsingtao
- Red Stripe Jamaican Lager
- Quilmes
- Budweiser
- Rolling Rock Extra Pale
- Corona Extra
- Miller High Life
- Narragansett Lager
- Presidente

LIGHT BEER
- Keystone Light
- Bud Light
- Coors Light
- Bud Light Platinum
- Bud Light Lime
- Budweiser Select 55
- Miller Light
- Sankaty Light

ICE BEER
- Natural Ice
- Labatt Ice
- Miller Icehouse
- Bud Ice

JAPANESE RICE LAGER
- Koshihikari Echigo Beer
- Bottle Logic Hanamachi
- Kirin Lager
- Sapporo Premium Beer
- Asahi Super Dry

Between 15 and 40 percent of adjunct lager is made up of "adjunct." Adjuncts include corn, rice, rye, oats, barley, and wheat.

India Pale Ale

IPA traces its history back to the eighteenth century, when London brewers developed a style of beer fit for those stationed in India by the British East India Company. The pale, high-alcohol, and highly hopped beer nearly died out by the mid-twentieth century, but American craft brewers have now made it the most popular craft beer style, relying on citrusy, resinous hops from the Pacific Northwest to give it its trademark bite.

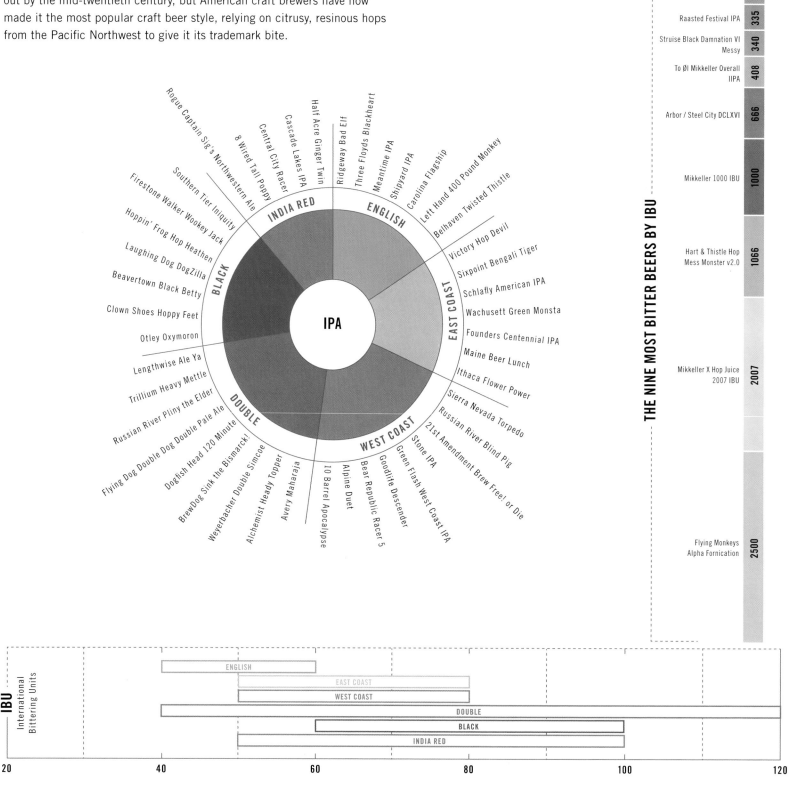

THE NINE MOST BITTER BEERS BY IBU

Beer	IBU
Pitstop The Hop	323
Raasted Festival IPA	335
Struise Black Damnation VI Messy	340
To Øl Mikkeller Overall IIPA	408
Arbor / Steel City DCLXVI	666
Mikkeller 1000 IBU	1000
Hart & Thistle Hop Mess Monster v2.0	1066
Mikkeller X Hop Juice 2007 IBU	2007
Flying Monkeys Alpha Fornication	2500

IPA

INDIA RED — ENGLISH — EAST COAST — WEST COAST — DOUBLE — BLACK

Rogue Captain Sig's Northwestern Ale, **8 Wired Tall Poppy**, **Central City Racer**, **Cascade Lakes IPA**, **Half Acre Ginger Twin**, **Ridgeway Bad Elf**, **Three Floyds Blackheart**, **Meantime IPA**, **Shipyard IPA**, **Carolina Flagship**, **Left Hand 400 Pound Monkey**, **Belhaven Twisted Thistle**, **Victory Hop Devil**, **Sixpoint Bengali Tiger**, **Schlafly American IPA**, **Wachusett Green Monsta**, **Founders Centennial IPA**, **Maine Beer Lunch**, **Ithaca Flower Power**, **Sierra Nevada Torpedo**, **Russian River Blind Pig**, **21st Amendment Brew Free! or Die**, **Green Flash West Coast IPA**, **Stone IPA**, **Goodlife Descender**, **Bear Republic Racer 5**, **Alpine Duet**, **10 Barrel Apocalypse**, **Avery Maharaja**, **Alchemist Heady Topper**, **Weyerbacher Double Simcoe**, **BrewDog Sink the Bismarck!**, **Dogfish Head 120 Minute**, **Flying Dog Double Dog Double Pale Ale**, **Russian River Pliny the Elder**, **Trillium Heavy Mettle**, **Lengthwise Ale Ya**, **Otley Oxymoron**, **Clown Shoes Hoppy Feet**, **Beavertown Black Betty**, **Laughing Dog DogZilla**, **Hoppin' Frog Hop Heathen**, **Firestone Walker Wookey Jack**, **Southern Tier Iniquity**

IBU — International Bittering Units

| ENGLISH |
| EAST COAST |
| WEST COAST |
| DOUBLE |
| BLACK |
| INDIA RED |

20 40 60 80 100 120

English Pale Ale

Pale ale was popularized in eighteenth-century England and owes its invention to the Industrial Revolution. Beers had always been dark because the kilning process, where heat is applied to the germinated grain, could not be finely controlled and resulted in a thoroughly roasted dark malt. The invention of coke smelting, however, allowed for controllable, consistent heat with no malodorous fumes, which meant maltsters could produce pale malts. Its history is interwoven with that of IPA, but today English pale ales are less hop-forward than IPAs.

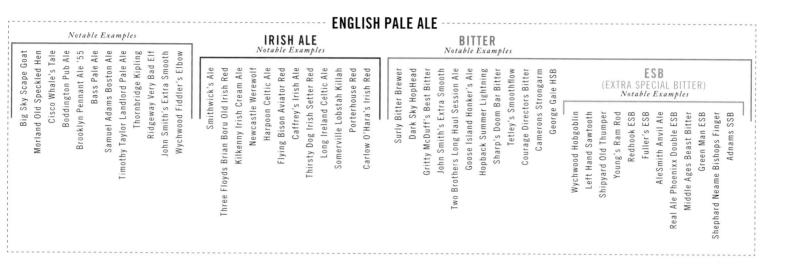

ENGLISH PALE ALE

Notable Examples

- Big Sky Scape Goat
- Morland Old Speckled Hen
- Cisco Whale's Tale
- Boddington Pub Ale
- Brooklyn Pennant Ale '55
- Bass Pale Ale
- Samuel Adams Boston Ale
- Timothy Taylor Landlord Pale Ale
- Thornbridge Kipling
- Ridgeway Very Bad Elf
- John Smith's Extra Smooth
- Wychwood Fiddler's Elbow

IRISH ALE

Notable Examples

- Smithwick's Ale
- Three Floyds Brian Boru Old Irish Red
- Kilkenny Irish Cream Ale
- Newcastle Werewolf
- Harpoon Celtic Ale
- Flying Bison Aviator Red
- Caffrey's Irish Ale
- Thirsty Dog Irish Setter Red
- Long Ireland Celtic Ale
- Somerville Lobstah Killah
- Porterhouse Red
- Carlow O'Hara's Irish Red

BITTER

Notable Examples

- Surly Bitter Brewer
- Dark Sky HopHead
- Gritty McDuff's Best Bitter
- John Smith's Extra Smooth
- Two Brothers Long Haul Session Ale
- Goose Island Honker's Ale
- Hopback Summer Lightning
- Sharp's Doom Bar Bitter
- Tetley's Smoothflow
- Courage Directors Bitter
- Camerons Strongarm
- George Gale HSB

ESB
(EXTRA SPECIAL BITTER)

Notable Examples

- Wychwood Hobgoblin
- Left Hand Sawtooth
- Shipyard Old Thumper
- Young's Ram Rod
- Redhook ESB
- Fuller's ESB
- AleSmith Anvil Ale
- Real Ale Phoenixx Double ESB
- Middle Ages Beast Bitter
- Green Man ESB
- Shephard Neame Bishops Finger
- Adnams SSB

Mild Ale

The terms *mild ale* and *brown ale* generally refer to moderate strength, low-hop beers originating in England. Most true mild ales are only found on draft, whereas the brown ales have been given wide distribution in bottles. As is usually the case, the American variant of brown ale is a stronger, hoppier version of its European parent.

MILD ALE

Notable Examples

- Tired Hands Caskette
- Coopers Dark Ale
- F&M Stone Hammer
- Eagle Rock Solidarity
- Relic The Hound's Tooth
- Motor City Ghettoblaster
- Sea Dog Owl's Head

ENGLISH BROWN

Notable Examples

- Newcastle Brown Ale
- Big Boss Bad Benny
- DuClaw Euforia
- Black Toad Dark Ale
- New Glarus Fat Squirrel
- Samuel Smith's Nut Brown Ale
- Long Trail Harvest

AMERICAN BROWN

Notable Examples

- Mikkeller Jackie Brown
- Tommyknocker Maple Nut
- Lonerider Sweet Josie
- Surly Bender
- Funky Buddha No Crusts
- Abita Turbodog
- Dogfish Head Indian Brown Ale

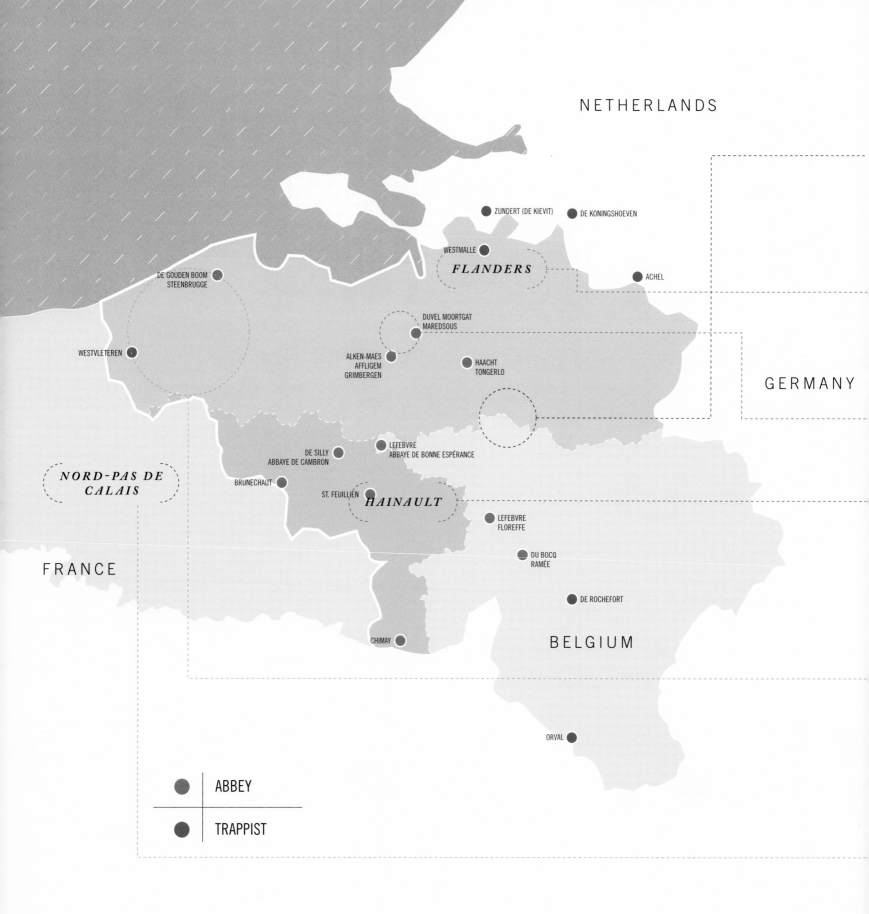

NETHERLANDS

ZUNDERT (DE KIEVIT) DE KONINGSHOEVEN

WESTMALLE

FLANDERS ACHEL

DE GOUDEN BOOM
STEENBRUGGE

DUVEL MOORTGAT
MAREDSOUS

WESTVLETEREN

ALKEN-MAES
AFFLIGEM HAACHT
GRIMBERGEN TONGERLO

GERMANY

LEFEBVRE
DE SILLY ABBAYE DE BONNE ESPÉRANCE
ABBAYE DE CAMBRON

*NORD-PAS DE
CALAIS*

BRUNECHAUT

ST. FEUILLIEN *HAINAULT*

LEFEBVRE
FLOREFFE

FRANCE DU BOCQ
 RAMÉE

DE ROCHEFORT

BELGIUM

CHIMAY

ORVAL

● | ABBEY
────┼────
● | TRAPPIST

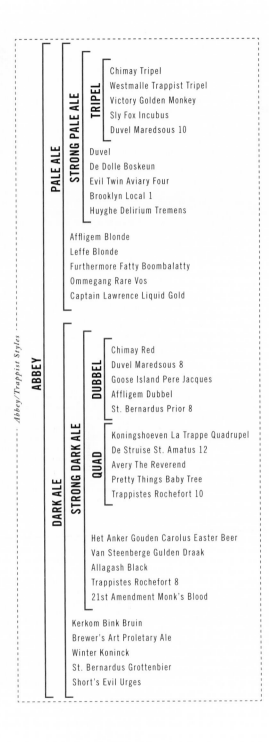

WITBIER *(From Leuven and Hoegaarden)*
- Hoegaarden Original White Ale
- Blue Moon Belgian White
- Dogfish Head Namaste
- Unibroue Blanche de Chambly
- Allagash White

FLANDERS RED ALE *(From Flanders)*
- Verhaeghe Duchesse de Bourgogne
- Westbrook Mr. Chipper
- Rodenbach Grand Cru
- Hair of the Dog Michael
- Central Waters Exodus

OUD BRUIN
- Petrus Oud Bruin
- Kuhnhenn Cherry Olde Brune
- Monk's Café Flemish Sour Ale
- Deschutes The Dissident
- Sun King Stupid Sexy Flanders

BIÈRE BRUT *(From Buggenhout)*
- Malheur Bière Brut
- DeuS Brut des Flandres
- Samuel Adams Infinium

SAISON *(From Hainault)*
- Saison Dupont
- Ommegang Hennepin
- Brooklyn Sorachi Ace
- Tired Hands HandFarm
- Goose Island Sofie

LAMBIC *(From Pajottenland)*

GEUZE
- Hanssens Artisanaal Oude Gueuze
- Drie Fonteinen Oude Geuze
- Boon Oude Geuze Mariage Parfait

UNBLENDED
- De Cam Oude Lambiek
- Vanberg & DeWulf Lambickx
- Cantillon Iris

FRUIT
- Lindemans Framboise
- Kriek de Ranke
- Tilquin Oude Quetsche à l'Ancienne

FARO
- De Troch Chapeau
- Boon Faro Pertotale
- Girardin Faro

BIÈRE DE GARDE *(From Nord–Pas de Calais)*
- Verhaeghe Duchesse de Bourgogne
- Westbrook Mr. Chipper
- Rodenbach Grand Cru
- Central Waters Exodus

ABBEY *(Abbey/Trappist Styles)*

PALE ALE — STRONG PALE ALE — TRIPEL
- Chimay Tripel
- Westmalle Trappist Tripel
- Victory Golden Monkey
- Sly Fox Incubus
- Duvel Maredsous 10

PALE ALE — STRONG PALE ALE
- Duvel
- De Dolle Boskeun
- Evil Twin Aviary Four
- Brooklyn Local 1
- Huyghe Delirium Tremens

PALE ALE
- Affligem Blonde
- Leffe Blonde
- Furthermore Fatty Boombalatty
- Ommegang Rare Vos
- Captain Lawrence Liquid Gold

DARK ALE — STRONG DARK ALE — DUBBEL
- Chimay Red
- Duvel Maredsous 8
- Goose Island Pere Jacques
- Affligem Dubbel
- St. Bernardus Prior 8

DARK ALE — STRONG DARK ALE — QUAD
- Koningshoeven La Trappe Quadrupel
- De Struise St. Amatus 12
- Avery The Reverend
- Pretty Things Baby Tree
- Trappistes Rochefort 10

DARK ALE — STRONG DARK ALE
- Het Anker Gouden Carolus Easter Beer
- Van Steenberge Gulden Draak
- Allagash Black
- Trappistes Rochefort 8
- 21st Amendment Monk's Blood

DARK ALE
- Kerkom Bink Bruin
- Brewer's Art Proletary Ale
- Winter Koninck
- St. Bernardus Grottenbier
- Short's Evil Urges

Belgian & French Ales

Belgium has the most famed brewing history of any country; its unique traditional styles have persisted for centuries and are still largely made the old way, many in actual monasteries. Belgian beer styles are all ales but vary wildly from there. From the wheat-based witbiers with their banana and clove notes to the fruity, vinous abbey styles to the Champagne-like bière brut to the sour lambics flavored by wild yeasts, Belgium is a wonderland of beer.

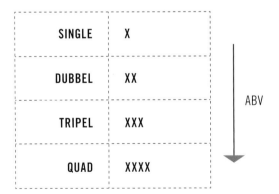

SINGLE	X
DUBBEL	XX
TRIPEL	XXX
QUAD	XXXX

ABV

The terms *dubbel*, *tripel*, and *quad* are marketing terms invented by Belgian brewers to denote alcoholic strength, although the legend is that monks would mark their basic beer with one X, a stronger beer with XX, etc.

GOSE
ABV 4%–5%

*Includes
salt and coriander*

Notable Examples

Gasthaus & Gosebrauerei Leipziger Gose
Brauhaus Goslar Gose
Off Color Troublesome
Brauhaus Hartmannsdorf Döllnitzer Ritterguts Gose
Westbrook Gozu

HAMBURG

GERMANY

BERLIN

GOSLAR

LEIPZIG

FRANCONIA

BAVARIA

Weissbier

Germany introduced the world to lagers, but there is also a strong ale tradition in the country, all of which are weissbiers. These beers (alternately known as weissbier, hefeweizen, and weizenbier) must be made of at least 50 percent wheat and use particular strains of yeast that give them their distinctive banana and clove aromas.

BERLINER WEISSE
ABV 2%–5%

Includes lactobacillus, served with syrup

Notable Examples

Professor Fritz Briem 1809 Berliner Weisse
Evil Twin Justin Blåbær
Dogfish Head Festina Pêche
New Glarus Thumbprint
Funky Buddha Key Lime Berliner

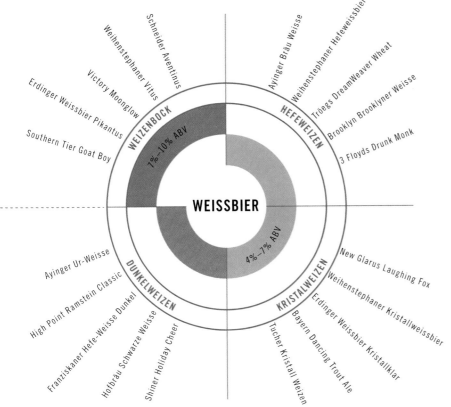

WEISSBIER

WEIZENBOCK — 7%–10% ABV
HEFEWEIZEN
KRISTALWEIZEN — 4%–7% ABV
DUNKELWEIZEN

Schneider Aventinus
Weihenstephaner Vitus
Victory Moonglow
Erdinger Weissbier Pikantus
Southern Tier Goat Boy
Ayinger Ur-Weisse
High Point Ramstein Classic
Franziskaner Hefe-Weisse Dunkel
Hofbräu Schwarze Weisse
Shiner Holiday Cheer
Tucher Kristall Weizen
Bayern Dancing Trout Ale
Erdinger Weissbier Kristallklar
Weihenstephaner Kristallweissbier
New Glarus Laughing Fox
3 Floyds Drunk Monk
Brooklyn Brooklyner Weisse
Tröegs DreamWeaver Wheat
Weihenstephaner Hefeweissbier
Ayinger Bräu Weisse

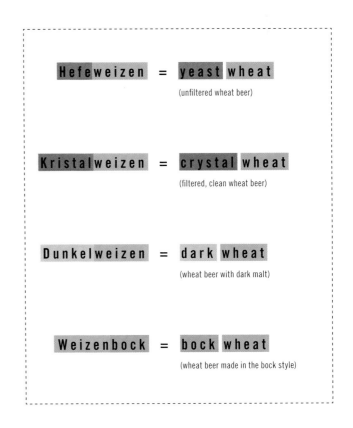

Hefeweizen = **yeast** **wheat**
(unfiltered wheat beer)

Kristalweizen = **crystal** **wheat**
(filtered, clean wheat beer)

Dunkelweizen = **dark** **wheat**
(wheat beer with dark malt)

Weizenbock = **bock** **wheat**
(wheat beer made in the bock style)

Stout & Porter

Stout and porter are the prototypical dark ales, taking their color and their chocolaty, coffee-like taste from the roasted grains used to produce them. Although they originated in eighteenth century England, the most popular stout today is Ireland's Guinness, and the lighter-flavored Irish version of the style has come to dominate. Today, the terms *stout* and *porter* are used interchangeably, although porter was the original term, with "stout porter" denoting a stronger version of porter. The chart on the opposite page traces the evolution of the styles and the terminology.

STOUT & PORTER

SWEET STOUT — 4–7% ABV
- Southern Tier Creme Brulee
- Mackeson Stout
- Butternuts Moo Thunder
- Keegan Mother's Milk
- Left Hand Milk Stout

RUSSIAN IMPERIAL STOUT — 8–12% ABV
- North Coast Old Rasputin
- Oskar Blues Ten FIDY
- Great Divide Yeti
- Sierra Nevada Narwhal
- Samuel Smith's Imperial Stout

AMERICAN DOUBLE STOUT — 7–12% ABV
- Founders Breakfast Stout
- Deschutes The Abyss
- Dogfish Head World Wide Stout
- Victory Storm King
- Avery Mephistopheles

ENGLISH PORTER — 4–7% ABV
- Samuel Smith Taddy Porter
- Fuller's London Porter
- Harviestoun Olde Engine Oil
- Meantime London Porter
- Ridgeway Santa's Butt

OATMEAL STOUT — 4–7% ABV
- Samuel Smith Oatmeal Stout
- Rogue Shakespeare
- Anderson Valley Barney Flats
- Firestone Walker Velvet Merkin
- Mikkeller Beer Geek Breakfast

AMERICAN PORTER — 4–7.5% ABV
- Great Lakes Edmund Fitzgerald
- Deschutes Black Butte
- Smuttynose Robust Porter
- Maine King Titus
- Avery New World Porter

AMERICAN STOUT — 4–7% ABV
- Bell's Kalamazoo
- Deschutes Obsidian
- Modern Times Black House
- Avery Out of Bounds
- Finch's Secret Stache

BALTIC PORTER — 7–10% ABV
- Sinebrychoff Porter
- Victory Baltic Thunder
- Carnegie Porter
- Baltika #6
- Flying Dog Gonzo

FOREIGN STOUT — 6–9% ABV
- Guinness Foreign Extra
- Lion Stout
- Coopers Best Extra
- Pike XXXXX Stout
- Ridgeway Lump of Coal

IRISH STOUT — 4–6% ABV
- Guinness Draught
- Murphy's Irish Stout
- Beamish Irish Stout
- Sly Fox O'Reilly's
- North Coast Old #38

FLAVORED STOUT
5–12% ABV

Coffee	Chocolate	Oyster	Cherry
Carton Regular Coffee	Young's Double Chocolate Stout	Porterhouse Oyster Stout	Bell's Cherry Stout
Bell's Java Stout	Southern Tier Choklat	Flying Dog Pearl Necklace	
		Wynkoop Rocky Mountain Oyster Stout	

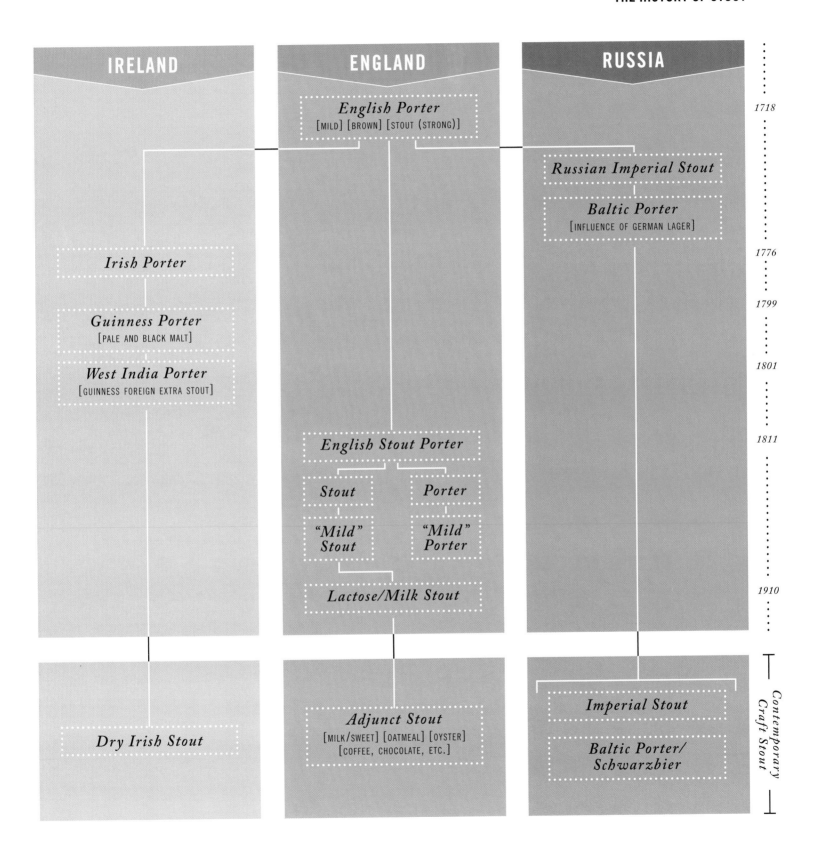

IRELAND

ENGLAND

RUSSIA

English Porter
[MILD] [BROWN] [STOUT (STRONG)]

Russian Imperial Stout

Baltic Porter
[INFLUENCE OF GERMAN LAGER]

Irish Porter

Guinness Porter
[PALE AND BLACK MALT]

West India Porter
[GUINNESS FOREIGN EXTRA STOUT]

English Stout Porter

Stout

Porter

"Mild" Stout

"Mild" Porter

Lactose/Milk Stout

Adjunct Stout
[MILK/SWEET] [OATMEAL] [OYSTER]
[COFFEE, CHOCOLATE, ETC.]

Imperial Stout

Baltic Porter/ Schwarzbier

Dry Irish Stout

1718

1776

1799

1801

1811

1910

Contemporary Craft Stout

Strong Pale Ale

Strong pale ale is a catchall category for "big beers" that use pale malts. All originate in Britain, and in the "parti-gyle" brewing system, where wort would be divided into several runnings, these beers would be made from the first, strongest runoff. Old ales used to be barrel-aged, and thus were literally old, but are not always matured today. Barleywines are so named because they approach wine in strength. American strong ale refers to a beer with an ABV over 7%, but they generally follow the British strong ale traditions.

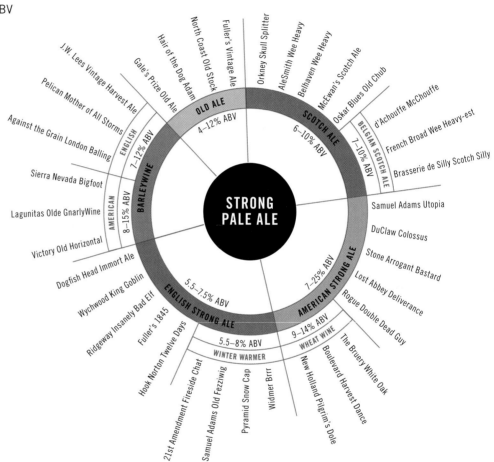

PARTI-GYLE BREWING

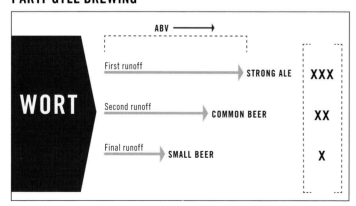

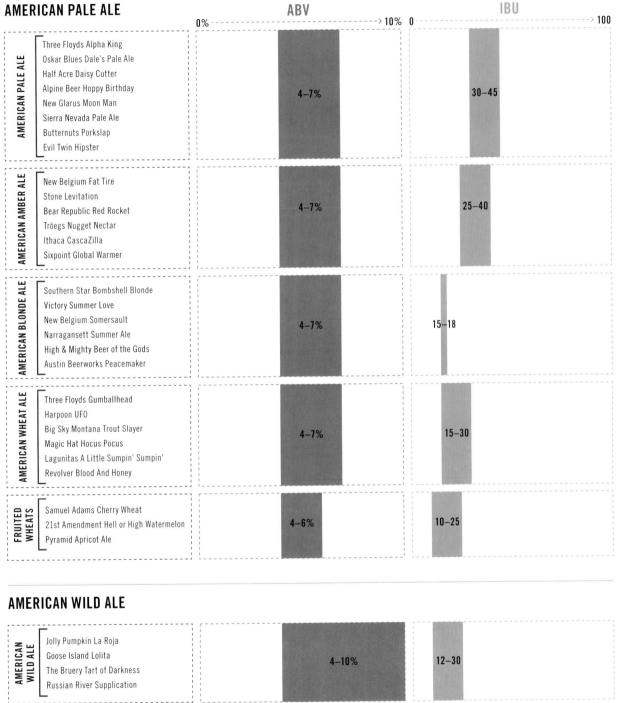

American Ales

American pale ale (APA) was born in the 1980s, when American craft brewers began to imitate the classic English pale ale. Soon enough, though, it diverged into several related styles, such as American amber ale, which is darker and has more caramel notes, and American blonde ale, which is colored like APA but not nearly as hoppy. American wheat styles, like the Bavarian styles they're modeled on, use wheat in the grain bill but use standard ale yeast rather than Bavarian strains, which results in a very different flavor profile. In recent years fruit-flavored wheats have become more and more popular. American wild ale uses *Brettanomyces* yeast or *Lactobacillus* for a decidedly funky and sour brew.

AMERICAN PALE ALE

ABV → 0% 10% | IBU 0 100

AMERICAN PALE ALE
- Three Floyds Alpha King
- Oskar Blues Dale's Pale Ale
- Half Acre Daisy Cutter
- Alpine Beer Hoppy Birthday
- New Glarus Moon Man
- Sierra Nevada Pale Ale
- Butternuts Porkslap
- Evil Twin Hipster

4–7% | 30–45

AMERICAN AMBER ALE
- New Belgium Fat Tire
- Stone Levitation
- Bear Republic Red Rocket
- Tröegs Nugget Nectar
- Ithaca CascaZilla
- Sixpoint Global Warmer

4–7% | 25–40

AMERICAN BLONDE ALE
- Southern Star Bombshell Blonde
- Victory Summer Love
- New Belgium Somersault
- Narragansett Summer Ale
- High & Mighty Beer of the Gods
- Austin Beerworks Peacemaker

4–7% | 15–18

AMERICAN WHEAT ALE
- Three Floyds Gumballhead
- Harpoon UFO
- Big Sky Montana Trout Slayer
- Magic Hat Hocus Pocus
- Lagunitas A Little Sumpin' Sumpin'
- Revolver Blood And Honey

4–7% | 15–30

FRUITED WHEATS
- Samuel Adams Cherry Wheat
- 21st Amendment Hell or High Watermelon
- Pyramid Apricot Ale

4–6% | 10–25

AMERICAN WILD ALE

AMERICAN WILD ALE
- Jolly Pumpkin La Roja
- Goose Island Lolita
- The Bruery Tart of Darkness
- Russian River Supplication

4–10% | 12–30

YEAST
{Saccharomyces} {Brettanomyces}

+

BACTERIA
{Pediococcus} {Lactobacillus}

Rye-Based Ale

Roggenbier, sahti, and American rye ale are three very different types of beer united by their usage of rye in the grain bill. Roggenbier is an ancient German beer that originated out of necessity—rye was easier to come by in the northern part of the country. Today only a handful of German breweries make this Reinheitsgebot-defying beer. Sahti is a Finnish beer that traditionally was made from rye bread, and the finished brew was strained through juniper branches, giving it a unique flavor. Like roggenbier, it is a rarity today, although some craft brewers have attempted to revive it. American rye ale, sometimes branded "Rye PA," on the other hand, is exploding in popularity due to examples such as Sixpoint Righteous Ale. Generally these beers use around 20 percent rye in their grain bill, and often up the hops to make them resemble American pale ales.

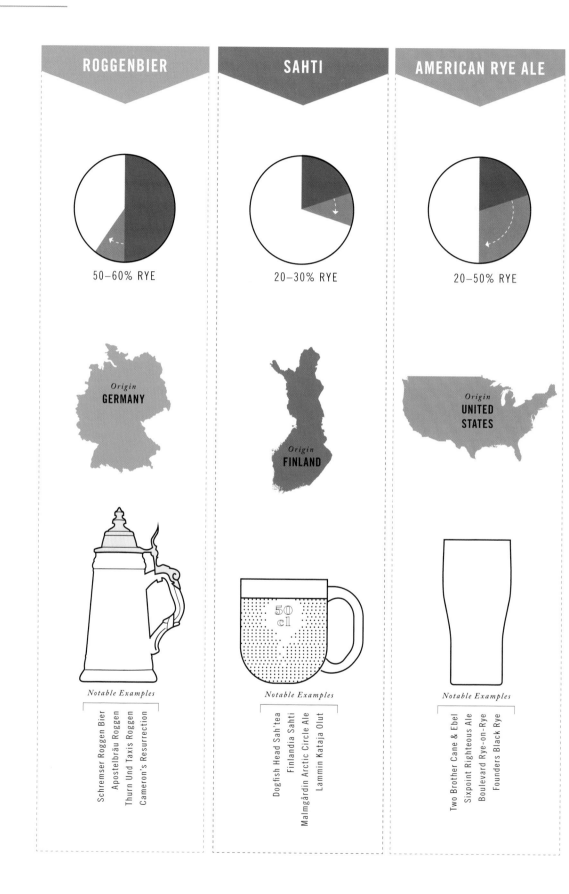

ROGGENBIER

50–60% RYE

Origin
GERMANY

Notable Examples

Schremser Roggen Bier
Apostelbräu Roggen
Thurn Und Taxis Roggen
Cameron's Resurrection

SAHTI

20–30% RYE

Origin
FINLAND

Notable Examples

Dogfish Head Sah'tea
Finlandia Sahti
Malmgårdin Arctic Circle Ale
Lammin Kataja Olut

AMERICAN RYE ALE

20–50% RYE

Origin
UNITED
STATES

Notable Examples

Two Brother Cane & Ebel
Sixpoint Righteous Ale
Boulevard Rye-on-Rye
Founders Black Rye

Vegetable Ale

Pumpkin ale was invented in the eighteenth century by English colonists who discovered the starchy fruit in the New World. In recent years, pumpkin ales have become extremely popular, alongside the surge in all things pumpkin-flavored. Chile- and herb-infused beers have also grown in popularity in the past decade, due to American craft brewers pushing the boundaries of beer.

COMMON CHILES

JALAPEÑO

ANCHO

ANAHEIM PEPPER

HABANERO

SERRANO

GHOST

Notable Examples

Rogue Chipotle Ale
Twisted Pine Ghost Face Killah
Dogfish Head Theobroma
5 Rabbit 5 Vulture
Horseheads Hot-Jala-Heim
No Label Don Jalapeño

COMMON HERBS & SPICES & NOTABLE EXAMPLES

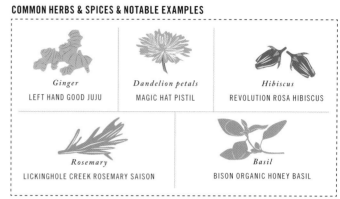

Ginger
LEFT HAND GOOD JUJU

Dandelion petals
MAGIC HAT PISTIL

Hibiscus
REVOLUTION ROSA HIBISCUS

Rosemary
LICKINGHOLE CREEK ROSEMARY SAISON

Basil
BISON ORGANIC HONEY BASIL

PUMPKIN-FLAVORED BEER

Notable Examples

Southern Tier Pumking
Dogfish Head Punkin
Shipyard Pumpkinhead
Cigar City Good Gourd
Schlafly Pumpkin Ale
New Holland Ichabod
Blue Moon Harvest Moon Pumpkin Ale
Imperial Pumpkin Ale
Smuttynose Pumpkin Ale

U.S. PUMPKIN-FLAVORED BEER SALES 1995–2013

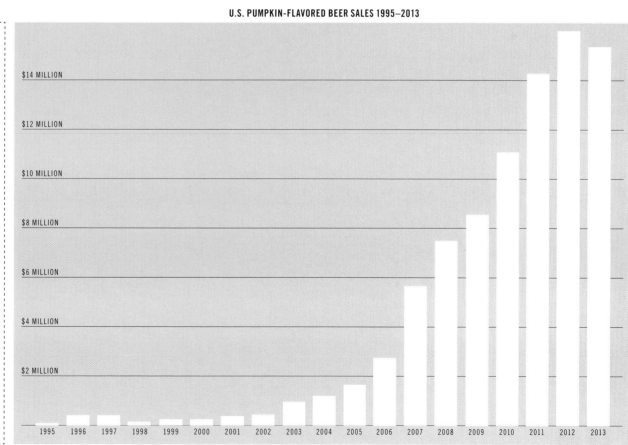

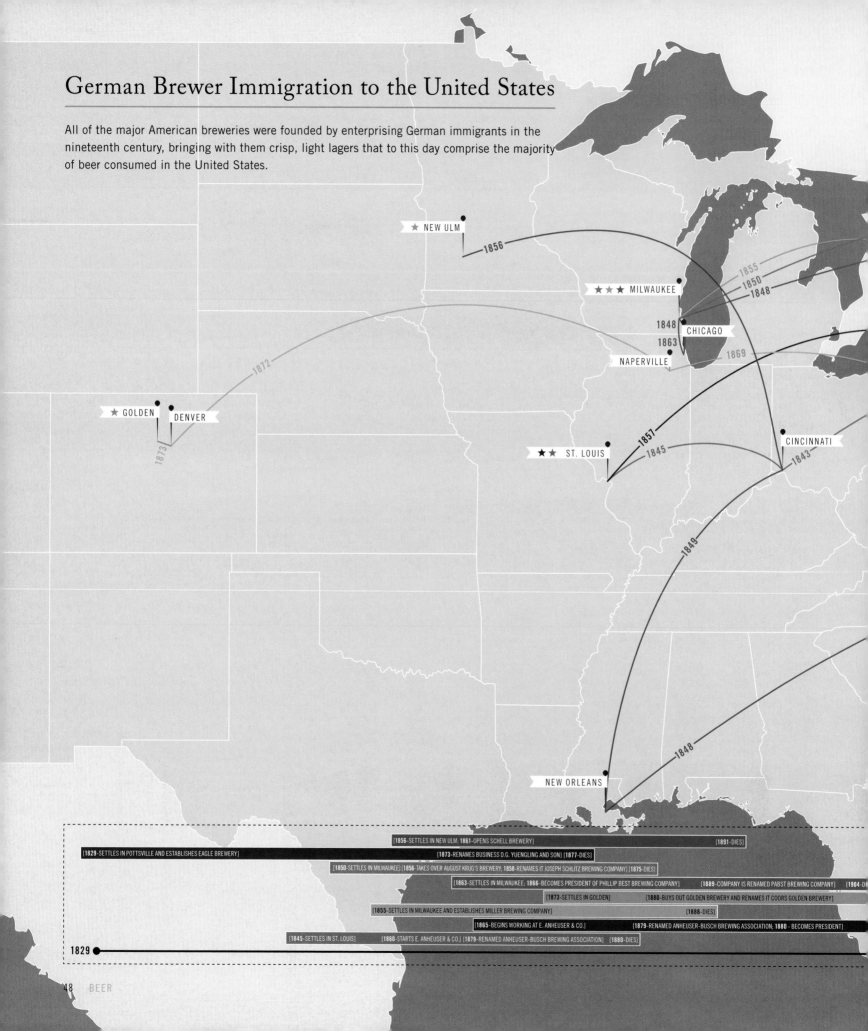

German Brewer Immigration to the United States

All of the major American breweries were founded by enterprising German immigrants in the nineteenth century, bringing with them crisp, light lagers that to this day comprise the majority of beer consumed in the United States.

★ NEW ULM

1856

★ ★ ★ MILWAUKEE

1855
1850
1848

1848
CHICAGO
1863
NAPERVILLE
1869

★ GOLDEN DENVER

1872

1873

★ ★ ST. LOUIS

1857
1845

CINCINNATI
1843

1849

1848

NEW ORLEANS

[1856-SETTLES IN NEW ULM; 1861-OPENS SCHELL BREWERY] [1891-DIES]

[1829-SETTLES IN POTTSVILLE AND ESTABLISHES EAGLE BREWERY] [1873-RENAMES BUSINESS D.G. YUENGLING AND SON] [1877-DIES]

[1850-SETTLES IN MILWAUKEE] [1856-TAKES OVER AUGUST KRUG'S BREWERY; 1858-RENAMES IT JOSEPH SCHLITZ BREWING COMPANY] [1875-DIES]

[1863-SETTLES IN MILWAUKEE; 1866-BECOMES PRESIDENT OF PHILLIP BEST BREWING COMPANY] [1889-COMPANY IS RENAMED PABST BREWING COMPANY] [1904-D...

[1873-SETTLES IN GOLDEN] [1880-BUYS OUT GOLDEN BREWERY AND RENAMES IT COORS GOLDEN BREWERY]

[1855-SETTLES IN MILWAUKEE AND ESTABLISHES MILLER BREWING COMPANY] [1888-DIES]

[1865-BEGINS WORKING AT E. ANHEUSER & CO.] [1879-RENAMED ANHEUSER-BUSCH BREWING ASSOCIATION; 1880 - BECOMES PRESIDENT]

[1845-SETTLES IN ST. LOUIS] [1860-STARTS E. ANHEUSER & CO.] [1879-RENAMED ANHEUSER-BUSCH BREWING ASSOCIATION] [1880-DIES]

1829

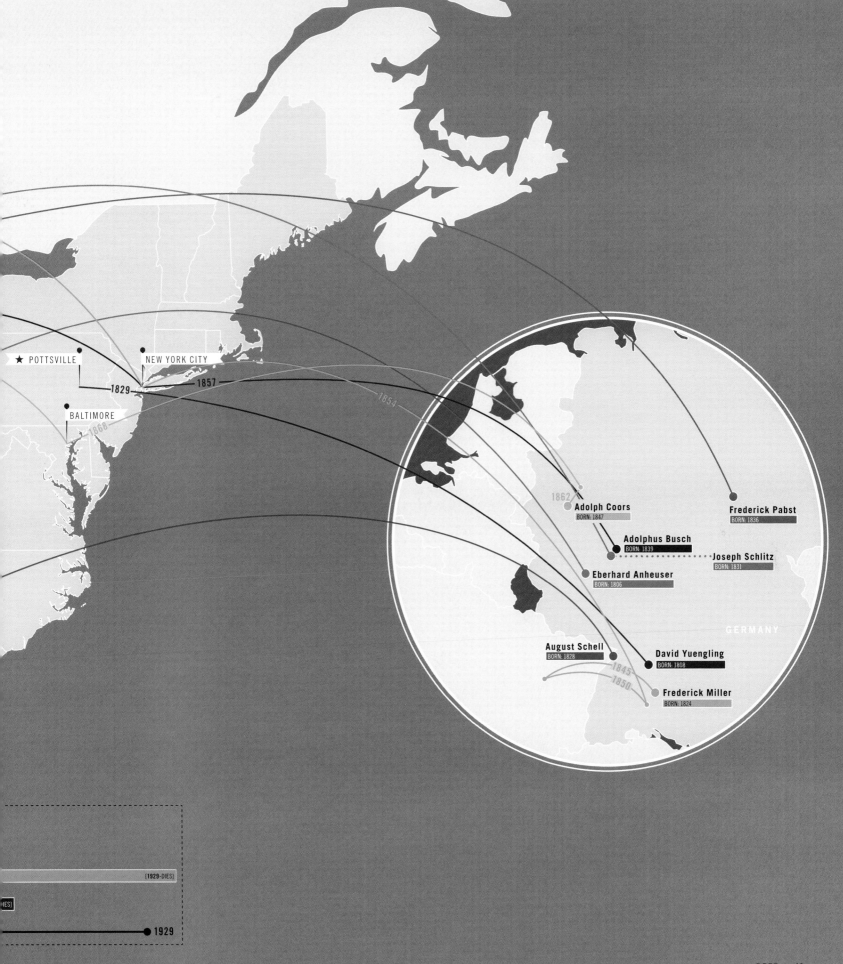

★ POTTSVILLE

NEW YORK CITY

1829 1857

BALTIMORE

1868

1854

1862

Adolph Coors
BORN: 1847

Frederick Pabst
BORN: 1836

Adolphus Busch
BORN: 1839

Joseph Schlitz
BORN: 1831

Eberhard Anheuser
BORN: 1806

GERMANY

August Schell
BORN: 1828

David Yuengling
BORN: 1808

1845

1850

Frederick Miller
BORN: 1824

[1929-DIES]

[IES]

1929

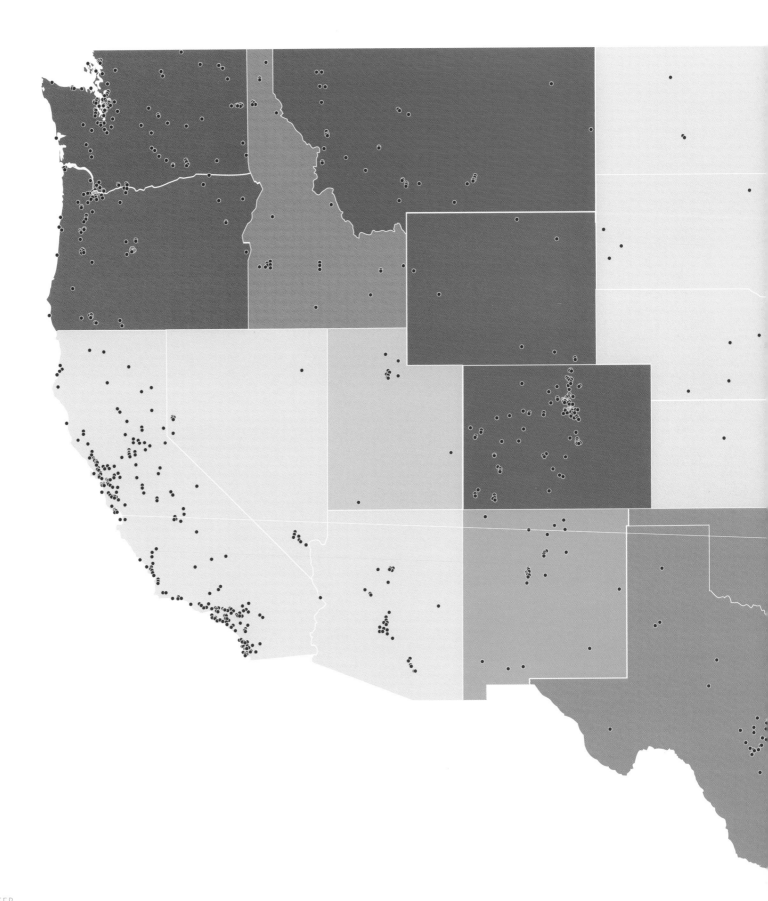

Breweries of the United States

Due to industry consolidation, by 1980 there were fewer than one hundred breweries in the United States. But the explosion of craft breweries since then has put the current number at more than three thousand, with more opening every day. The map below marks all currently operating breweries, as well as each state's breweries per capita.

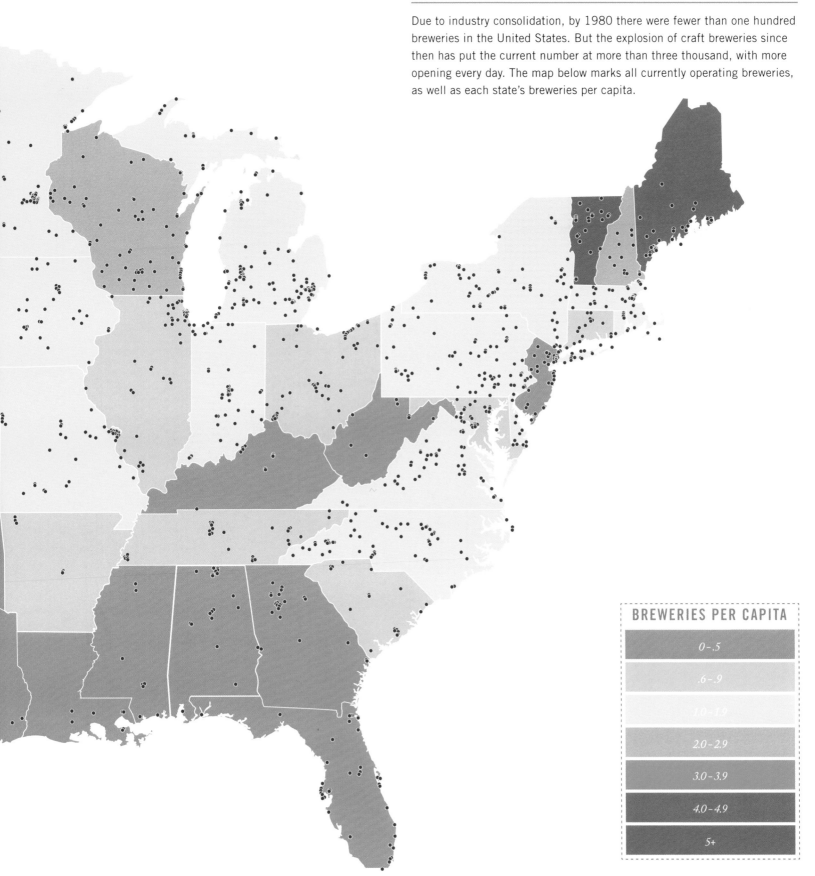

BREWERIES PER CAPITA

- 0-.5
- .6-.9
- 1.0-1.9
- 2.0-2.9
- 3.0-3.9
- 4.0-4.9
- 5+

Breweries of the New York Metro Area

New York City was once a hotbed of brewing, with forty-eight breweries calling Brooklyn home at the end of the nineteenth century. By 1988, there was only one left: Brooklyn Brewery. Today New York and its suburbs once again lead East Coast brewing, anchored by giants such as the aforementioned Brooklyn Brewery, Sixpoint, and Captain Lawrence.

Brooklyn Brewery,
BROOKLYN BLACK CHOCOLATE STOUT

High Point,
RAMSTEIN WINTER WHEAT

Cricket Hill,
HOPNOTIC IPA

Sixpoint,
RESIN

Captain Lawrence,
SMOKED PORTER

Barrage,
YADA YADA YADA

SingleCut Beersmiths,
BILLY FULL-STACK IIPA

Grimm,
DOUBLE NEGATIVE

Other Half,
GREEN DIAMONDS

Transmitter,
B2

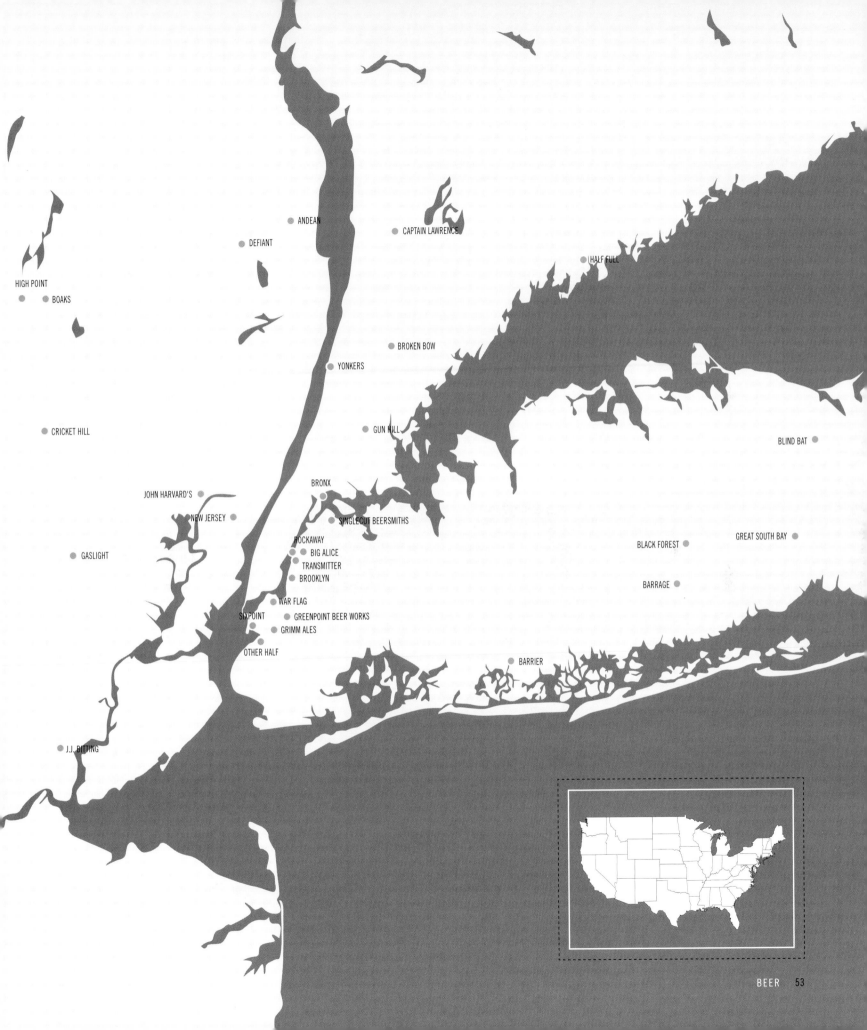

ANDEAN

CAPTAIN LAWRENCE

DEFIANT

HALF FULL

HIGH POINT

BOAKS

BROKEN BOW

YONKERS

CRICKET HILL

GUN HILL

BLIND BAT

JOHN HARVARD'S

BRONX

NEW JERSEY

SINGLECUT BEERSMITHS

GREAT SOUTH BAY

ROCKAWAY

BLACK FOREST

GASLIGHT

BIG ALICE

TRANSMITTER

BROOKLYN

BARRAGE

WAR FLAG

SIXPOINT

GREENPOINT BEER WORKS

GRIMM ALES

OTHER HALF

BARRIER

J.J. BITTING

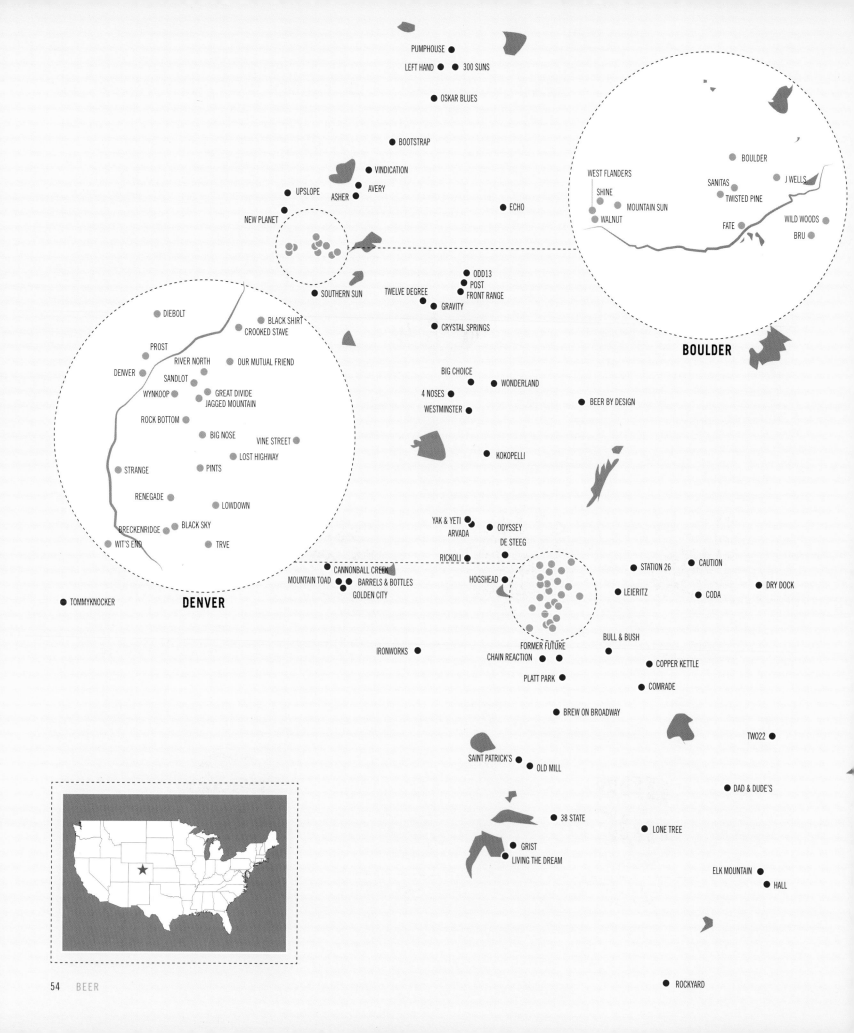

PUMPHOUSE

LEFT HAND ● ● 300 SUNS

OSKAR BLUES

BOOTSTRAP

VINDICATION

UPSLOPE ASHER AVERY

NEW PLANET

ECHO

SOUTHERN SUN

ODD13
POST
FRONT RANGE

TWELVE DEGREE

GRAVITY

CRYSTAL SPRINGS

BOULDER

WEST FLANDERS
SHINE MOUNTAIN SUN
WALNUT

BOULDER

SANITAS J WELLS
TWISTED PINE

FATE WILD WOODS
BRU

DIEBOLT

BLACK SHIRT
CROOKED STAVE

PROST

RIVER NORTH OUR MUTUAL FRIEND

DENVER SANDLOT

WYNKOOP GREAT DIVIDE
JAGGED MOUNTAIN

ROCK BOTTOM

BIG NOSE

VINE STREET

LOST HIGHWAY

STRANGE

PINTS

RENEGADE

LOWDOWN

BRECKENRIDGE BLACK SKY

WIT'S END TRVE

BIG CHOICE
WONDERLAND

4 NOSES
WESTMINSTER

BEER BY DESIGN

KOKOPELLI

YAK & YETI ODYSSEY
ARVADA DE STEEG

RICKOLI

DENVER

TOMMYKNOCKER

CANNONBALL CREEK

MOUNTAIN TOAD BARRELS & BOTTLES
GOLDEN CITY

HOGSHEAD

STATION 26 CAUTION

LEIERITZ CODA DRY DOCK

FORMER FUTURE BULL & BUSH

IRONWORKS CHAIN REACTION COPPER KETTLE

PLATT PARK COMRADE

BREW ON BROADWAY

TWO22

SAINT PATRICK'S
OLD MILL

DAD & DUDE'S

38 STATE LONE TREE

GRIST
LIVING THE DREAM

ELK MOUNTAIN
HALL

ROCKYARD

Breweries of Denver & Boulder

Home to industry giant Coors as well as the Boulder Beer Company, which was among the first microbreweries, and influential craft brewers such as Avery and Oskar Blues, Colorado has an impressive representation of breweries. Each fall, Denver is home to the Great American Beer Festival, the largest beer bash in the United States, where more than one hundred thousand people turn out to celebrate craft brewing.

Bull & Bush,
RELEASE THE HOUNDS

Great Divide,
HOSS RYE LAGER

Upslope,
BROWN ALE

4 Noses,
MAKE MY DAY SESSIONS IPA

Oskar Blues,
TEN FIDY

Dry Dock,
HOP ABOMINATION

Renegade,
HAMMER & SICKLE RUSSIAN IMPERIAL STOUT

Twisted Pine,
INDIA PALE ALE

Breckenridge,
OATMEAL STOUT

Avery,
WHITE RASCAL

Breweries of the Bay Area

San Francisco's brewing scene is anchored by, well, Anchor, and the unique "steam beer" style that they helped popularize. The city's first brewery naturally opened in 1849 at the peak of the Gold Rush, and today the Bay Area is home to nationally recognized breweries such as 21st Amendment and Russian River.

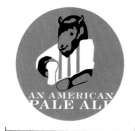

Anchor,
CALIFORNIA LAGER

Buffalo Bill's,
AMERICAN PALE ALE

Black Diamond,
RAMPAGE IMPERIAL IPA

Russian River,
DAMNATION

Speakeasy,
BIG DADDY IPA

21st Amendment,
DOWN TO EARTH SESSION IPA

Hermitage,
CITRA

Heretic,
EVIL TWIN

The Rare Barrel,
MAP OF THE SUN

Carneros,
JEFEWEIZEN

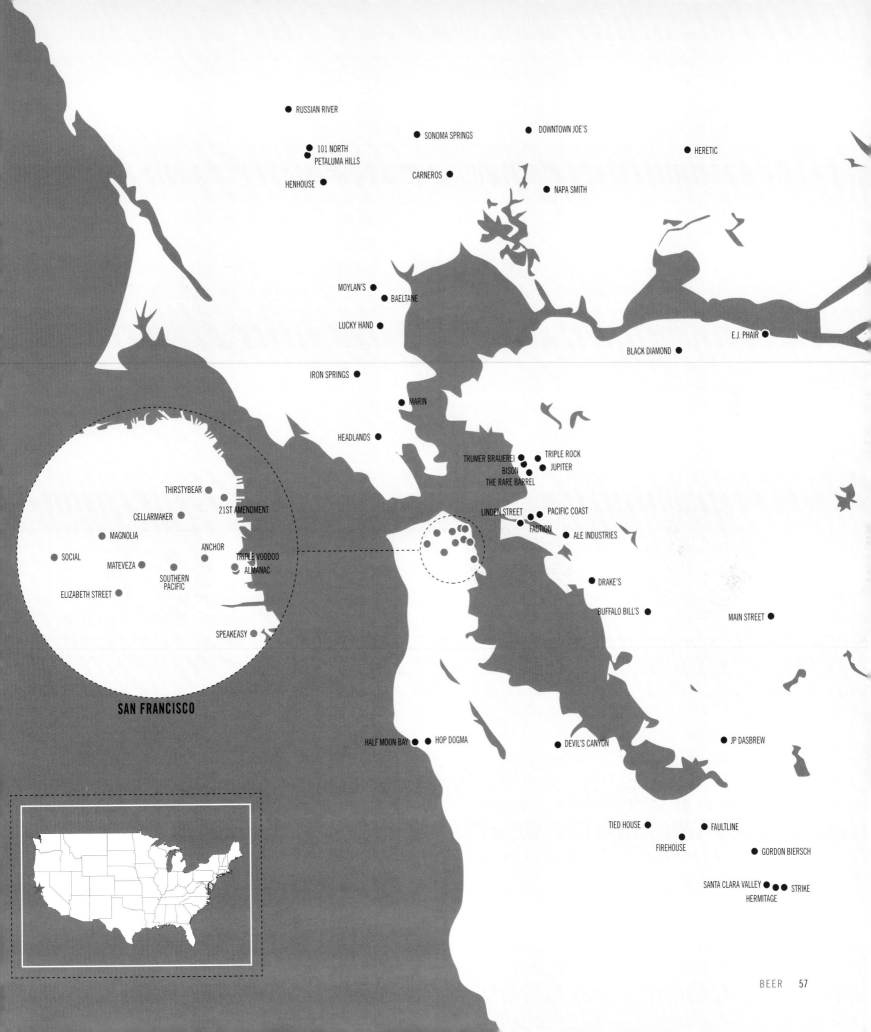

RUSSIAN RIVER

SONOMA SPRINGS

DOWNTOWN JOE'S

HERETIC

101 NORTH
PETALUMA HILLS

CARNEROS

HENHOUSE

NAPA SMITH

MOYLAN'S

BAELTANE

LUCKY HAND

E.J. PHAIR

BLACK DIAMOND

IRON SPRINGS

MARIN

HEADLANDS

TRUMER BRAUEREI

TRIPLE ROCK

BISON

JUPITER

THE RARE BARREL

THIRSTYBEAR

21ST AMENDMENT

LINDEN STREET

PACIFIC COAST

CELLARMAKER

FACTION

ALE INDUSTRIES

MAGNOLIA

ANCHOR

SOCIAL

TRIPLE VOODOO

MATEVEZA

ALMANAC

DRAKE'S

SOUTHERN
PACIFIC

ELIZABETH STREET

BUFFALO BILL'S

MAIN STREET

SPEAKEASY

SAN FRANCISCO

HALF MOON BAY

HOP DOGMA

DEVIL'S CANYON

JP DASBREW

TIED HOUSE

FAULTLINE

FIREHOUSE

GORDON BIERSCH

SANTA CLARA VALLEY

STRIKE

HERMITAGE

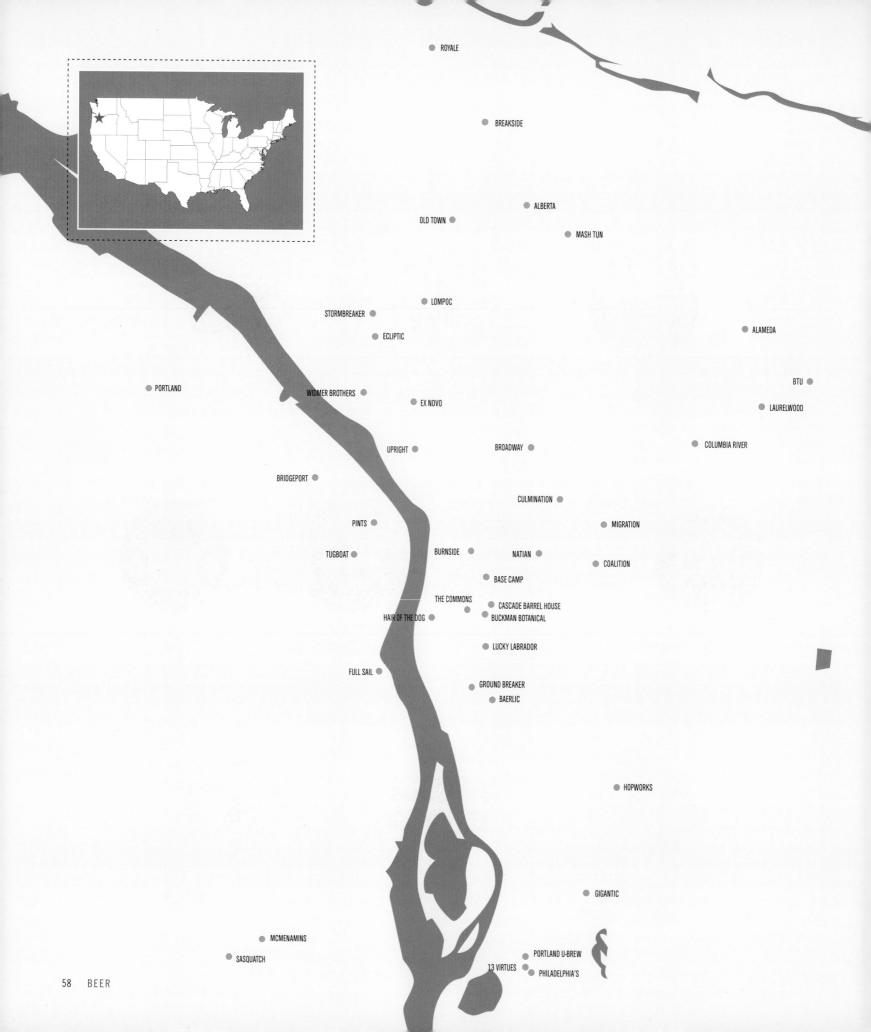

ROYALE

BREAKSIDE

ALBERTA

OLD TOWN

MASH TUN

LOMPOC

STORMBREAKER

ALAMEDA

ECLIPTIC

BTU

PORTLAND

WIDMER BROTHERS

LAURELWOOD

EX NOVO

UPRIGHT

BROADWAY

COLUMBIA RIVER

BRIDGEPORT

CULMINATION

PINTS

MIGRATION

BURNSIDE

NATIAN

TUGBOAT

COALITION

BASE CAMP

THE COMMONS

CASCADE BARREL HOUSE

HAIR OF THE DOG

BUCKMAN BOTANICAL

LUCKY LABRADOR

FULL SAIL

GROUND BREAKER

BAERLIC

HOPWORKS

GIGANTIC

MCMENAMINS

PORTLAND U-BREW

SASQUATCH

13 VIRTUES

PHILADELPHIA'S

Breweries of Portland

German immigrant Henry Saxer founded the first brewery in Portland in 1852, but it was the passage of a law legalizing brewpubs in 1985 that started the city's craft brewery revolution. Today, nearly 40 percent of all draft beers served in Portland are craft beers. Nationally known brands such as Full Sail and Widmer call Portland home, and it's the anchor of an Oregon suds scene that leads the nation in breweries per capita.

Alameda,
YELLOW WOLF IMPERIAL IPA

Ecliptic,
FILAMENT WINTER IPA

Ground Breaker,
DARK ALE

Hopworks,
IPA

Laurelwood
WORKHORSE IPA

Natian,
CUDA CASCADIAN DARK ALE

Hair of the Dog,
ADAM

Breakside,
WANDERLUST INDIA PALE ALE

Base Camp,
IN-TENTS IPL

Lompoc,
PROLETARIAT NORTHWEST
RED ALE

Evolution of Beer Vessels

Over the past two centuries, glassmakers, brewers, and other members of the beverage industry have made great strides in the design of vessels used for personal beer storage and consumption. The Export Bottle and Sta-Tab Can, in particular, should be familiar to any casual drinker.

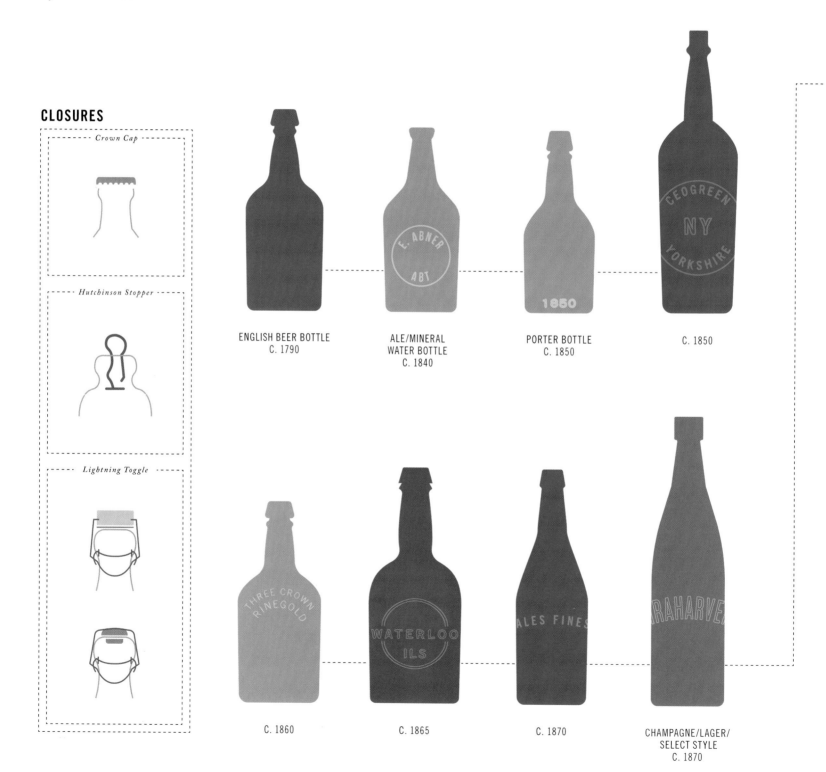

CLOSURES

Crown Cap

Hutchinson Stopper

Lightning Toggle

ENGLISH BEER BOTTLE
C. 1790

ALE/MINERAL
WATER BOTTLE
C. 1840

PORTER BOTTLE
C. 1850

C. 1850

C. 1860

C. 1865

C. 1870

CHAMPAGNE/LAGER/
SELECT STYLE
C. 1870

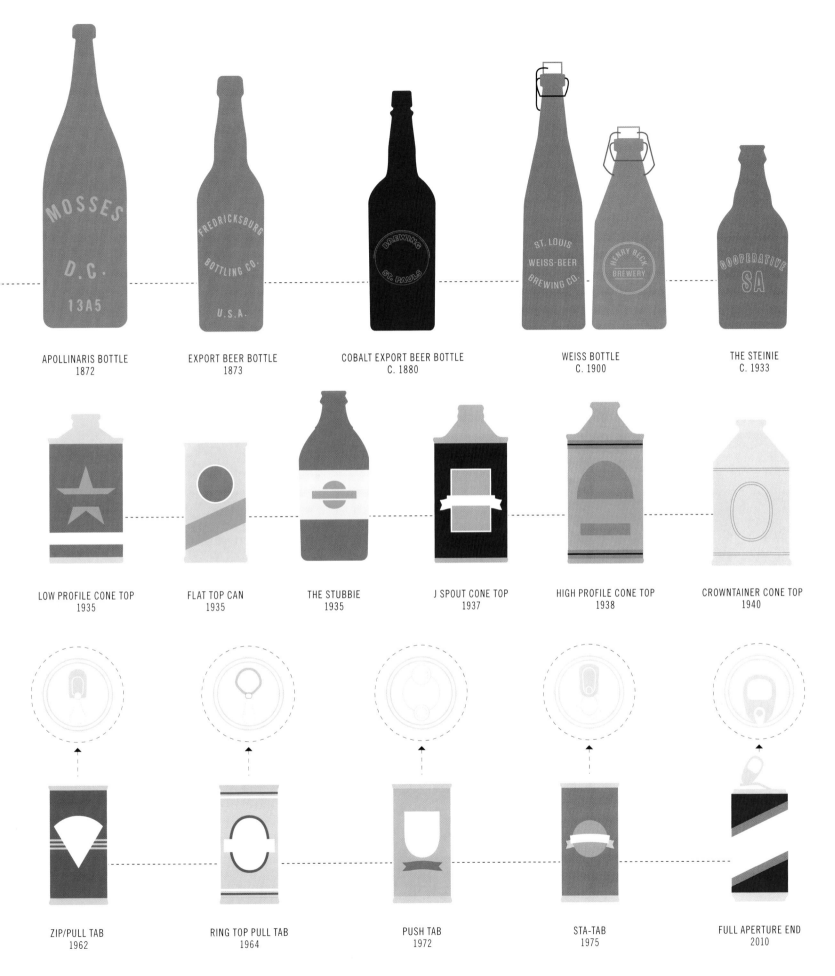

APOLLINARIS BOTTLE
1872

EXPORT BEER BOTTLE
1873

COBALT EXPORT BEER BOTTLE
C. 1880

WEISS BOTTLE
C. 1900

THE STEINIE
C. 1933

LOW PROFILE CONE TOP
1935

FLAT TOP CAN
1935

THE STUBBIE
1935

J SPOUT CONE TOP
1937

HIGH PROFILE CONE TOP
1938

CROWNTAINER CONE TOP
1940

ZIP/PULL TAB
1962

RING TOP PULL TAB
1964

PUSH TAB
1972

STA-TAB
1975

FULL APERTURE END
2010

Bottle Size & Keg Size

Packaged beer comes in a variety of sizes, from the standard 12-ounce bottle or can up to the growler. Keg capacity ranges from just over a 12-pack's worth of beer up to the half-barrel, which dispenses nearly 170 beers at every kegger.

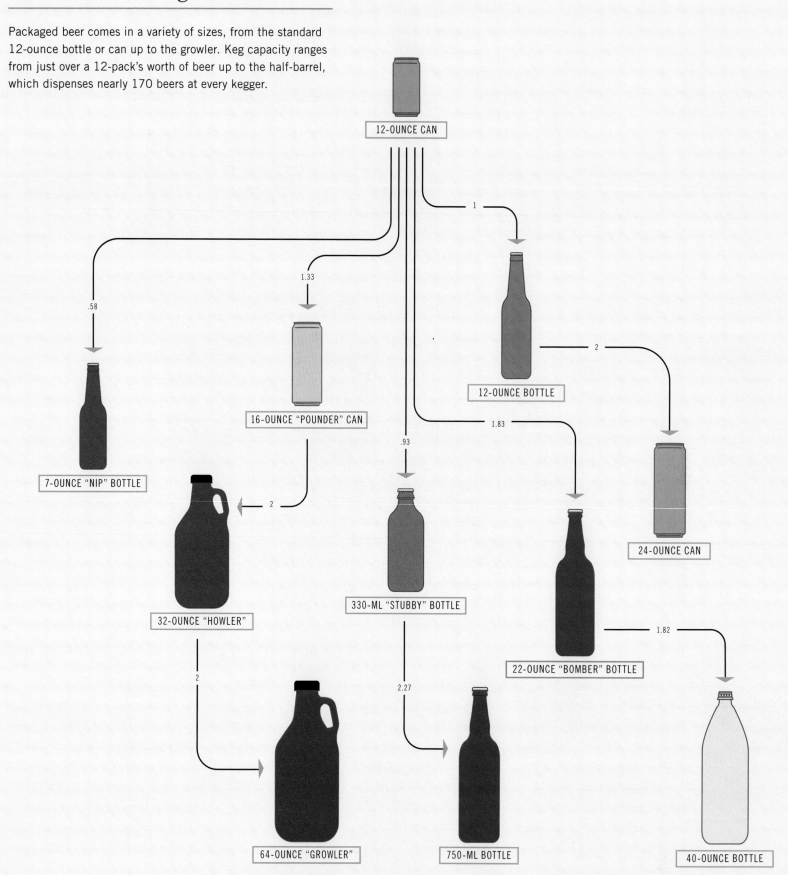

12-OUNCE CAN

1

1.33

.58

.93

2

1.83

16-OUNCE "POUNDER" CAN

12-OUNCE BOTTLE

7-OUNCE "NIP" BOTTLE

24-OUNCE CAN

2

32-OUNCE "HOWLER"

330-ML "STUBBY" BOTTLE

22-OUNCE "BOMBER" BOTTLE

1.82

2

2.27

64-OUNCE "GROWLER"

750-ML BOTTLE

40-OUNCE BOTTLE

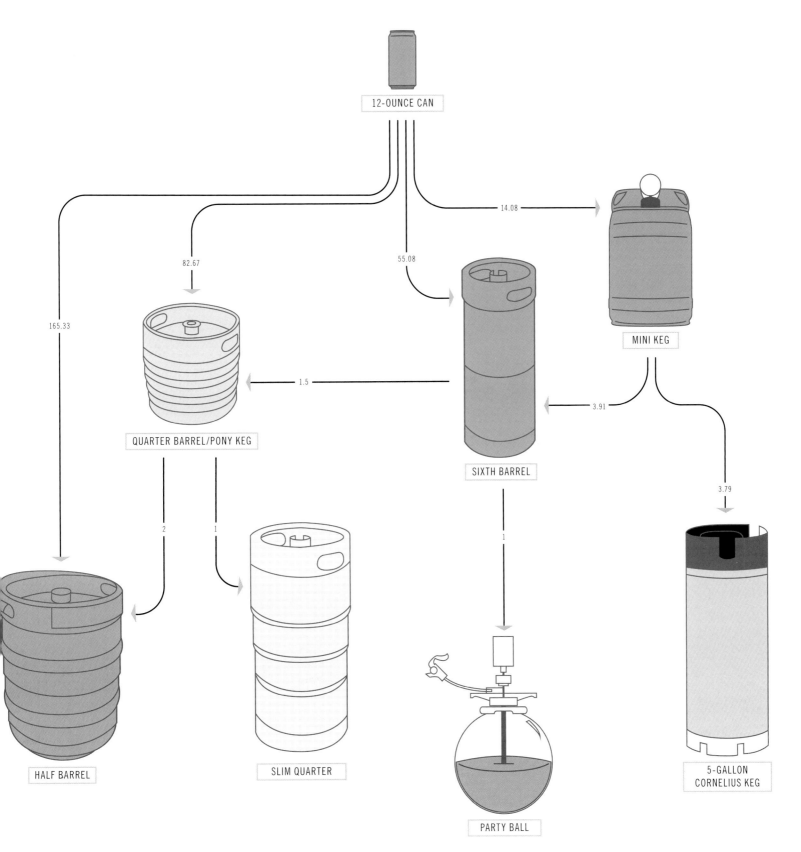

12-OUNCE CAN

14.08

82.67

55.08

165.33

MINI KEG

1.5

3.91

QUARTER BARREL/PONY KEG

SIXTH BARREL

3.79

2

1

1

HALF BARREL

SLIM QUARTER

PARTY BALL

5-GALLON
CORNELIUS KEG

Glassware

Beyond the utilitarian pint glass, there are all manner of shaped glasses for consuming specific varieties of beer. Proper glassware allows the appearance of a beer to be appreciated, forms the right amount of head, and concentrates aroma near the nose. The association of glasses with particular styles of beers is largely traditional, and many beer experts hold that the tulip glass or even a wineglass is the "right" glass for all beers, whereas others maintain that traditional glassware is essential to certain styles. Many breweries have designed glassware for specific beers, albeit mainly for marketing purposes.

THISTLE
Scotch Ale,
Belgian Scotch Ale

GOBLET/CHALICE
Quadrupel, Belgian Strong Ale,
Flanders Red Ale, Belgian Pale
Ale, Berliner Weisse, Belgian
Strong, Dark Ale, Dubbel, Tripel

FLUTE
Bière de Champagne,
Unblended, American
Wild Ale, Fruit, Faro

BEER BOOT
Vienna Lager,
Märzen

PINT
Sweet Stout, Foreign Stout, Blonde Ale,
American Pale Ale, Flavored Stout,
Oatmeal Stout, India Red Ale, English
Pale Ale, Pumpkin Ale, Schwarzbier,
Bitter, English Strong Ale, Winter
Warmer, American Stout, American
Porter, East Coast IPA, West Coast IPA,
Rye Ale, European Pale Lager, American
Dark/Amber Lager, Chile Ale, Burton
Pale Ale, Baltic Porter, English IPA, Irish
Stout, Cream Ale, American Pale Lager,
English Porter, Sahti, American Brown
Ale, Premium Bitter, Irish Ale, Amber
Ale, English Brown Ale

WEIZEN
Wheat Ale, Fruited Wheats,
Kristalweizen, Weizenbock,
Roggenbier, European, Stronga,
Gose, Lager, American,
Hefeweizen

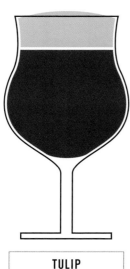

TULIP
Black IPA,
Scotch Ale

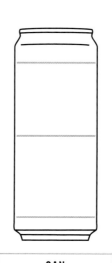

CAN
Ice Beer, Japanese
Rice Lager, Light Beer, American
Adjunct Lager

STANGE
Rauchbier,
Kölsch, Altbier

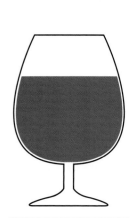

SNIFTER
American Strong Ale,
American Double Stout,
Russian Imperial Stout,
American Barleywine,
Wheat Wine, Old Ale

PILSNER/POKAL
Pilsner, German Pilsner, Bohemian, American Pilsner, Dortmunder, American Imperial Pilsner

WILLIBECHER
Rauchbier, Schwarzbier, Munich Helles, Maibock/Helles

STEIN/MUG
Bock, Lager, Eisbock, Doppelbock, Dunkler Bock, Munich Dunkel, Vienna Kellerbier

WINE GLASS
Belgian Dark Ale, English Barleywine, Belgian Strong Dark Ale, Belgian Strong Pale Ale, American Wild Ale, Belgian Pale Ale, Bière de Garde, Wheat Wine, Old Ale, Saison

BRANDED GLASSWARE

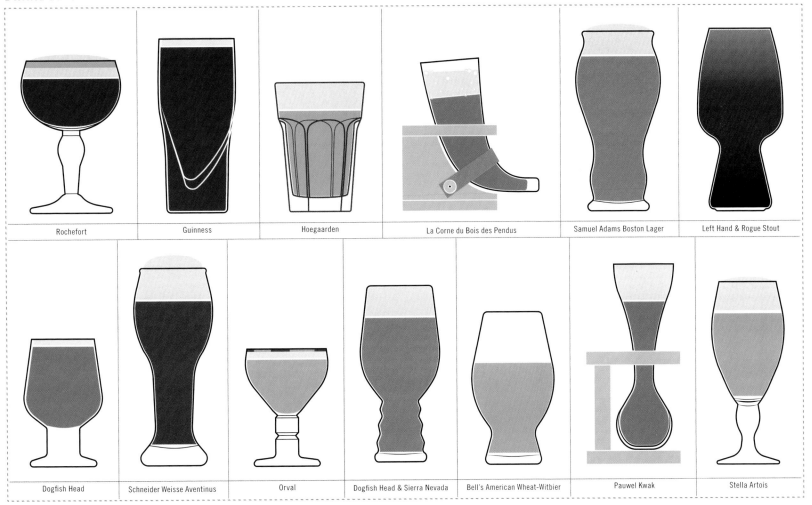

Rochefort

Guinness

Hoegaarden

La Corne du Bois des Pendus

Samuel Adams Boston Lager

Left Hand & Rogue Stout

Dogfish Head

Schneider Weisse Aventinus

Orval

Dogfish Head & Sierra Nevada

Bell's American Wheat-Witbier

Pauwel Kwak

Stella Artois

Fictional Beer

Whether to avoid trademark issues or simply for artistic reasons, TV and film have a rich history of fictional brews.

WHARMPESS
How I Met Your Mother

BUZZ BEER
The Drew Carey Show

JEKYLL ISLAND LAGER
Dexter

SCHRADERBRÄU
Breaking Bad

ST. ANKY BEER
Super Troopers

ST. PAULI EXCLUSION PRINCIPLE GIRL
Futurama

SHOTZ BEER
Laverne & Shirley

BUTTERBEER
Harry Potter

ALDERAANIAN ALE
Star Wars

ROCKET FUEL MALT LIQUOR
NewsRadio

BLACK DEATH MALT LIQUOR
WKRP in Cincinnati

ELSINORE
Strange Brew

SCHMITTS GAY
Saturday Night Live

PAWTUCKET PATRIOT ALE
Family Guy

SAMUEL JACKSON BEER
Chappelle's Show

SCHNITZENGIGGLE
Beerfest

NEWTON AND RIDLEY
Coronation Street

CHURCHILL'S
EastEnders

ROMULAN ALE
Star Trek

PANTHER PILSNER
The Three Stooges

PIßWASSER
Grand Theft Auto IV

HEISLER
*New Girl, Superbad,
How I Met Your Mother,
My Name Is Earl,
Two and a Half Men, etc.*

MONKEY SHINE BEER
Friends

PABST BLUE ROBOT
Futurama

FLAGLER
Magnum, P.I.

VÄN DER BRÄU
*Don't Trust the B----
in Apartment 23*

LEOPARD LAGER
Red Dwarf

MARSHALL BEER
Happy Hour a.k.a. Sour Grapes

DUFF BEER
The Simpsons

DHARMA INITIATIVE BEER
Lost

GIRLIE GIRL BEER
Married with Children

ASPEN BEER
Alien

CANOGA BEER
Roseanne

EPHRAIM MONK ALE
Emmerdale

ALAMO
King of the Hill

BIG TOP BEER
Mama's Family

CERVEZA CHANGO
*From Dusk Till Dawn,
Sin City, El Mariachi, Grindhouse,
Once Upon a Time in Mexico*

Malt Liquor Names

Malt liquors are powerful brews offering high alcohol content at a cheap price, and the "forty" is beloved in both hip-hop culture and ironic hipster culture. Their sobriquets reflect their edgy nature.

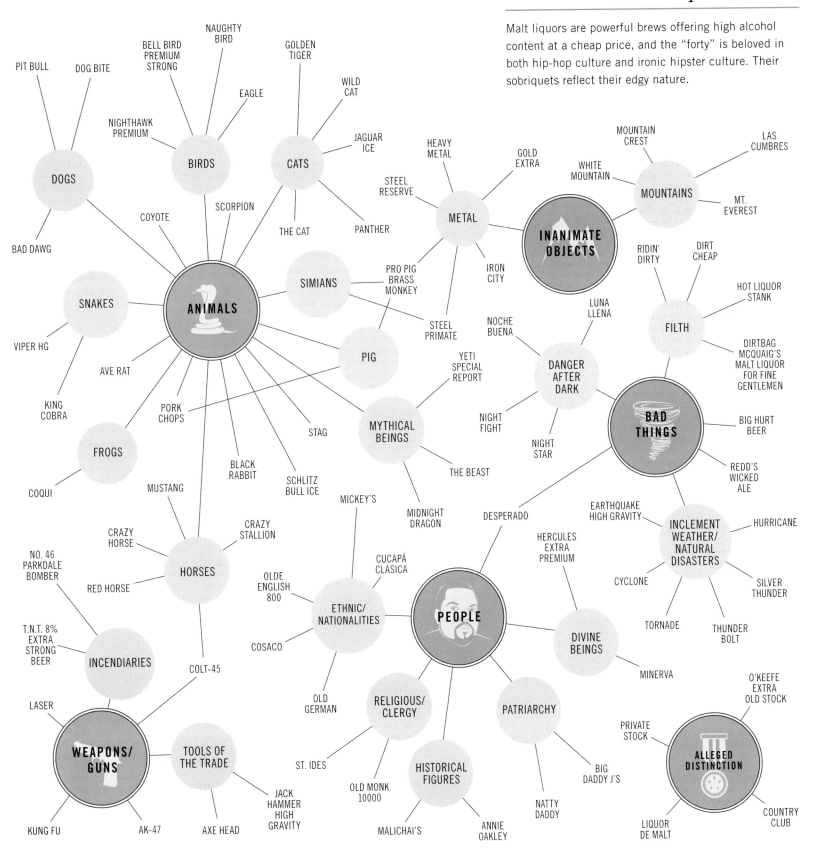

Hop-ular Beer Names

Perhaps the only thing craft breweries love more than hops is playfully using the word *hops* in the names of their beers.

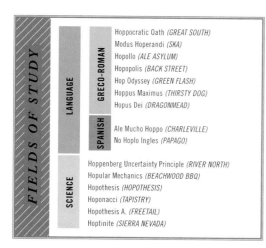

FIELDS OF STUDY

LANGUAGE

GRECO-ROMAN
- Hoppocratic Oath (GREAT SOUTH)
- Modus Hoperandi (SKA)
- Hopollo (ALE ASYLUM)
- Hopopolis (BACK STREET)
- Hop Odyssey (GREEN FLASH)
- Hoppus Maximus (THIRSTY DOG)
- Hopus Dei (DRAGONMEAD)

SPANISH
- Ale Mucho Hoppo (CHARLEVILLE)
- No Hoplo Ingles (PAPAGO)

SCIENCE
- Hoppenberg Uncertainty Principle (RIVER NORTH)
- Hopular Mechanics (BEACHWOOD BBQ)
- Hopothesis (HOPOTHESIS)
- Hoponacci (TAPISTRY)
- Hopothesis A. (FREETAIL)
- Hoptinite (SIERRA NEVADA)

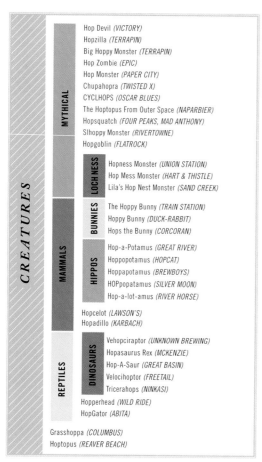

CREATURES

MYTHICAL
- Hop Devil (VICTORY)
- Hopzilla (TERRAPIN)
- Big Hoppy Monster (TERRAPIN)
- Hop Zombie (EPIC)
- Hop Monster (PAPER CITY)
- Chupahopra (TWISTED X)
- CYCLHOPS (OSCAR BLUES)
- The Hoptopus From Outer Space (NAPARBIER)
- Hopsquatch (FOUR PEAKS, MAD ANTHONY)
- Slhoppy Monster (RIVERTOWNE)
- Hopgoblin (FLATROCK)

MAMMALS

LOCH NESS
- Hopness Monster (UNION STATION)
- Hop Mess Monster (HART & THISTLE)
- Lila's Hop Nest Monster (SAND CREEK)

BUNNIES
- The Hoppy Bunny (TRAIN STATION)
- Hoppy Bunny (DUCK-RABBIT)
- Hops the Bunny (CORCORAN)

HIPPOS
- Hop-a-Potamus (GREAT RIVER)
- Hoppopotamus (HOPCAT)
- Hoppapotamus (BREWBOYS)
- HOPpopatamus (SILVER MOON)
- Hop-a-lot-amus (RIVER HORSE)

- Hopcelot (LAWSON'S)
- Hopadillo (KARBACH)

REPTILES

DINOSAURS
- Vehopciraptor (UNKNOWN BREWING)
- Hopasaurus Rex (MCKENZIE)
- Hop-A-Saur (GREAT BASIN)
- Velocihoptor (FREETAIL)
- Tricerahops (NINKASI)

- Hopperhead (WILD RIDE)
- HopGator (ABITA)

- Grasshoppa (COLUMBUS)
- Hoptopus (REAVER BEACH)

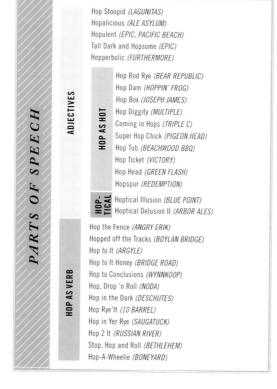

PARTS OF SPEECH

ADJECTIVES
- Hop Stoopid (LAGUNITAS)
- Hopalicious (ALE ASYLUM)
- Hopulent (EPIC, PACIFIC BEACH)
- Tall Dark and Hopsome (EPIC)
- Hopperbolic (FURTHERMORE)

HOP AS HOT
- Hop Rod Rye (BEAR REPUBLIC)
- Hop Dam (HOPPIN' FROG)
- Hop Box (JOSEPH JAMES)
- Hop Diggity (MULTIPLE)
- Coming in Hops (TRIPLE C)
- Super Hop Chick (PIGEON HEAD)
- Hop Tub (BEACHWOOD BBQ)
- Hop Ticket (VICTORY)
- Hop Head (GREEN FLASH)
- Hopspur (REDEMPTION)

HOP-TICAL
- Hoptical Illusion (BLUE POINT)
- Hoptical Delusion II (ARBOR ALES)

HOP AS VERB
- Hop the Fence (ANGRY ERIK)
- Hopped off the Tracks (BOYLAN BRIDGE)
- Hop to It (ARGYLE)
- Hop to It Honey (BRIDGE ROAD)
- Hop to Conclusions (WYNNKOOP)
- Hop, Drop 'n Roll (NODA)
- Hop in the Dark (DESCHUTES)
- Hop Rye'It (10 BARREL)
- Hop in Yer Rye (SAUGATUCK)
- Hop 2 It (RUSSIAN RIVER)
- Stop, Hop and Roll (BETHLEHEM)
- Hop-A-Wheelie (BONEYARD)

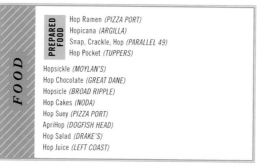

FOOD

PREPARED FOOD
- Hop Ramen (PIZZA PORT)
- Hopicana (ARGILLA)
- Snap, Crackle, Hop (PARALLEL 49)
- Hop Pocket (TUPPERS)

- Hopsickle (MOYLAN'S)
- Hop Chocolate (GREAT DANE)
- Hopsicle (BROAD RIPPLE)
- Hop Cakes (NODA)
- Hop Suey (PIZZA PORT)
- ApriHop (DOGFISH HEAD)
- Hop Salad (DRAKE'S)
- Hop Juice (LEFT COAST)

WORDPLAY

IDIOMS
- Good Hop Bad Hop (PUB DOG)
- Loch Hop & Barrel (SIERRA NEVADA)
- The Hops You Rode In On (LONERIDER)

META
- Hoppiness Is a Warm Pun (BREWMASTER JACK)
- Insert Hop Pun Here (AARDWOLF)
- What Hop Pun? (RARE BARREL)
- Hoppun (CARTON)
- C:/Hops (BREWSTERS)

OBJECTS

VEHICLES
- Hop Rocket (ARCADIA)
- Hop Buggy (LANCASTER)
- Hopduster (FLYERS)

- Coal Hopper (ROANOKE)
- Clodhopper (COUNCIL)
- Hopback (TREÖGS)

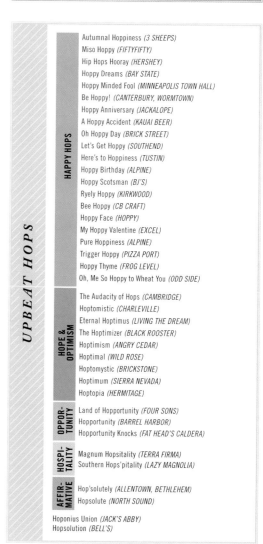

UPBEAT HOPS

HAPPY HOPS
- Autumnal Hoppiness (3 SHEEPS)
- Miso Hoppy (FIFTYFIFTY)
- Hip Hops Hooray (HERSHEY)
- Hoppy Dreams (BAY STATE)
- Hoppy Minded Fool (MINNEAPOLIS TOWN HALL)
- Be Hoppy! (CANTERBURY, WORMTOWN)
- Hoppy Anniversary (JACKALOPE)
- A Hoppy Accident (KAUAI BEER)
- Oh Hoppy Day (BRICK STREET)
- Let's Get Hoppy (SOUTHEND)
- Here's to Hoppiness (TUSTIN)
- Hoppy Birthday (ALPINE)
- Hoppy Scotsman (BJ'S)
- Ryely Hoppy (KIRKWOOD)
- Bee Hoppy (CB CRAFT)
- Hoppy Face (HOPPY)
- My Hoppy Valentine (EXCEL)
- Pure Hoppiness (ALPINE)
- Trigger Hoppy (PIZZA PORT)
- Hoppy Thyme (FROG LEVEL)
- Oh, Me So Hoppy to Wheat You (ODD SIDE)

HOPE & OPTIMISM
- The Audacity of Hops (CAMBRIDGE)
- Hoptomistic (CHARLEVILLE)
- Eternal Hoptimus (LIVING THE DREAM)
- The Hoptimizer (BLACK ROOSTER)
- Hoptimism (ANGRY CEDAR)
- Hoptimal (WILD ROSE)
- Hoptomystic (BRICKSTONE)
- Hoptimum (SIERRA NEVADA)
- Hoptopia (HERMITAGE)

OPPORTUNITY
- Land of Hopportunity (FOUR SONS)
- Hopportunity (BARREL HARBOR)
- Hopportunity Knocks (FAT HEAD'S CALDERA)

HOSPITALITY
- Magnum Hopsitality (TERRA FIRMA)
- Southern Hops'pitality (LAZY MAGNOLIA)

AFFIRMATIVE
- Hop'solutely (ALLENTOWN, BETHLEHEM)
- Hopsolute (NORTH SOUND)

- Hoponius Union (JACK'S ABBY)
- Hopsolution (BELL'S)

POP CULTURE

MUSIC

HIP-HOP
Detroit Hip Hops *(BLACK LOTUS)*
Drop It Like It's Hops *(ABIGAILE)*
Mama Said Hop You Out *(FRANKLIN'S)*
Drop It Like It's Hop *(PLATT PARK)*
Hip Hop *(LANGHAM)*
Money, Cash, Hops *(IRON HILL)*
This Is Why I'm Hop *(NINKASI)*
Dr. Hoptagon *(PARISH)*
Hippity Hops *(CAUTION)*

MUSICALS
Rock Hopera *(VINO'S)*
Phantom of the Hopera *(FREETAIL)*
Fandom of the Hopera *(THREE NOTCH'D)*

Hop Making Sense *(CELLARMAKER)*
Grand O'Hopry *(ORLANDO)*
Misty Mountain Hop *(OFF THE RAIL)*
Bohemian HOPsidy *(WILLMANTIC)*
Janis Hoplin *(KABINET)*
Don't Worry Be Hoppy *(RIVERSIDE)*
Hop for Teacher *(FOUNTAIN SQUARE)*
King of Hop *(STARR HILL, ALEBROWAR)*
Hop Lobster *(SPRINGFIELD)*
Hop Way to the Danger Zone *(ACOUSTIC)*
Hopapalooza *(BIG SHOULDERS)*
1 Hop Wonder *(HARMON)*
Smooth Hoperator *(STOUDTS)*
Mmmhops *(MUSTANG)*

TV & MOVIES

ACTORS
Audrey Hopburn *(GREAT LAKES)*
Menace Hopper *(TAPISTRY)*
Dennis Hop'rd *(BOBCAT)*

CHARACTERS
Hoptimus Prime *(RUCKUS)*
Java the Hop *(FORT GEORGE)*
RoboHop *(GREAT LAKES)*
Hoppa Smurf *(BEACHWOOD BBQ)*
Hoppy Balboa *(COOL SPRINGS)*
Hoppy Balboa v. Apollo Green *(CHERRY STREET)*

Hop Gun *(FUNKY BUDDHA)*
Red Hoptober *(NEW BELGIUM)*
A Hopwork Orange *(BLUE MOUNTAIN)*
Get to the Hopper *(PIZZA PORT)*
Hop-a-Long Cascade *(FAT HEAD'S)*
Everlasting Hopstopper *(FIFTYFIFTY)*
Hopacalypse Now *(NAKED CITY)*
Hopfather II *(BREW WHARF)*
Hoppy Feet *(CLOWN SHOES)*
1.2 Gigahops *(FARGO)*
What's Hoppenin *(RUN OF THE MILL)*
Hoppy Dazed *(COBRA)*

BOOKS
The Shape of Hops to Come *(NESHAMINY)*
Something Hoppy This Way Comes *(PIPEWORKS)*
The Hoppit *(PIZZA PORT)*
Black Hop Down *(GIZMO)*
Count Hopula *(SANTAN, BARLEY)*
Hops of Wrath *(DUST BOWL)*
Hop Fiction *(BREWDOG)*
Pipa Long Hoppings *(NODA)*
Goldihops *(KELBURN)*
Necrohopicon *(OLDE BURNSIDE)*
Hop on Top *(LYNNWOOD, SICK N TWISTED)*

ADULTS ONLY

SEXUAL
Hoppy Ending *(PALO ALTO)*
Hop Whore *(TYRANENA)*
Hop Slobber *(MILLBOCK)*
Hop Karl *(BULL & BUSH)*
Hopgasm *(FIVE SEASONS, BULLFROG)*
Mother Hoppin' *(BLUE TARP)*

DRUGS
Hoppyum *(FOOTHILLS)*
Hop Hash *(SWEETWATER)*
Nitrous Hopcide *(ELLICOTTVILLE)*

THE BODY

MALADIES
Hopochondria *(LAKEWOOD)*
Hopothermia *(ALASKA)*
PsycHOPathy *(MADTREE)*
Hopititis C *(515)*
Diprohopus *(ELYSIAN)*
Hopsomniac *(CAPTAIN LAWRENCE)*
Hopturnal Emission *(WIDMER)*
Hopidemic *(WIG & PEN)*

BODY PARTS
Hoppus Callosum *(ELLIOTT BAY)*
Hoptic Nerve *(HOPTIC NERVE)*
Hopstache *(SHORT'S)*
HopMouth *(ARCADIA)*

SEASONAL

SEASON'S GREETINGS
Mazel Hops *(HE'BREW)*
Hoppy Christmas *(BREWDOG)*
Hoppy Holidays *(CHELSEA)*
Hoppy Holidaze *(MARIN)*
Hoppy Halleeday *(ROCK BOTTOM)*
Hoppy New Year *(BLOCK 15)*

Hoptober *(NEW BELGIUM)*
Hoptoberfest *(MULTIPLE)*

PEOPLE & PLACES

PLACES
Hoplahoma *(MUSTANG)*
Hopsconsin *(THIRSTY PAGAN)*
Hop Henge *(DESCHUTES)*
Hoparillo *(KNEE DEEP)*
Hoppy Hollow *(SINGIN' RIVER)*
Hoplantic *(BARRIER)*

FAMOUS PERSONS
Pocahoptas *(CENTER OF THE UNIVERSE)*
Hopstradamus *(BLOOMINGTON)*

OCCUPATIONS
Hoptologist *(KNEE DEEP)*
Hoparazzi *(PARALLEL 49)*
Hop Burglar *(WICKED WEED)*
Hopsecutioner *(TERRAPIN)*
Hoptometrist *(LOOKOUT, ROUGHTAIL)*

FRIGHTENING HOPS

AGGRESSIVE

ASSAULTED BY HOPS
Hop Wallop *(VICTORY)*
Hoppercut *(LE TREFLE NOIR)*
Hop Clobber *(EMMETT'S)*
Hopslam *(BELL'S)*
Hop Suplex *(SAUCONY)*
HOPSMACK! *(TOPPLING GOLIATH)*
I'll Hop Your Rye Out *(ACOUSTIC)*
Hop Your Face *(FOUNTAIN SQUARE)*

DEATH BY HOPS
Suicide by Hops *(BLUEGRASS)*
Death by Hops *(SMOG CITY)*
Hopsphyxiation *(BULLFROG)*
Hoptopsy *(BARLEY & HOPS)*

APOCA-LYPTIC
Post-Hopocalypse *(DRAKE'S)*
Hop-Ocalypse *(CLAY PIPE)*
Hopocalypse *(DRAKE'S)*

UNPLEASANT
Hop Venom *(BONEYARD)*
Hopnoxxxious *(WALLDORFF)*
Hopnoxious *(SEABRIGHT)*
Vulgar Display of Hoppiness *(AARDWOLF)*
Hop Abomination *(DRY DOCK)*
Hop Hazard *(RIVER HORSE)*

HELLISH
To Hell in a Hop Basket *(NORTH SOUND)*
Hoppier than Helles *(CIGAR CITY)*
Hoppy as Helles *(TAP)*
Holy Hoppin' Hell *(WEIRD BEARD)*

Hoperation Overload *(DESTIHL)*
Fully Hoperational Battlestation *(PIPEWORKS)*
Hopping Mad *(MULTIPLE)*
Hopnado *(NEXT DOOR)*
Hop Zealot *(TWISTED PINE)*
Hopdemonium *(POWELL STREET)*
Hop-N-Awe *(ANGRY ERIK)*
Hop Villain *(BIG AL)*
Hoptrocity *(NAKED CITY)*
Hop Bomb *(ROCK BOTTOM)*

DISORIENTING
Inhopsicated *(PIZZA PORT)*
Hopsy Turvy *(FOUR FRIENDS)*
Hopped Up *(SNIPES)*
Hopside Down *(WIDMER BROTHERS)*
Hopnotic *(CRICKET HILL)*
Hopsy Dazy *(GREAT SOUTH)*
Hopsided *(BLUE TARP)*

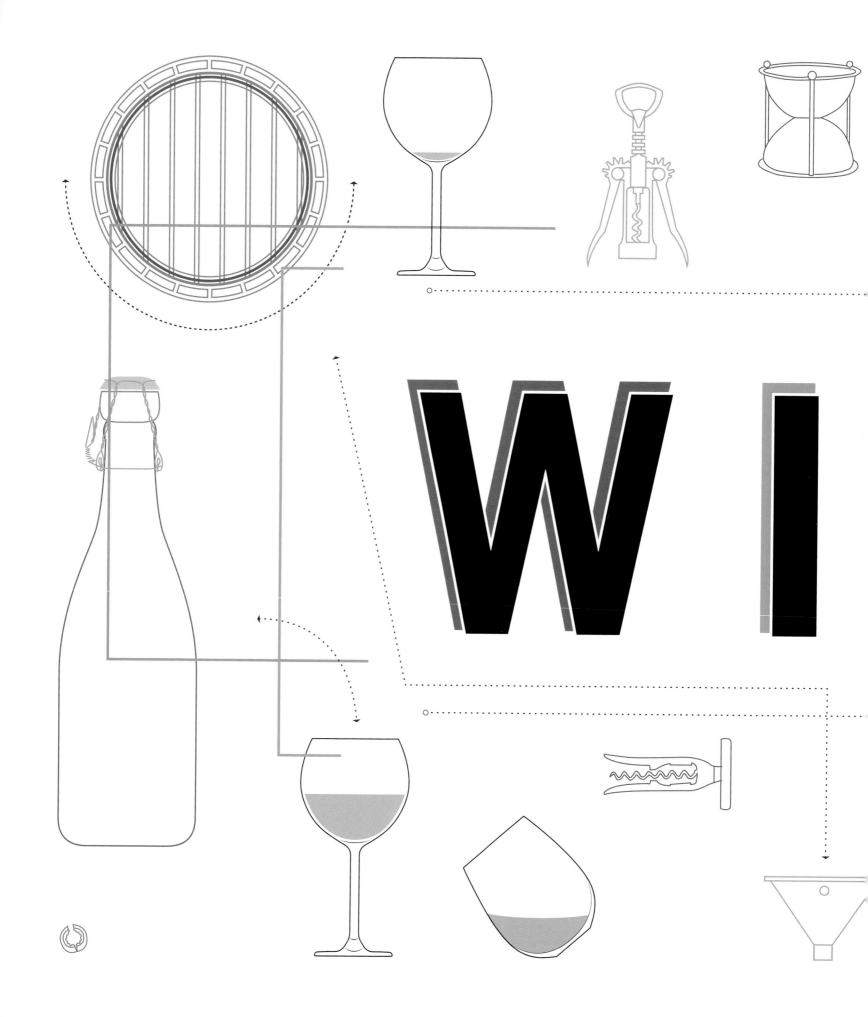

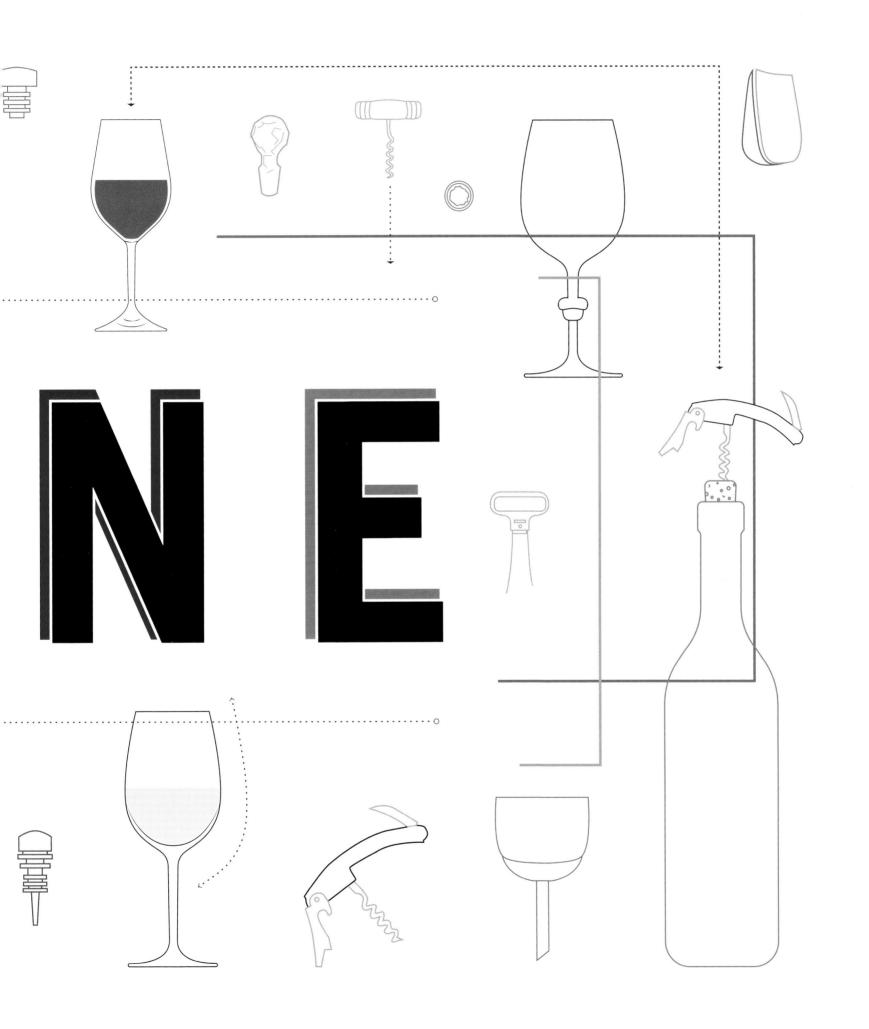

The Wine Plant

The grapevine plant is a liana—a woody, climbing vine. Taxonomically, grapevines belong to the *Vitis* genus. There are rougly 60 different species of *Vitis*, but the overwhelming majority of grapes used for wine are of the *Vitis vinifera* species, the only grapevine originating in Europe. Some American species, such as *Vitis labrusca* and *Vitis riparia*, have been crossed with *Vitis vinifera* to create new grape cultivars.

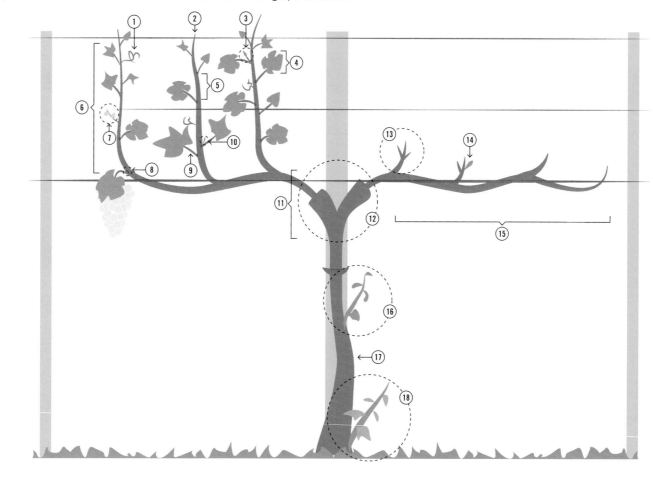

① Tendril
② Shoot Tip
③ Lateral Shoot
④ Leaf Blade
⑤ Internode
⑥ Shoot
⑦ Flower Cluster
⑧ Node
⑨ Petiole
⑩ Bud Compound
⑪ Head
⑫ Arms
⑬ Spur
⑭ Bud
⑮ Cordon
⑯ Watersprout
⑰ Trunk
⑱ Sucker

WINE LEAVES

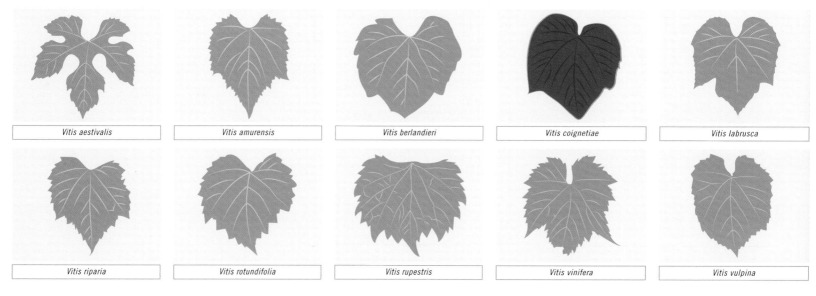

Vitis aestivalis	*Vitis amurensis*	*Vitis berlandieri*	*Vitis coignetiae*	*Vitis labrusca*
Vitis riparia	*Vitis rotundifolia*	*Vitis rupestris*	*Vitis vinifera*	*Vitis vulpina*

Vine Training

Because grapevines are vines, they need something to climb. Pruning and training to a supporting structure determines the final shape of the plant, which allows the winemaker to control how much light reaches the plant and also can make the fruit more accessible for harvesting. There are dozens of vine-training schemes—some notable ones are illustrated below.

BUSH

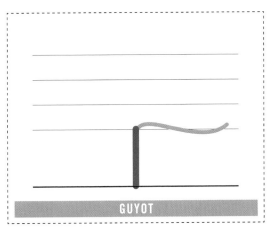

GUYOT

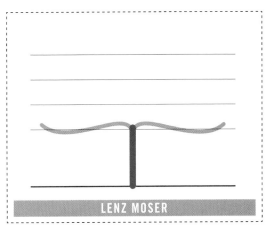

LENZ MOSER

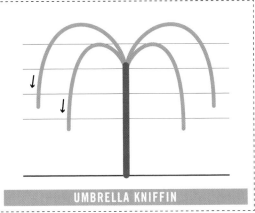

UMBRELLA KNIFFIN

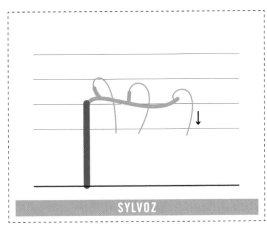

SYLVOZ

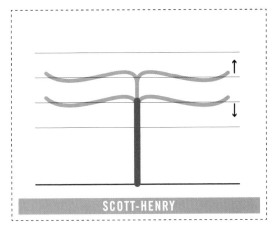

SCOTT-HENRY

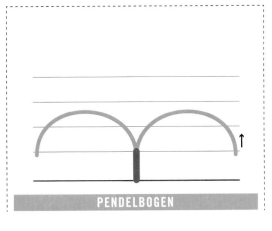

PENDELBOGEN

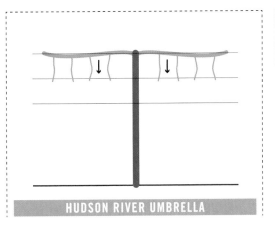

HUDSON RIVER UMBRELLA

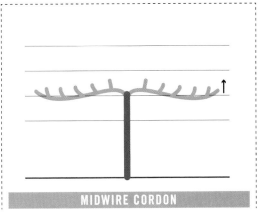

MIDWIRE CORDON

Terroir

The French term *terroir* is used to describe the complex interplay among soil, topography, and climate that produces specific flavors in grapes. The concept has been derided as Old World mysticism, and indeed advances in technology have allowed quality wines to be produced all over the world. Scientific studies have, however, confirmed that soil types and nitrogen levels affect the growth rates of grape plants and the size and density of their leaves, which in turn affects how much sugar and other flavor compounds are found in the ripened grapes. The topography of a site also affects how much sunlight reaches each individual plant.

INTENSITY OF SUNLIGHT

TEMPERATURE OF GRAPES

HUMIDITY

TEMPERATURE

RAINFALL

WATER UPTAKE BY ROOTS

VINE VIGOR
(Vine Size & Density)

AMOUNT OF SUNLIGHT RECEIVED BY LEAVES

GRAPE COMPOSITION & RIPENING PROCESS

SOIL TEXTURE

SOIL NITROGEN LEVEL

TOPOGRAPHY

QUALITY OF WINE

SAND
2.00–0.05 mm

SILT
0.05–0.002 mm

CLAY
less than 0.002 mm

Flower

Fruit Set

Veraison

Engustment

DAYS 0 10 60 120

BERRY FORMATION

BERRY RIPENING

Wine Pests

From planting to maturity, grapevines are inhibited in their growth by diseases as well as pests. These two forces are not mutually exclusive, though, as pests will often also serve as carriers for disease. A particularly devastating example is the Great French Wine Blight of the mid-nineteenth century, in which a massive phylloxera infestation nearly destroyed the entire French wine industry.

DISEASES

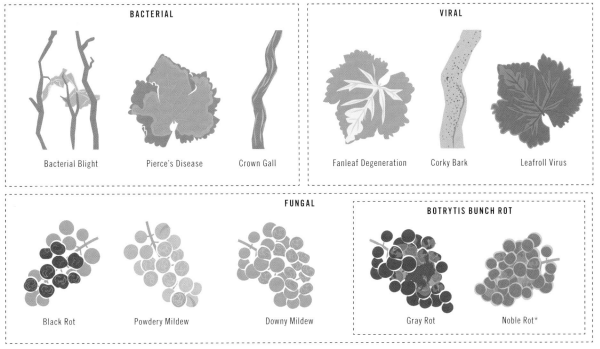

BACTERIAL

Bacterial Blight Pierce's Disease Crown Gall

VIRAL

Fanleaf Degeneration Corky Bark Leafroll Virus

FUNGAL

Black Rot Powdery Mildew Downy Mildew

BOTRYTIS BUNCH ROT

Gray Rot Noble Rot*

Under the right weather conditions, Noble Rot can actually contribute to the development of extremely high-quality, sweet grapes.

PESTS

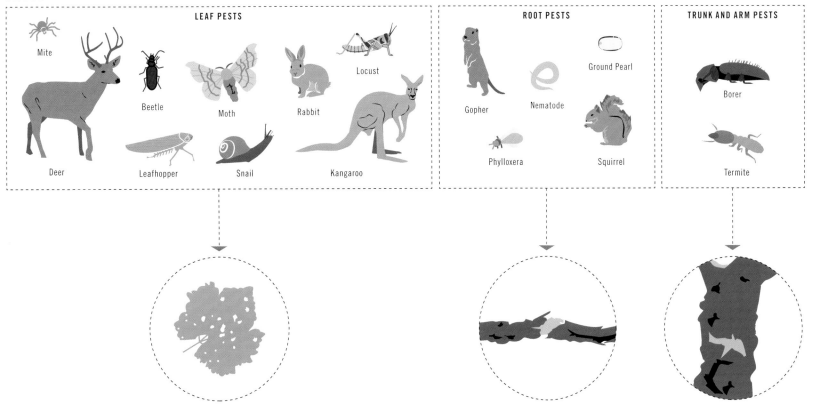

LEAF PESTS

Mite Deer Beetle Moth Leafhopper Snail Rabbit Locust Kangaroo

ROOT PESTS

Gopher Nematode Ground Pearl Phylloxera Squirrel

TRUNK AND ARM PESTS

Borer Termite

The Red Wine–Making Process

While minor aspects of the process (such as the ratio of free-run to pressed wine and the purposeful introduction of yeast) may vary among different producers, the fundamental aspects of red wine-making—the crushing and fermentation of dark-skinned grapes and the resulting liquid's maturation—remain the same.

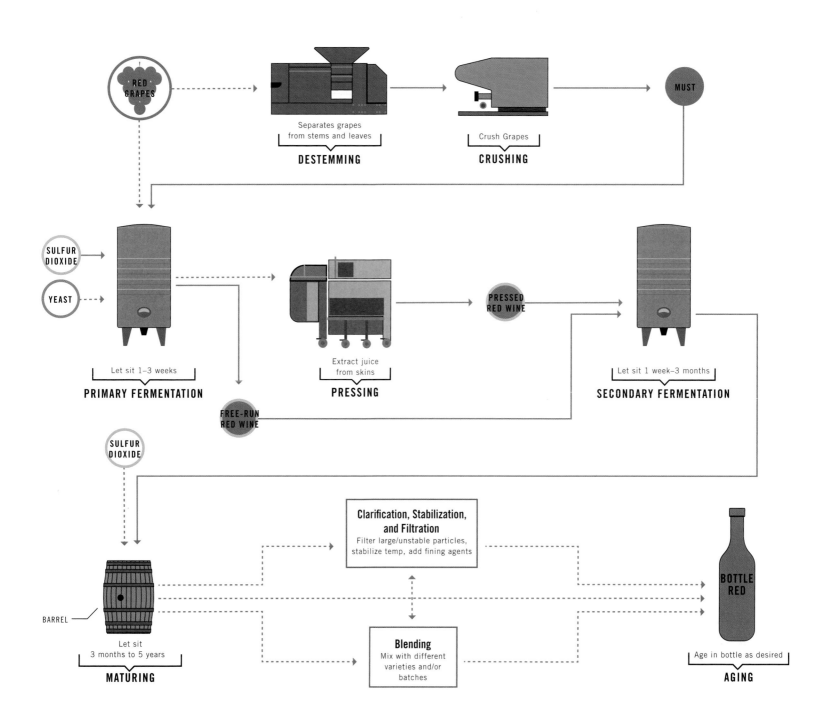

RED GRAPES

DESTEMMING
Separates grapes from stems and leaves

CRUSHING
Crush Grapes

MUST

SULFUR DIOXIDE

YEAST

PRIMARY FERMENTATION
Let sit 1–3 weeks

PRESSING
Extract juice from skins

FREE-RUN RED WINE

PRESSED RED WINE

SECONDARY FERMENTATION
Let sit 1 week–3 months

SULFUR DIOXIDE

BARREL

MATURING
Let sit 3 months to 5 years

Clarification, Stabilization, and Filtration
Filter large/unstable particles, stabilize temp, add fining agents

Blending
Mix with different varieties and/or batches

BOTTLE RED

AGING
Age in bottle as desired

The White Wine–Making Process

The white wine-making process follows the same basic steps as its darker counterpart, but differs in a few key respects—namely, the use of light-skinned grape varieties and the pressing of these grapes into juice before the start of fermentation.

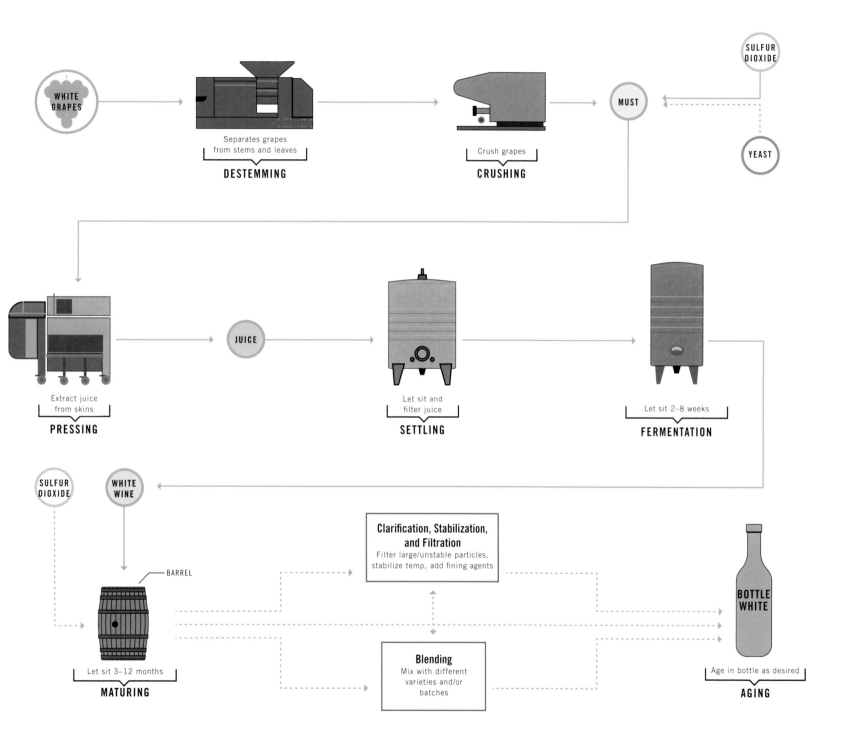

WHITE GRAPES

Separates grapes from stems and leaves
DESTEMMING

Crush grapes
CRUSHING

MUST

SULFUR DIOXIDE

YEAST

Extract juice from skins
PRESSING

JUICE

Let sit and filter juice
SETTLING

Let sit 2–8 weeks
FERMENTATION

SULFUR DIOXIDE

WHITE WINE

BARREL

Let sit 3–12 months
MATURING

Clarification, Stabilization, and Filtration
Filter large/unstable particles, stabilize temp, add fining agents

Blending
Mix with different varieties and/or batches

BOTTLE WHITE

Age in bottle as desired
AGING

Global Climate Map

There are three types of climates suitable for grape growing: Mediterranean, Maritime, and Continental. Nearly all the wine-producing regions in the world fall into two bands between 30 degrees and 50 degrees latitude in each hemisphere.

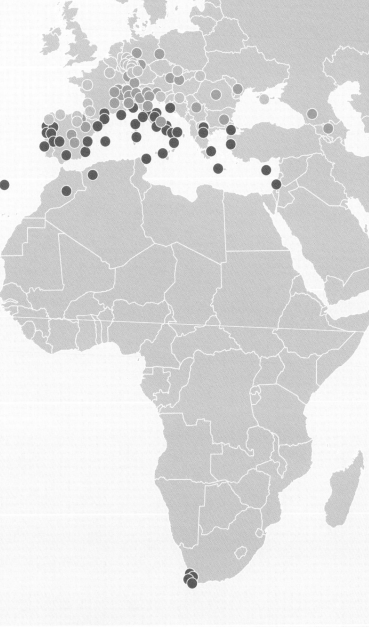

- ● MEDITERRANEAN
- ● MARITIME
- ● CONTINENTAL

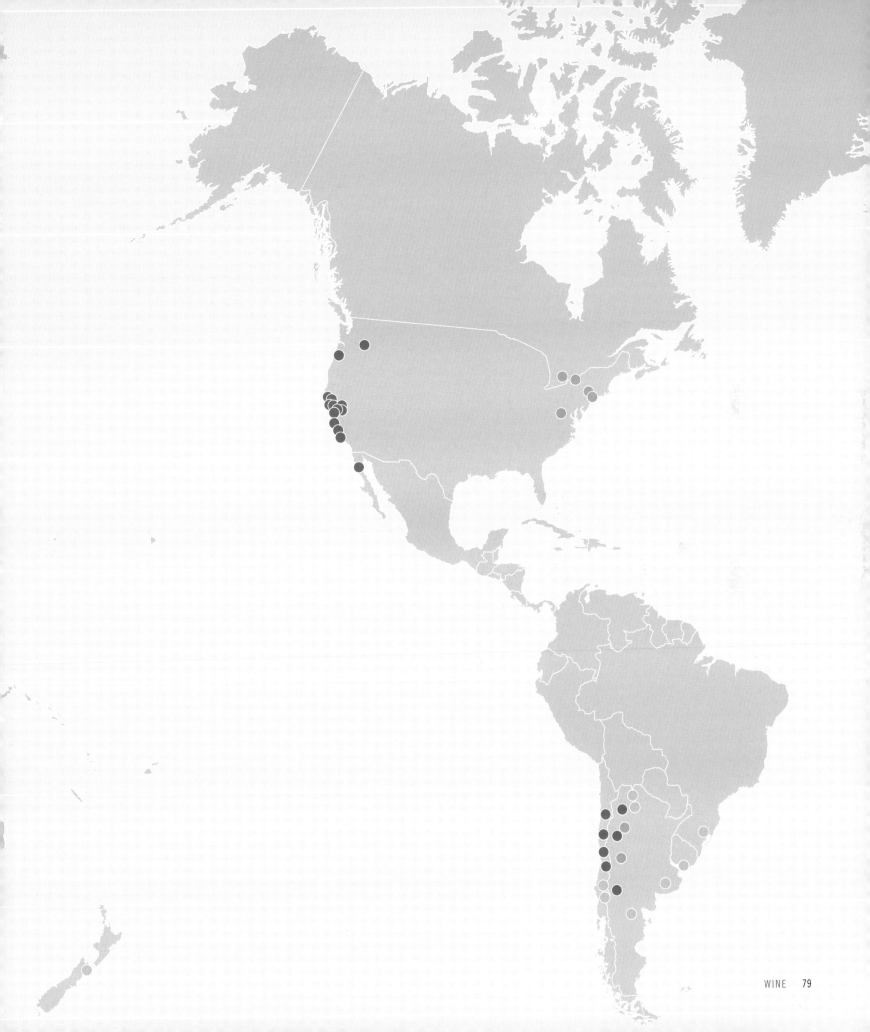

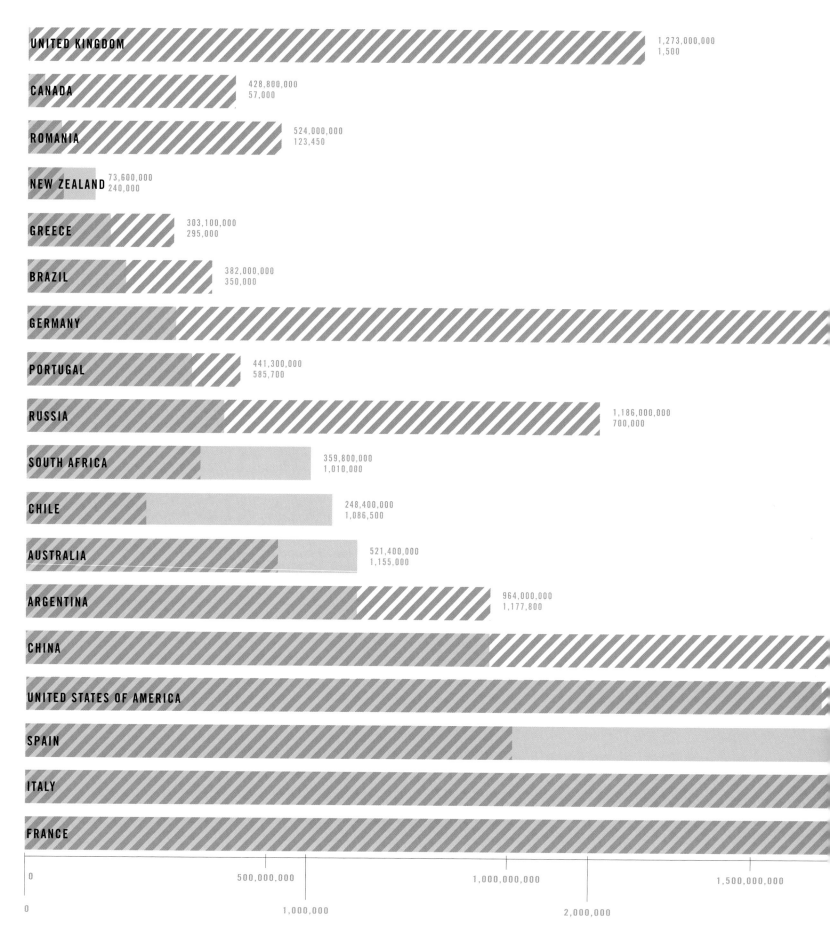

UNITED KINGDOM 1,273,000,000 / 1,500

CANADA 428,800,000 / 57,000

ROMANIA 524,000,000 / 123,450

NEW ZEALAND 73,600,000 / 240,000

GREECE 303,100,000 / 295,000

BRAZIL 382,000,000 / 350,000

GERMANY

PORTUGAL 441,300,000 / 585,700

RUSSIA 1,186,000,000 / 700,000

SOUTH AFRICA 359,800,000 / 1,010,000

CHILE 248,400,000 / 1,086,500

AUSTRALIA 521,400,000 / 1,155,000

ARGENTINA 964,000,000 / 1,177,800

CHINA

UNITED STATES OF AMERICA

SPAIN

ITALY

FRANCE

0 500,000,000 1,000,000,000 1,500,000,000

0 1,000,000 2,000,000

Production vs. Consumption

The United States now leads the world in wine consumption and continues to catch up to Europe in production. China is growing the quickest, however, in both consumption and production.

1,950,000,000
528,515

CONSUMPTION (LITERS)
AS OF 2012

PRODUCTION QUANTITY (METRIC TONS)
AS OF 2012

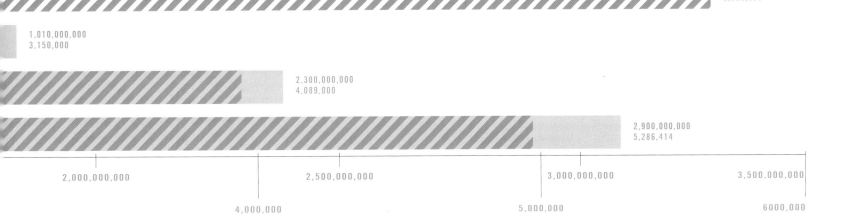

773,700,000
650,000

3,269,238,000
2,820,000

1,010,000,000
3,150,000

2,300,000,000
4,089,000

2,900,000,000
5,286,414

2,000,000,000 2,500,000,000 3,000,000,000 3,500,000,000

4,000,000 5,000,000 6000,000

Wine Sweetness

There are a number of factors that account for a wine's sweetness, from relative alcohol levels to acids to tannins. But perhaps the most important element is "Residual Sugar," which refers to natural grape sugars that remain in wine liquid after fermentation ceases. Generally speaking, a greater presence of residual sugar makes a sweeter wine, while lower levels yield a drier wine. One must also consider a wine's serving temperature, which will affect a varietal's flavor profile and "bouquet."

APPROXIMATE % OF RESIDUAL SUGAR IN WINES DRY TO SWEET

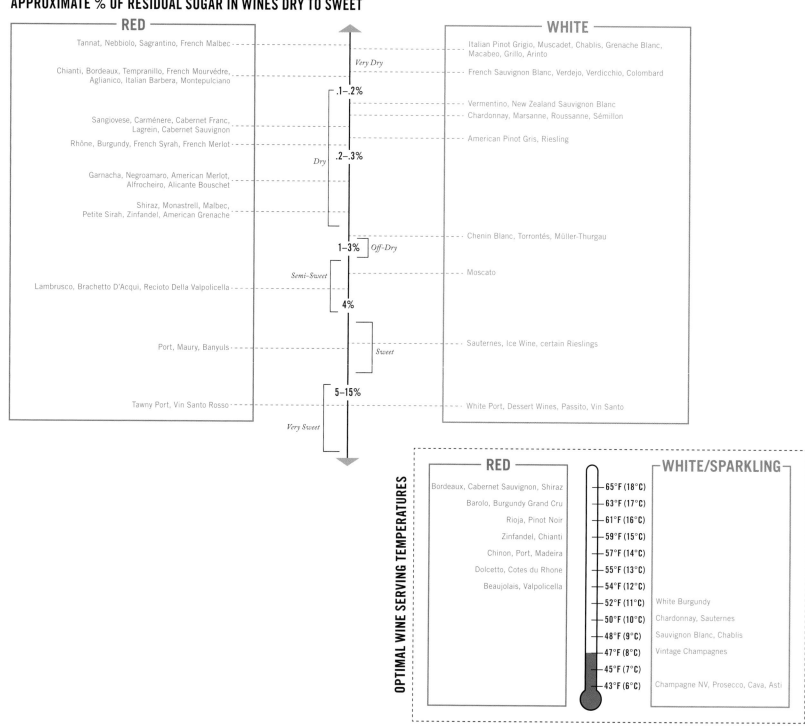

RED

Tannat, Nebbiolo, Sagrantino, French Malbec

Chianti, Bordeaux, Tempranillo, French Mourvèdre, Aglianico, Italian Barbera, Montepulciano

Sangiovese, Carménère, Cabernet Franc, Lagrein, Cabernet Sauvignon

Rhône, Burgundy, French Syrah, French Merlot

Garnacha, Negroamaro, American Merlot, Alfrocheiro, Alicante Bouschet

Shiraz, Monastrell, Malbec, Petite Sirah, Zinfandel, American Grenache

Lambrusco, Brachetto D'Acqui, Recioto Della Valpolicella

Port, Maury, Banyuls

Tawny Port, Vin Santo Rosso

Very Dry

.1–.2%

Dry

.2–.3%

1–3% *Off-Dry*

Semi-Sweet

4%

Sweet

5–15%

Very Sweet

WHITE

Italian Pinot Grigio, Muscadet, Chablis, Grenache Blanc, Macabeo, Grillo, Arinto

French Sauvignon Blanc, Verdejo, Verdicchio, Colombard

Vermentino, New Zealand Sauvignon Blanc

Chardonnay, Marsanne, Roussanne, Sémillon

American Pinot Gris, Riesling

Chenin Blanc, Torrontés, Müller-Thurgau

Moscato

Sauternes, Ice Wine, certain Rieslings

White Port, Dessert Wines, Passito, Vin Santo

OPTIMAL WINE SERVING TEMPERATURES

RED

Bordeaux, Cabernet Sauvignon, Shiraz — 65°F (18°C)
Barolo, Burgundy Grand Cru — 63°F (17°C)
Rioja, Pinot Noir — 61°F (16°C)
Zinfandel, Chianti — 59°F (15°C)
Chinon, Port, Madeira — 57°F (14°C)
Dolcetto, Cotes du Rhone — 55°F (13°C)
Beaujolais, Valpolicella — 54°F (12°C)
— 52°F (11°C)
— 50°F (10°C)
— 48°F (9°C)
— 47°F (8°C)
— 45°F (7°C)
— 43°F (6°C)

WHITE/SPARKLING

White Burgundy — 52°F (11°C)
Chardonnay, Sauternes — 50°F (10°C)
Sauvignon Blanc, Chablis — 48°F (9°C)
Vintage Champagnes — 47°F (8°C)
Champagne NV, Prosecco, Cava, Asti — 43°F (6°C)

Wine Classifications

Around the world, wines are assigned grades of quality according to where exactly the grapes are grown. European countries are far stricter in both the definition and enforcement of these classifications.

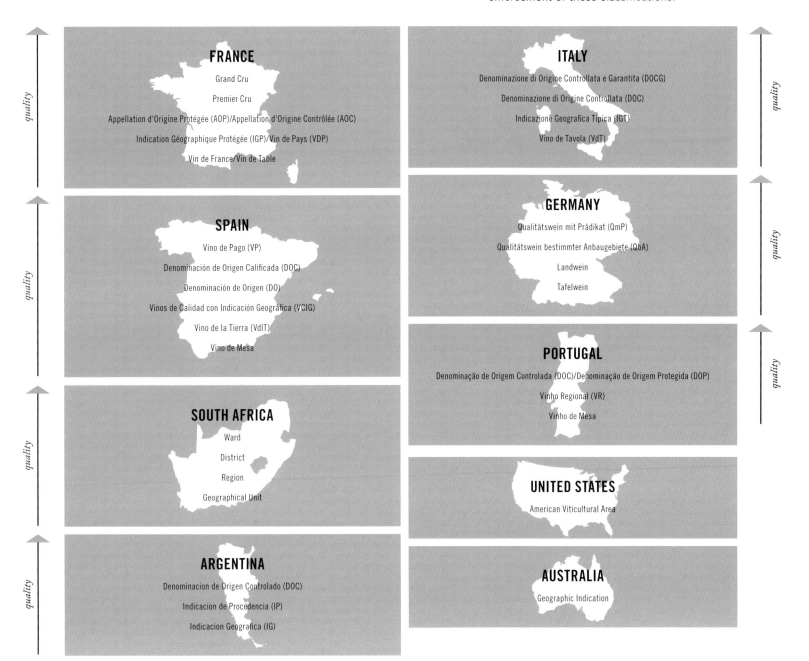

FRANCE
quality

Grand Cru

Premier Cru

Appellation d'Origine Protégée (AOP)/Appellation d'Origine Contrôlée (AOC)

Indication Géographique Protégée (IGP)/Vin de Pays (VDP)

Vin de France/Vin de Table

ITALY
quality

Denominazione di Origine Controllata e Garantita (DOCG)

Denominazione di Origine Controllata (DOC)

Indicazione Geografica Tipica (IGT)

Vino de Tavola (VdT)

SPAIN
quality

Vino de Pago (VP)

Denominación de Origen Calificada (DOC)

Denominación de Origen (DO)

Vinos de Calidad con Indicación Geográfica (VCIG)

Vino de la Tierra (VdlT)

Vino de Mesa

GERMANY
quality

Qualitätswein mit Prädikat (QmP)

Qualitätswein bestimmter Anbaugebiete (QbA)

Landwein

Tafelwein

PORTUGAL
quality

Denominação de Origem Controlada (DOC)/Denominação de Origem Protegida (DOP)

Vinho Regional (VR)

Vinho de Mesa

SOUTH AFRICA
quality

Ward

District

Region

Geographical Unit

UNITED STATES

American Viticultural Area

ARGENTINA
quality

Denominacion de Origen Controlado (DOC)

Indicacion de Procedencia (IP)

Indicacion Geografica (IG)

AUSTRALIA

Geographic Indication

French Grape Origins

The origins of grapes can never be exactly pinned down, but researchers can combine historical research with DNA analysis to make best guesses as to where certain grapes first arose.

① Auxerrois / Savagnin Blanc/Traminer

② Aubin Blanc / Aubin Vert

③ Knipperle

④ Petit Meslier

⑤ Bachet Noir / Beaunoir

⑥ César / Tressot

⑦ Gascon

⑧ Meslier Saint-François

⑨ Teinturier

⑩ Chenin Blanc

⑪ Madeleine Angevine / Muscat Ottonel

⑫ Grolleau Noir

⑬ Genoillet

⑭ Savagnin Blanc/Traminer / Mézy / Poulsard

⑮ Béclan / Trousseau

⑯ Gringet

⑰ Chardonnay

⑱ Syrah / Roussanne / Viognier

⑲ Noir Fleurien

⑳ Aligote / Marsanne

㉑ Chouchillon

㉒ Mornen Noir

㉓ Counoise

㉔ Mècle de Bourgoin

㉕ Verdesse / Onchette / Peloursin

㉖ Roussette d'Ayze

㉗ Petite Syrah/Durif

㉘ Altesse / Cacaboué / Jacquère / Molette / Mondeuse Blanche / Douce Noire / Mondeuse Noire / Persan

㉙ Mollard

㉚ Chatus / Chichaud / Dureza

㉛ Braquet Noir

㉜ Aubun / Bouteillan Noir / Plant Droit / Bourboulenc / Piquepoul

㉝ Aramon Noir

㉞ Barbaroux

㉟ Rivairenc/Aspiran Noir

㊱ Cinsaut

㊲ Clairette / Terret

㊳ Mauzac Noir / Milgranet / Prunelard / Duras / Ondenc

㊴ Canari Noir / Duras

㊵ Fer / Cabernet Franc

㊶ Tannat

㊷ Blanc Dame / Folle Blanche / Graisse

㊸ Negrette

㊹ Jurançon Blanc

㊺ Cot/Malbec

㊻ Gros Manseng

㊼ Manseng Noir

㊽ Crouchen / Raffiat de Moncade / Gros Verdot / Petit Verdot

㊾ Camaralet de Lasseube / Camaraou Noir

㊿ Petit Courbu / Petit Manseng

51 Baroque

52 Jurançon Noir

53 Bouchalès / Mérille / Abouriou

54 Castets

55 Sémillon

56 Balzac Blanc / Colombard / Monbadon / Montils

57 Bequignol Noir / Cabernet Sauvignon / Carmenere / Merlot / Muscadelle

CHAMPAGNE
Savagnin Blanc/ Traminer

LOIRE VALLEY
Menu Pineau / Sauvignon Blanc / Pineau d'Aunis

PROVENCE
Brun Fourca / Calitor Noir / Oeillade Noire / Tibouren / Colombaud / Pascal Blanc / Rosé du Var

BURGUNDY
Melon / Sacy / Gamay Noir

BORDEAUX
Saint-Macaire

Unknown Origin
Gouais Blanc / Pinots

French Wine Regions

France produces more wine than any other country and has a rigorous system for controlling its production. Top-level wines are regulated by the *appellation d'origine contrôlée* (AOC) system, which designates from where wines can claim origin, the allowed grapes, and the production method. There are more than three hundred AOCs within France, and below that there are separate designations for table wine.

REGIONS

- Champagne
- Burgundy
- Alsace
- Jura and Savoie
- Rhône
- Loire Valley
- Bordeaux
- Languedoc
- Provence
- Roussillon
- Southwest

French Grape Genealogy

Many French grapes are related to each other; the ancient varieties Pinot and Gouais Blanc have nearly twenty offspring; and important grapes such as Merlot, Cabernet Sauvignon, Sauvignon Blanc, and Malbec are all closely related. The exact color variant of Pinot used in any crossing is usually unknown because the color variants are genetically identical.

Savagnin/Traminer *(France or Germany)*

Black Morocco *(Unknown)*

Schiava Grossa *Italy*

Duc d'Anjou

Kerner *Germany*

Rotberger

Juwel

Sciaccarello/Mammolo *Italy*

Muscat Blanc à Petit Grains *Greece*

Bukettraube

Pinot Teinturier

Silvaner *Austria*

Bicane

Schiras

Ingram's Muscat *UK*

Muscadelle

Muscat Rouge de Madere

Muscat Fleur d'Oranger

Romorantin

Chasselas Blanc *Switzerland*

Blanc d'Ambre

Milgranet

Gringet

Muscat Ottonel

Circe

Menu Pineau

Graisse

Molette

Madeleine Angevine

Grolleau Noir

Blanc Dame

Noir Fleurien

Jacquère

Altesse

Afus Ali *Lebanon*

Csaba Gyöngye *Hungary*

Gouais Blanc *(France or Germany)*

Grec Rouge

Malingre Precoce

Riesling *Germany*

Friulano *Italy*

Rauschling *Germany*

Aubin Blanc

Petit Meslier

Fernand Rose

St Pierre Dore

Garnacha Roja *Spain*

Roussette d'Ayze

Muscat Bouschet

Aranel

M-G 101-14 OP

Goldriesling *Serbia*

Louisette

Seibel 6468

Subereux

Léon Millot

Maréchal Foch

Lucie Kuhlmann

Knipperle

Beaunoir

Dameron

François Noir Femelle

Gamay Blanc Gloriod

Auxerrois

Millot-Foch

Seibel 5163

Seibel 880

Gamay Noir

Bachet Noir

Chancellor

S-V 12-417

Villard Blanc

Mézy

Chambourcin

Landot Noir

Muscat of Hamburg *UK*

Dodrelyabi *Georgia*

Sultanina *Turkey*

Seibel 5656

Szoloskertek Kiralynoje *Hungary*

Alphonse Lavallée

Alvina

Palomino Fino *Spain*

Chardonnay

Seyval Blanc

Cardinal *U.S.*

Madina

Chasan

L, Liliorila

Baroque

Chardonel *U.S.*

Legend

- Noir
- Blanc
- Rouge
- Rosé
- Breeding Grape
- {🍇} Unknown Grape

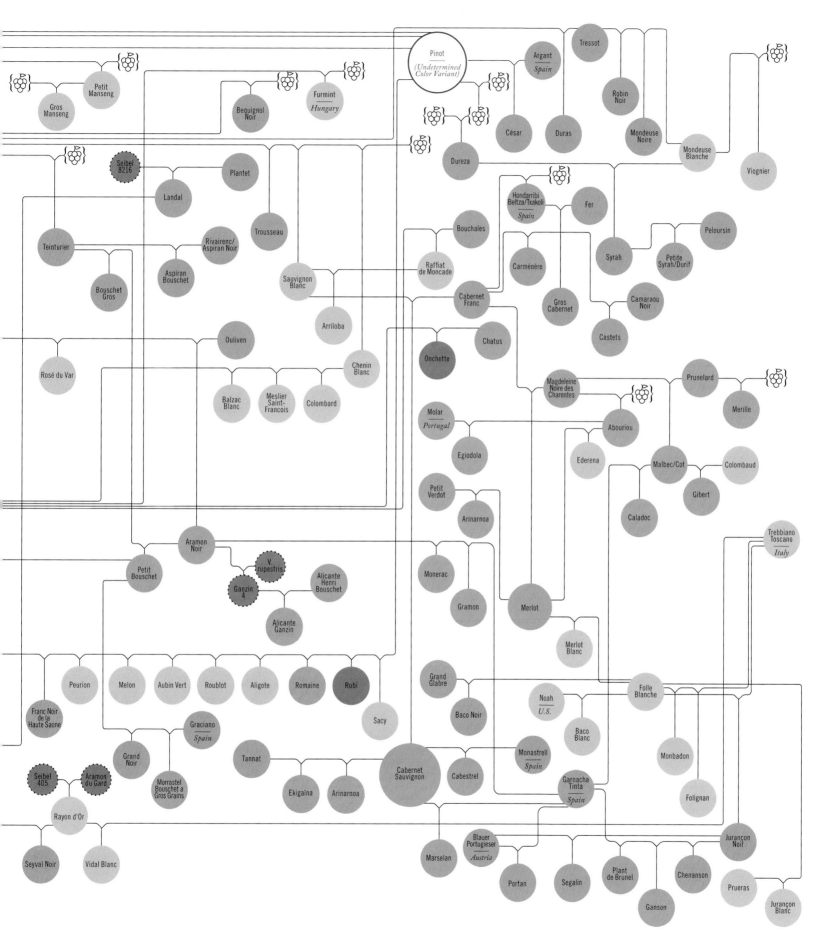

Pinot
(Undetermined Color Variant)

Argant
Spain

Tressot

Robin Noir

César

Duras

Mondeuse Noire

Mondeuse Blanche

Viognier

Dureza

Petit Manseng

Gros Manseng

Bequignol Noir

Furmint
Hungary

Seibel 8216

Plantet

Landal

Trousseau

Hondarribi Beltza/Txakoli
Spain

Fer

Peloursin

Syrah

Petite Syrah/Durif

Carménère

Camaraou Noir

Bouchales

Rivairenc/ Aspiran Noir

Aspiran Bouschet

Teinturier

Sauvignon Blanc

Raffiat de Moncade

Cabernet Franc

Gros Cabernet

Castets

Bouschet Gros

Arriloba

Chatus

Ouliven

Chenin Blanc

Onchette

Rosé du Var

Magdeleine Noire des Charentes

Prunelard

Merille

Balzac Blanc

Meslier Saint-Francois

Colombard

Molar
Portugal

Abouriou

Egiodola

Ederena

Malbec/Cot

Colombaud

Petit Verdot

Gibert

Caladoc

Arinarnoa

Trebbiano Toscano
Italy

Aramon Noir

V. rupestris

Monerac

Ganzin 4

Alicante Henri Bouschet

Gramon

Merlot

Petit Bouschet

Alicante Ganzin

Merlot Blanc

Peurion

Melon

Aubin Vert

Roublot

Aligote

Romaine

Rubi

Grand Glabre

Folle Blanche

Noah
U.S.

Franc Noir de la Haute Saone

Sacy

Baco Noir

Baco Blanc

Monbadon

Graciano
Spain

Grand Noir

Tannat

Monastrell
Spain

Folignan

Seibel 405

Aramon du Gard

Morrastel Bouschet a Gros Grains

Ekigaïna

Arinarnoa

Cabernet Sauvignon

Cabestrel

Garnacha Tinta
Spain

Rayon d'Or

Jurançon Noir

Seyval Noir

Vidal Blanc

Marselan

Blauer Portugieser
Austria

Plant de Brunel

Chenanson

Prueras

Portan

Segalin

Ganson

Jurançon Blanc

French Oak Cooperage

The term *cooperage* refers to the activities associated with the construction of wooden barrels. The production of these vessels, which are most commonly used to age wines and spirits, has changed very little over the past few centuries and requires considerable technical skill. Those casks made of French oak are especially well suited to the maturation of wine.

Tree Sources

OAK TREE
150–250 Years Old

A tree is cut down and carefully selected pieces of wood are split into long blocks

FELLING, SHAPING, AND TRIMMING

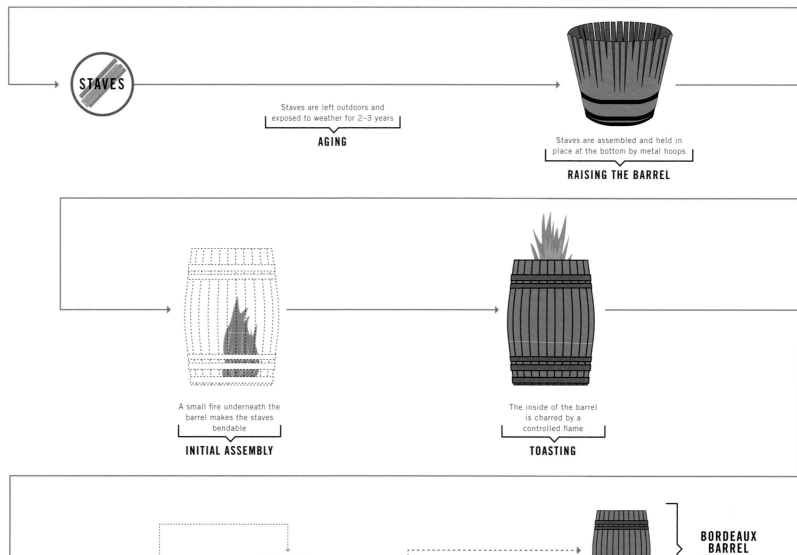

STAVES

Staves are left outdoors and exposed to weather for 2–3 years

AGING

Staves are assembled and held in place at the bottom by metal hoops

RAISING THE BARREL

A small fire underneath the barrel makes the staves bendable

INITIAL ASSEMBLY

The inside of the barrel is charred by a controlled flame

TOASTING

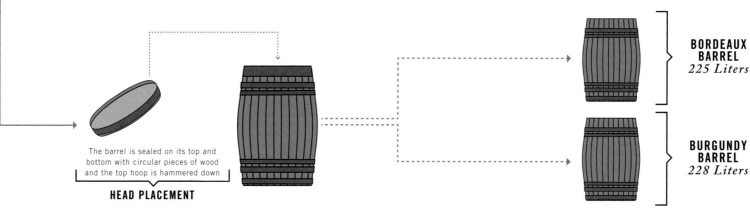

The barrel is sealed on its top and bottom with circular pieces of wood and the top hoop is hammered down

HEAD PLACEMENT

BORDEAUX BARREL
225 Liters

BURGUNDY BARREL
228 Liters

Bordeaux Wine Regions

Bordeaux produces more top-quality wines than any other region in the world. Based around the Gironde estuary of the Garonne River, 18,000 producers spread over 300,000 acres of vineyards produce the famed Bordeaux reds. Wine has been grown in the region since at least the fourth century AD, and its worldwide popularity peaked in the 1980s.

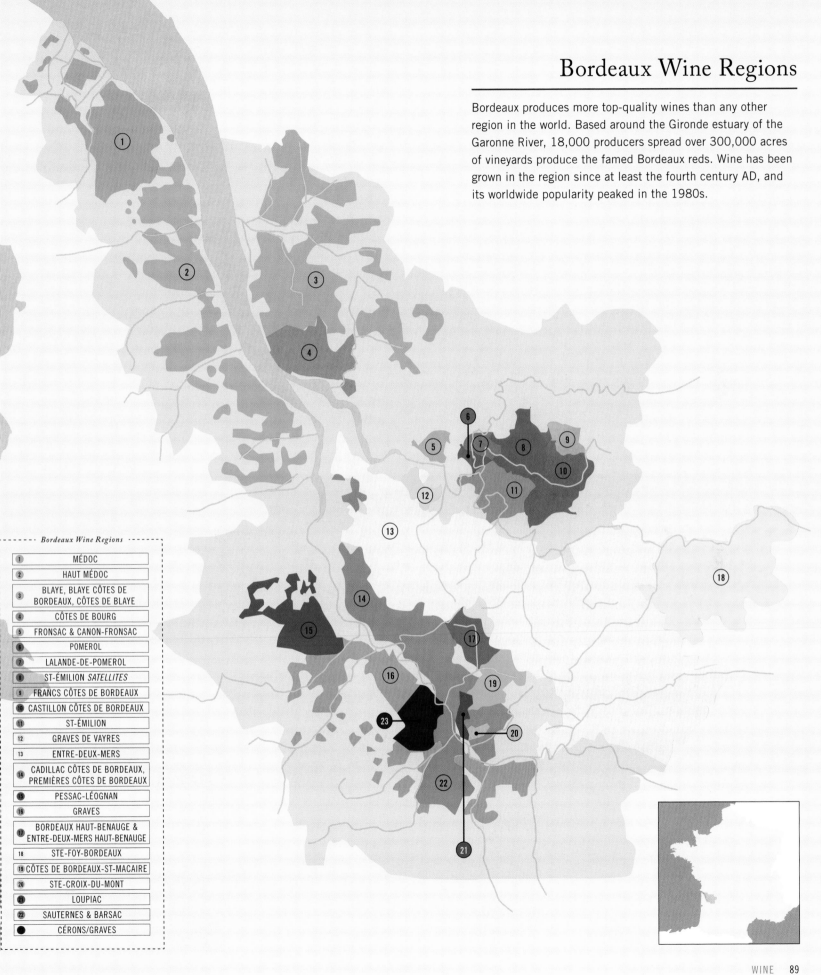

- - - - - - Bordeaux Wine Regions - - - - - - -

1	MÉDOC
2	HAUT MÉDOC
3	BLAYE, BLAYE CÔTES DE BORDEAUX, CÔTES DE BLAYE
4	CÔTES DE BOURG
5	FRONSAC & CANON-FRONSAC
6	POMEROL
7	LALANDE-DE-POMEROL
8	ST-ÉMILION *SATELLITES*
9	FRANCS CÔTES DE BORDEAUX
10	CASTILLON CÔTES DE BORDEAUX
11	ST-ÉMILION
12	GRAVES DE VAYRES
13	ENTRE-DEUX-MERS
14	CADILLAC CÔTES DE BORDEAUX, PREMIÈRES CÔTES DE BORDEAUX
15	PESSAC-LÉOGNAN
16	GRAVES
17	BORDEAUX HAUT-BENAUGE & ENTRE-DEUX-MERS HAUT-BENAUGE
18	STE-FOY-BORDEAUX
19	CÔTES DE BORDEAUX-ST-MACAIRE
20	STE-CROIX-DU-MONT
21	LOUPIAC
22	SAUTERNES & BARSAC
●	CÉRONS/GRAVES

Grapes in Bordeaux Wines

The classic "Bordeaux blend" is a combination of the Cabernet Sauvignon, Cabernet Franc, Merlot, Petit Verdot, and, to a lesser extent, Malbec and Carménère grapes. The range for the percentages of each is set by French law and is specific to the *appellation d'origine contrôlée* (AOC), which are designated places (ranging in size from a region down to a specific vineyard) from which a wine can claim origin. In addition to the famed Bordeaux reds, dry white wines are also produced in Bordeaux.

Regional Bordeaux AOCs

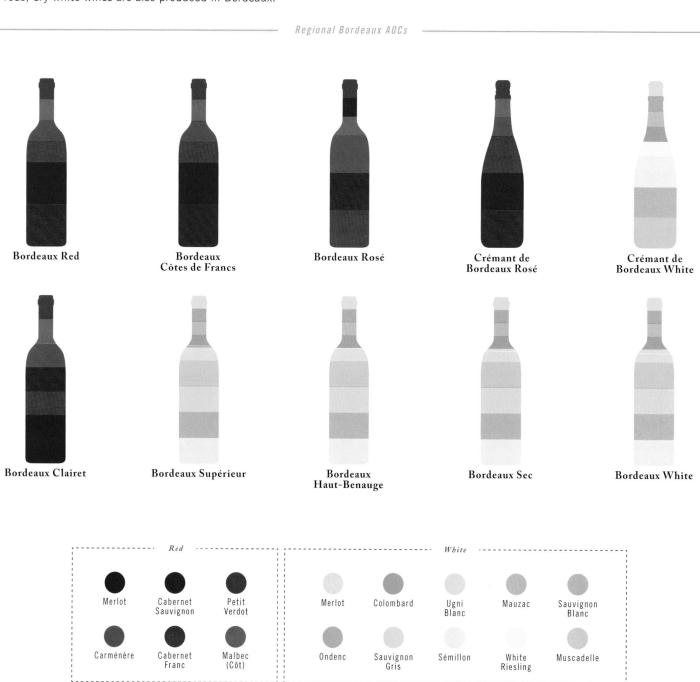

Bordeaux Red

Bordeaux
Côtes de Francs

Bordeaux Rosé

Crémant de
Bordeaux Rosé

Crémant de
Bordeaux White

Bordeaux Clairet

Bordeaux Supérieur

Bordeaux
Haut-Benauge

Bordeaux Sec

Bordeaux White

Red

Merlot

Cabernet
Sauvignon

Petit
Verdot

Carménère

Cabernet
Franc

Malbec
(Côt)

White

Merlot

Colombard

Ugni
Blanc

Mauzac

Sauvignon
Blanc

Ondenc

Sauvignon
Gris

Sémillon

White
Riesling

Muscadelle

Graves de Vayres
White

Graves de Vayres
Red

Graves Supérieures

Haut-Médoc

Margaux

Pomerol

Pessac-Léognan
White

Pessac-Léognan
Red

Cadillac

Barsac

Sauternes

Côtes de Bordeaux Saint-Macaire

Saint-Estephe

Blaye

Pauillac

Saint-Julien

Côtes de Blaye

Médoc

Graves
Red

Graves
White

Lussac-Saint-Émilion

Puisseguin Saint-Émilion

Saint-Émilion

Montagne Saint-Émilion

Saint-Georges Saint-Émilion

Lalande-de-Pomerol

Côtes de Bourg

Grapes in Burgundy Wines

Burgundy makes world-class red and white wines. The red wines are Pinot blends, and the whites are Chardonnay. The color varieties of Pinot, laid out below, are all genetic mutations of the same grape.

Chambertin
Chambertin-Clos de Bèze
Chapelle-Chambertin
Charmes-Chambertin
Latricières-Chambertin
Mazis-Chambertin
Mazoyères-Chambertin
Ruchottes-Chambertin
Griotte-Chambertin

THE CHAMBERTINS

Bonnes-Mares
Clos de La Roche
Clos de Tart
Clos de Vougeot
Clos des Lambrays
Clos Saint-Denis
Échezeaux
La Grande Rue
Grands Échezeaux
La Romanée
La Tâche
Richebourg
Romanée-Conti
Romanée-Saint-Vivant

85% Pinot
*Up to 15% total
Chardonnay,
Pinot Blanc,
Pinot Gris*

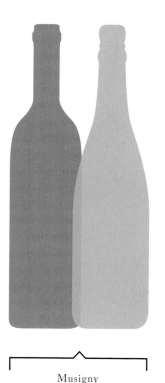

Musigny
Both Pinot & Chardonnay

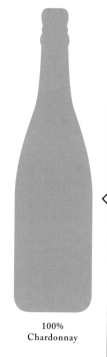

Bienvenues-Bâtard-Montrachet
Bâtard-Montrachet
Chevalier-Montrachet
Criots-Bâtard-Montrachet
Montrachet

MONTRACHET FAMILY

Bougros
Valmur
Blanchot
Les Clos
Grenouilles
Preuses
Vaudésir

CHABLIS GRAND CRU

Charlemagne
Corton
Corton-Charlemagne

CORTON-CHARLEMAGNE

100% Chardonnay

PINOT GRAPES

Pinot Noir

Pinot Gris

Pinot Blanc

Pinot Teinturier

Pinot Meunier

Pinot Noir Précoce

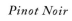

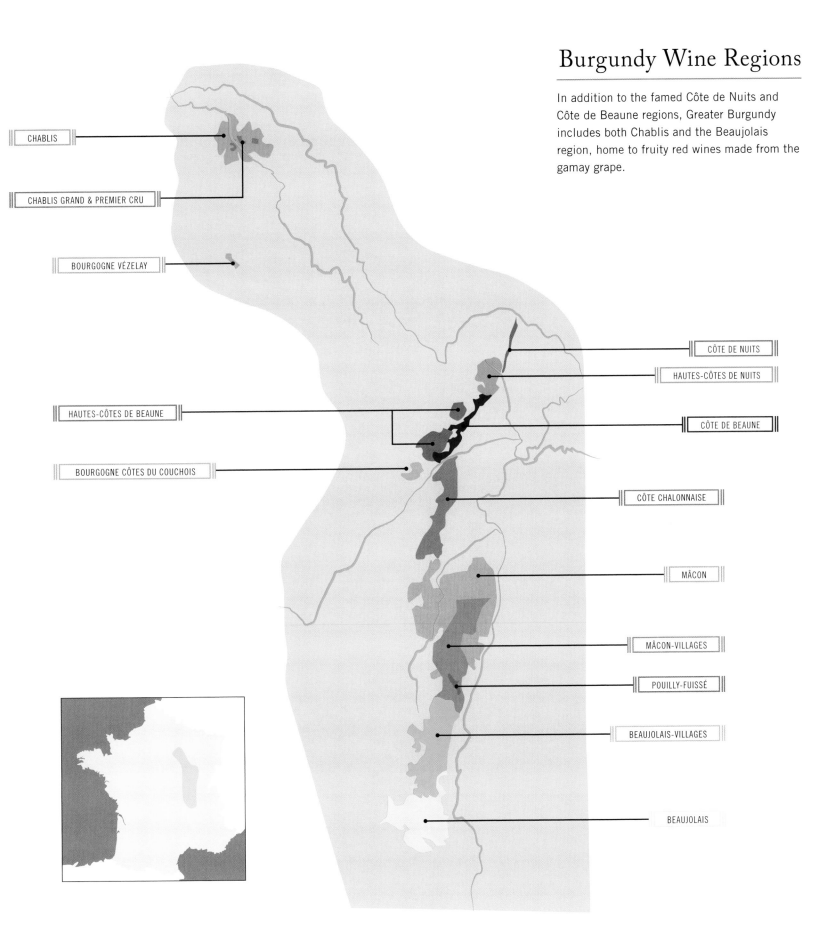

Burgundy Wine Regions

In addition to the famed Côte de Nuits and Côte de Beaune regions, Greater Burgundy includes both Chablis and the Beaujolais region, home to fruity red wines made from the gamay grape.

CHABLIS

CHABLIS GRAND & PREMIER CRU

BOURGOGNE VÉZELAY

CÔTE DE NUITS

HAUTES-CÔTES DE NUITS

HAUTES-CÔTES DE BEAUNE

CÔTE DE BEAUNE

BOURGOGNE CÔTES DU COUCHOIS

CÔTE CHALONNAISE

MÂCON

MÂCON-VILLAGES

POUILLY-FUISSÉ

BEAUJOLAIS-VILLAGES

BEAUJOLAIS

Rhône Wine Regions

The Rhône region is actually two regions, northern and southern, which only have a river in common. Northern Rhône makes much less wine but of a much higher quality, most of it world-class Syrah. Southern Rhône also has Syrah, along with the famed Châteauneuf-du-Pape spicy red.

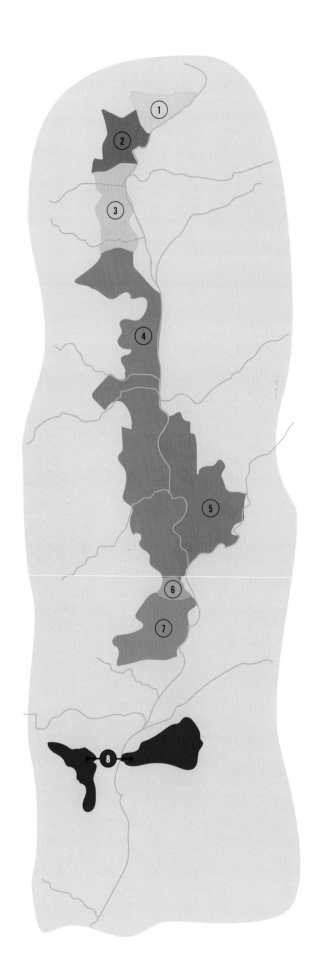

Wine Regions of Rhône

1	CÔTE-RÔTIE
2	CONDRIEU
3	CONDRIEU/ST-JOSEPH
4	ST-JOSEPH
5	CROZES-HERMITAGE
6	CORNAS
7	ST-PÉRAY
8	CÔTES DU RHÔNE
9	GRIGNAN-LES-ADHÉMAR
10	CÔTES DU VIVARAIS
11	GIGONDAS
12	MUSCAT DE BEAUMES-DE-VENISE
13	VACQUEYRAS
14	CHÂTEAUNEUF-DU-PAPE
15	LIRAC
16	TAVEL
17	VENTOUX
18	COSTIÈRES DE NîMES
19	CLAIRETTE DE BELLEGARDE

LEFT

RIGHT

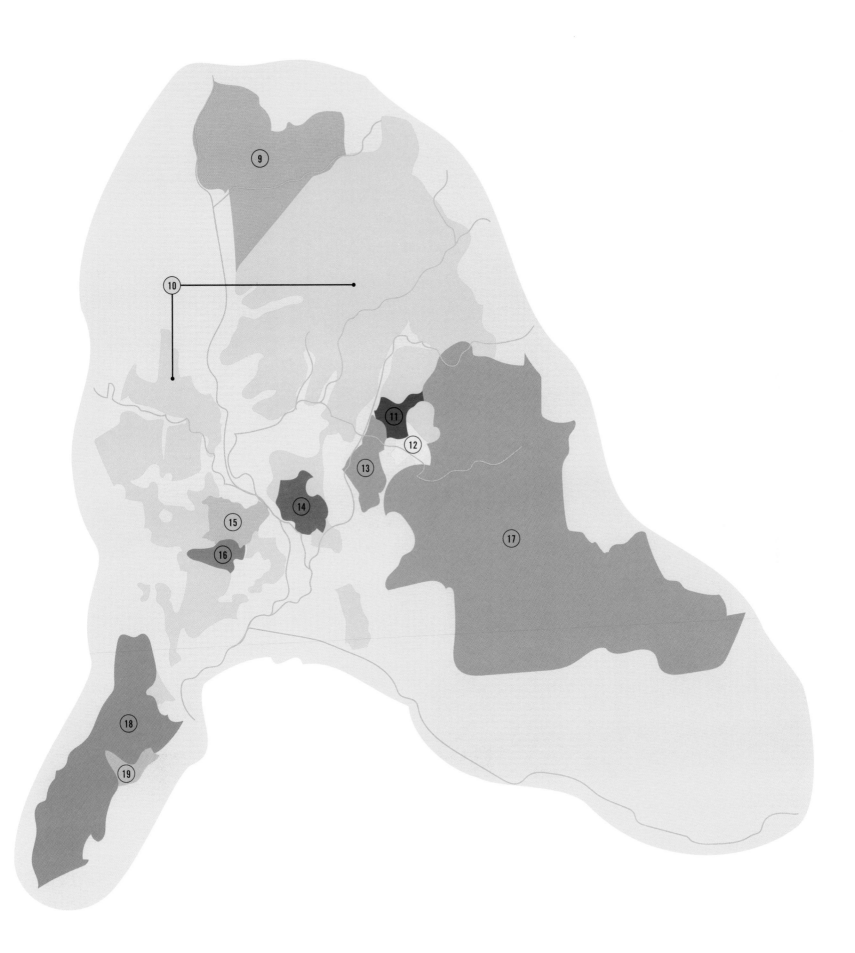

Grapes in Rhône Wines

The Rhône wine region is located in southern France, nestled into the valley through which the Rhône River flows. Rhône's AOC designations are typically split between the northern and southern parts of the region, each with unique vinicultural practices, traditions, and regulations. In the north (northern crus), red wine is made primarily from Syrah grapes, with white wine produced from Roussanne, Viognier, and Marsanne. A limited number of accessory grapes are permitted in the northern crus blends. The south of Rhône (southern crus) is home to the region's most notorious appellation, Côtes du Rhône, and here wines are produced from blends of nearly thirty distinct grape varietals.

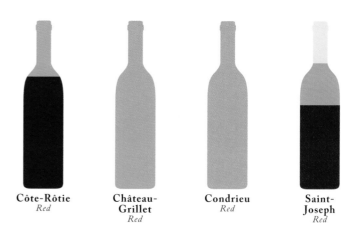

Côte-Rôtie
Red

Château-Grillet
Red

Condrieu
Red

Saint-Joseph
Red

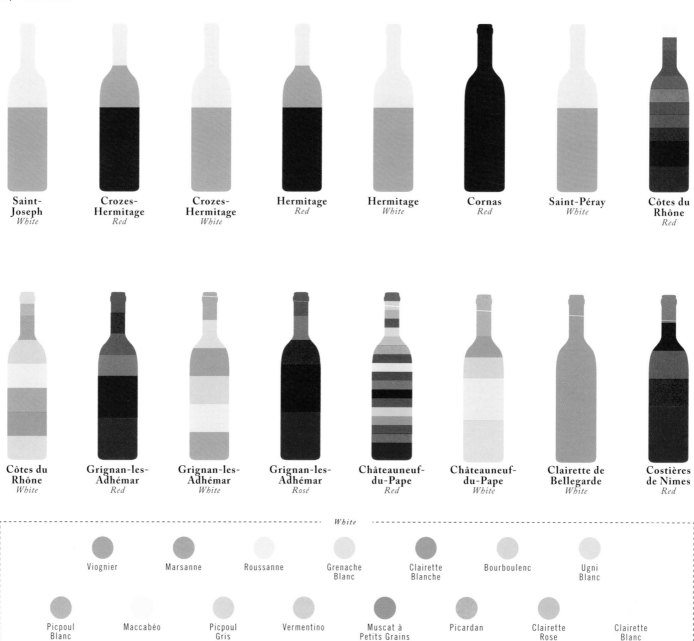

Saint-Joseph
White

Crozes-Hermitage
Red

Crozes-Hermitage
White

Hermitage
Red

Hermitage
White

Cornas
Red

Saint-Péray
White

Côtes du Rhône
Red

Côtes du Rhône
White

Grignan-les-Adhémar
Red

Grignan-les-Adhémar
White

Grignan-les-Adhémar
Rosé

Châteauneuf-du-Pape
Red

Châteauneuf-du-Pape
White

Clairette de Bellegarde
White

Costières de Nîmes
Red

White

Viognier

Marsanne

Roussanne

Grenache Blanc

Clairette Blanche

Bourboulenc

Ugni Blanc

Picpoul Blanc

Maccabéo

Picpoul Gris

Vermentino

Muscat à Petits Grains

Picardan

Clairette Rose

Clairette Blanc

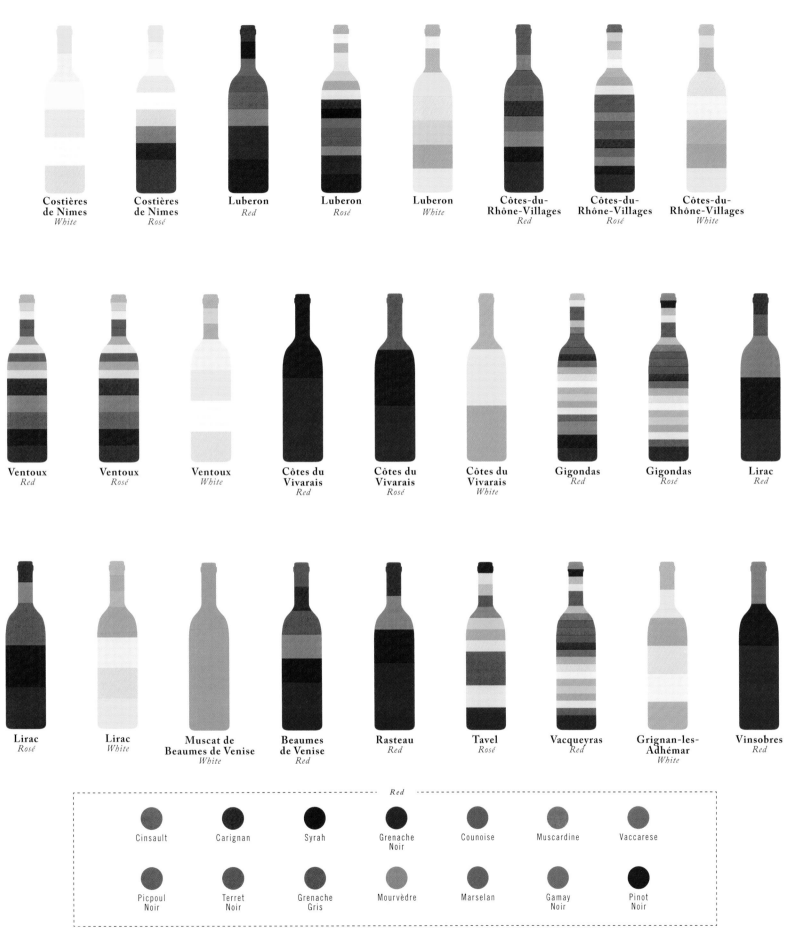

Costières de Nimes
White

Costières de Nimes
Rosé

Luberon
Red

Luberon
Rosé

Luberon
White

Côtes-du-Rhône-Villages
Red

Côtes-du-Rhône-Villages
Rosé

Côtes-du-Rhône-Villages
White

Ventoux
Red

Ventoux
Rosé

Ventoux
White

Côtes du Vivarais
Red

Côtes du Vivarais
Rosé

Côtes du Vivarais
White

Gigondas
Red

Gigondas
Rosé

Lirac
Red

Lirac
Rosé

Lirac
White

Muscat de Beaumes de Venise
White

Beaumes de Venise
Red

Rasteau
Red

Tavel
Rosé

Vacqueyras
Red

Grignan-les-Adhémar
White

Vinsobres
Red

Red

Cinsault

Carignan

Syrah

Grenache Noir

Counoise

Muscardine

Vaccarese

Picpoul Noir

Terret Noir

Grenache Gris

Mourvèdre

Marselan

Gamay Noir

Pinot Noir

The Champagne-Making Process

Though it is often used as a catchall term for sparkling wine, Champagne is in fact a very specific creation defined by both its geographic origin and the process of its production. Winemakers in Champagne employ the *méthode traditionalle* (traditional method), which requires a considerable amount of skill and attention to detail. Once bottled, Champagnes are classified by sweetness level, of which there are seven tiers.

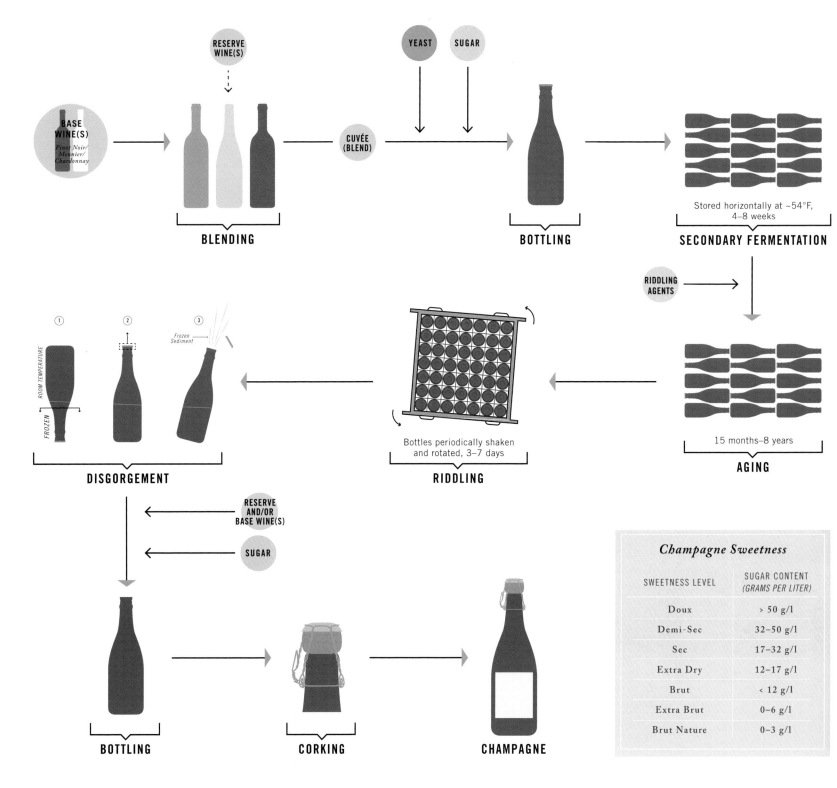

BASE WINE(S)
Pinot Noir/ Meunier/ Chardonnay

RESERVE WINE(S)

BLENDING

CUVÉE (BLEND)

YEAST SUGAR

BOTTLING

Stored horizontally at ~54°F, 4–8 weeks

SECONDARY FERMENTATION

RIDDLING AGENTS

15 months–8 years

AGING

Bottles periodically shaken and rotated, 3–7 days

RIDDLING

ROOM TEMPERATURE

FROZEN

Frozen Sediment

DISGORGEMENT

RESERVE AND/OR BASE WINE(S)

SUGAR

BOTTLING

CORKING

CHAMPAGNE

Champagne Sweetness

SWEETNESS LEVEL	SUGAR CONTENT (GRAMS PER LITER)
Doux	> 50 g/l
Demi-Sec	32–50 g/l
Sec	17–32 g/l
Extra Dry	12–17 g/l
Brut	< 12 g/l
Extra Brut	0–6 g/l
Brut Nature	0–3 g/l

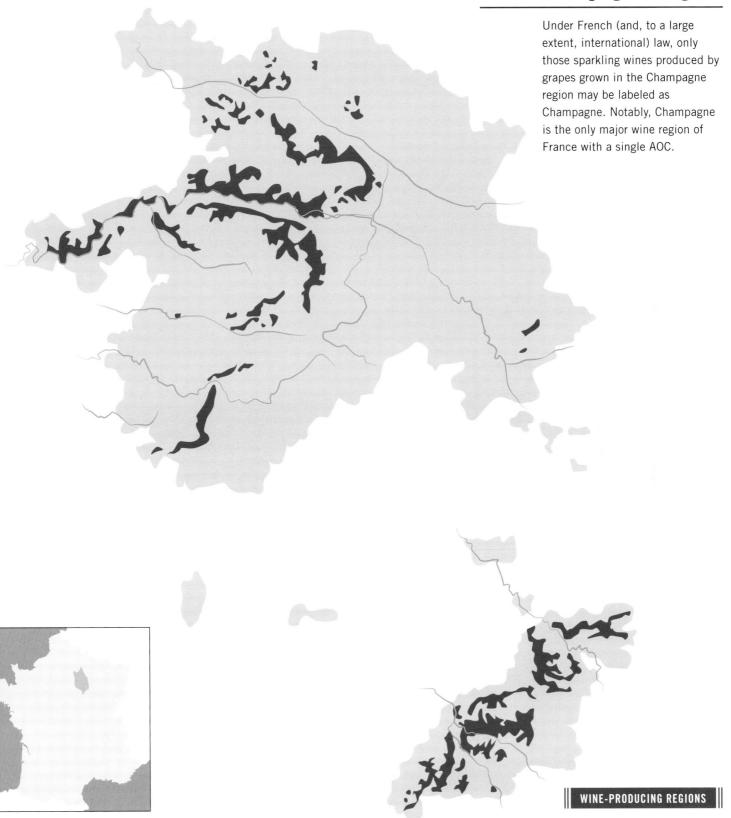

The Champagne Region

Under French (and, to a large extent, international) law, only those sparkling wines produced by grapes grown in the Champagne region may be labeled as Champagne. Notably, Champagne is the only major wine region of France with a single AOC.

WINE-PRODUCING REGIONS

German Wine Regulations

In 1971, Germany enacted a set of regulations for the production of quality wines. After subsequent reconciliations with EU chema, there are today two general levels: Table Wines and Quality Wines. Among the Quality Wines, the top wines are classified according to the Prädikat ("rating") levels, which denote the ripeness and the selection of the grapes used. The table below lays out the six Prädikat designations, along with the minimum density of the grape juice (an indication of sugar levels) measured on the German scale of degrees Oechsle.

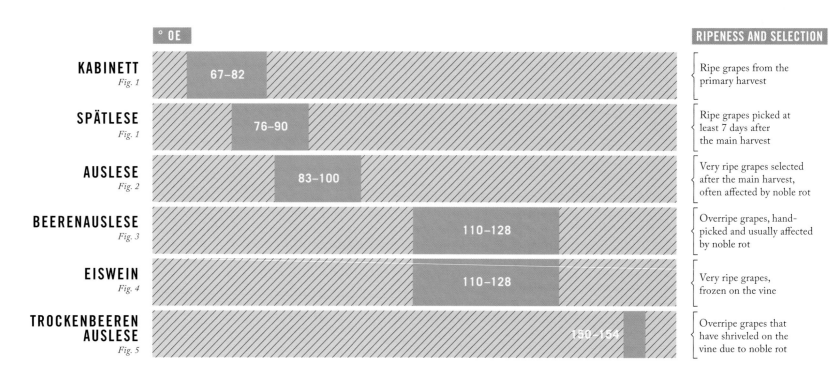

	° OE	RIPENESS AND SELECTION
KABINETT *Fig. 1*	67–82	Ripe grapes from the primary harvest
SPÄTLESE *Fig. 1*	76–90	Ripe grapes picked at least 7 days after the main harvest
AUSLESE *Fig. 2*	83–100	Very ripe grapes selected after the main harvest, often affected by noble rot
BEERENAUSLESE *Fig. 3*	110–128	Overripe grapes, hand-picked and usually affected by noble rot
EISWEIN *Fig. 4*	110–128	Very ripe grapes, frozen on the vine
TROCKENBEEREN AUSLESE *Fig. 5*	150–154	Overripe grapes that have shriveled on the vine due to noble rot

- Fig. 1 -

- Fig. 2 -

- Fig. 3 -

- Fig. 4 -

- Fig. 5 -

German Wine Regions

Germany produces less wine than France, Italy, and Spain, and the vast majority of its wine is produced near the French border. However, there are many world-class German wines, especially the Rieslings.

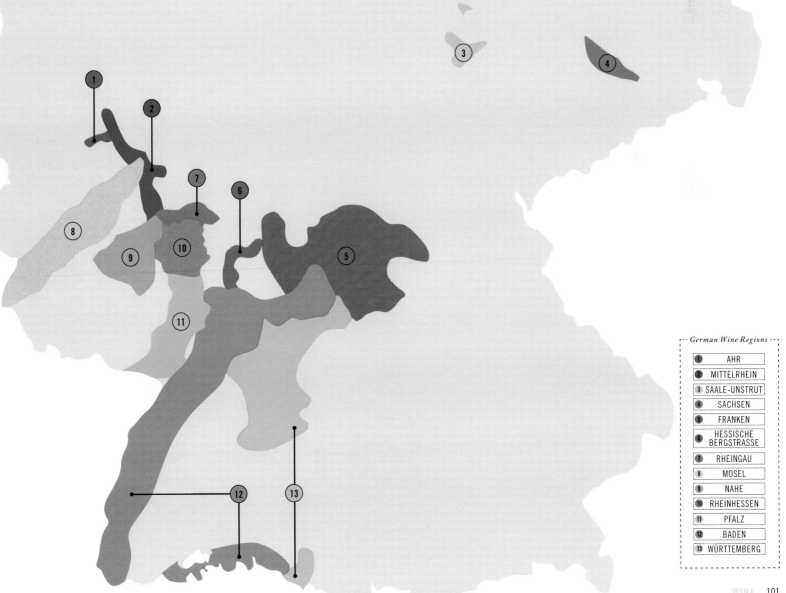

German Wine Regions

1	AHR
2	MITTELRHEIN
3	SAALE-UNSTRUT
4	SACHSEN
5	FRANKEN
6	HESSISCHE BERGSTRASSE
7	RHEINGAU
8	MOSEL
9	NAHE
10	RHEINHESSEN
11	PFALZ
12	BADEN
13	WÜRTTEMBERG

German Grape Genealogy

The family tree of German grapes is marked by both frequent crossing with grapes from neighboring Austria and Switzerland as well as intentional breeding, such as the prolific Muller Thurgau family of white grapes.

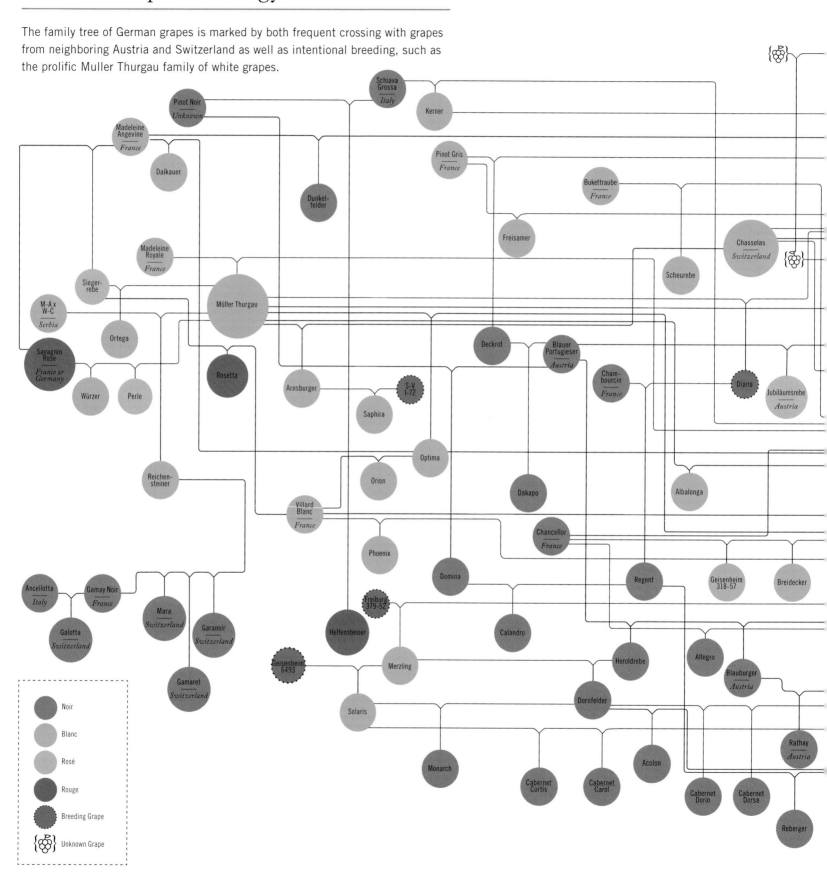

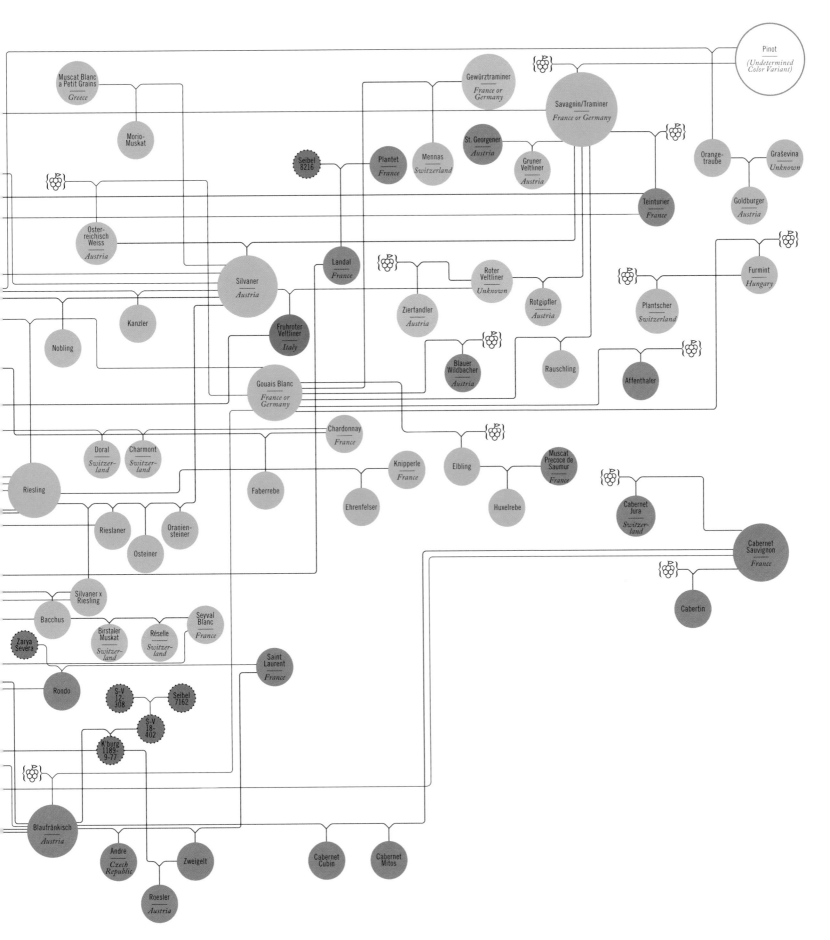

Pinot
(Undetermined Color Variant)

Muscat Blanc
a Petit Grains
Greece

Gewürztraminer
France or Germany

Savagnin/Traminer
France or Germany

Morio-Muskat

Seibel
8216

Plantet
France

Mennas
Switzerland

St. Georgener
Austria

Gruner
Veltliner
Austria

Orange-
traube

Graševina
Unknown

Teinturier
France

Goldburger
Austria

Osterreichisch
Weiss
Austria

Silvaner
Austria

Landal
France

Roter
Veltliner
Unknown

Furmint
Hungary

Kanzler

Zierfändler
Austria

Rotgipfler
Austria

Plantscher
Switzerland

Nobling

Fruhroter
Veltliner
Italy

Blauer
Wildbacher
Austria

Rauschling

Affenthaler

Gouais Blanc
France or Germany

Chardonnay
France

Doral
Switzerland

Charmont
Switzerland

Knipperle
France

Elbling

Muscat
Precoce de
Saumur
France

Faberrebe

Riesling

Ehrenfelser

Huxelrebe

Cabernet
Jura
Switzerland

Cabernet
Sauvignon
France

Rieslaner

Oranien-
steiner

Osteiner

Cabertin

Silvaner x
Riesling

Bacchus

Birstaler
Muskat
Switzerland

Réselle
Switzerland

Seyval
Blanc
France

Zarya
Severa

Saint
Laurent
France

Rondo

S-V
12-
308

Seibel
7162

S-V
18-
402

K'burg
1189-
9-77

Blaufränkisch
Austria

André
*Czech
Republic*

Zweigelt

Cabernet
Cubin

Cabernet
Mitos

Roesler
Austria

Italian Grape Origins & Wine Regions

There are more planted cultivars of grapes in Italy than any other country. As opposed to France, Italy, for most of its history, has existed in distinct kingdoms and territories, so grapes have had less time to move around the country and compete with each other.

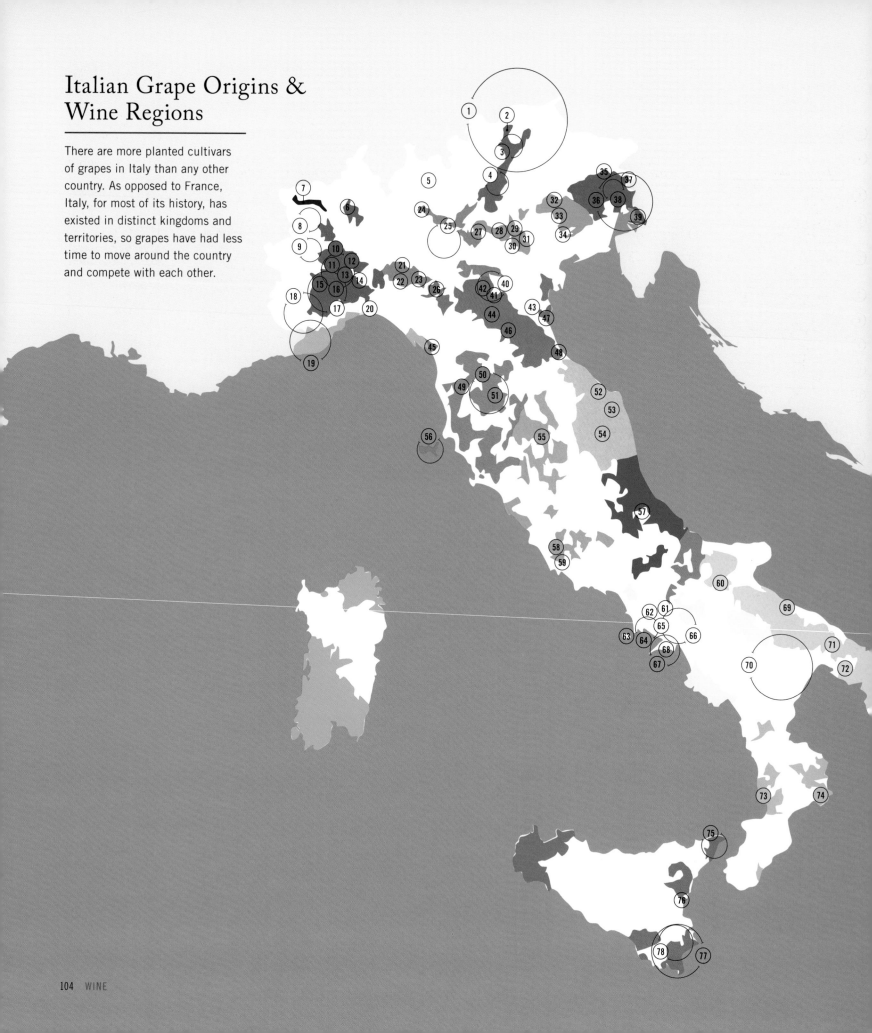

1. Lagrein / Schiava Gentile / Schiava Grigia / Schiava Grossa
2. Fraueler
3. Versoaln / Lagarino Bianco
4. Casetta
5. Brugnola / Pignola Valtellinese
6. Avanà / Baratuciat
7. Vien de Nus
8. Erbaluce
9. Bonarda Piemontese
10. Grignolino
11. Doux d'Henry / Grisa Nera / Lambrusca Vittona / Plassa
12. Barbera
13. Ruché
14. Lambrusca di Alessandria / Timorasso
15. Avarengo
16. Rossese Bianco di Monforte
17. Gamba di Pernice / Nascetta / Arneis
18. Bubbierasco / Pelaverga Piccolo / Quagliano
19. Lumassina / Scimiscià
20. Albarola
21. Croatina
22. Pelaverga
23. Moradella
24. Moscato di Scanzo
25. Corva / Erbamat / Invernenga
26. Besgano Bianco / Melara / Santa Maria

27. Molinara / Raboso Veronese / Rondinella
28. Forsellina / Bigolona
29. Gruaja / Durella / Vespaiola
30. Verdiso
31. Pavana
32. Raboso Piave / Prosecco/Giera / Prosecco Lungo
33. Recantina / Bianchetta Trevigiana / Grapariol
34. Dorona di Venezia
35. Cianorie
36. Picolit / Sciaglin / Verduzzo Friulano / Cividin / Forgiarin / Piculit Neri / Tazzelenghe
37. Pinella
38. Pignolo / Refosco di Faedis / Schioppettino
39. Piccola Nera
40. Alionza / Ruggine
41. Maligia / Pignoletto
42. Lambrusco Maestri
43. Uva Longanesi
44. Lambrusco Barghi / Termarina Rossa
45. Caloria / Vermentino Nero
46. Lambrusco Salamino
47. Centesimino / Trebbiano Romagnolo
48. Cargarello / Ciurlese
49. Vernaccia di San Gimignano
50. Foglia Tonda / Malvasia Bianca Lunga

51. Ciliegiolo
52. Lacrima di Morro d'Alba
53. Maceratino
54. Pecorino
55. Sagrantino
56. Biancone di Portoferraio
57. Montepulciano
58. Abbuoto
59. Moscato di Terracina
60. Nero di Troia
61. Barbera del Sannio
62. San Pietro / Sant'Antonio
63. Arilla / Biancolella / Forastera / San Lunardo / Sorbigno / Cannamela
64. Sabato / Piedirosso / Caprettone / Coda di Cavallo
65. Casavecchia
66. Tintore di Tramonti / Falanghina Beneventana
67. Tronto
68. Fenile
69. Impigno
70. Malvasia Bianca di Basilicata
71. Marchione / Minutolo
72. Francavidda
73. Addoraca
74. Guardavalle
75. Nocera
76. Catanese Nero / Nerello Cappuccio / Nerello Mascalese / Acitana / Carricante
77. Albanello
78. Nero d'Avola

ABRUZZO
Maiolica / Trebbiano d'Abruzzo

FRIULI VENEZIA GIULIA
Cordenossa / Refosco dal Peduncolo Rosso / Ribolla Gialla

CALABRIA
Calabrese di Montenuovo / Greco Nero / Magliocco Canino / Magliocco Dolce / Prunesta / Sangiovese / Greco Bianco / Mantonico Bianco

LIGURIA
Bracciola Nera / Bosco / Carica l'Asino / Rollo / Ruzzese

PIEDMONT
Brachetto del Piemonte / Crovassa / Dolcetto / Freisa / Lambruschetto / Malvasia di Casorzo / Malvasia di Schierano / Nebbiolo / Nebbiolo Rosé / Ner D'Ala / Neretta Cuneese / Neretto di Bairo / Rastajola / Uvalino / Barbera Bianca / Cascarolo Bianco / Cortese / Luglienga / Malvasia Bianca di Piemonte / Rossese Bianco

SICILY
Frappato / Perricone / Tignolino / Catarratto Bianco / Grillo / Inzolia / Minella Bianca

VENETO
Cavrara / Dindarella / Marzemino / Garganega / Marzemina Bianca / Perera / Verdicchio Bianca

LAZIO
Bellone / Cesanese

SARDINIA
Albanranzeuli Nero / Barbera Sarda / Caddiu / Nieddera / Pascale / Albanranzeuli Bianco / Arvesiniadu / Bariadorgia / Brustiano Bianco / Nasco / Nuragus / Retagliado Bianco / Semidano / Torbato / Vernaccia di Oristano

CAMPANIA
Aglianico / Aglianicone / Castagnara / Castiglione / Pallagrello Nero / Sciascinoso / Cacamosca / Coda di Pecora / Coda di Volpe Bianca / Falanghina Flegrea / Fiano / Ginestra / Greco / Pallagrello Bianco / Pepella / Rovello Bianco

PUGLIA
Malvasia Nera di Basilicata / Malvasia Nera di Brindisi / Negroamaro / Bombino Bianco / Bianco d'Alessano / Bombino Nero / Maruggio / Moscatello Selvatico

EMILIA-ROMAGNA
Ancellotta / Colombana Nera / Fogarina / Fortana / Lambrusco di Fiorano / Lambrusco di Sorbara / Lambrusco Grasparossa / Lambrusco Marani / Negretto / Uva Tosca / Ortrugo / Spergola / Trebbiano Modenese

TRENTINO-ALTO ADIGE
Nosiola / Negrara Trentina / Enantio / Teroldego / Moscato Rosa del Trentino / Rossara Trentina

UMBRIA
Grechetto di Orvieto / Trebbiano Spoletino / Verdello

AOSTA VALLEY
Prié / Bonda / Cornalin / Mayolet / Petit Rouge / Rouge de Fully / Roussin / Vuillermin / Fumin / Primetta

TUSCANY
Abrusco / Aleatico / Barsaglina / Canaiolo Nero / Colorino del Valdarno / Mammolo / Mazzese / Morone / Trebbiano Toscano / Verdea

MARCHE
Gallioppo Delle Marche

LOMBARDY
Groppello di Mocasina / Maiolina / Schiava Lombarda

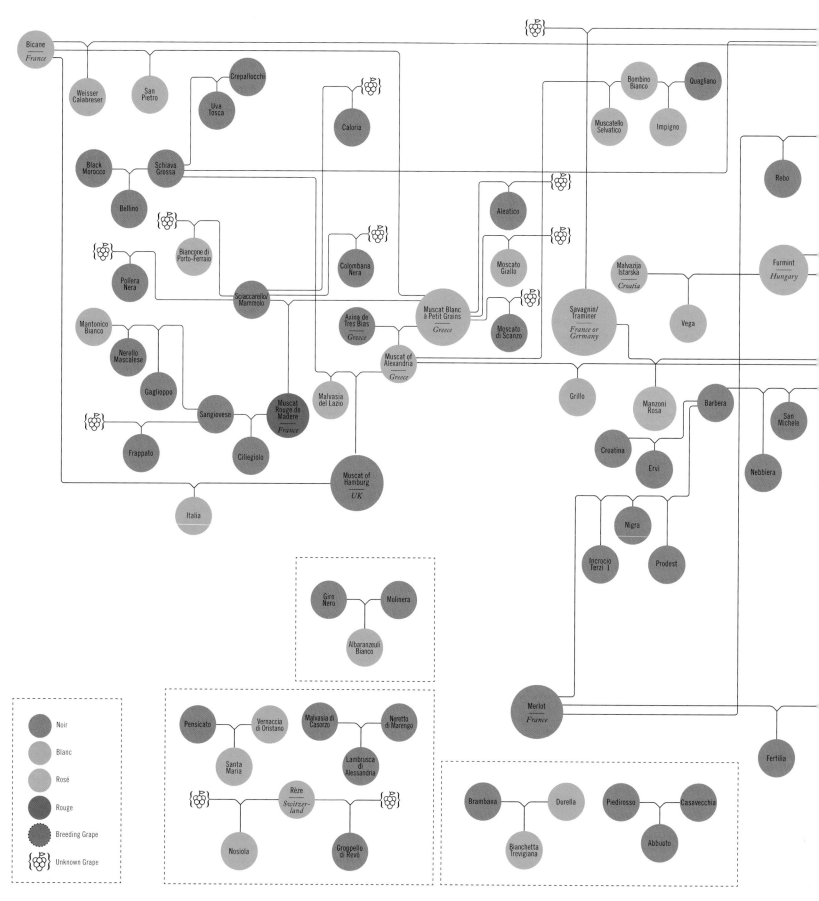

Noir

Blanc

Rosé

Rouge

Breeding Grape

Unknown Grape

Italian Grape Genealogy

Most Italian grapes are very old, and tracing their parentage is difficult due to the fact that their ancestors may no longer be cultivated. The parentage of Sangiovese wasn't uncovered until 2004, and conflicting follow-up studies have muddied its origin.

Pinot
(Undetermined Color Variant)

Teroldego

Schiava Gentile

Negrera

Lagrein

Neretto di Bairo

Brugnola

Vespolina

Rossola Nera

Rossolino Nero

Freisa

Nebbiolo

Bianchetta di Saluzzo

Graševina
Unknown

Verdiso

Bussanello

Flavis

Italica

Fubiano

Catarratto Bianco

Uva Sogra

Susumaniello

Malvasia Bianca di Candia

Albana

Mostosa

Bubbierasco

Chatus
France

Dolcetto

Albarossa

Valentino Nero

Soperga

Passau

San Martino

Garganega

Montonico Bianco

Ragusano

Marchione

Cornarea

Trebbiano Toscano

Marzemino

Bermestia Bianca

Refosco dal Peduncolo Rosso

Dorona di Venezia

Luglienga

Corvina Veronese

Rondinella

Prié

Primetta

Riesling
Germany

Verdicchio Bianco

Pinot Bianco

Manzoni Bianco

Incrocio Bruni 154

Marzemina Bianca

Raboso Piave

Fogarina

Fumin

Vuillermin

Raboso Veronese

Malvasia Bianca Lunga

Negroamaro

Petit Rouge

Mayolet

Forcelese d'Ascoli

Dindarella

Montonico Pinto

Scacco

Carricante

Incrocio Bianco Fedit 51

Malvasia Nera di Brindisi

Vien de Nus

Rouge du Pays
Switzerland

Roussin

Cornalin d'Aoste

Grapes in Italian Wines

In Italy, wine regions can be certified according to three standards, all differing in levels of strictness and regulation: *Denominazione di Origine Controllata e Garantita* (DOCG) regions follow the most stringent rules, and all of these wines are appraised by a committee that guarantees the quality and geographic authenticity of the wines. *Denominazione di Origine Controllata* (DOC) and *Indicazione Geografica Tipica* (IGT) regions employ standards that accommodate growers who can't meet the rigorous requirements for DOCG designation. Here, we look at the grapes and wine varieties that comprise DOCGs, where more than twenty grape varietals combine to produce a number of rossos, biancos, and sparkling wines (including spumante).

ITALIAN DOCGs BY WINE TYPE

RED

Dogliani
Amarone della Valpolicella
Bardolino Superiore
Recioto della Valpolicella
Cesanese del Piglio
Suvereto
Val di Cornia Rosso
Montello Rosso
Brachetto d'Acqui
Barbera del Monferrato Superiore
Barbera d'Asti
Aglianico del Taburno
Aglianico del Vulture Superiore
Taurasi
Sforzato di Valtellina
Valtellina Superiore
Scanzo
Cònero
Montepulciano d'Abruzzo Colline Teramane
Oltrepò Pavese Metodo Classico
Barbaresco
Barolo
Primitivo di Manduria Dolce Naturale
Gattinara
Ghemme
Alta Langa
Franciacorta
Roero
Offida

WHITE

Asolo Prosecco
Asti
Cannellino di Frascati
Colli Bolognesi Pignoletto
Colli Euganei Fior d'Arancio
Colli Orientali del Friuli Picolit
Conegliano Valdobbiadene Prosecco
Erbaluce di Caluso
Fiano di Avellino
Frascati Superiore
Gavi
Greco di Tufo
Lison
Ramandolo
Recioto di Gambellara
Recioto di Soave
Romagna Albana
Rosazzo
Soave Superiore
Vermentino di Gallura
Vernaccia di San Gimignano

PRINCIPAL RED GRAPE DISTRIBUTION IN ITALIAN RED WINES

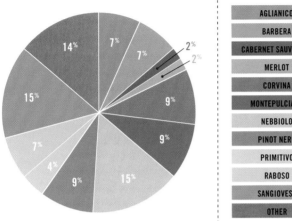
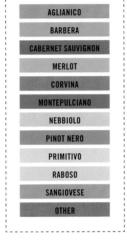

14% 7% 7% 2% 2% 9% 15% 9% 7% 4% 9% 15%

AGLIANICO
BARBERA
CABERNET SAUVIGNON
MERLOT
CORVINA
MONTEPULCIANO
NEBBIOLO
PINOT NERO
PRIMITIVO
RABOSO
SANGIOVESE
OTHER

PRINCIPAL WHITE GRAPE DISTRIBUTION IN ITALIAN WHITE WINES

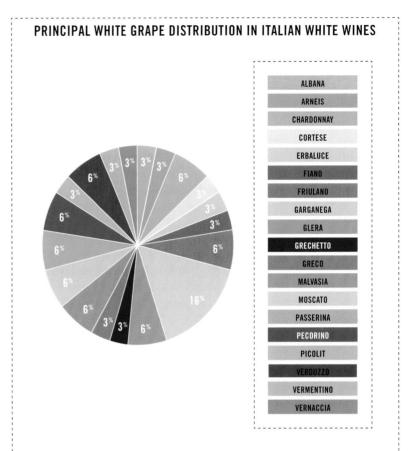

3% 3% 3% 3% 6% 6% 3% 6% 3% 3% 6% 6% 6% 6% 3% 3% 6% 16%

ALBANA
ARNEIS
CHARDONNAY
CORTESE
ERBALUCE
FIANO
FRIULANO
GARGANEGA
GLERA
GRECHETTO
GRECO
MALVASIA
MOSCATO
PASSERINA
PECORINO
PICOLIT
VERDUZZO
VERMENTINO
VERNACCIA

ITALIAN RED WINES

ROSSO
SUPERIORE
CABERNET SAUVIGNON
MERLOT
SANGIOVESE
VINO NOVILLE
BRUNELLO

ITALIAN WHITE WINES

BIANCO
SUPERIORE
PECORINO
PASSERINA
FRIZZANTE
MOSCATO D'ASTI
ARNEIS

Spanish Wine Regions

Despite Spain's Mediterranean location, most of its vineyards are located not near the sea but in mountainous regions. Rioja, Spain's answer to Bordeaux, exports famed Tempranillo wines around the world.

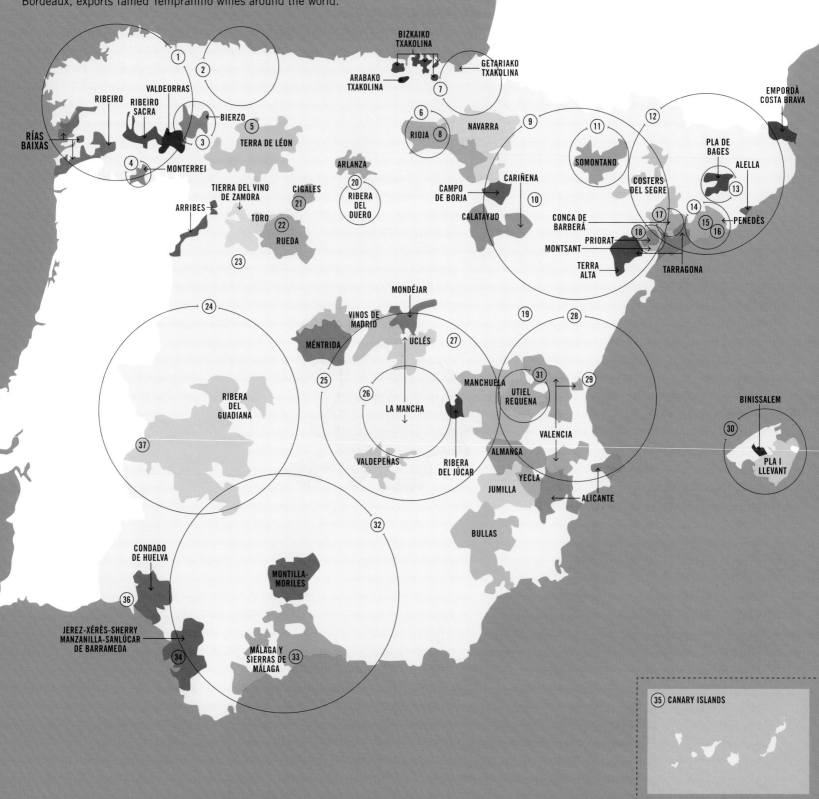

BIZKAIKO TXAKOLINA

ARABAKO TXAKOLINA

GETARIAKO TXAKOLINA

EMPORDÀ COSTA BRAVA

VALDEORRAS

RIBEIRO

RIBEIRO SACRA

BIERZO

RÍAS BAIXAS

TERRA DE LÉON

RIOJA

NAVARRA

SOMONTANO

PLA DE BAGES

ALELLA

MONTERREI

CAMPO DE BORJA

CARIÑENA

COSTERS DEL SEGRE

ARLANZA

CIGALES

RIBERA DEL DUERO

CALATAYUD

CONCA DE BARBERÁ

PENEDÈS

TIERRA DEL VINO DE ZAMORA

ARRIBES

TORO

RUEDA

PRIORAT

MONTSANT

TERRA ALTA

TARRAGONA

MONDÉJAR

VINOS DE MADRID

UCLÉS

MÉNTRIDA

MANCHUELA

UTIEL REQUENA

BINISSALEM

RIBERA DEL GUADIANA

LA MANCHA

VALENCIA

PLA I LLEVANT

VALDEPEÑAS

RIBERA DEL JÚCAR

ALMANSA

YECLA

JUMILLA

ALICANTE

BULLAS

CONDADO DE HUELVA

MONTILLA-MORILES

JEREZ-XÉRÈS-SHERRY MANZANILLA-SANLÚCAR DE BARRAMEDA

MÁLAGA Y SIERRAS DE MÁLAGA

CANARY ISLANDS

Spanish Grape Origins

Though a comparatively small number of grape varieties originate from Spain, this diminishes neither their quality nor their utility.

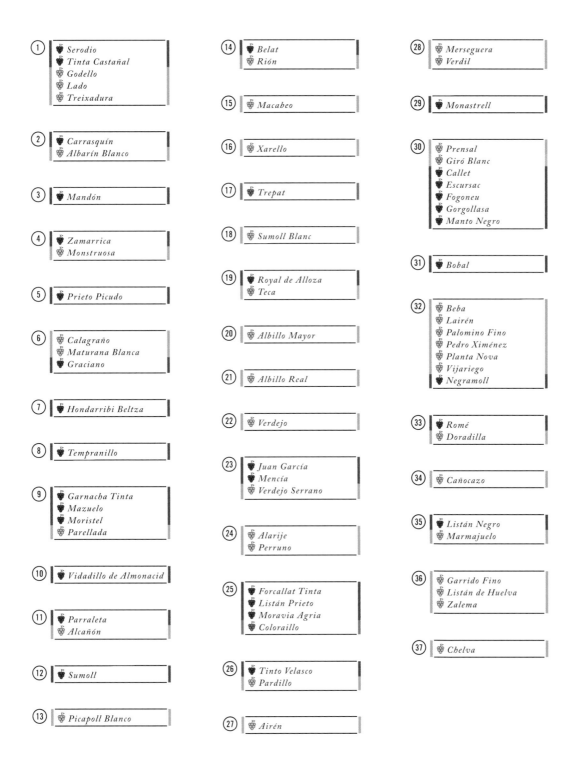

1. Serodio
 Tinta Castañal
 Godello
 Lado
 Treixadura

2. Carrasquín
 Albarín Blanco

3. Mandón

4. Zamarrica
 Monstruosa

5. Prieto Picudo

6. Calagraño
 Maturana Blanca
 Graciano

7. Hondarribi Beltza

8. Tempranillo

9. Garnacha Tinta
 Mazuelo
 Moristel
 Parellada

10. Vidadillo de Almonacid

11. Parraleta
 Alcañón

12. Sumoll

13. Picapoll Blanco

14. Belat
 Rión

15. Macabeo

16. Xarello

17. Trepat

18. Sumoll Blanc

19. Royal de Alloza
 Teca

20. Albillo Mayor

21. Albillo Real

22. Verdejo

23. Juan García
 Mencía
 Verdejo Serrano

24. Alarije
 Perruno

25. Forcallat Tinta
 Listán Prieto
 Moravia Agria
 Coloraillo

26. Tinto Velasco
 Pardillo

27. Airén

28. Merseguera
 Verdil

29. Monastrell

30. Prensal
 Giró Blanc
 Callet
 Escursac
 Fogoneu
 Gorgollasa
 Manto Negro

31. Bobal

32. Beba
 Lairén
 Palomino Fino
 Pedro Ximénez
 Planta Nova
 Vijariego
 Negramoll

33. Romé
 Doradilla

34. Cañocazo

35. Listán Negro
 Marmajuelo

36. Garrido Fino
 Listán de Huelva
 Zalema

37. Chelva

Fortified Wine-Making

On a basic level, fortified wine is simply wine mixed with a spirit. Most often, the distilled alcohol used in this fortification process is brandy (i.e., distilled wine) or some other type of grape spirit.

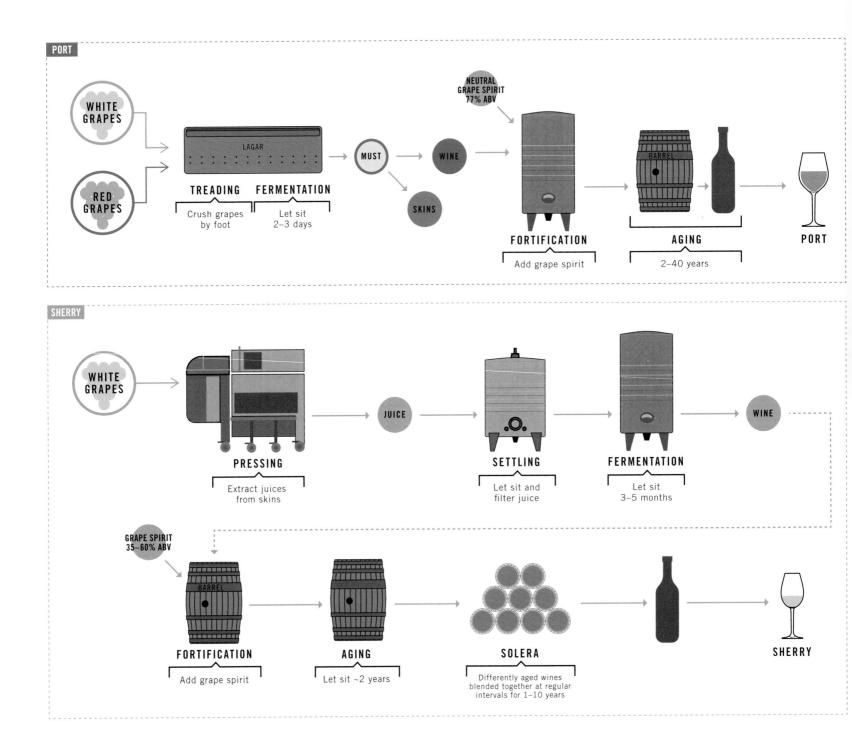

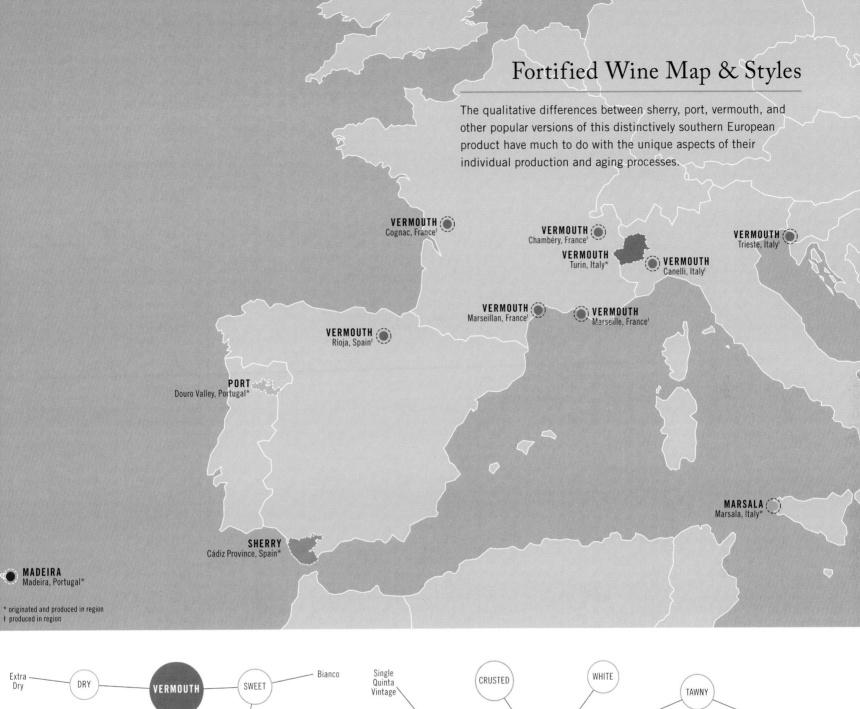

Fortified Wine Map & Styles

The qualitative differences between sherry, port, vermouth, and other popular versions of this distinctively southern European product have much to do with the unique aspects of their individual production and aging processes.

VERMOUTH
Cognac, France†

VERMOUTH
Chambéry, France†

VERMOUTH
Turin, Italy*

VERMOUTH
Canelli, Italy†

VERMOUTH
Trieste, Italy†

VERMOUTH
Marseillan, France†

VERMOUTH
Marseille, France†

VERMOUTH
Rioja, Spain†

PORT
Douro Valley, Portugal*

MARSALA
Marsala, Italy*

SHERRY
Cádiz Province, Spain*

MADEIRA
Madeira, Portugal*

* originated and produced in region
† produced in region

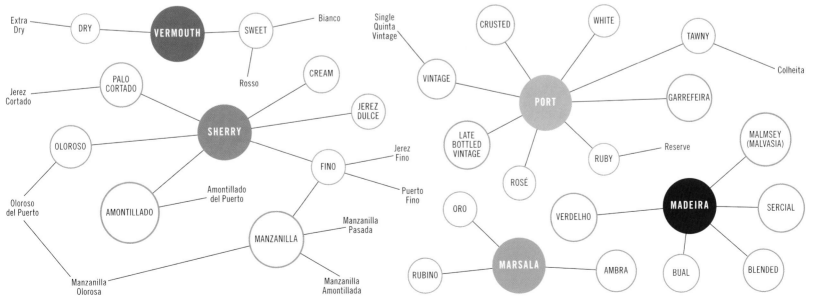

Grape Emigration from Old World to New

Although there are grape species native to areas beyond Europe, particularly to America, the vast majority of grapes planted outside Europe were brought there from Europe. This chart outlines the most popular grapes in South Africa, Australia, Chile, Argentina, and California and traces them back to their country of origin.

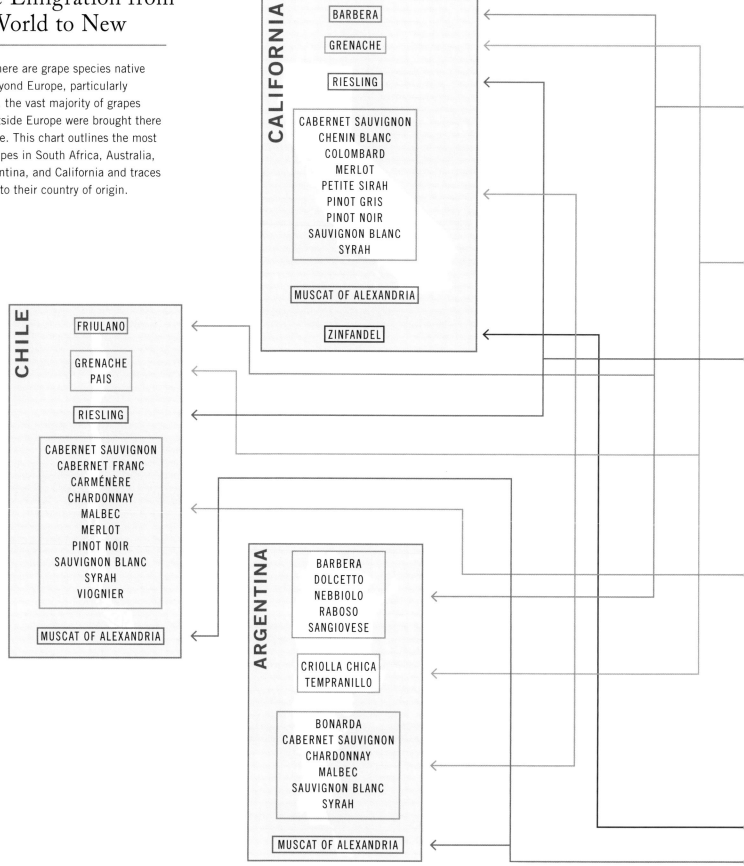

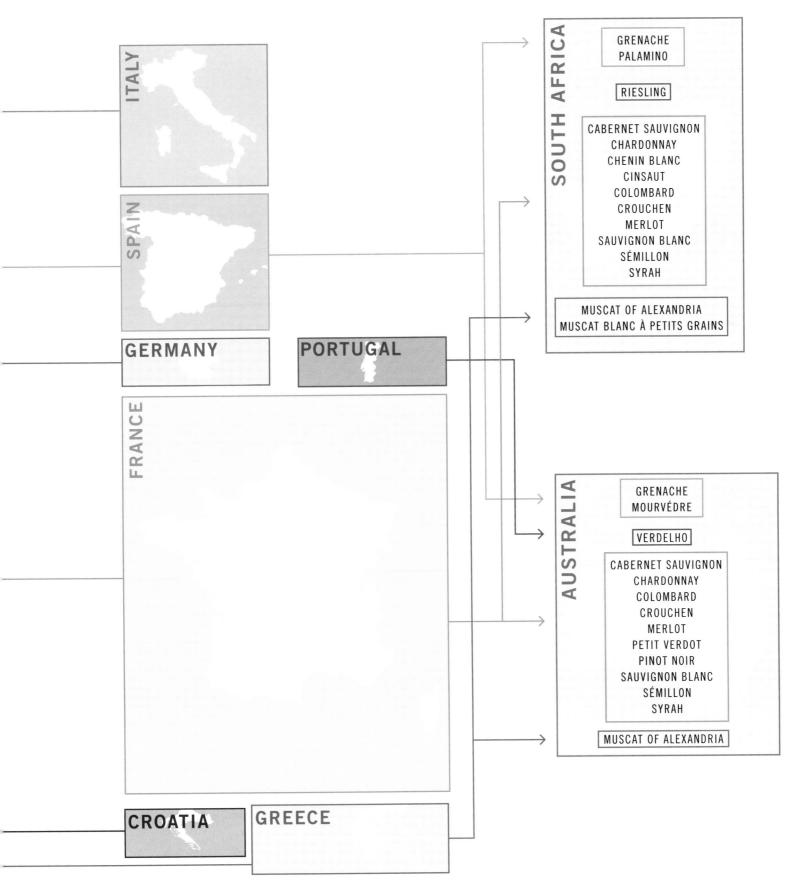

ITALY

SPAIN

GERMANY

PORTUGAL

FRANCE

CROATIA

GREECE

SOUTH AFRICA

GRENACHE
PALAMINO

RIESLING

CABERNET SAUVIGNON
CHARDONNAY
CHENIN BLANC
CINSAUT
COLOMBARD
CROUCHEN
MERLOT
SAUVIGNON BLANC
SÉMILLON
SYRAH

MUSCAT OF ALEXANDRIA
MUSCAT BLANC À PETITS GRAINS

AUSTRALIA

GRENACHE
MOURVÉDRE

VERDELHO

CABERNET SAUVIGNON
CHARDONNAY
COLOMBARD
CROUCHEN
MERLOT
PETIT VERDOT
PINOT NOIR
SAUVIGNON BLANC
SÉMILLON
SYRAH

MUSCAT OF ALEXANDRIA

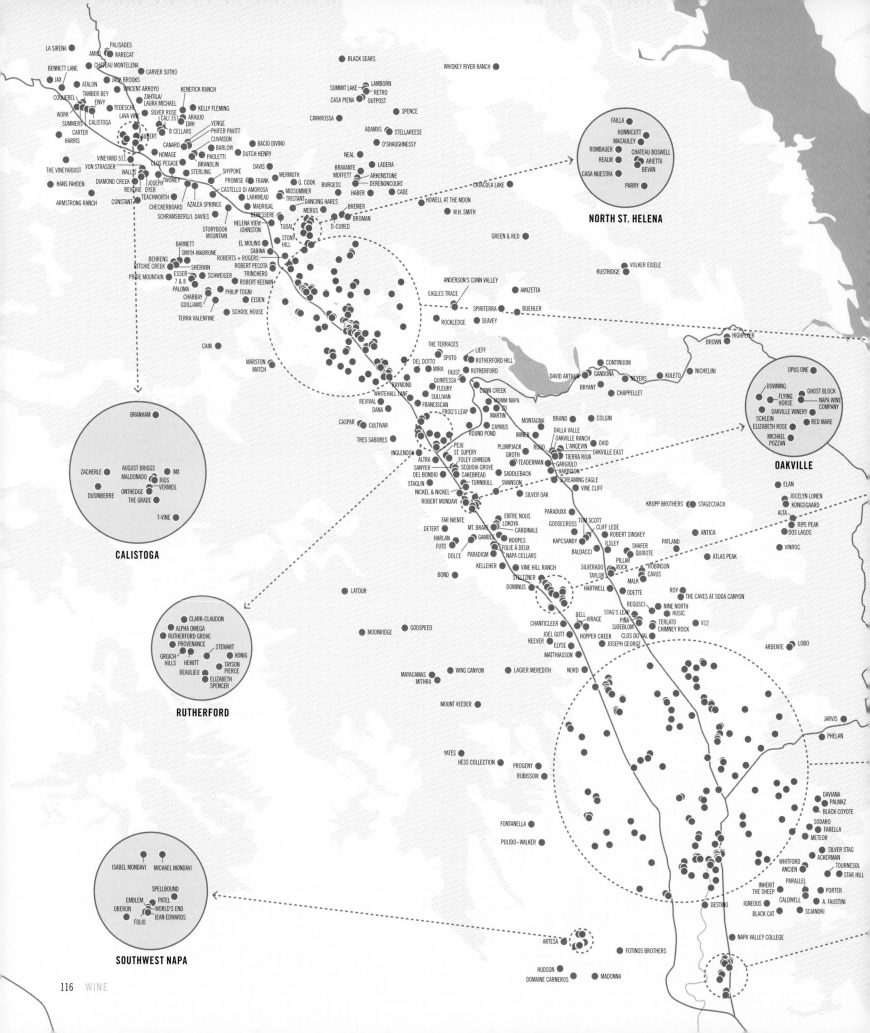

LA SIRENA
AMICI
PALISADES
RARECAT
BENNETT LANE
CHATEAU MONTELENA
JAX
CARVER SUTRO
ATALON
JACK BROOKS
COQUEREL
TAMBER BEY
VINCENT ARROYO
KENEFICK RANCH
WORK
ENVY
ZAHTILA/
LAURA MICHAEL
SUMMERS
TEDESCHI
KELLY FLEMING
CALISTOGA
SILVER ROSE
ARAUJO
CARTER
LAVA VINE
I CALI 351
VENGE
HARRIS
EMH
PHIFER PAVITT
BLACK SEARS
WHISKEY RIVER RANCH
B CELLARS
CUVAISON
SUMMIT LAKE
LAMBORN
AUBERT
CANARD
BACIO DIVINO
RETRO
CASA PIENA
OUTPOST
THE VINEYARDIST
HOMAGE
BARLOW
DUTCH HENRY
SPENCE
VON STRASSER
WALLIS
CLOS PEGASE
BRANDLIN
DAVIS
CIMAROSSA
ADAMVS
STELLAREESE
VINEYARD 511
PAOLETTI
O'SHAUGHNESSY
DIAMOND CREEK
JOSEPH
TWOMEY
SHYPOKE
WERMUTH
HANS FAHDEN
REVERIE
DYER
PROMISE
FRANK
NEAL
LADERA
TEACHWORTH
CASTELLO DI AMOROSA
G. COOK
BRAVANTE
ARKENSTONE
ARMSTRONG RANCH
CONSTANT
LARKMEAD
MIDSUMMER
MOFFETT
DERENONCOURT
CHECKERBOARD
AZALEA SPRINGS
MADRIGAL
TRISTANT
BURGESS
HABER
CADE
SCHRAMSBERG/J. DAVIES
BENESSERE
DANCING HARES
HOWELL AT THE MOON
HELENA VIEW
MERUS
BREMER
JOHNSTON
TUDAL
D-CUBED
BROMAN
W.H. SMITH
STORYBOOK
STONY
MOUNTAIN
EL MOLINO
HILL
BARNETT
SABINA
GREEN & RED
SMITH-MADRONE
BEHRENS
ROBERTS + ROGERS
RITCHIE CREEK
SHERWIN
ROBERT PECOTA
VOLKER EISELE
PRIDE MOUNTAIN
ESSER
SCHWEIGER
TRINCHERO
RUSTRIDGE
7 & 8
ROBERT KEENAN
PALOMA
ANDERSON'S CONN VALLEY
CHARBAY
PHILIP TOGNI
AMIZETTA
GUILLIAMS
EEDEN
EAGLES TRACE
TERRA VALENTINE
SCHOOL HOUSE
SPIRITERRA
BUEHLER
ROCKLEDGE
SEAVEY
CAIN
THE TERRACES
BROWN
HIGHFLYER
LIEFF
MARSTON
SPOTO
DEL DOTTO
RUTHERFORD HILL
CONTINUUM
MATCH
MIRA
FAUST
RUTHERFORD
DAVID ARTHUR
GANDONA
NEYERS
KULETO
NICHELINI
QUINTESSA
FLEURY
BRYANT
CHAPPELLET
RAYMOND
SULLIVAN
CONN CREEK
WHITEHALL LANE
FRANCISCAN
MUMM NAPA
REVIVAL
ZD
CASPAR
DANA
FROG'S LEAP
MARTIN
BRAND
COLGIN
CULTIVAR
CAYMUS
MINER
DALLA VALLE
BRANHAM
ROUND POND
MONTAGNA
OAKVILLE RANCH
OVID
TRES SABORES
PEJU
RUDD
L'ANGEVIN
OAKVILLE EAST
ZACHERLE
MX
ST. SUPÉRY
PLUMPJACK
GROTH
TIERRA ROJA
INGLENOOK
ALTRA
FOLEY JOHNSON
TEADERMAN
GARGIULO
AUGUST BRIGGS
RIOS
SAWYER
SEQUOIA GROVE
HARBISON
MALDONADO
VERMEIL
DEL BONDIO
CAKEBREAD
SADDLEBACK
ONTHEDGE
STAGLIN
TURNBULL
SWANSON
SCREAMING EAGLE
DUSINBERRE
THE GRADE
NICKEL & NICKEL
VINE CLIFF
ROBERT MONDAVI
SILVER OAK
KRUPP BROTHERS
STAGECOACH
T-VINE
FAR NIENTE
ENTRE NOUS
PARADUXX
LOKOYA
DETERT
MT. BRAVE
CARDINALE
GOOSECROSS
TOM SCOTT
HARLAN
GAMBLE
HOOPES
CLIFF LEDE
ROBERT SINSKEY
ANTICA
FUTO
FOLIE À DEUX
KAPCSANDY
ILSLEY
PATLAND
DOLCE
PARADIGM
NAPA CELLARS
SHAFER
QUIXOTE
KELLEHER
BALDACCI
PILLAR
LATOUR
BOND
VINE HILL RANCH
ROCK
SILVERADO
ROBINSON
STELTZNER
TAYLOR
CAVUS
MALK
DOMINUS
HARTWELL
ROY
THE CAVES AT SODA CANYON
MOONRIDGE
GODSPEED
ODETTE
REGUSCI
NINE NORTH
CHANTICLEER
BELL
STAG'S LEAP
HUSIC
V12
CLARK-CLAUDON
PIÑA
TERLATO
ALPHA OMEGA
JOEL GOTT
VIRAGE
SJOEBLOM
CHIMNEY ROCK
RUTHERFORD GROVE
KEEVER
HOPPER CREEK
CLOS DU VAL
ARDENTE
LOBO
PROVENANCE
STEWART
ELYSE
JOSEPH GEORGE
GRGICH
HONIG
MATTHIASSON
HILLS
HEWITT
TAYSON
BEAULIEU
PIERCE
ELIZABETH
MAYACAMAS
WING CANYON
SPENCER
MITHRA
LAGIER MEREDITH
NORD
MOUNT VEEDER
DAVIANA
PALMAZ
JARVIS
BLACK COYOTE
YATES
PHELAN
SODARO
HESS COLLECTION
FARELLA
PROGENY
METEOR
RUBISSOW
SILVER STAG
ACKERMAN
WHITFORD
TOURNESOL
ANCIEN
STAR HILL
FONTANELLA
PARALLEL
PORTER
PULIDO-WALKER
INHERIT
THE SHEEP
CALDWELL
A. FAUSTINI
ISABEL MONDAVI
IGNEOUS
SCIANDRI
MICHAEL MONDAVI
DESTINO
BLACK CAT
SPELLBOUND
EMBLEM
PATEL
OBERON
WORLD'S END
FOLIO
JEAN EDWARDS
ARTESA
FOTINOS BROTHERS
NAPA VALLEY COLLEGE
HUDSON
DOMAINE CARNEROS
MADONNA

NORTH ST. HELENA

FAILLA
HUNNICUTT
MACAULEY
ROMBAUER
CHATEAU BOSWELL
REALM
ARIETTA
BEVAN
CASA NUESTRA
PARRY

OAKVILLE

OPUS ONE
DOWNING
GHOST BLOCK
FLYING
HORSE
NAPA WINE
OAKVILLE WINERY
COMPANY
SCHLEIN
ELIZABETH ROSE
RED MARE
MICHAEL
POZZAN
ELAN
JOCELYN LONEN
KONGSGAARD
ALTA
RIPE PEAK
DOS LAGOS
VINROC
ATLAS PEAK

CALISTOGA

RUTHERFORD

SOUTHWEST NAPA

Wineries of Napa Valley

Though vinification has taken place in the Napa Valley of northern California since the nineteenth century, the area's winemakers didn't actually begin to produce the premium product associated with the region until the mid-1960s. The vineyards and wineries here, which benefit from Napa's unique climate and topography, grow grapes and produce wines that rival those of the Old World.

THE JUDGMENT OF PARIS

In 1976, British wine merchant Steven Spurrier arranged a blind tasting in Paris of chardonnays and red wines, pitting California wines against top French wines. There were eleven judges (nine French, one American, and one British), and when the scores of the French judges were tallied, they were shocked to discover that not only had California wines held their own, but they'd actually taken the top two spots:

RED		
RANK	WINE (VINTAGE)	ORIGIN
1	Stag's Leap Wine Cellars (1973)	USA
2	Château Mouton-Rothschild (1970)	France
3	Château Montrose (1970)	France
4	Château Haut-Brion (1970)	France
5	Ridge Vineyards (1971)	USA
6	Château Leoville Las Cases (1971)	France
7	Heitz Wine Cellars (1970)	USA
8	Clos Du Val Winery (1972)	USA
9	Mayacamas Vineyards (1971)	USA
10	Freemark Abbey Winery (1969)	USA

WHITE		
RANK	WINE (VINTAGE)	ORIGIN
1	Chaeteau Montelena (1973)	USA
2	Meursault Charmes Roulot (1973)	France
3	Chalone Vineyard (1974)	USA
4	Spring Mountain Vineyard (1973)	USA
5	Beaune Clos des Mouches Joseph Drouhin (1973)	France
6	Freemark Abbey Winery (1972)	USA
7	Batard-Montrachet Ramonet-Prudhon (1973)	France
8	Puligny-Montrachet Les Pucelles Domaine Leflaive (1972)	France
9	Veedercrest Vineyards (1972)	USA
10	David Bruce Winery (1973)	USA

These results, although discounted by the French, put California wines on the map and proved that New World wines could stand up to prestigious European vintages.

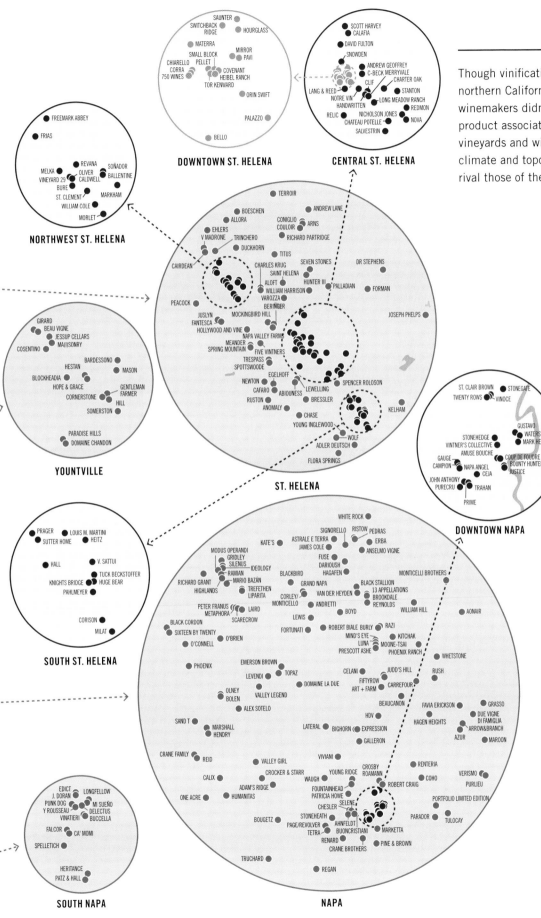

Wine Regions of Chile & Argentina

South America's production of wine is concentrated mainly in two countries—Argentina and Chile. The latter features extremely diverse growing conditions across its different wine regions, while the former is known chiefly for the exceptionally high altitude at which its grapes are grown.

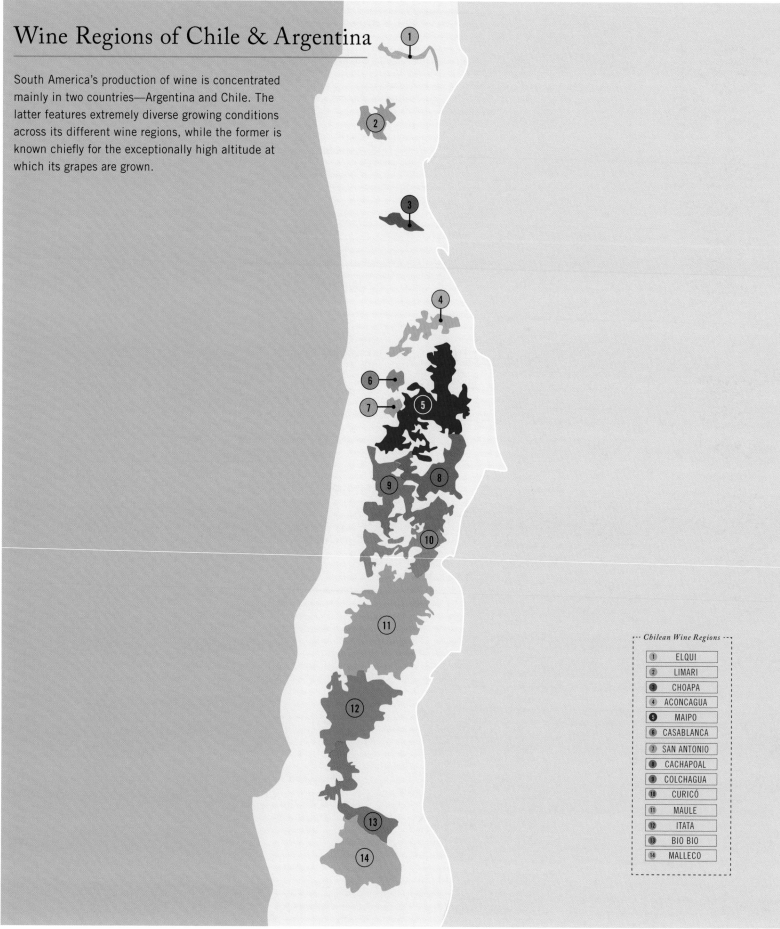

---- Chilean Wine Regions ----

1	ELQUI
2	LIMARI
3	CHOAPA
4	ACONCAGUA
5	MAIPO
6	CASABLANCA
7	SAN ANTONIO
8	CACHAPOAL
9	COLCHAGUA
10	CURICÓ
11	MAULE
12	ITATA
13	BIO BIO
14	MALLECO

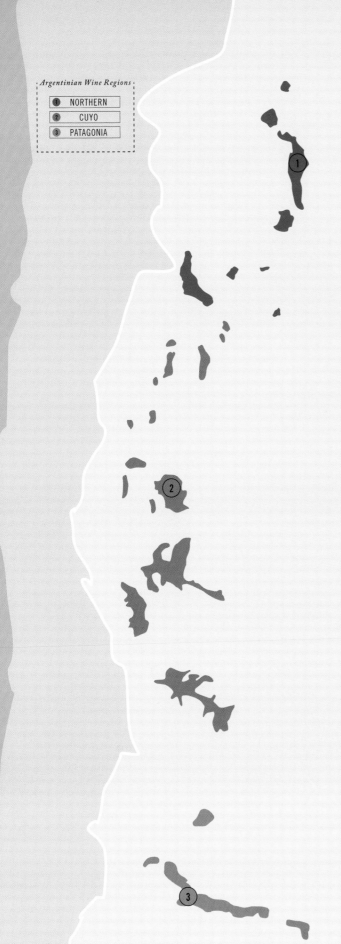

Argentinian Wine Regions

❶	NORTHERN
❷	CUYO
❸	PATAGONIA

THE CRIOLLAS

The Criolla family of grapes originated in Argentina, albeit from European parents that were planted there. The grape long known as Criolla Chica in Argentina was proven via genetic testing in the 1990s to actually be the Spanish grape Listan Prieto. The rest of the Criolla family descends from this grape crossing with the Greek grape Muscat of Alexandria.

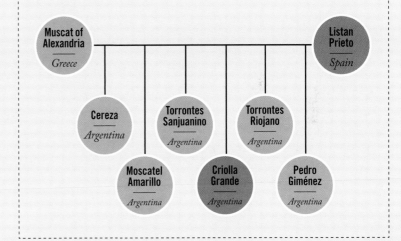

Muscat of Alexandria — *Greece*

Listan Prieto — *Spain*

Cereza — *Argentina*

Torrontes Sanjuanino — *Argentina*

Torrontes Riojano — *Argentina*

Moscatel Amarillo — *Argentina*

Criolla Grande — *Argentina*

Pedro Giménez — *Argentina*

Evolution of Wine Storage

The shape of wine bottles has greatly changed over time, mostly alongside innovations in manufacturing. The classic Burgundy and Bordeaux bottle shapes have been fixed for the past 150 years, albeit the wine industry is still innovating, as seen with boxed wine.

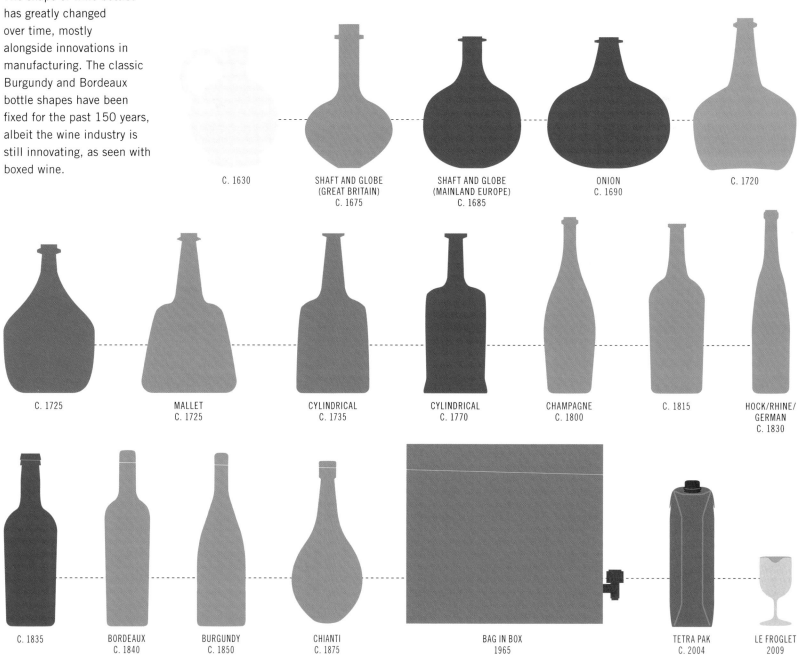

C. 1630

SHAFT AND GLOBE
(GREAT BRITAIN)
C. 1675

SHAFT AND GLOBE
(MAINLAND EUROPE)
C. 1685

ONION
C. 1690

C. 1720

C. 1725

MALLET
C. 1725

CYLINDRICAL
C. 1735

CYLINDRICAL
C. 1770

CHAMPAGNE
C. 1800

C. 1815

HOCK/RHINE/
GERMAN
C. 1830

C. 1835

BORDEAUX
C. 1840

BURGUNDY
C. 1850

CHIANTI
C. 1875

BAG IN BOX
1965

TETRA PAK
C. 2004

LE FROGLET
2009

CLOSURES

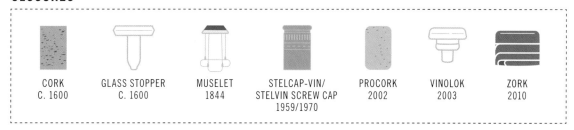

CORK
C. 1600

GLASS STOPPER
C. 1600

MUSELET
1844

STELCAP-VIN/
STELVIN SCREW CAP
1959/1970

PROCORK
2002

VINOLOK
2003

ZORK
2010

Wine Bottle Sizes

Beyond the standard 750-ml size, each of the three main bottle shapes exists in larger and smaller variants. The largest sizes are named for biblical figures and are manufactured exclusively for promotional purposes.

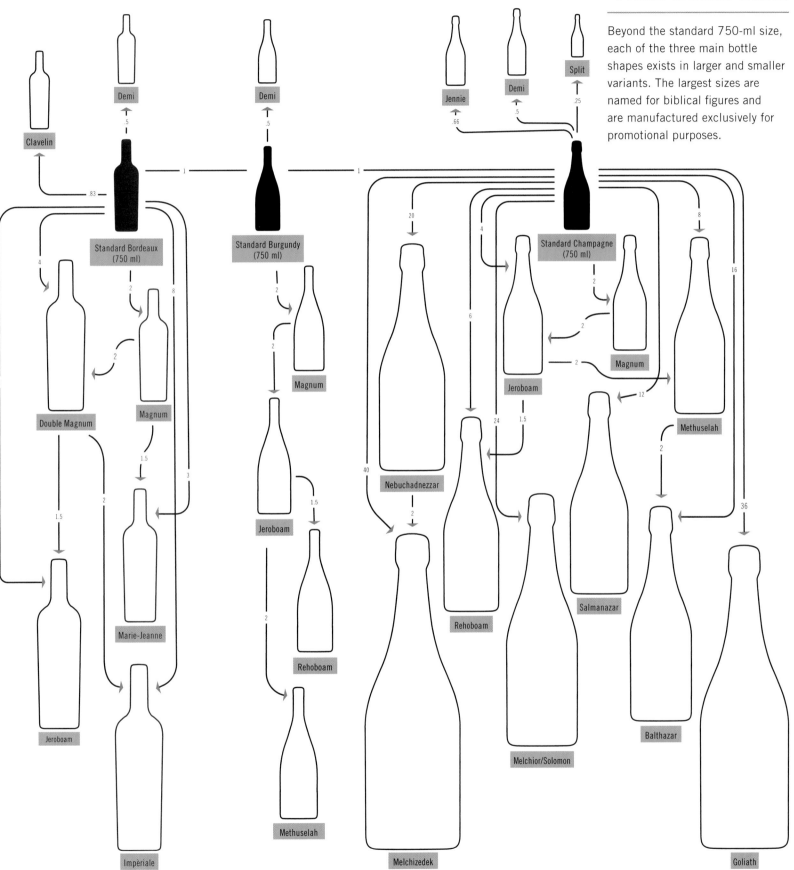

Glassware

A proper wineglass is constructed of thin, completely clear glass. Glasses narrow toward the rim to concentrate aroma, and the stem prevents one's hand from affecting the temperature of the wine and allows the wine to be swirled. The stem is also a place where the glassmaker can include a stylized knop. Some wines have their own specific glassware, such as the flute and the sherry glass, and stemless glassware has been growing in popularity for stylistic reasons.

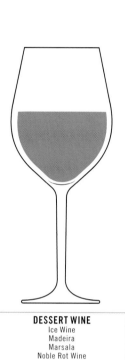

COUPE
Vintage Champagne

SHERRY
Fino
Oloroso
Amontillado
Palo Cortado
Cream

DESSERT WINE
Ice Wine
Madeira
Marsala
Noble Rot Wine
Orange Muscat
Port

STANDARD/ROSÉ
White Zinfandel
Rosé de Pinot Noir
Rosé de Cabernet
Rosé de Merlot
Rosado

SPARKLING
Asti
Prosecco
Champagne
Cava

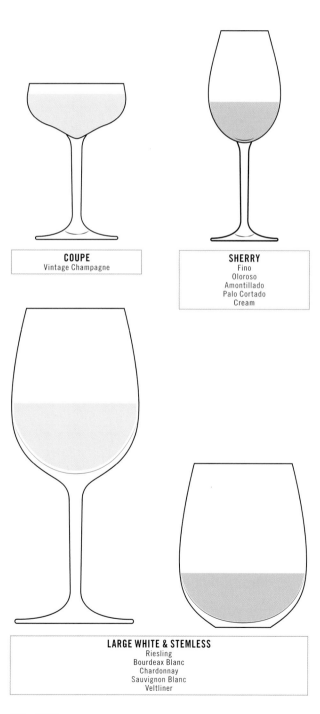

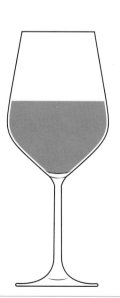

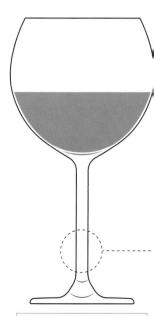

LARGE WHITE & STEMLESS
Riesling
Bourdeax Blanc
Chardonnay
Sauvignon Blanc
Veltliner

SMALL WHITE
Sémillon
Chenin Blanc
Gewürztraminer
Chianti Classico
Bardolino

SMALL RED
Syrah
Malbec
Zinfandel
Cabernet Sauvignon
Merlot

LARGE RED
Burgundy
Pinot Noir
Grenache
Nebbiolo
Gamay

Other Equipment

Decanters have been around for hundreds of years and started as simple serving vessels. In modern times, wine is decanted primarily to remove sediment that may have formed in the bottle. There is much debate over the secondary reason for decanting: aerating a wine. Some hold that exposing wine to air will allow it to "breathe," that is, to reduce harsh tannins and allow other flavors to come forward. However, studies have found that aeration destroys flavor in wine and that decanting is a purely detrimental process.

There have been hundreds of patents issued for corkscrews, and still there is no agreement on the best device for removing the cork from a bottle. Today the waiter's friend is the choice of most sommeliers, although many wine drinkers prefer one of the more elaborate implements.

DECANTERS

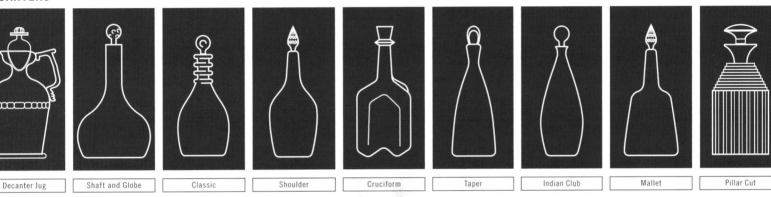

| Decanter Jug | Shaft and Globe | Classic | Shoulder | Cruciform | Taper | Indian Club | Mallet | Pillar Cut |

OPENERS

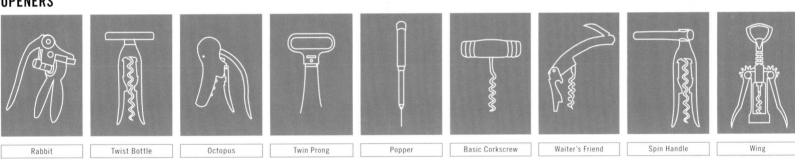

| Rabbit | Twist Bottle | Octopus | Twin Prong | Popper | Basic Corkscrew | Waiter's Friend | Spin Handle | Wing |

KNOPS

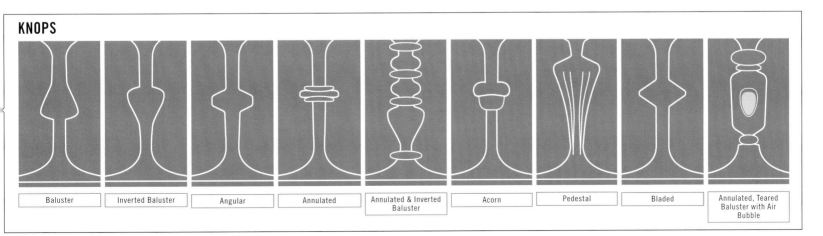

| Baluster | Inverted Baluster | Angular | Annulated | Annulated & Inverted Baluster | Acorn | Pedestal | Bladed | Annulated, Teared Baluster with Air Bubble |

Wine Cocktails

Wine isn't just enjoyed on its own—there's a long history of wine being mixed with other alcohols and with mixers to form delightful cocktails. From Hemingway's Death in the Afternoon to the classic Bellini, wine combines well with spirits and other beverages.

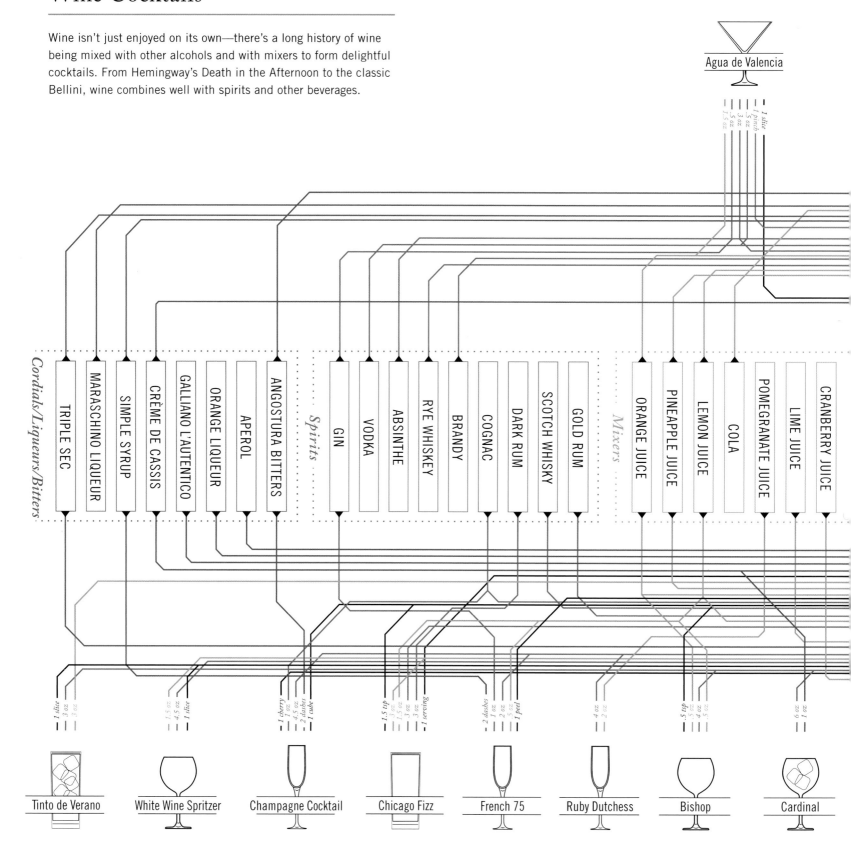

Agua de Valencia

Cordials/Liqueurs/Bitters

TRIPLE SEC
MARASCHINO LIQUEUR
SIMPLE SYRUP
CRÈME DE CASSIS
GALLIANO L'AUTENTICO
ORANGE LIQUEUR
APEROL
ANGOSTURA BITTERS

Spirits

GIN
VODKA
ABSINTHE
RYE WHISKEY
BRANDY
COGNAC
DARK RUM
SCOTCH WHISKY
GOLD RUM

Mixers

ORANGE JUICE
PINEAPPLE JUICE
LEMON JUICE
COLA
POMEGRANATE JUICE
LIME JUICE
CRANBERRY JUICE

Tinto de Verano
White Wine Spritzer
Champagne Cocktail
Chicago Fizz
French 75
Ruby Dutchess
Bishop
Cardinal

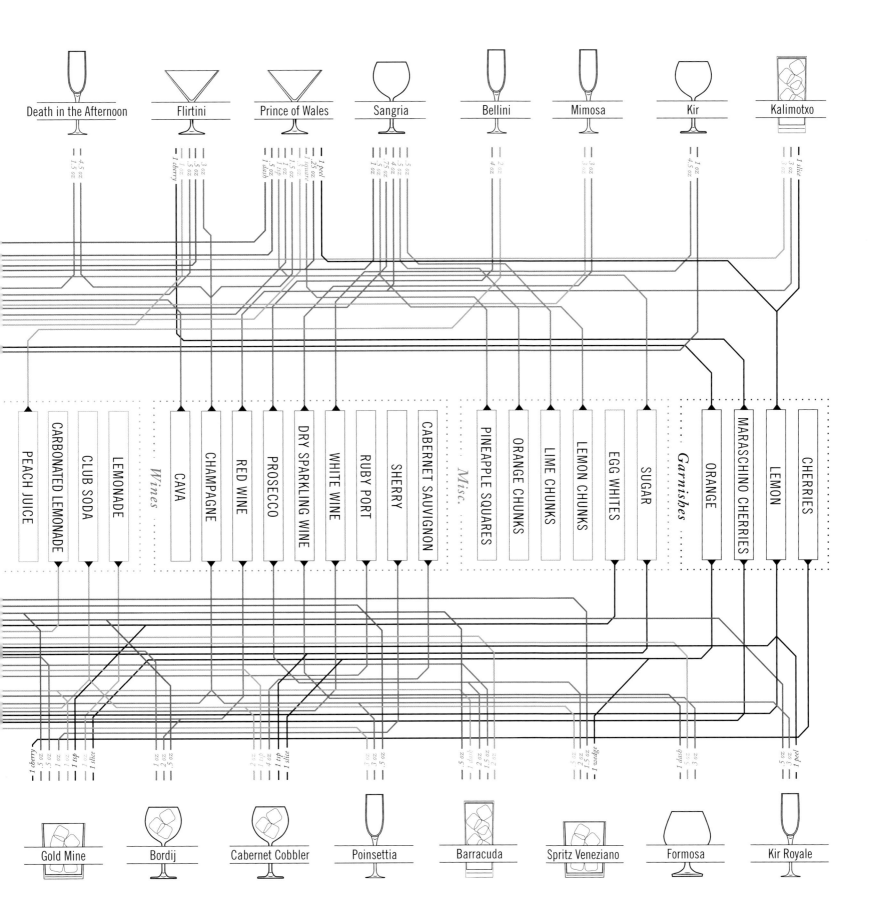

Wine Terminology

Wine drinkers are famously florid in the vocabulary they use to describe the tastes and aromas they detect. The table below organizes some of the more common terms used by professional wine writers.

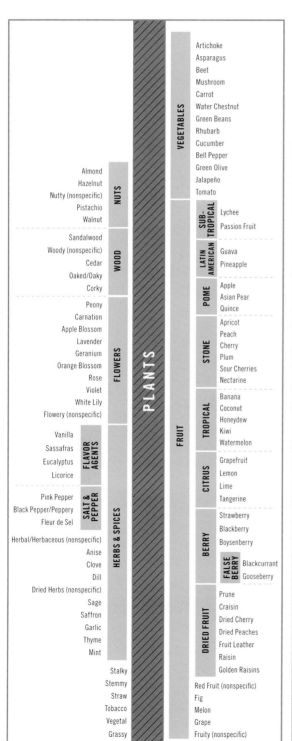

PLANTS

NUTS: Almond, Hazelnut, Nutty (nonspecific), Pistachio, Walnut

WOOD: Sandalwood, Woody (nonspecific), Cedar, Oaked/Oaky, Corky

FLOWERS: Peony, Carnation, Apple Blossom, Lavender, Geranium, Orange Blossom, Rose, Violet, White Lily, Flowery (nonspecific)

FLAVOR AGENTS: Vanilla, Sassafras, Eucalyptus, Licorice

SALT & PEPPER: Pink Pepper, Black Pepper/Peppery, Fleur de Sel

HERBS & SPICES: Herbal/Herbaceous (nonspecific), Anise, Clove, Dill, Dried Herbs (nonspecific), Sage, Saffron, Garlic, Thyme, Mint

Stalky, Stemmy, Straw, Tobacco, Vegetal, Grassy

VEGETABLES: Artichoke, Asparagus, Beet, Mushroom, Carrot, Water Chestnut, Green Beans, Rhubarb, Cucumber, Bell Pepper, Green Olive, Jalapeño, Tomato

FRUIT

SUB-TROPICAL: Lychee, Passion Fruit

LATIN AMERICAN: Guava, Pineapple

POME: Apple, Asian Pear, Quince

STONE: Apricot, Peach, Cherry, Plum, Sour Cherries, Nectarine

TROPICAL: Banana, Coconut, Honeydew, Kiwi, Watermelon

CITRUS: Grapefruit, Lemon, Lime, Tangerine

BERRY: Strawberry, Blackberry, Boysenberry

FALSE BERRY: Blackcurrant, Gooseberry

DRIED FRUIT: Prune, Craisin, Dried Cherry, Dried Peaches, Fruit Leather, Raisin, Golden Raisins

Red Fruit (nonspecific), Fig, Melon, Grape, Fruity (nonspecific)

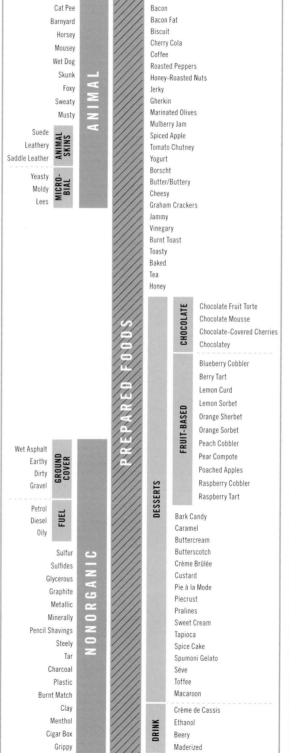

ANIMAL: Cat Pee, Barnyard, Horsey, Mousey, Wet Dog, Skunk, Foxy, Sweaty, Musty

ANIMAL SKINS: Suede, Leathery, Saddle Leather

MICRO-BIAL: Yeasty, Moldy, Lees

PREPARED FOODS: Bacon, Bacon Fat, Biscuit, Cherry Cola, Coffee, Roasted Peppers, Honey-Roasted Nuts, Jerky, Gherkin, Marinated Olives, Mulberry Jam, Spiced Apple, Tomato Chutney, Yogurt, Borscht, Butter/Buttery, Cheesy, Graham Crackers, Jammy, Vinegary, Burnt Toast, Toasty, Baked, Tea, Honey

CHOCOLATE: Chocolate Fruit Torte, Chocolate Mousse, Chocolate-Covered Cherries, Chocolatey

FRUIT-BASED: Blueberry Cobbler, Berry Tart, Lemon Curd, Lemon Sorbet, Orange Sherbet, Orange Sorbet, Peach Cobbler, Pear Compote, Poached Apples, Raspberry Cobbler, Raspberry Tart

DESSERTS: Bark Candy, Caramel, Buttercream, Butterscotch, Crème Brûlée, Custard, Pie à la Mode, Piecrust, Pralines, Sweet Cream, Tapioca, Spice Cake, Spumoni Gelato, Sève, Toffee, Macaroon

DRINK: Crème de Cassis, Ethanol, Beery, Maderized

NONORGANIC

GROUND COVER: Wet Asphalt, Earthy, Dirty, Gravel

FUEL: Petrol, Diesel, Oily

Sulfur, Sulfides, Glycerous, Graphite, Metallic, Minerally, Pencil Shavings, Steely, Tar, Charcoal, Plastic, Burnt Match, Clay, Menthol, Cigar Box, Grippy

ADJECTIVES

SIZE-RELATED

- *CORPULENT:* Fat, Flabby, Fleshy, Heavy, Voluptuous, Supple
- Big, Long, Short

ENERGETIC/EXPRESSIVE: Zesty, Zippy, Vigorous, Racy, Lively, Expressive, Flamboyant, Nerve, Hot

HIGH AND LOW

- *UPPER CLASS:* Opulent, Noble, Refined, Elegant, Finesse, Complex
- *UN-REFINED:* Rough, Hard, Harsh, Coarse

STRAIGHT-FORWARD: Dry, Sweet, Tart, Sour, Spicy, Piquant, Creamy, Ripe

POWERFUL

- *STRONG/THICK:* Powerful, Muscular, Firm, Concentrated, Dense, Sound
- *FIXED:* Rigid, Structured, Tight, Crisp
- *POINTY:* Angular, Sharp, Edgy
- *WEAK/SHY:* Fallen Over, Spineless, Soft, Reticent, Watery, Delicate

HARD & SOFT

SLICK: Smooth, Silky, Unctuous, Velvety

SWEET: Cloying, Rich, Insipid, Luscious

CLINICAL: Astringent, Oxidized/Oxidative, Clean, Extracted, Typicity

TOPOLOGY/ENVIRONMENT: Cliff-Edge, Flat, Rounded/Round, Green, Smoky, Hollow

RE-SERVED: Closed, Mellow, Austere

Chewy, Fresh, Juicy

The Brewing Process

Sake has been brewed in Japan for more than one thousand years. Its production process is somewhat similar to the brewing of beer, but unique in that a mold is introduced to convert the rice starch into sugar, and then brewer's yeast converts that starch into alcohol.

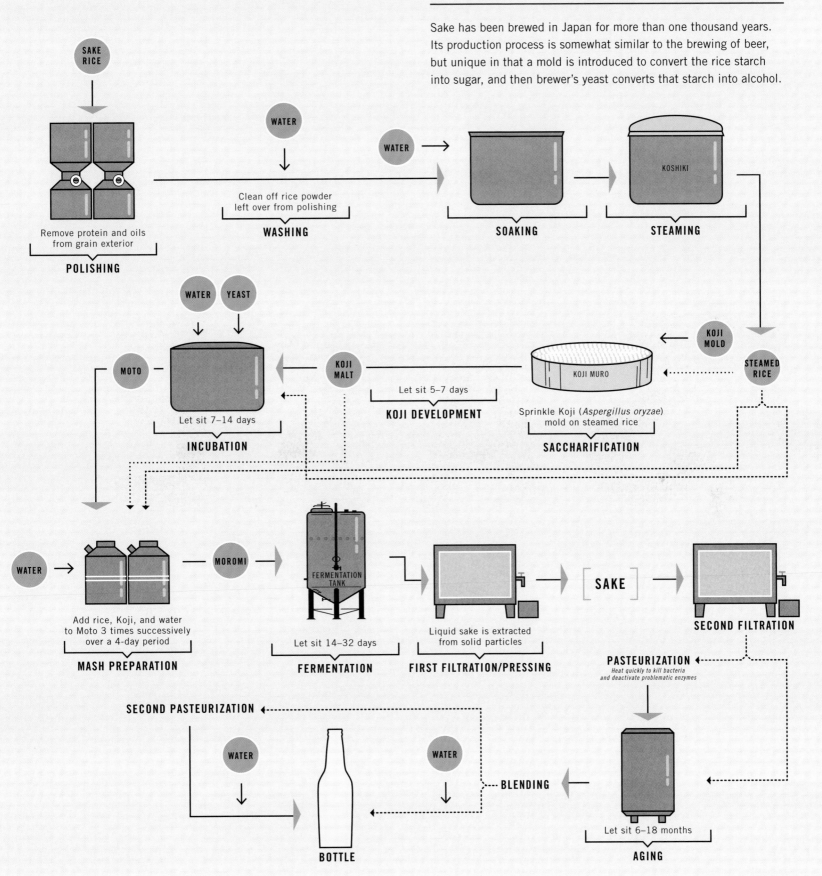

SAKE RICE

WATER

WATER

KOSHIKI

Clean off rice powder left over from polishing

WASHING

SOAKING

STEAMING

Remove protein and oils from grain exterior

POLISHING

WATER YEAST

KOJI MOLD

MOTO

KOJI MALT

KOJI MURO

STEAMED RICE

Let sit 5–7 days

KOJI DEVELOPMENT

Sprinkle Koji (*Aspergillus oryzae*) mold on steamed rice

Let sit 7–14 days

INCUBATION

SACCHARIFICATION

WATER

MOROMI

FERMENTATION TANK

SAKE

SECOND FILTRATION

Add rice, Koji, and water to Moto 3 times successively over a 4-day period

MASH PREPARATION

Let sit 14–32 days

FERMENTATION

Liquid sake is extracted from solid particles

FIRST FILTRATION/PRESSING

PASTEURIZATION
Heat quickly to kill bacteria and deactivate problematic enzymes

SECOND PASTEURIZATION

WATER

WATER

BLENDING

Let sit 6–18 months

AGING

BOTTLE

Brewery Map

Befitting a national drink, sake breweries are found all over Japan, with the Niigata region in the middle of Honshu home to most of the major manufacturers due to its exceptional rice production.

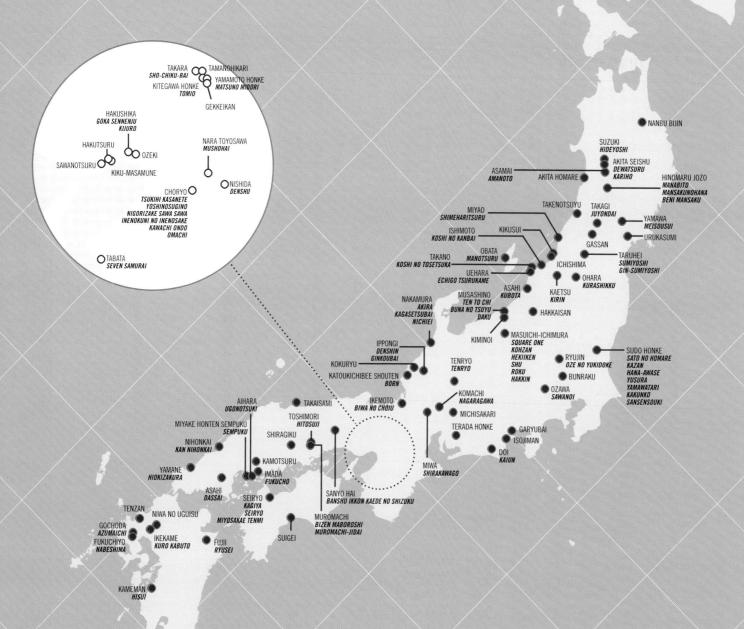

Sake is broadly broken down into Futsū-shu (ordinary sake, the equivalent of table wine) and Tokutei meishō-shu (special designation sake). Tokutei meishō-shu can be subclassifed as laid out below, with distinctions drawn according to the type of rice used, production method, etc.

FUTSŪ-SHU (ORDINARY SAKE)

DEWATSURU CHOINAMA	DOOSAN CHUNGHA	GEKKEIKAN	MASUMI	CHOYA	OZEKI
HAKKAISAN FUTSUSHU	HAKUTSURU SAYURI	NISHINOSEKI	SHIRAYUKI	DAISEKKEI KURADASI	

TOKUTEI MEISHŌ-SHU (SPECIAL DESIGNATION SAKE)

JUNMAI-SHU

TOSA-TSURU	JUNMAI-SHU URAKASUMI	HATSUMAGO KIMOTO	MASUMI OKUDEN KANZUKURI
HAKUBOTAN	DENSHU JUNMAI	UMENISHIKI	JUNMAI KINMATSU HAKUTAKA
TAKASHIMIZU	GEKKEIKAN	SUEHIRO DENSHO	SAWANOTSURU
RYOZEKI AKITAKOMACHI	MICHIZAKARI	TSUKASABOTAN	SHOCHIKUBAI
ARAMASA	KIKUSUI JUNMAI-SHU	KAMOTSURU	OZEKI
NISHINOSEKI TEDUKURI	HAKUTSURU JUNMAI	ICHINOKURA	EISEN

TOKUBETSU JUNMAI-SHU

- KOSHINO KANBAI MUKU
- OKUNOMATSU TOKUBETSU JINMAI
- ARAMASA ROKUGO #6
- SHOCHIKUBAI TOKUBETSU JUNMAI
- HAKKAISAN TOKUBESTU JUNMAI
- OZEKI YAMADANISHIKI
- TOKUBETSU JUNMAI-SHU KIIPPON URAKASUMI
- SAWANOTSURU TOKUBEUTSU JUNMAI
- GEKKEIKAN HAIKU
- DENSHU TOKUBETSU JUNMAI

JUNMAI GINJŌ-SHU

FUKUMASAMUNE GOLD	NISHINOSEKI BIJIN
ARAMASA ROKUGO #6	MASUMI
JUYONDAI JUNMAI GINJO	DENSHU JUNMAI GINJO
SUEHIRO KATANA	KIKUSUI JUNMAI GINJO
KOSHINO KANBAI KINMUKU	UMENISHIKI
SHOCHIKUBAI GINJO	GEKKEIKAN SUZAKU
HAKKAISAN JUNMAI GINJO	KOKURYU JUNMAI GINJO
HAKUTSURU JUNMAI GINJO	TATEYAMA
JUNMAI GINJO URAKASUMI ZEN	KORO
JUNMAI GINJYO GOKUJYO HAKUTAKA	

JUNMAI DAIGINJŌ-SHU

JUYONDAI JUNMAI DAIGINJO	UMENISHIKI
TSUKASABOTAN	OZEKI PLATINUM
MASUMI	GINBAN BANSHU 50
KUBOTA MANJYU	JUNMAI DAIGINJO URAKASUMI
DENSHU JUNMAI DAIGINJO	SAKAMAI KIKUSUI
RYOZEKI SETSUGEKKA	GEKKEIKAN HORIN
HATSUMAGO SHOZUI	NISHINOSEKI HANNARI
HAKUTSURU SHO-UNE	ARAMASA ROKUGO #6
KOSHINO KANBAI CHOTOKUSEN	ISOJIMAN JUNMAI DAIGINJO YAMADA NISHIKI
KAMOTSURU TOKUSEI GOLD	SHOCHIKUBAI JUNMAI DAIGINJO

HONJŌZŌ-SHU

DEWAZAKURA	KIKUSUI KARAKUCHI
FUNAGUCHI KIKISUI	HAKKAISAN HONJOZO
NISHINOSEKI	HONJIKOMI URAKASUMI
OZEKI KARATAMBA	KOKURYU HONJOZO
MASUMI TOKUSEN	SAWANOTSURU HONJOZO GENSHU
SUEHIRO KIRA	

GINJŌ-SHU

- DEWAZAKURA OUKA GINJYOSHU
- TOSA-TSURU GINREI SENJU
- MASUMI KADEN TEZUKURI
- NISHINOSEKI BIJIN
- SHOCHIKUBAI REI
- SAWANOTSURU GINJO
- OKUNOMATSU GINJO
- JUYONDAI HONMARU GINJO
- ISOJIMAN GINJO
- KOKURYU TOKUSEN GINJO
- HAKKAISAN GINJO

DAIGINJŌ-SHU

- TOSA-TSURU TENPYO
- KUBOTA MANJYU
- SUEHIRO
- MASUMI YUMEDONO
- JUYONDAI GINSEN DAIGINJO
- NISHINOSEKI
- OZEKI OSAKAYA CHOBEI
- KOKURYU DAIGINJO
- ISOJIMAN DAIGINJO
- SAWANOTSURU DAIGINJO
- DEWAZAKURA DAIGINJYOSHU

TOKUBETSU HONJŌZŌ-SHU

- GINREI TATEYAMA HONJOZO
- KUBOTA SENJYU
- JUYONDAI TENSEN ASAHITAKA
- NISHINOSEKI

Sake Cocktails

Sake combines well with spirits as well as fruit juices and other mixers, and enterprising barkeeps have found it a worthy addition to the library of cocktails.

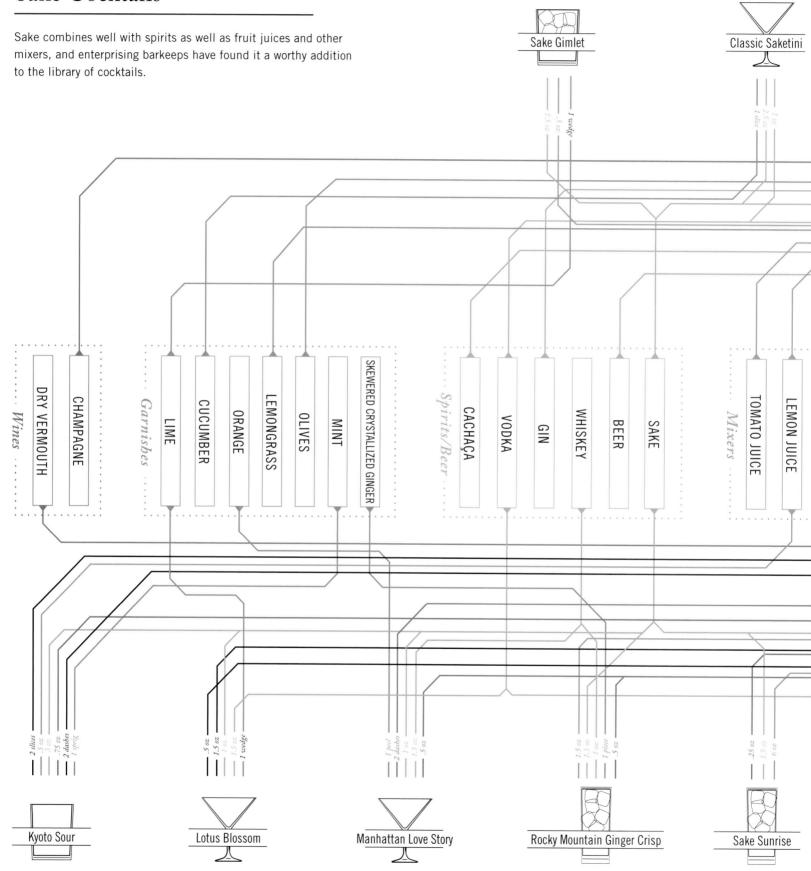

Sake Gimlet

Classic Saketini

Wines

DRY VERMOUTH

CHAMPAGNE

Garnishes

LIME

CUCUMBER

ORANGE

LEMONGRASS

OLIVES

MINT

SKEWERED CRYSTALLIZED GINGER

Spirits/Beer

CACHAÇA

VODKA

GIN

WHISKEY

BEER

SAKE

Mixers

TOMATO JUICE

LEMON JUICE

Kyoto Sour

Lotus Blossom

Manhattan Love Story

Rocky Mountain Ginger Crisp

Sake Sunrise

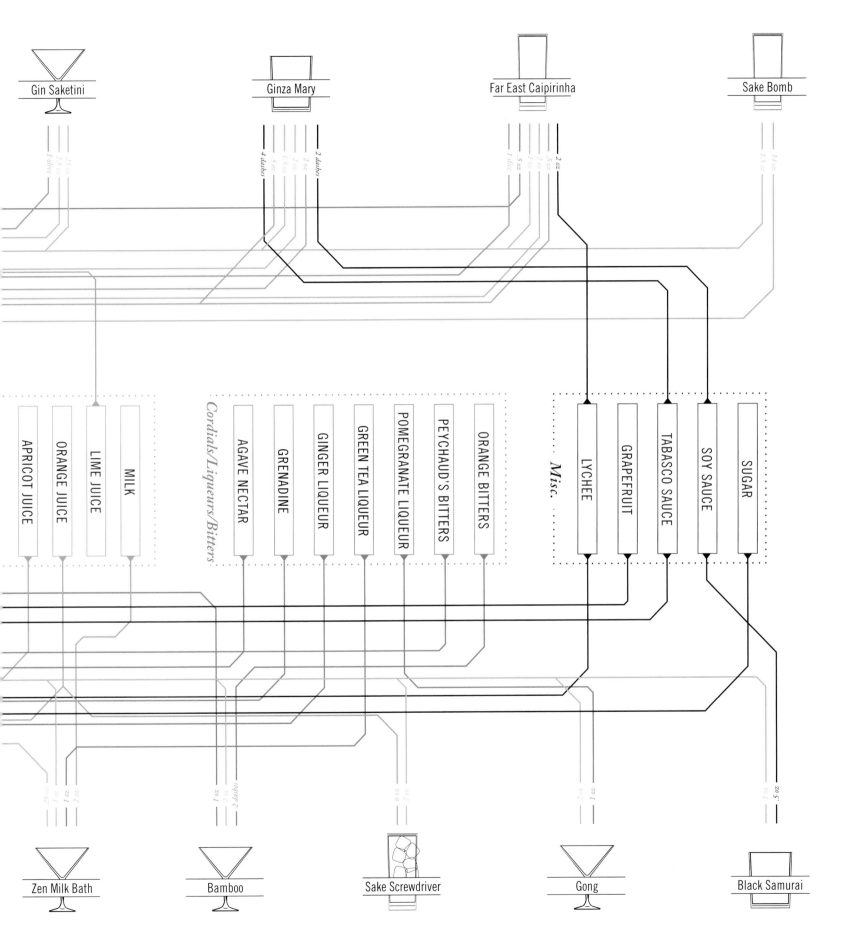

Gin Saketini

.25 oz
1 olive
2.5 oz
1.5 oz

Ginza Mary

4 dashes
.5 oz
1.5 oz
2 oz
2 oz
2 dashes

Far East Caipirinha

1 slice
.5 oz
2 oz
.5 oz
2 oz

Sake Bomb

1.5 oz
14 oz

APRICOT JUICE
ORANGE JUICE
LIME JUICE
MILK

Cordials/Liqueurs/Bitters

AGAVE NECTAR
GRENADINE
GINGER LIQUEUR
GREEN TEA LIQUEUR
POMEGRANATE LIQUEUR
PEYCHAUD'S BITTERS
ORANGE BITTERS

Misc.

LYCHEE
GRAPEFRUIT
TABASCO SAUCE
SOY SAUCE
SUGAR

Zen Milk Bath

.25 oz
1 oz
2 oz

Bamboo

2 oz
1 oz
2 dashes

Sake Screwdriver

.05 oz

Gong

.25 oz
1 oz

Black Samurai

1 oz
.5 oz

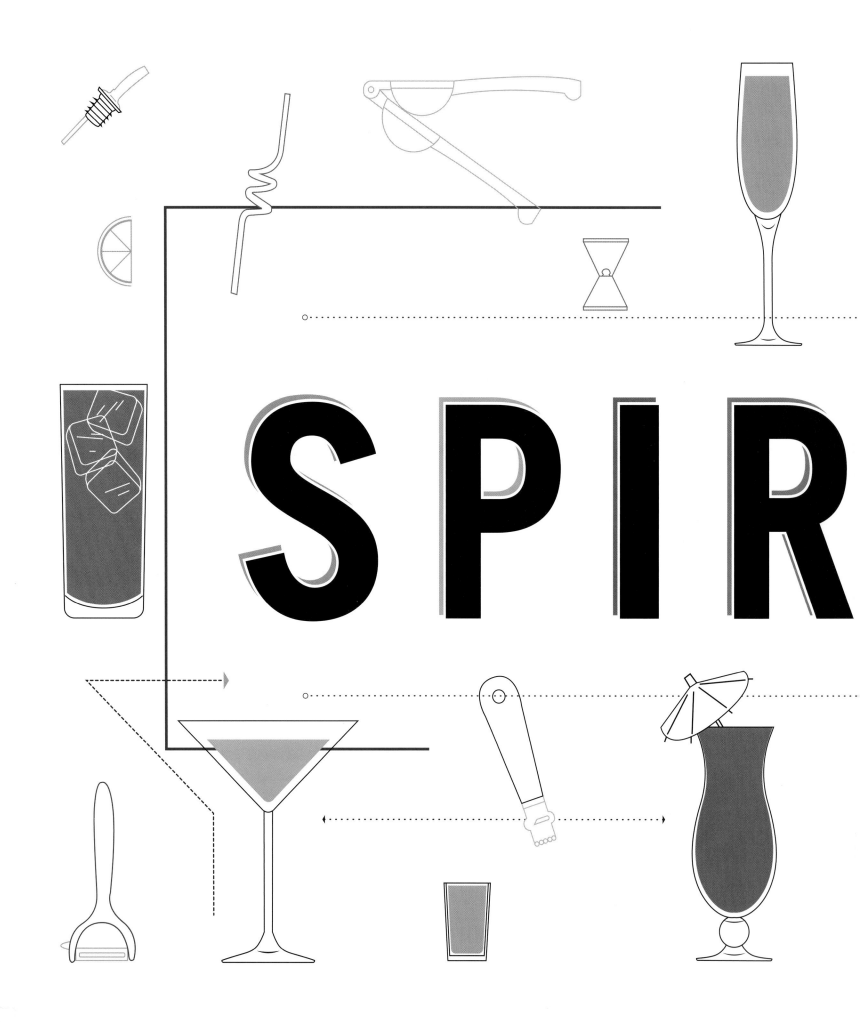

SPIR

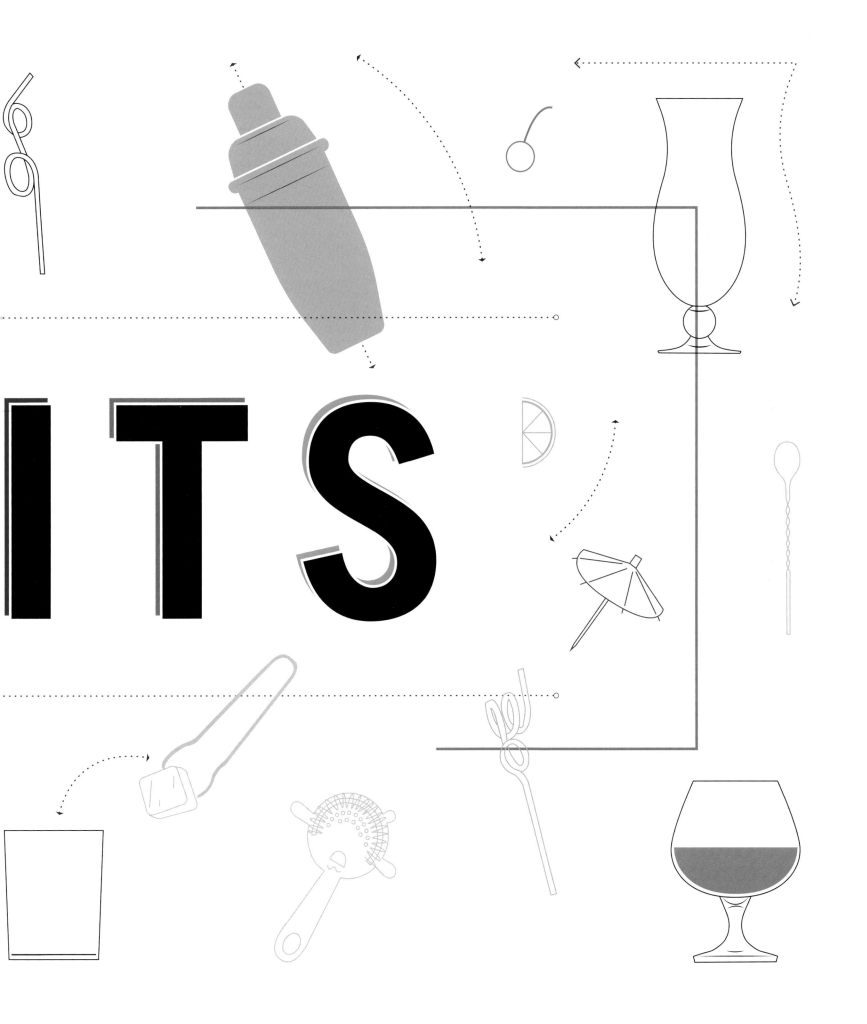

The Etymology of Alcohol

The word *alcohol* is derived from the Arabic *al khul*, an ancient compound historically used as eye makeup. *Al khul* (or more scientifically, *antimony sulfide*) was made via a process of vaporization and reconstitution-by-condensation—the same method by which modern spirits are distilled into pure ethanol.

al kuhl/koh'l
Ancient Arabic
a fine metallic powder
*(antimony sulfide/collyrium) pulverized**
and used as eye makeup

alcool
French (16th Century)
any fine powder that's been vaporized and condensed

The Ancient Greek kollyrion—
a poultice or eye salve—is
conspicuously similar to
the Arabic eye powder
collyrium. *Both products, like*
alcoholic beverages, color
the eyes.

alcohol
English (c. 1753)
liquid spirits (quintessences) derived by the same process,
the most popular of which was "essence of wine"

Some relate the Spanish word for
eyes, ojos, *to the derivation of*
alcohol *as it makes the* ojos
*very shiny (*brillante*!) indeed.*

alcool/alcohol/etc.
English, French, etc. (c. 1834)
in France, Dumas and Péligot demonstrate the chemical
relation between spirit of wine and other intoxicating
substances derived from ethanol distillation, applying
the word alcohol *to all distilled beverages*

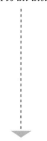

ALCOHOL

** refined by heating to vapor,*
then letting condense into a fine powder

The Distillation Process

Distillation—the process by which gin, whiskey, and a number of other spirits are made—is the separation of ethanol from water. Using controlled tiers of successively higher boiling points, a distillation column allows ethanol vapor to separate from water and travel into a condenser, whereupon the vapor cools and condenses into pure liquid ethanol—commonly referred to as "moonshine." That ethanol can then be aged, redistilled, or mixed with adjuncts to create most of our common spirits.

MASH

Yeast + H$_2$O + sugar
(from grain)

FERMENTER

1 Yeast absorbs sugar, and **MASH** becomes **WASH**.

WASH

2 Travels via pipe into **COLUMN**, which drips into **POT**.

Tiers of successively higher temps

LYNE ARM PIPE

RECTIFIER/CONDENSER

DISTILLATION COLUMN/ANALYZER

5 **RECTIFIER**, which contains a pipe of cool water, turns alcohol vapor back into liquid, which drips into **COLLECTION TANK**.

3 Pumps steam into two-walled metal sleeve that surrounds bottom of **POT**. **WASH** begins to turn into **VAPOR** of alcohol and H$_2$O.

BOILER

POT

4 **VAPOR** travels up column, and **VAPOR** with highest alcohol content travels into **LYNE ARM**, while **VAPOR** with low alcohol condenses and falls back into **POT**.

7 Alcohol can be aged in oak barrels (**WHISKEY**), redistilled (**VODKA**), or redistilled with botanical blends and other adjuncts (**GIN**).

COLLECTION TANK

6 Bulk of run is called the **HEARTS**, which is occasionally mixed with trace amounts of **HEADS**, then aged and diluted to make **SPIRITS**.

First 5% of the run, called the **HEADS**, contains large amounts of volatile chemical compounds. Most of this is discarded.

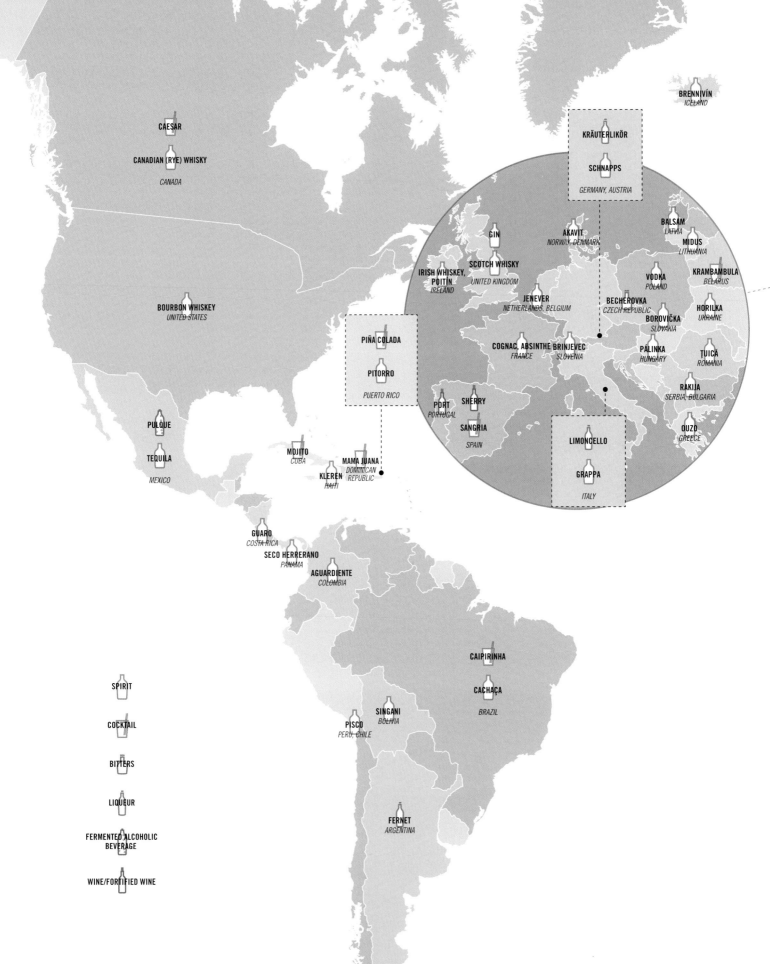

CAESAR

CANADIAN (RYE) WHISKY
CANADA

BRENNIVÍN
ICELAND

KRÄUTERLIKÖR

SCHNAPPS
GERMANY, AUSTRIA

GIN

AKAVIT
NORWAY, DENMARK

BALSAM
LATVIA

MIDUS
LITHUANIA

SCOTCH WHISKY
UNITED KINGDOM

IRISH WHISKEY,
POITÍN
IRELAND

VODKA
POLAND

KRAMBAMBULA
BELARUS

JENEVER
NETHERLANDS, BELGIUM

BECHEROVKA
CZECH REPUBLIC

HORILKA
UKRAINE

BOROVIČKA
SLOVAKIA

BOURBON WHISKEY
UNITED STATES

COGNAC, ABSINTHE
FRANCE

BRINJEVEC
SLOVENIA

PÁLINKA
HUNGARY

ȚUICĂ
ROMANIA

PIÑA COLADA

PITORRO
PUERTO RICO

PULQUE

TEQUILA
MEXICO

PORT
PORTUGAL

SHERRY

SANGRIA
SPAIN

RAKIJA
SERBIA, BULGARIA

OUZO
GREECE

LIMONCELLO

GRAPPA
ITALY

MOJITO
CUBA

MAMA JUANA
*DOMINICAN
REPUBLIC*

KLEREN
HAITI

GUARO
COSTA RICA

SECO HERRERANO
PANAMA

AGUARDIENTE
COLOMBIA

SPIRIT

COCKTAIL

BITTERS

LIQUEUR

FERMENTED ALCOHOLIC
BEVERAGE

WINE/FORTIFIED WINE

CAIPIRINHA

CACHAÇA
BRAZIL

SINGANI
BOLIVIA

PISCO
PERU, CHILE

FERNET
ARGENTINA

Atlas of Spirits

A country's national beverage can serve as a defining cultural indicator along with other (less fun) factors such as cuisine and dress. It can also be a source of conflict when two countries claim the same drink as their own—Russia and Poland, for instance, have been feuding for decades over the true origin of vodka.

AKEVITT
NORWAY

BRÄNNVIN
SWEDEN

VANA TALLINN
ESTONIA

VODKA
RUSSIA

KUMIS
MONGOLIA

CHACHA
GEORGIA

RAKI
TURKEY

OGHI
ARMENIA

BAIJIU
CHINA

SOJU
SOUTH KOREA

SAKE,
SHŌCHŪ
JAPAN

BRANDY SOUR
CYPRUS

ARAK
LEBANON, ISRAEL, SYRIA

KAOLIANG
TAIWAN

TODDY
INDIA

MEKHONG
THAILAND

TEJ
ETHIOPIA AND ERITREA

BASI
PHILIPPINES

OGOGORO
NIGERIA

FUO
A

ARRACK
SRI LANKA

WARAGI
UGANDA

TUAK
MALAYSIA, INDONESIA

CHHAANG

RAKSI

NEPAL

The Whiskey-Making Process

Whiskey is a spirit distilled from fermented grain mash and is usually aged in some sort of wooden barrel or cask. This aging process is crucial as it imparts both color and flavor to the maturing alcohol. The American version of this beverage comes in several different forms, which are defined by their primary mash ingredients.

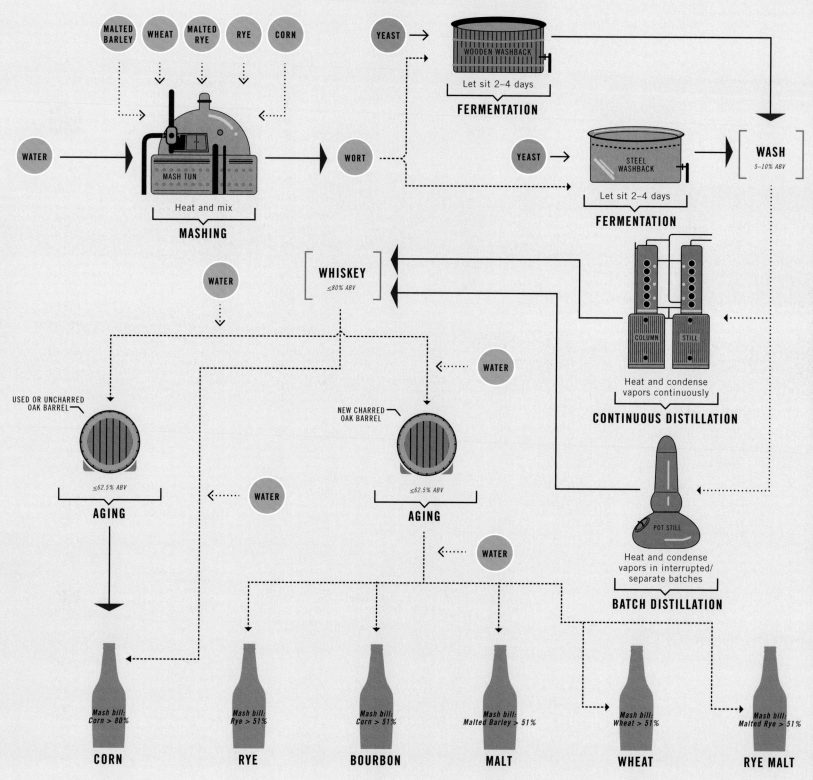

MALTED BARLEY

WHEAT

MALTED RYE

RYE

CORN

YEAST

WOODEN WASHBACK

Let sit 2–4 days

FERMENTATION

WATER

MASH TUN

Heat and mix

MASHING

WORT

YEAST

STEEL WASHBACK

Let sit 2–4 days

FERMENTATION

WASH
5–10% ABV

WATER

WHISKEY
≤80% ABV

WATER

COLUMN

STILL

Heat and condense vapors continuously

CONTINUOUS DISTILLATION

USED OR UNCHARRED OAK BARREL

≤62.5% ABV

AGING

WATER

NEW CHARRED OAK BARREL

≤62.5% ABV

AGING

POT STILL

Heat and condense vapors in interrupted/ separate batches

BATCH DISTILLATION

WATER

Mash bill: Corn > 80%

CORN

Mash bill: Rye > 51%

RYE

Mash bill: Corn > 51%

BOURBON

Mash bill: Malted Barley > 51%

MALT

Mash bill: Wheat > 51%

WHEAT

Mash bill: Malted Rye > 51%

RYE MALT

American Whiskey Guidelines

Title 27 of the Code of Federal Regulations outlines the American government's official requirements for the labeling of different types of whiskeys. In general, corn whiskey is subject to the loosest guidelines and is consequently regarded as a lower-quality product.

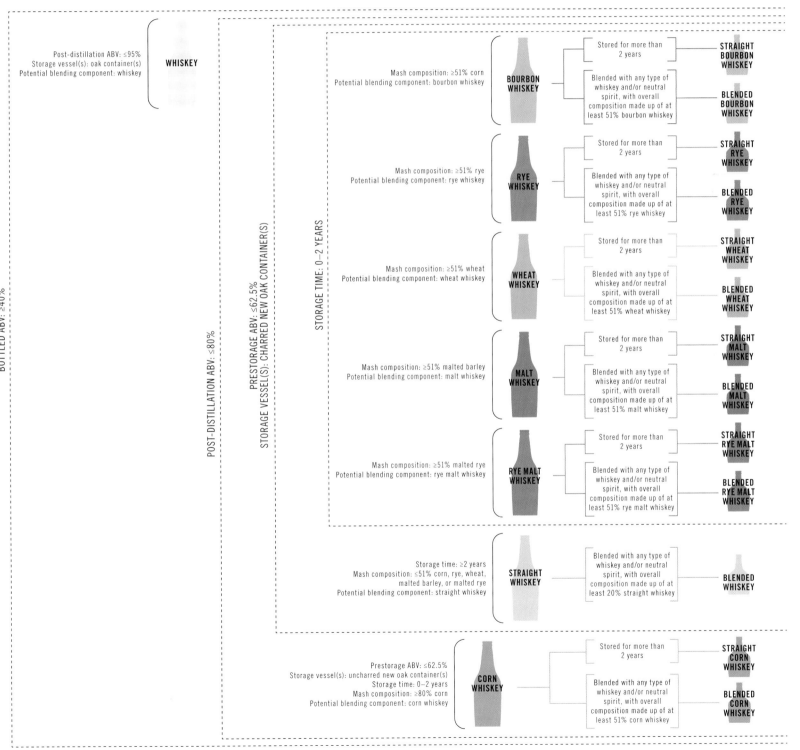

American Whiskey Map & Styles

The American states of Kentucky and Tennessee, originally settled by Scotch-Irish immigrants in the eighteenth century, have for many years served as the historic center of bourbon whiskey production. In an effort to distinguish itself from its northern neighbor, famous for "Kentucky Bourbon," the state of Tennessee actually applies its denomination of origin ("Tennessee Whiskey") to all bourbons produced there but not necessarily to other types of whiskey.

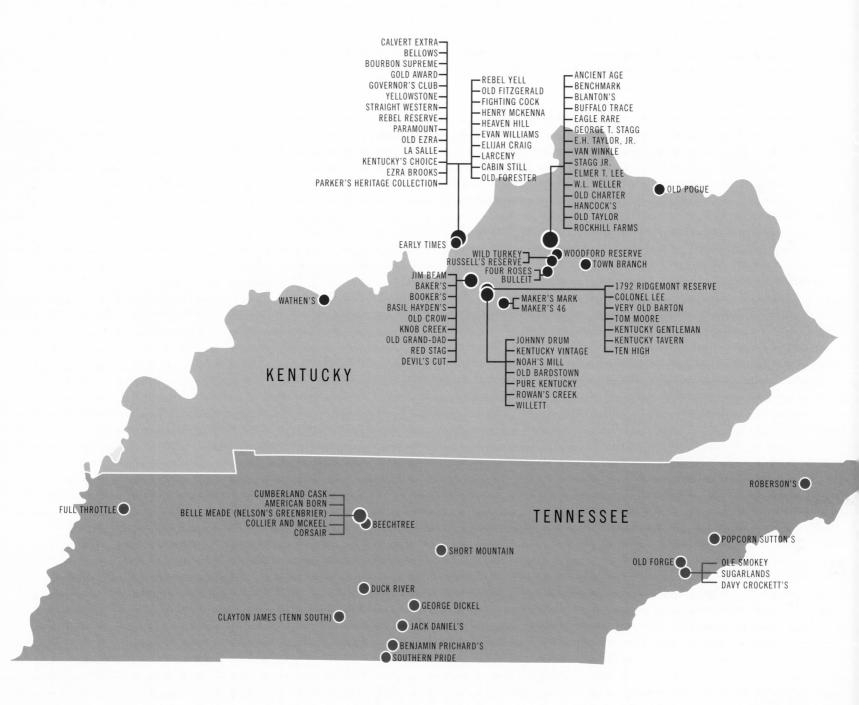

CALVERT EXTRA
BELLOWS
BOURBON SUPREME
GOLD AWARD
GOVERNOR'S CLUB
YELLOWSTONE
STRAIGHT WESTERN
REBEL RESERVE
PARAMOUNT
OLD EZRA
LA SALLE
KENTUCKY'S CHOICE
EZRA BROOKS
PARKER'S HERITAGE COLLECTION

REBEL YELL
OLD FITZGERALD
FIGHTING COCK
HENRY MCKENNA
HEAVEN HILL
EVAN WILLIAMS
ELIJAH CRAIG
LARCENY
CABIN STILL
OLD FORESTER

ANCIENT AGE
BENCHMARK
BLANTON'S
BUFFALO TRACE
EAGLE RARE
GEORGE T. STAGG
E.H. TAYLOR, JR.
VAN WINKLE
STAGG JR.
ELMER T. LEE
W.L. WELLER
OLD CHARTER
HANCOCK'S
OLD TAYLOR
ROCKHILL FARMS

OLD POGUE

EARLY TIMES

WILD TURKEY
RUSSELL'S RESERVE
FOUR ROSES
BULLEIT

WOODFORD RESERVE
TOWN BRANCH

JIM BEAM
BAKER'S
BOOKER'S
BASIL HAYDEN'S
OLD CROW
KNOB CREEK
OLD GRAND-DAD
RED STAG
DEVIL'S CUT

WATHEN'S

MAKER'S MARK
MAKER'S 46

1792 RIDGEMONT RESERVE
COLONEL LEE
VERY OLD BARTON
TOM MOORE
KENTUCKY GENTLEMAN
KENTUCKY TAVERN
TEN HIGH

JOHNNY DRUM
KENTUCKY VINTAGE
NOAH'S MILL
OLD BARDSTOWN
PURE KENTUCKY
ROWAN'S CREEK
WILLETT

KENTUCKY

ROBERSON'S

CUMBERLAND CASK
AMERICAN BORN
BELLE MEADE (NELSON'S GREENBRIER)
COLLIER AND MCKEEL
CORSAIR

BEECHTREE

FULL THROTTLE

TENNESSEE

POPCORN SUTTON'S

SHORT MOUNTAIN

OLD FORGE

OLE SMOKEY
SUGARLANDS
DAVY CROCKETT'S

DUCK RIVER

GEORGE DICKEL

CLAYTON JAMES (TENN SOUTH)

JACK DANIEL'S

BENJAMIN PRICHARD'S
SOUTHERN PRIDE

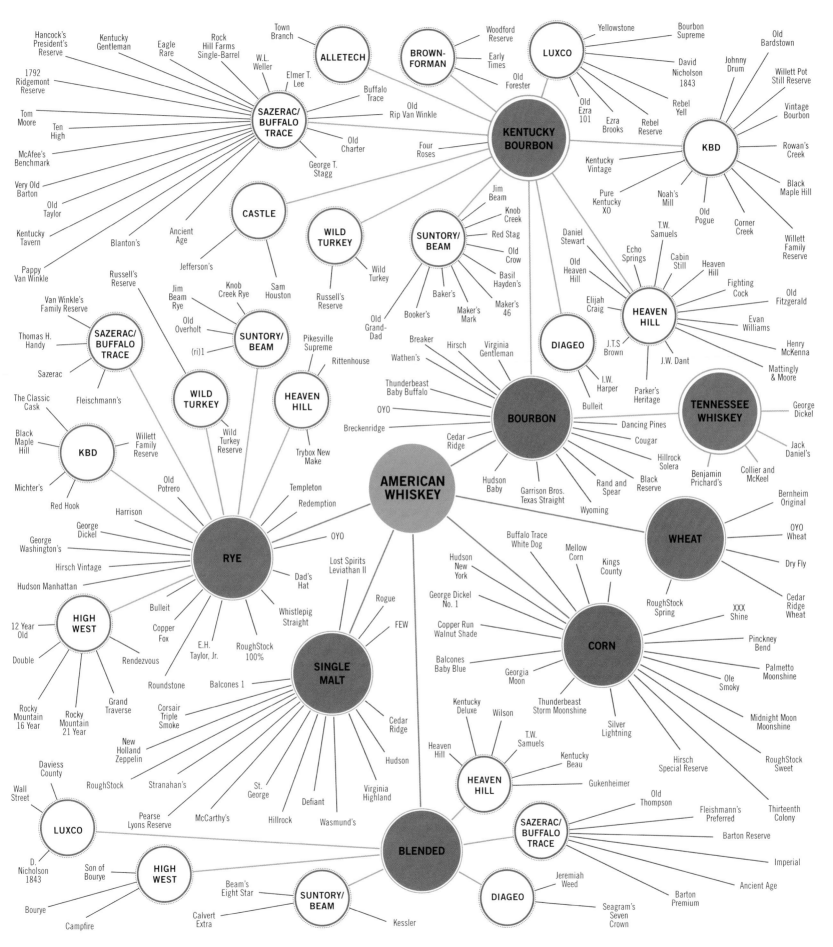

Hancock's President's Reserve
Kentucky Gentleman
Eagle Rare
Rock Hill Farms Single-Barrel
Town Branch
ALLETECH
W.L. Weller
Elmer T. Lee
BROWN-FORMAN
Woodford Reserve
Early Times
Yellowstone
LUXCO
Bourbon Supreme
David Nicholson 1843
Old Bardstown
Johnny Drum
Willett Pot Still Reserve

1792 Ridgemont Reserve
Tom Moore
Ten High
McAfee's Benchmark
Very Old Barton
Old Taylor
Kentucky Tavern
Pappy Van Winkle
SAZERAC/ BUFFALO TRACE
Blanton's
Buffalo Trace
Old Rip Van Winkle
Old Charter
George T. Stagg
Four Roses
Old Forester
KENTUCKY BOURBON
Old Ezra 101
Ezra Brooks
Rebel Yell
Rebel Reserve
Kentucky Vintage
Vintage Bourbon
Rowan's Creek
KBD
Black Maple Hill
Willett Family Reserve
Corner Creek
Old Pogue

CASTLE
Ancient Age
Jefferson's
Sam Houston
WILD TURKEY
Wild Turkey
Russell's Reserve
SUNTORY/ BEAM
Jim Beam
Knob Creek
Red Stag
Old Crow
Basil Hayden's
Maker's 46
Baker's
Booker's
Maker's Mark
Old Grand-Dad
DIAGEO
Daniel Stewart
Old Heaven Hill
Elijah Craig
J.T.S Brown
Echo Springs
T.W. Samuels
Cabin Still
Heaven Hill
Fighting Cock
HEAVEN HILL
J.W. Dant
Evan Williams
Old Fitzgerald
Henry McKenna
Mattingly & Moore

Van Winkle's Family Reserve
Russell's Reserve
Jim Beam Rye
Knob Creek Rye
Pikesville Supreme
Rittenhouse
Thomas H. Handy
SAZERAC/ BUFFALO TRACE
Old Overholt
(ri)1
SUNTORY/ BEAM
HEAVEN HILL
Breaker
Hirsch
Virginia Gentleman
I.W. Harper
Parker's Heritage
TENNESSEE WHISKEY
George Dickel
Jack Daniel's
Sazerac
Fleischmann's
WILD TURKEY
Wild Turkey Reserve
Wathen's
Thunderbeast Baby Buffalo
OYO
Bulleit
Benjamin Prichard's
Collier and McKeel

The Classic Cask
Black Maple Hill
KBD
Michter's
Red Hook
Willett Family Reserve
Old Potrero
Trybox New Make
Templeton
Redemption
Breckenridge
Cedar Ridge
BOURBON
Dancing Pines
Cougar
Hillrock Solera
Black Reserve
Bernheim Original
OYO Wheat
Dry Fly
Cedar Ridge Wheat

Harrison
George Dickel
George Washington's
Hirsch Vintage
Hudson Manhattan
OYO
Dad's Hat
AMERICAN WHISKEY
Hudson Baby
Garrison Bros. Texas Straight
Rand and Spear
Wyoming
WHEAT
Buffalo Trace White Dog
Mellow Corn
Kings County
RoughStock Spring
XXX Shine

HIGH WEST
Bulleit
Copper Fox
Whistlepig Straight
RYE
E.H. Taylor, Jr.
RoughStock 100%
Lost Spirits Leviathan II
Rogue
FEW
Hudson New York
George Dickel No. 1
Copper Run Walnut Shade
Pinckney Bend
Palmetto Moonshine

12 Year Old
Double
Rendezvous
Roundstone
Grand Traverse
Balcones 1
SINGLE MALT
Cedar Ridge
CORN
Ole Smoky
Silver Lightning
Hirsch Special Reserve
Midnight Moon Moonshine
RoughStock Sweet

Rocky Mountain 16 Year
Rocky Mountain 21 Year
Corsair Triple Smoke
New Holland Zeppelin
Balcones Baby Blue
Georgia Moon
Kentucky Deluxe
Wilson
Thunderbeast Storm Moonshine
Thirteenth Colony

Daviess County
Wall Street
RoughStock
Stranahan's
St. George
Defiant
Hillrock
Hudson
Virginia Highland
Wasmund's
Heaven Hill
T.W. Samuels
HEAVEN HILL
Kentucky Beau
Gukenheimer
Old Thompson
Fleischmann's Preferred
SAZERAC/ BUFFALO TRACE
Barton Reserve
Imperial

LUXCO
Pearse Lyons Reserve
McCarthy's
BLENDED
Jeremiah Weed
Ancient Age
Barton Premium

D. Nicholson 1843
Son of Bourye
HIGH WEST
Beam's Eight Star
SUNTORY/ BEAM
Kessler
DIAGEO
Seagram's Seven Crown

Bourye
Campfire
Calvert Extra

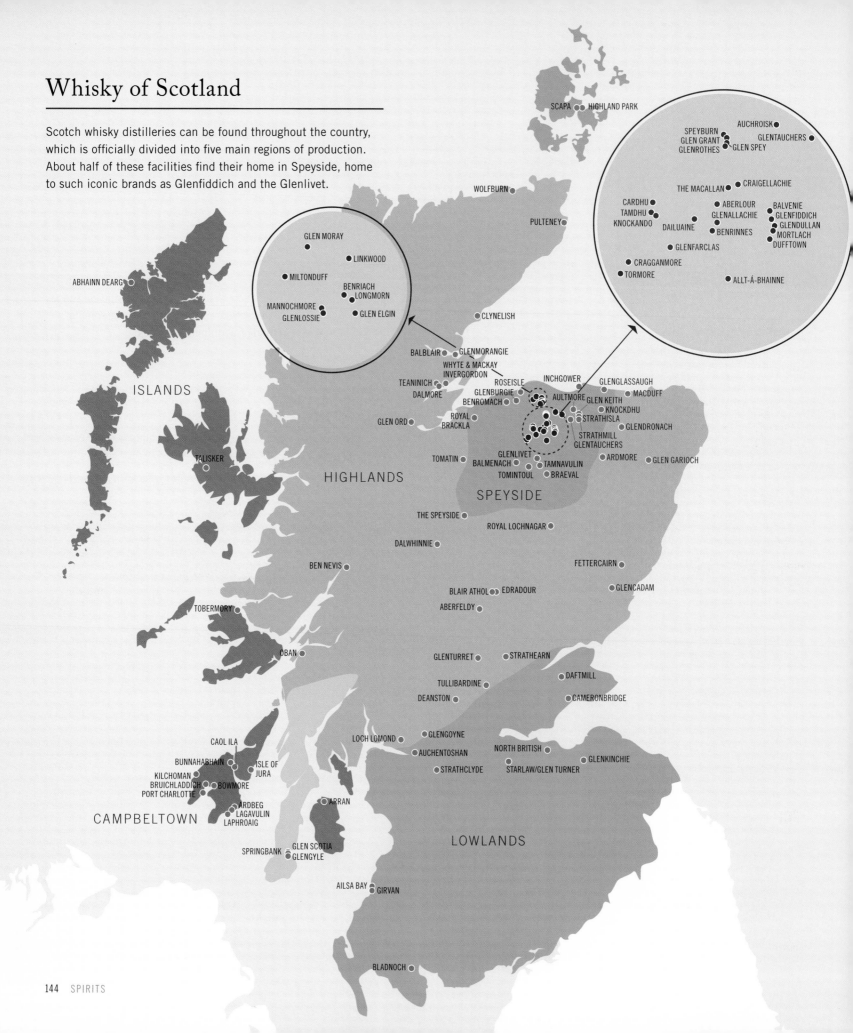

Whisky of Scotland

Scotch whisky distilleries can be found throughout the country, which is officially divided into five main regions of production. About half of these facilities find their home in Speyside, home to such iconic brands as Glenfiddich and the Glenlivet.

SCAPA HIGHLAND PARK

AUCHROISK
SPEYBURN
GLEN GRANT GLENTAUCHERS
GLENROTHES GLEN SPEY

CRAIGELLACHIE
THE MACALLAN

CARDHU ABERLOUR BALVENIE
TAMDHU GLENALLACHIE GLENFIDDICH
KNOCKANDO DAILUAINE GLENDULLAN
 BENRINNES MORTLACH
 DUFFTOWN
 GLENFARCLAS

CRAGGANMORE
TORMORE ALLT-Á-BHAINNE

WOLFBURN

GLEN MORAY

LINKWOOD

MILTONDUFF

BENRIACH
LONGMORN

MANNOCHMORE
GLENLOSSIE GLEN ELGIN

PULTENEY

CLYNELISH

ISLANDS

ABHAINN DEARG

BALBLAIR GLENMORANGIE
 WHYTE & MACKAY
 INVERGORDON
TEANINICH ROSEISLE INCHGOWER GLENGLASSAUGH
DALMORE GLENBURGIE AULTMORE MACDUFF
 BENROMACH GLEN KEITH
 KNOCKDHU
GLEN ORD ROYAL STRATHISLA GLENDRONACH
 BRACKLA STRATHMILL
 GLENTAUCHERS
TALISKER GLEN GARIOCH
 TOMATIN GLENLIVET ARDMORE
HIGHLANDS BALMENACH TAMNAVULIN
 TOMINTOUL BRAEVAL

SPEYSIDE

THE SPEYSIDE

ROYAL LOCHNAGAR

DALWHINNIE

BEN NEVIS FETTERCAIRN

 BLAIR ATHOL EDRADOUR GLENCADAM
 ABERFELDY

TOBERMORY

OBAN

 GLENTURRET STRATHEARN

 DAFTMILL
 TULLIBARDINE
 DEANSTON CAMERONBRIDGE

CAOL ILA
 GLENGOYNE
 LOCH LOMOND
BUNNAHABHAIN AUCHENTOSHAN NORTH BRITISH
KILCHOMAN ISLE OF GLENKINCHIE
BRUICHLADDICH JURA STRATHCLYDE STARLAW/GLEN TURNER
PORT CHARLOTTE BOWMORE

ARDBEG ARRAN
LAGAVULIN
CAMPBELTOWN LAPHROAIG

 LOWLANDS
 GLEN SCOTIA
SPRINGBANK GLENGYLE

 AILSA BAY GIRVAN

BLADNOCH

Scotch Whisky Guidelines & Styles

The production and labeling of Scotch whiskies are governed by legislation passed by the parliament of the United Kingdom in 2009. According to these rules, Scotch must be made primarily of malted barley and aged for at least three years in oak casks. Variations (e.g., single malt, single grain, blended) are based on production location, distillation method, and presence (or lack) of secondary mash ingredients and/or additional whiskies.

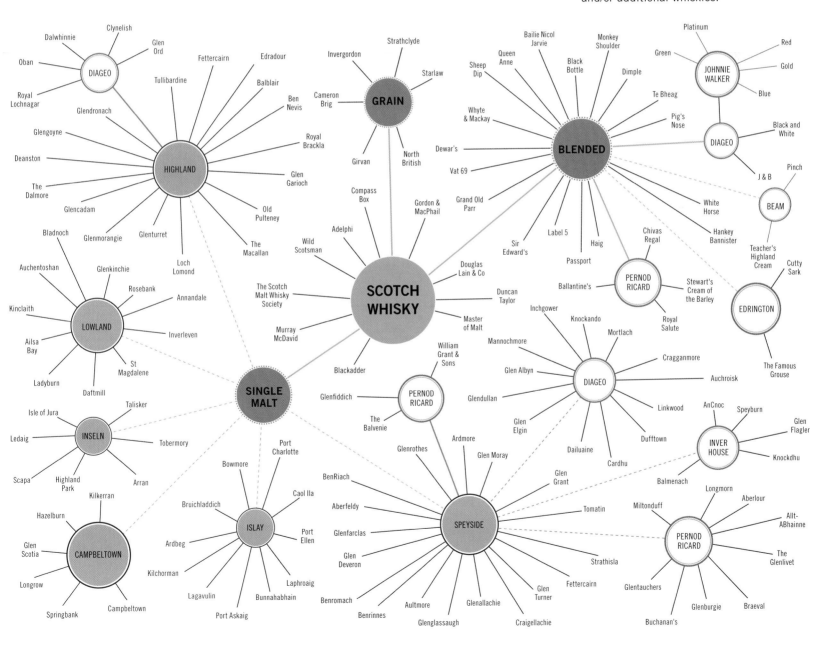

Irish Whiskey & Canadian Whisky Guidelines & Styles

Ireland and Canada boast strong whiskey-making traditions and grant considerable leeway to producers in terms of how their products are labeled.

CANADIAN

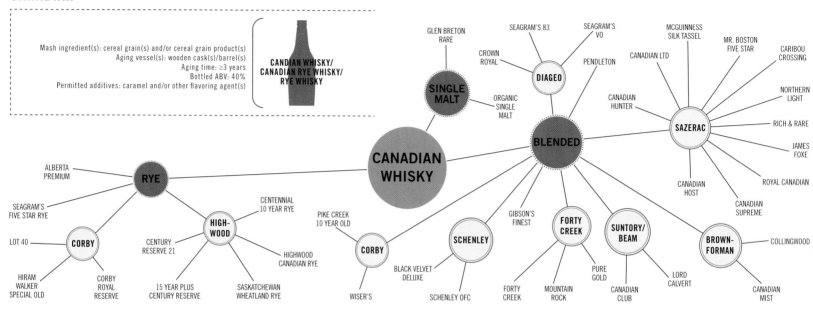

Mash ingredient(s): cereal grain(s) and/or cereal grain product(s)
Aging vessel(s): wooden cask(s)/barrel(s)
Aging time: ≥3 years
Bottled ABV: 40%
Permitted additives: caramel and/or other flavoring agent(s)

CANDIAN WHISKY/
CANADIAN RYE WHISKY/
RYE WHISKY

IRISH

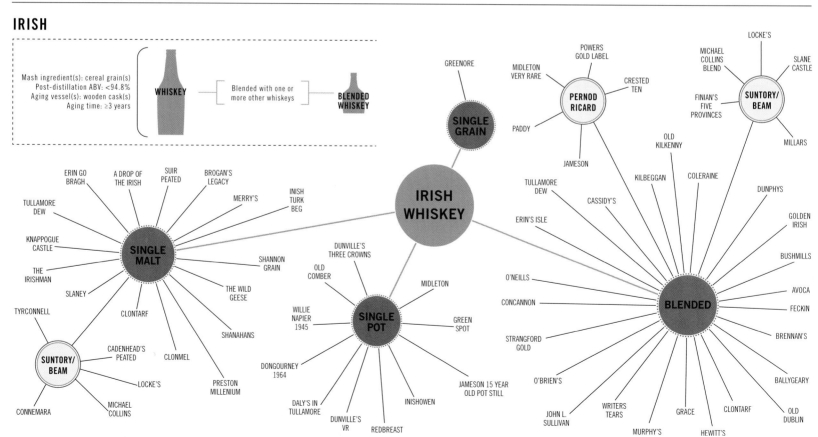

Mash ingredient(s): cereal grain(s)
Post-distillation ABV: <94.8%
Aging vessel(s): wooden cask(s)
Aging time: ≥3 years

WHISKEY — Blended with one or more other whiskeys → BLENDED WHISKEY

Flavored Whisk(e)y

Though not as numerous as their vodka and rum counterparts, flavored whiskeys represent an emerging trend in distillation. Fireball, a cinnamon-flavored whiskey favored by college students, has experienced particularly explosive growth in popularity over the last few years.

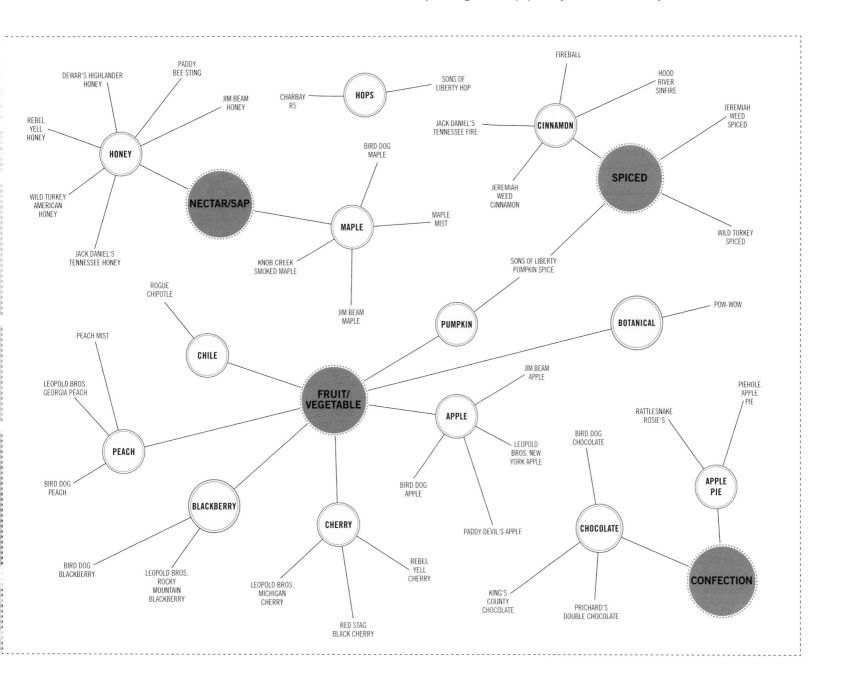

Whiskey Cocktails

Though a well-aged whiskey is probably best enjoyed on its own, this spirit is still used as the base ingredient in many iconic mixed drinks, such as the Manhattan and the Old Fashioned.

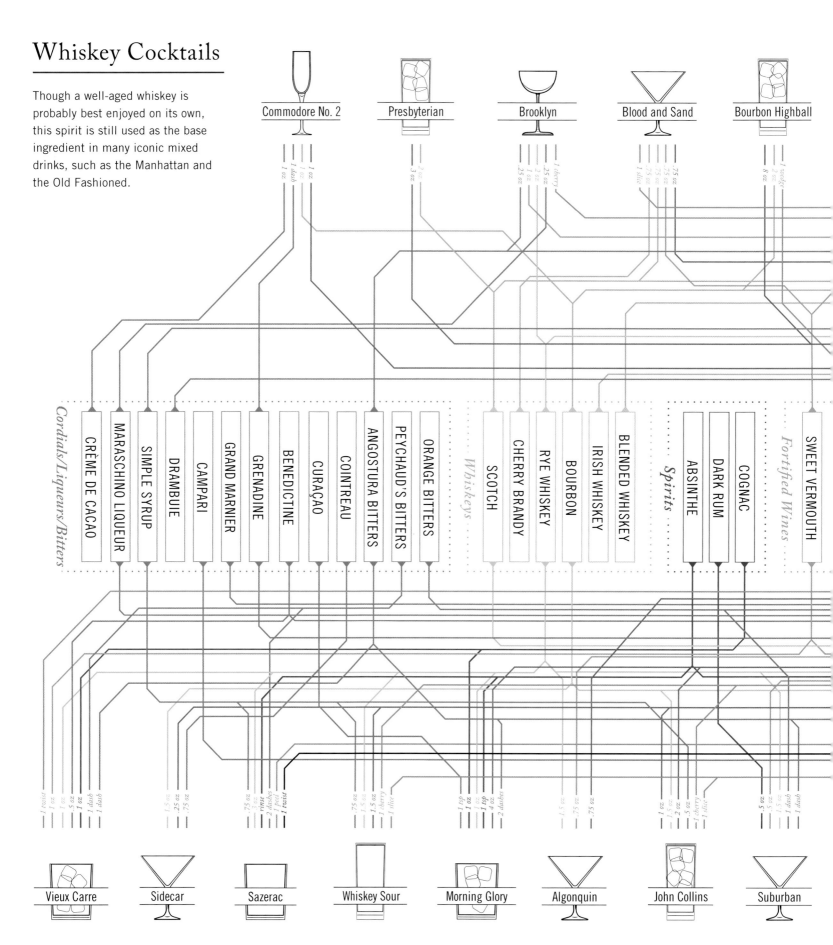

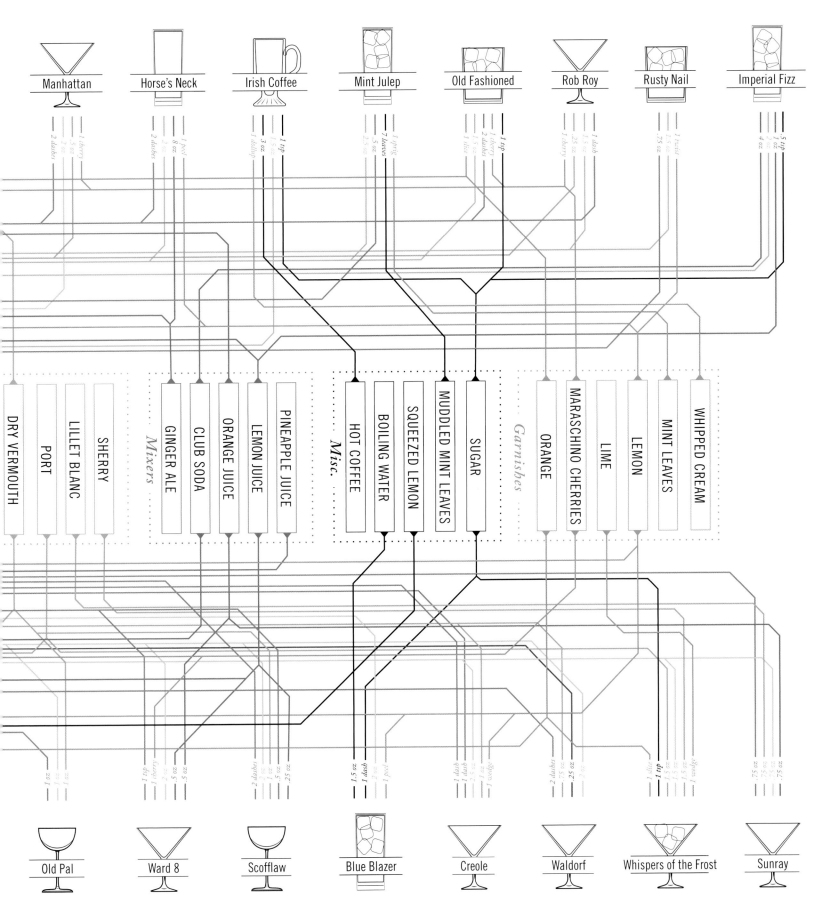

Manhattan Horse's Neck Irish Coffee Mint Julep Old Fashioned Rob Roy Rusty Nail Imperial Fizz

DRY VERMOUTH PORT LILLET BLANC SHERRY *Mixers* GINGER ALE CLUB SODA ORANGE JUICE LEMON JUICE PINEAPPLE JUICE *Misc.* HOT COFFEE BOILING WATER SQUEEZED LEMON MUDDLED MINT LEAVES SUGAR *Garnishes* ORANGE MARASCHINO CHERRIES LIME LEMON MINT LEAVES WHIPPED CREAM

Old Pal Ward 8 Scofflaw Blue Blazer Creole Waldorf Whispers of the Frost Sunray

The Vodka-Making Process

The vodka-making process is all in pursuit of the cleanest, most unadulterated form of alchohol possible. The desired output should taste of nothing other than ethanol.

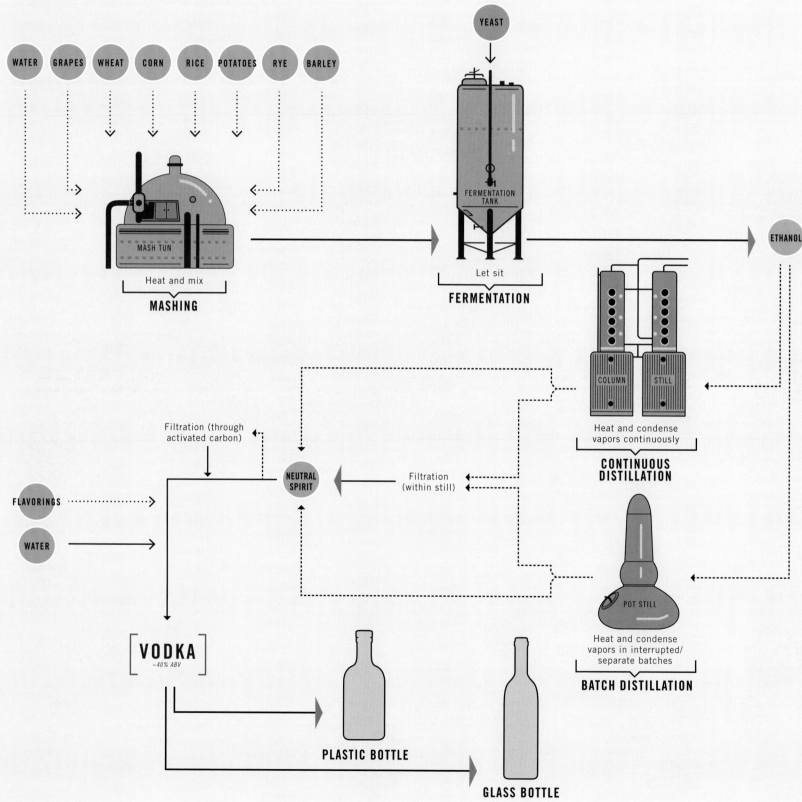

Vodka Styles

Vodkas can be sorted according to their base starch. Vodkas are commonly flavored, and although such drinks are eschewed by purists today, it appears that flavored vodkas are substantially older than today's clean vodkas.

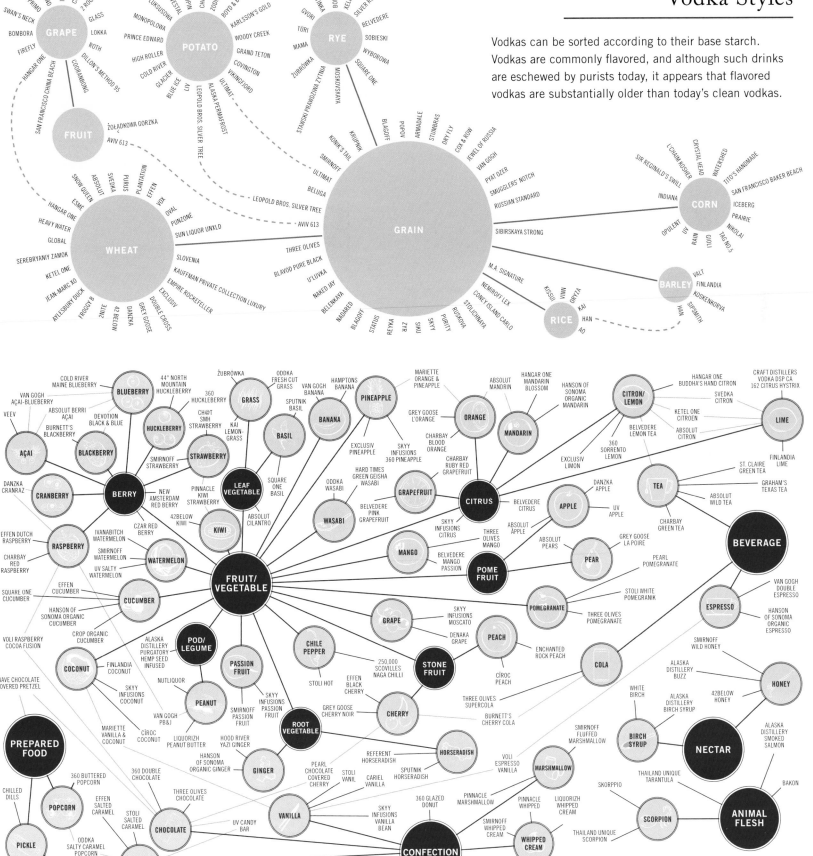

The Vodka Belt

Vodka is closely associated with eastern Europe and Russia, and most likely originated in Poland. Today, most distilleries are still found in this part of the world.

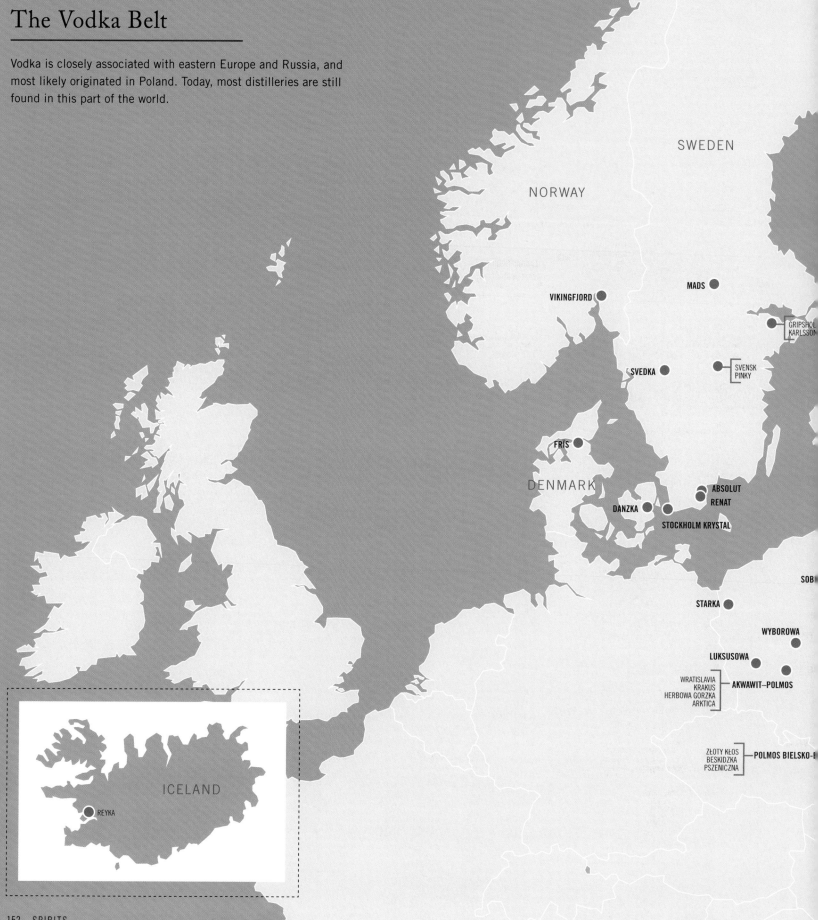

NORWAY

SWEDEN

VIKINGFJORD

MADS

GRIPSHOL
KARLSSON

SVEDKA

SVENSK
PINKY

FRÍS

DENMARK

ABSOLUT
RENAT

DANZKA

STOCKHOLM KRYSTAL

SOB

STARKA

WYBOROWA

LUKSUSOWA

WRATISLAVIA
KRAKUS
HERBOWA GORZKA
ARKTICA

AKWAWIT–POLMOS

ZŁOTY KŁOS
BESKIDZKA
PSZENICZNA

POLMOS BIELSKO-E

ICELAND

REYKA

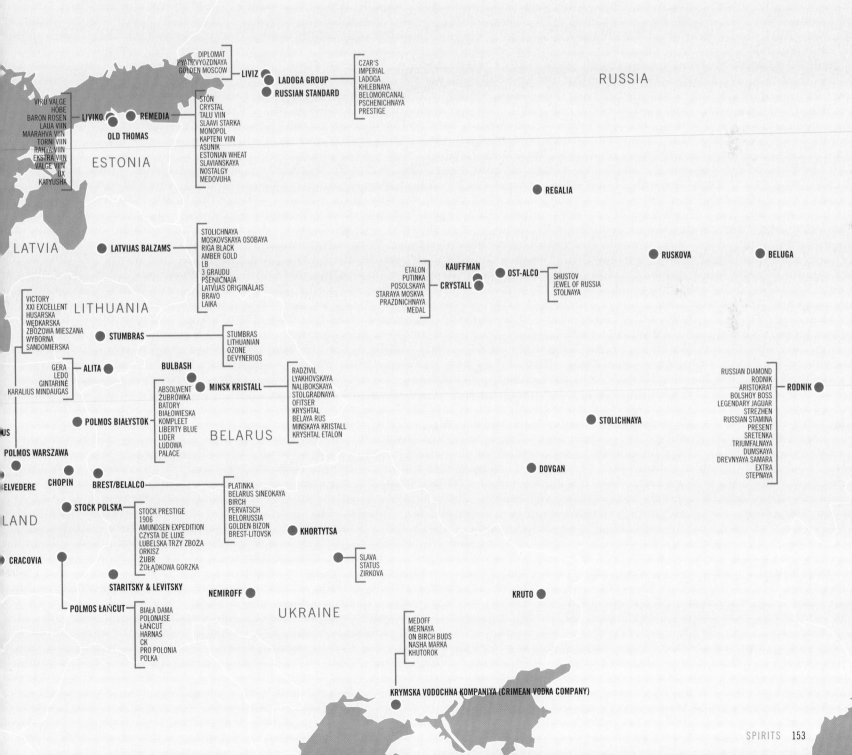

GLOBAL DRINKS FINLAND
- MOSES
- LAPLANDIA
- FINNTASTIC
- LITTLEONE
- DIESEL

ALTIA
- KOSKENKORVA
- FINLANDIA

FINLAND

DIPLOMAT
PYATIZVYOZDNAYA
GOLDEN MOSCOW

LIVIZ

LADOGA GROUP
- CZAR'S
- IMPERIAL
- LADOGA
- KHLEBNAYA
- BELOMORCANAL
- PSCHENICHNAYA
- PRESTIGE

RUSSIAN STANDARD

RUSSIA

VIRU VALGE
HÕBE
BARON ROSEN
LAUA VIIN
MAARAHVA VIIN
TORNI VIIN
RAHVA VIIN
EKSTRA VIIN
VALGE VIIN
ÜX
KATYUSHA

LIVIKO

REMEDIA

OLD THOMAS

- STÖN
- CRYSTAL
- TALU VIIN
- SLAAVI STARKA
- MONOPOL
- KAPTENI VIIN
- ASUNIK
- ESTONIAN WHEAT
- SLAVIANSKAYA
- NOSTALGY
- MEDOVUHA

ESTONIA

REGALIA

LATVIA

LATVIJAS BALZAMS
- STOLICHNAYA
- MOSKOVSKAYA OSOBAYA
- RIGA BLACK
- AMBER GOLD
- LB
- 3 GRAUDU
- PŠENIČNAJA
- LATVIJAS ORIĢINĀLAIS
- BRAVO
- LAIKA

RUSKOVA

BELUGA

ETALON
PUTINKA
POSOLSKAYA
STARAYA MOSKVA
PRAZDNICHNAYA
MEDAL

KAUFFMAN

CRYSTALL

OST-ALCO
- SHUSTOV
- JEWEL OF RUSSIA
- STOLNAYA

LITHUANIA

VICTORY
XXI EXCELLENT
HUSARSKA
WĘDKARSKA
ZBOŻOWA MIESZANA
WYBORNA
SANDOMIERSKA

STUMBRAS
- STUMBRAS
- LITHUANIAN
- OZONE
- DEVYNERIOS

GERA
LEDO
GINTARINĖ
KARALIUS MINDAUGAS

ALITA

BULBASH

MINSK KRISTALL
- RADZIVIL
- LYAKHOVSKAYA
- NALIBOKSKAYA
- STOLGRADNAYA
- OFITSER
- KRYSHTAL
- BELAYA RUS
- MINSKAYA KRISTALL
- KRYSHTAL ETALON

RUSSIAN DIAMOND
RODNIK
ARISTOKRAT
BOLSHOY BOSS
LEGENDARY JAGUAR
STREZHEN
RUSSIAN STAMINA
PRESENT
SRETENKA
TRIUMFALNAYA
DUMSKAYA
DREVNYAYA SAMARA
EXTRA
STEPNAYA

RODNIK

ABSOLWENT
ŻUBRÓWKA
BATORY
BIAŁOWIESKA
KOMPLEET
LIBERTY BLUE
LIDER
LUDOWA
PALACE

POLMOS BIAŁYSTOK

BELARUS

STOLICHNAYA

POLMOS WARSZAWA

DOVGAN

BELVEDERE

CHOPIN

BREST/BELALCO
- PLATINKA
- BELARUS SINEOKAYA
- BIRCH
- PERVATSCH
- BELORUSSIA
- GOLDEN BIZON
- BREST-LITOVSK

POLAND

STOCK POLSKA
- STOCK PRESTIGE
- 1906
- AMUNDSEN EXPEDITION
- CZYSTA DE LUXE
- LUBELSKA TRZY ZBOŻA
- ORKISZ
- ŻUBR
- ŻOŁĄDKOWA GORZKA

CRACOVIA

KHORTYTSA

SLAVA
STATUS
ZIRKOVA

STARITSKY & LEVITSKY

NEMIROFF

KRUTO

POLMOS ŁAŃCUT
- BIAŁA DAMA
- POLONAISE
- ŁAŃCUT
- HARNAŚ
- CK
- PRO POLONIA
- POLKA

UKRAINE

MEDOFF
MERNAYA
ON BIRCH BUDS
NASHA MARKA
KHUTOROK

KRYMSKA VODOCHNA KOMPANIYA (CRIMEAN VODKA COMPANY)

Vodka Cocktails

Vodka didn't rise to popularity in the United States until the 1950s, and thus many early vodka cocktails simply used it in place of a darker spirit. Over time, though, cocktails were developed that took advantage of vodka's unique clean flavor, such as the White Russian.

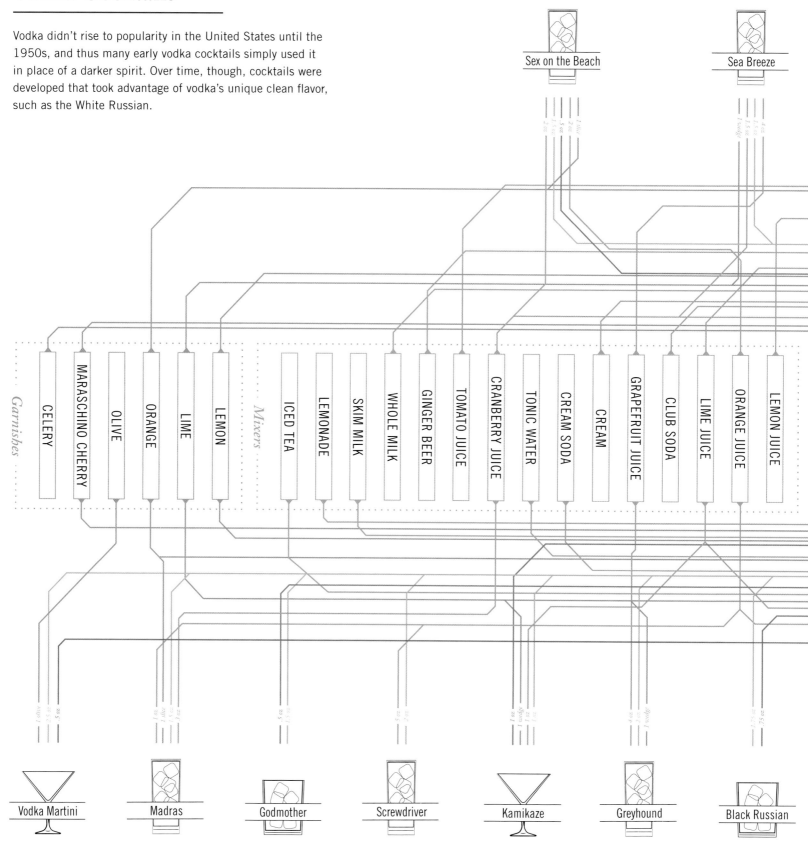

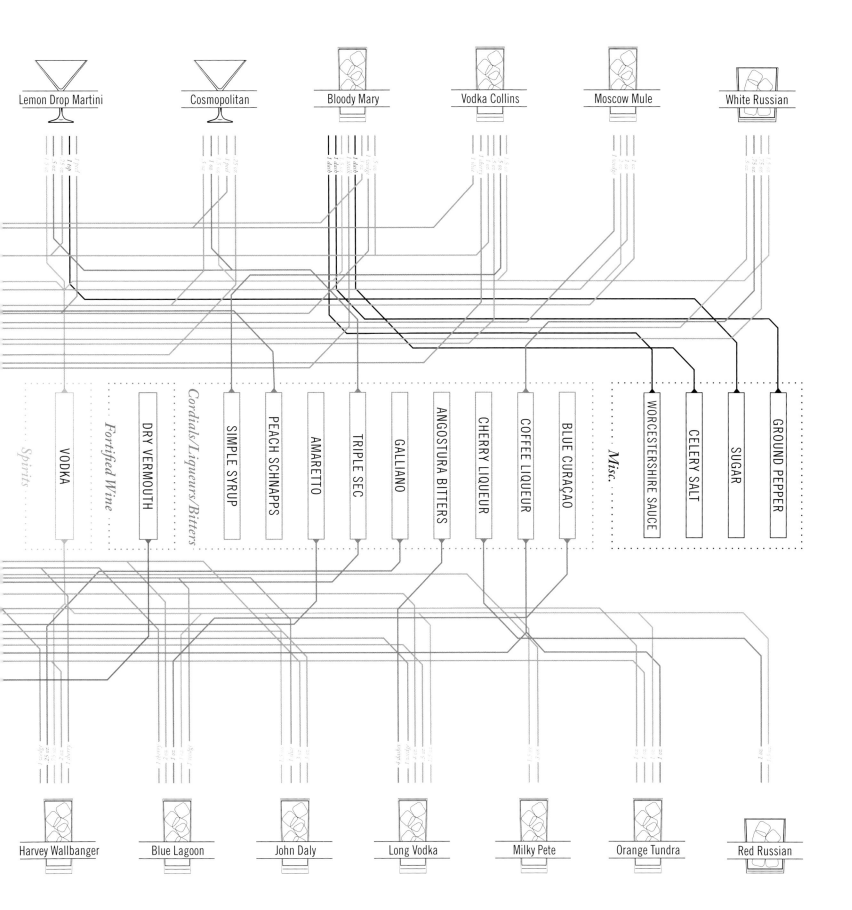

Lemon Drop Martini

Cosmopolitan

Bloody Mary

Vodka Collins

Moscow Mule

White Russian

Spirits

VODKA

Fortified Wine

DRY VERMOUTH

Cordials/Liqueurs/Bitters

SIMPLE SYRUP

PEACH SCHNAPPS

AMARETTO

TRIPLE SEC

GALLIANO

ANGOSTURA BITTERS

CHERRY LIQUEUR

COFFEE LIQUEUR

BLUE CURAÇAO

Misc.

WORCESTERSHIRE SAUCE

CELERY SALT

SUGAR

GROUND PEPPER

Harvey Wallbanger

Blue Lagoon

John Daly

Long Vodka

Milky Pete

Orange Tundra

Red Russian

The Gin-Making Process

Gin can basically be understood as vodka steeped with juniper berries. The production process first involves the creation of a neutral spirit, and then juniper and other botanicals are added before further distillation.

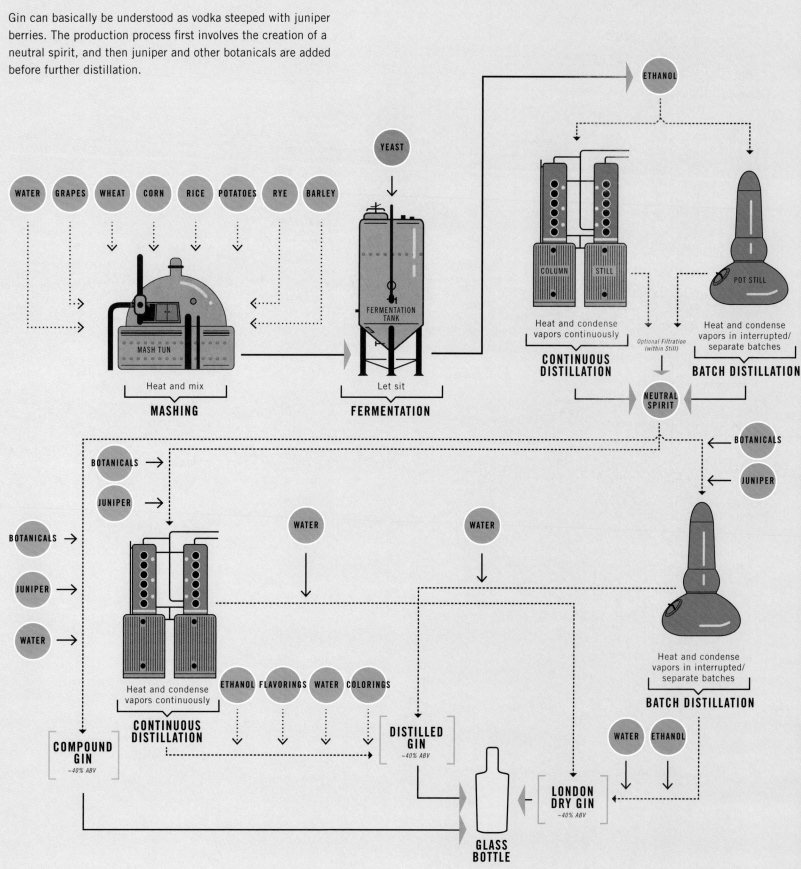

Gin Styles

Gin is generally sorted by country of origin—whether from Holland (where it first originated as genever), Great Britain, or the United States.

EXTRA DRY
- FLEISCHMANN'S
- SEAGRAM'S
- BARTON
- GILPIN'S WESTMORLAND
- WILLIAMS CHASE

LONDON DRY
- BLUE RIBBON
- GERANIUM
- TANQUERAY
- GORDON'S
- SIPSMITH
- BLOOM
- BERKSHIRE MOUNTAIN GREYLOCK
- HAYMAN'S LONDON DRY
- MARTIN MILLER'S
- BERKELEY SQUARE
- GILBEY'S
- FINSBURY
- GREENALL'S
- BEEFEATER
- FIFTY POUNDS
- ICEBERG
- OLIVER CROMWELL
- BOODLES BRITISH
- SAINSBURY'S BLACKFRIARS
- BULLDOG
- JODHPUR
- ADNAMS COPPER HOUSE DISTILLED
- OXLEY
- WHITLEY NEILL
- CH
- JUNIPER GREEN
- BOOTH'S
- BOMBAY SAPPHIRE
- BROKER'S
- ELEPHANT

SPICED LONDON DRY
- DARNLEY'S VIEW

OLD TOM
- THE DORCHESTER OLD TOM
- VALENTINE LIBERATOR OLD TOM
- GIN XORIGUER
- LIBERATOR OLD TOM
- HAYMAN'S OLD TOM
- JENSEN'S OLD TOM
- THE SECRET TREASURES OLD TOM
- HAMMER & SON OLD ENGLISH
- TANQUERAY OLD TOM
- RANSOM OLD TOM

DRY
- BLACKWOODS
- MONOPOLOWA
- ANCHOR JUNIPERO GIN
- BRUICHLADDICH THE BOTANIST
- NORTH SHORE DISTILLER'S GIN NO. 11
- PACIFIC DISTILLERY VOYAGER
- MONKEY 47
- ARIA PORTLAND DRY
- BLACKWOOD'S VINTAGE
- WARNER EDWARDS HARRINGTON
- SLOANE'S
- CORK
- MONTGOMERY WHYTE LAYDIE
- CLEARHEART
- BLUECOAT
- GREENHOOK GINSMITHS
- DRY FLY
- ROUNDHOUSE
- 35 MAPLE STREET UNCLE VAL'S

INTERNATIONAL
- CAORUNN
- CITADELLE
- HENDRICK'S
- DAMRAK
- OPIHR
- MAGELLAN
- BOË SUPERIOR
- UNGAVA
- VAN GOGH
- SOUTH
- LONDON Nº 1
- GIN MARE
- G'VINE NOUAISON

GENEVER/DUTCH
- BOLS GENEVER
- ANCHOR GENEVIEVE
- GINEBRA SAN MIGUEL
- ZUIDAM
- BOOMSMA

NEW AMERICAN
- COPPERWORKS
- ROCK TOWN BRANDON'S
- ROGUE SPRUCE
- ORGANIC NATION
- DESERT JUNIPER
- COLD RIVER
- VALENTINE LIBERATOR
- TUTHILLTOWN HALF MOON
- AVIATION
- BENDISTILLERY CRATER LAKE
- ORYZA
- FEW AMERICAN
- RANSOM SMALL'S
- GREAT LAKES REHORST
- BROOKLYN
- CORSAIR
- COPPER FOX VIRGIN
- NO. 209
- NEW AMSTERDAM
- COLORADO GOLD
- TOPO ORGANIC PIEDMONT
- LEOPOLD BROS.

Gin Cocktails

Gin is the main ingredient in the premier cocktail: the Martini. Its origins are a bit cloudy, but it was invented in America in the nineteenth century. The name possibly derives from an older drink known as the Martinez; a competing theory is that the name came from an Italian vermouth brand. Today many gin cocktails are Martini variants, but the venerable Tom Collins and Negroni drinks are also gin based.

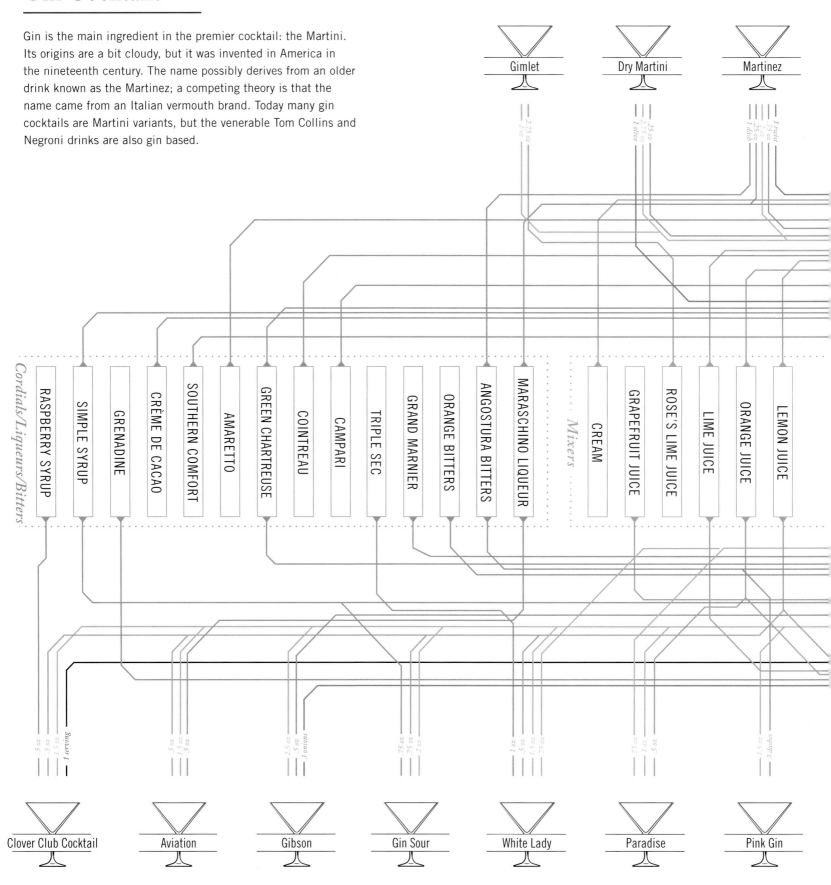

Gimlet

Dry Martini

Martinez

Cordials/Liqueurs/Bitters

RASPBERRY SYRUP
SIMPLE SYRUP
GRENADINE
CRÈME DE CACAO
SOUTHERN COMFORT
AMARETTO
GREEN CHARTREUSE
COINTREAU
CAMPARI
TRIPLE SEC
GRAND MARNIER
ORANGE BITTERS
ANGOSTURA BITTERS
MARASCHINO LIQUEUR

Mixers

CREAM
GRAPEFRUIT JUICE
ROSE'S LIME JUICE
LIME JUICE
ORANGE JUICE
LEMON JUICE

Clover Club Cocktail

Aviation

Gibson

Gin Sour

White Lady

Paradise

Pink Gin

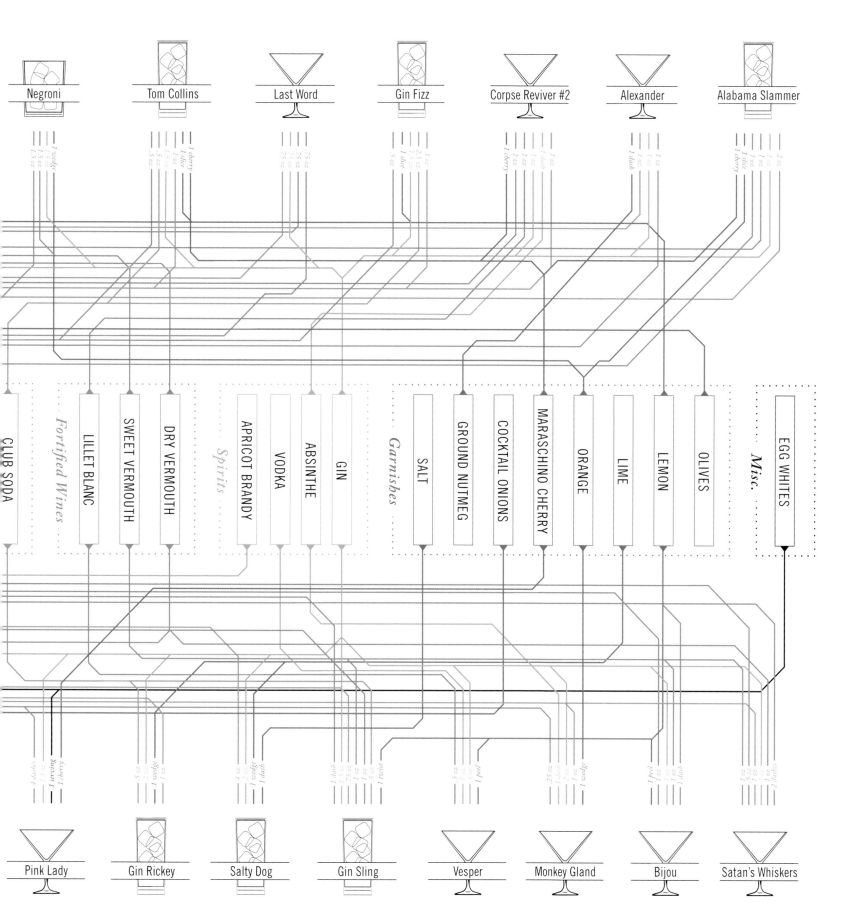

The Rum-Making Process

Although it is technically possible to make rum using sugarcane juice (a product sometimes referred to as Cachaça), it is more often produced through the distillation of molasses, a by-product of the sugarcane-refining process. Specific production methods vary considerably among different distilleries, especially in regard to the level of mechanization involved.

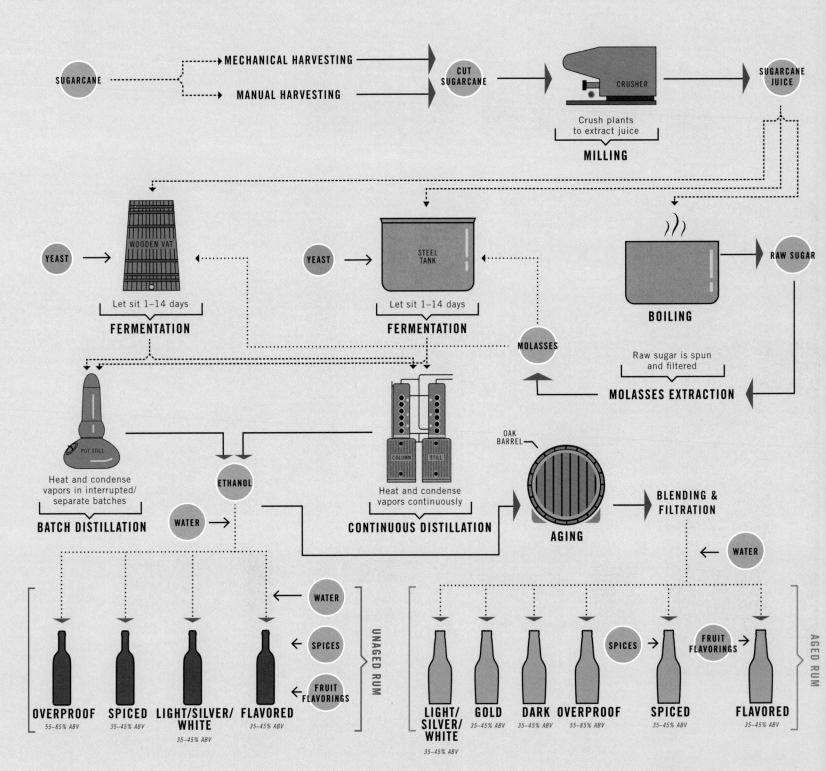

Rum Styles

Because rum is produced by myriad distilleries across different countries, its classifications are a bit looser than those of other spirits, and many brands actually fit into multiple categories. Age and color generally correspond with one another—a darker hue probably indicates a longer barrel-aging period. Flavored and spiced rums are distinguished by their infusion of additional ingredients while overproof rums are noted for their high alcohol content.

PREMIUM/AGED

Matusalem Gran Reserva 23
Santa Teresa 1796
Reserva Exclusiva
Reserva
Añejo — DIPLOMÁTICO
Clément
Aged Dark
Single Barrel
Aged Light — CRUZAN
Brugal Extra Dry
Real McCoy Aged 3 Years
Debonaire Private Reserve
Zaya Gran Reserva
Aged 15 Years
Chairman's Reserve
SVDL Captain Bligh XO
La Hechicera
TØZ White Gold
Royal Oak Select Trinidad
Vizcaya VXOP
Ron Zacapa
1703
Extra Old — MOUNT GAY
Dictador
3 Year Old
21 Year Old — EL DORADO
Pampero Aniversario
Añejo
8 Años — BACARDI
Ron Abuelo
Fortuna 8 Year Old
Rhum Agricole Extra Vieux Neisson
Reserve
30 Year Old
20 Year Old — APPLETON ESTATE
Plantation Grande Réserve
Pyrat 1623
Angostura 5 Year Old
Carupano
Havana Club
Solera 1893
Reserva — BOTRAN

DARK

Lamb's
Rhum Barbancourt Pango
Bacardi Select
The Kraken
McDowell's No. 1 Celebration
Rogue Dark
Cruzan Aged Dark
Ironworks Bluenose Black
Screech
Sainsbury's Superior Dark
Gosling's Black Seal
Old New Orleans Amber
Stolen Dark
Plantation Original Dark
Blue Label
Aged 15 Years — PUSSER'S

GOLD

Cockspur Fine
Rhum J.M Gold
Koloa Kaua'i Gold
Sergeant Classick Gold
Stolen Gold
Elements Eight Gold
Bounty
Mount Gay Eclipse
Ragged Mountain
Bacardi Gold
Chairman's Reserve
SVDL Captain Bligh XO
La Hechicera
TØZ White Gold

FLAVORED

Below Deck Coffee
Grand Melon
Dragon Berry
Limón — BACARDI
Spirit of Texas Pecan Street
Limon
Coco — DON Q
Whaler's Vanillé
Orange
Citrus
Coconut
Banana
Mango — CRUZAN
Charbay Tahitian Vanilla Bean

LIGHT

Bacardi Superior
Don Q Cristal
Rhum Barbancourt White
Mount Gay Eclipse Silver
Trader Vic's Silver
El Dorado 3 Year Old
Clarke's Court Superior
Wray & Nephew
SVDL Sunset Very Strong
Bully Boy White
Miami Club
Brugal Extra Dry
Real McCoy Aged 3 Years
Cruzan Aged Light
Debonaire Private Reserve
Sergeant Classick Silver
Stolen White
Envy
Plantation 3 Stars
Diplomático Blanco
Rhum J.M Agricole Blanc
Montanya Platino
Owney's
Below Deck Silver
Vizcaya Cristal
Glaser Distillery White
Prichard's Crystal

SPICED

Cruzan 9
Koloa Kaua'i Spice
Red Leg
Admiral Nelson's
The Lash
The Kraken
Old New Orleans Cajun Spice
Trader Vic's Spiced
Sailor Jerry
Chairman's Reserve Spiced
Maximon Spiced
Calypso
Bacardi Oakheart
Rogue Hazelnut

OVERPROOF

Original — CAPTAIN MORGAN
100 Proof
Black — CAPTAIN MORGAN
Bacardi 151
Rougaroux Sugarshine
Inner Circle
Pusser's Gunpowder Proof
Lemon Hart 151
Wray & Nephew
SVDL Sunset Very Strong

Rum Distilleries of the Caribbean

Rum originated in the West Indies when Europeans established large-scale sugarcane plantations (worked almost exclusively by slave labor). Today most rum distilleries are still located in these islands, although some have been established in recent years in the United States and elsewhere.

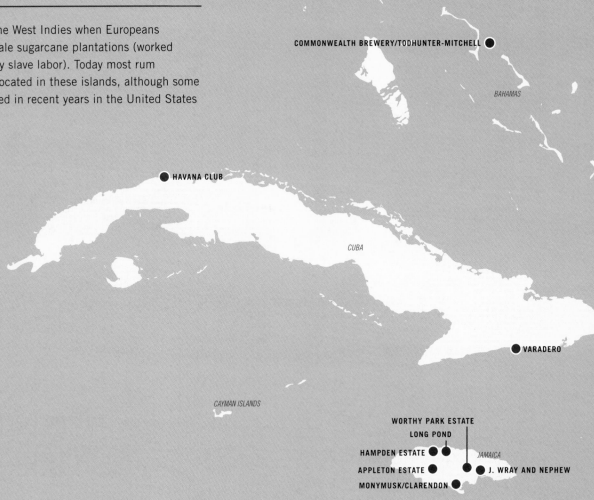

COMMONWEALTH BREWERY/TODHUNTER-MITCHELL ●

BAHAMAS

● HAVANA CLUB

CUBA

● VARADERO

CAYMAN ISLANDS

WORTHY PARK ESTATE
LONG POND ●
HAMPDEN ESTATE ● ● *JAMAICA*
APPLETON ESTATE ● ● J. WRAY AND NEPHEW
MONYMUSK/CLARENDON ●

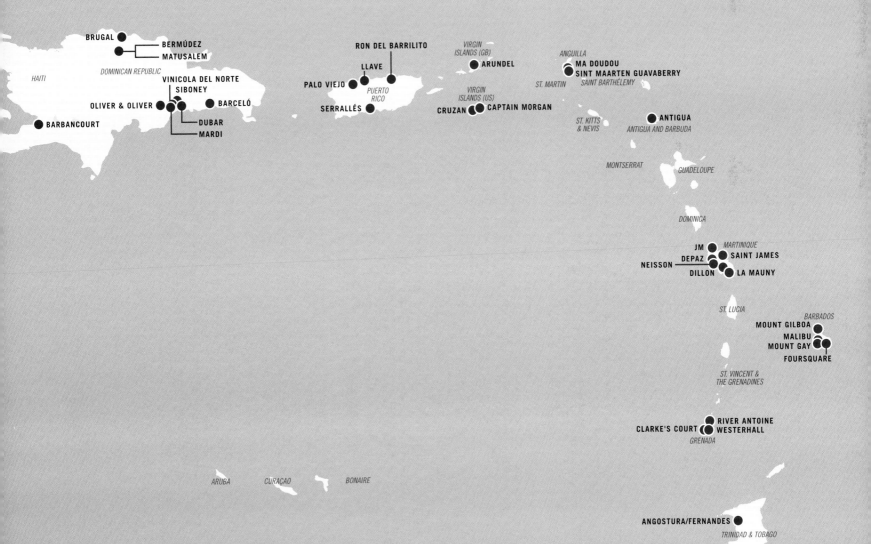

TURKS &
CAICOS ISLANDS

● **BAMBARRA**

● **BRUGAL**

BERMÚDEZ

MATUSALEM

DOMINICAN REPUBLIC

HAITI

VINICOLA DEL NORTE
SIBONEY

OLIVER & OLIVER ●

● **BARCELÓ**

● **BARBANCOURT**

DUBAR

MARDI

RON DEL BARRILITO

VIRGIN
ISLANDS (GB)

● **ARUNDEL**

ANGUILLA

● **MA DOUDOU**
SINT MAARTEN GUAVABERRY

ST. MARTIN *SAINT BARTHÉLEMY*

LLAVE

PALO VIEJO ●
PUERTO
RICO

SERRALLÉS ●

VIRGIN
ISLANDS (US)

CRUZAN ●● **CAPTAIN MORGAN**

ST. KITTS
& NEVIS

● **ANTIGUA**
ANTIGUA AND BARBUDA

MONTSERRAT *GUADELOUPE*

DOMINICA

JM ● *MARTINIQUE*
DEPAZ ●● **SAINT JAMES**
NEISSON ●
DILLON ●● **LA MAUNY**

ST. LUCIA

BARBADOS
MOUNT GILBOA ●
MALIBU ●
MOUNT GAY ●●
FOURSQUARE

ST. VINCENT &
THE GRENADINES

● **RIVER ANTOINE**
CLARKE'S COURT ●● **WESTERHALL**
GRENADA

ARUBA *CURAÇAO* *BONAIRE*

ANGOSTURA/FERNANDES ●
TRINIDAD & TOBAGO

Rum Cocktails

Perhaps owing to its Caribbean heritage, rum is the liquor most identified with the spirit of relaxation. This is borne out in such classic cocktails as the Daiquiri, the Mojito, and the Piña Colada.

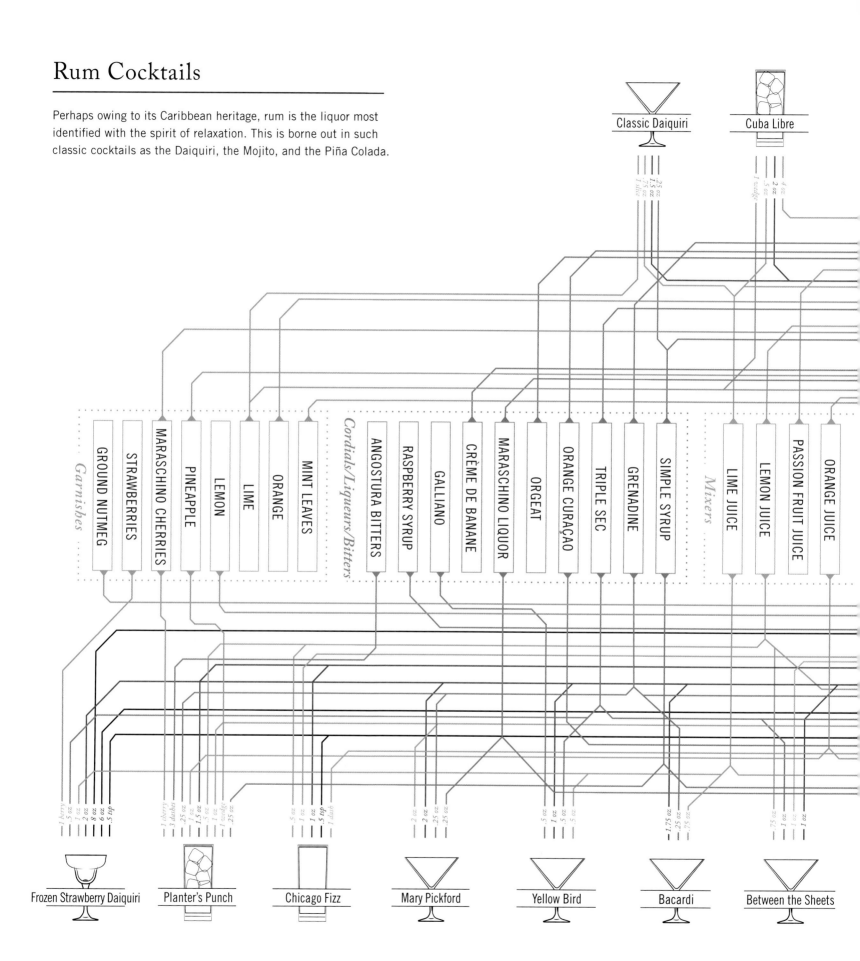

Classic Daiquiri

Cuba Libre

Garnishes

GROUND NUTMEG

STRAWBERRIES

MARASCHINO CHERRIES

PINEAPPLE

LEMON

LIME

ORANGE

MINT LEAVES

Cordials/Liqueurs/Bitters

ANGOSTURA BITTERS

RASPBERRY SYRUP

GALLIANO

CRÊME DE BANANE

MARASCHINO LIQUOR

ORGEAT

ORANGE CURAÇAO

TRIPLE SEC

GRENADINE

SIMPLE SYRUP

Mixers

LIME JUICE

LEMON JUICE

PASSION FRUIT JUICE

ORANGE JUICE

Frozen Strawberry Daiquiri

Planter's Punch

Chicago Fizz

Mary Pickford

Yellow Bird

Bacardi

Between the Sheets

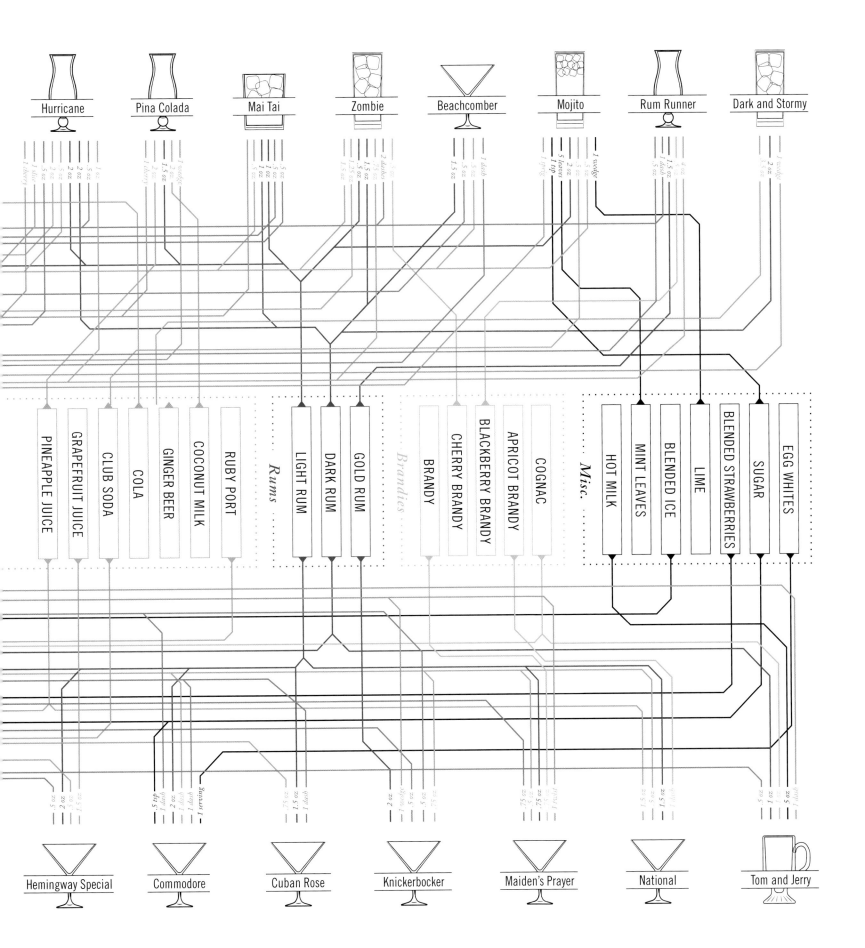

Hurricane

Pina Colada

Mai Tai

Zombie

Beachcomber

Mojito

Rum Runner

Dark and Stormy

PINEAPPLE JUICE

GRAPEFRUIT JUICE

CLUB SODA

COLA

GINGER BEER

COCONUT MILK

RUBY PORT

Rums

LIGHT RUM

DARK RUM

GOLD RUM

Brandies

BRANDY

CHERRY BRANDY

BLACKBERRY BRANDY

APRICOT BRANDY

COGNAC

Misc.

HOT MILK

MINT LEAVES

BLENDED ICE

LIME

BLENDED STRAWBERRIES

SUGAR

EGG WHITES

Hemingway Special

Commodore

Cuban Rose

Knickerbocker

Maiden's Prayer

National

Tom and Jerry

The Tequila-Making Process

Due to its government-mandated denomination of origin status, tequila is produced in a fairly uniform fashion across different distilleries. The main opportunities for variation in the process include repeated distillations, aging, and the limited addition of colorants and/or flavorings.

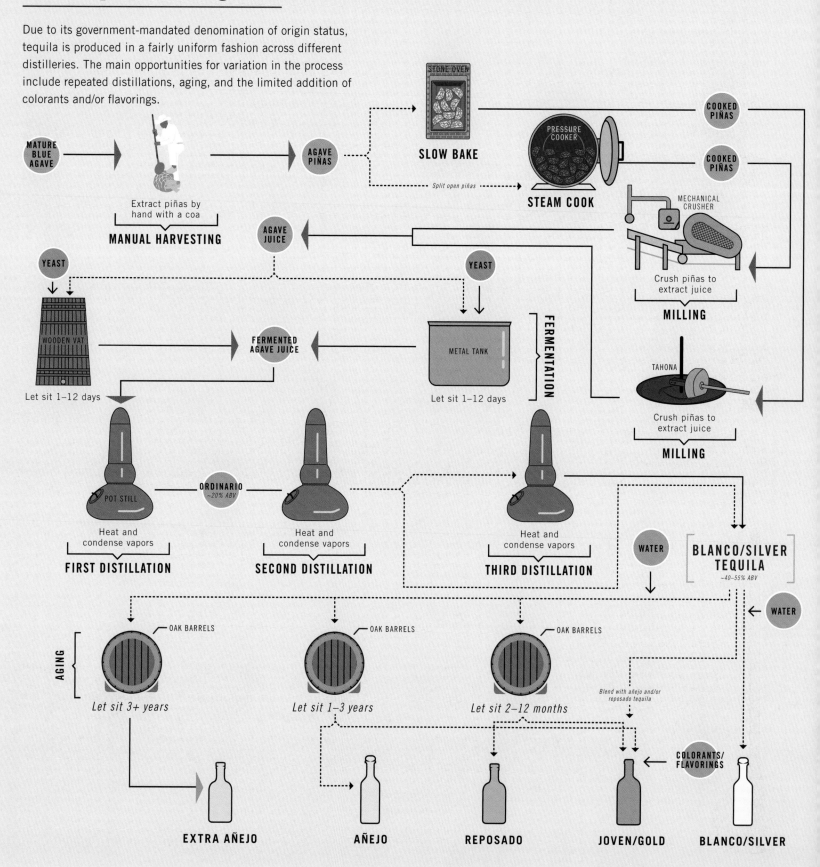

The Agave Plant

Agave tequilana, commonly referred to as blue agave due to its distinctive color, is one of more than two hundred species of the agave plant genus. Native to the Mexican state of Jalisco, a legally defined center of tequila production, its sap is fermented and distilled in order to make the quintessential Mexican spirit.

As blue agave ages over the course of several years, the *jimador*, or harvester, is responsible for trimming the plant's leaves and stalk, both of which are capable of growing an additional several feet if left untended. This process helps to enlarge the piña, or heart of the plant, which is eventually stripped completely of its leaves and uprooted by the *jimador* in order to have its sap extracted.

①

②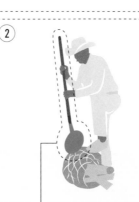

③

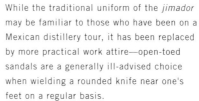

What truly distinguishes the cultivation of tequila's base ingredient from those of other spirits is the striking lack of technological aid. The form and design of the coa, a specialized hoe used by the *jimador* throughout the cultivation and harvesting process, has remained virtually the same over the years.

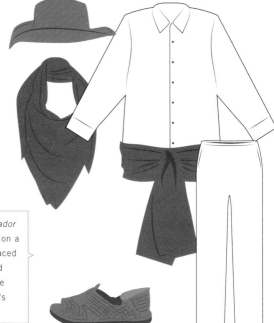

While the traditional uniform of the *jimador* may be familiar to those who have been on a Mexican distillery tour, it has been replaced by more practical work attire—open-toed sandals are a generally ill-advised choice when wielding a rounded knife near one's feet on a regular basis.

Tequila Distilleries of Mexico

Although tequila production spans five Mexican states, the vast majority (along with the bulk of the blue agave harvest) takes place in Jalisco. Most countries legally recognize tequila as a uniquely Mexican product produced in these specific areas.

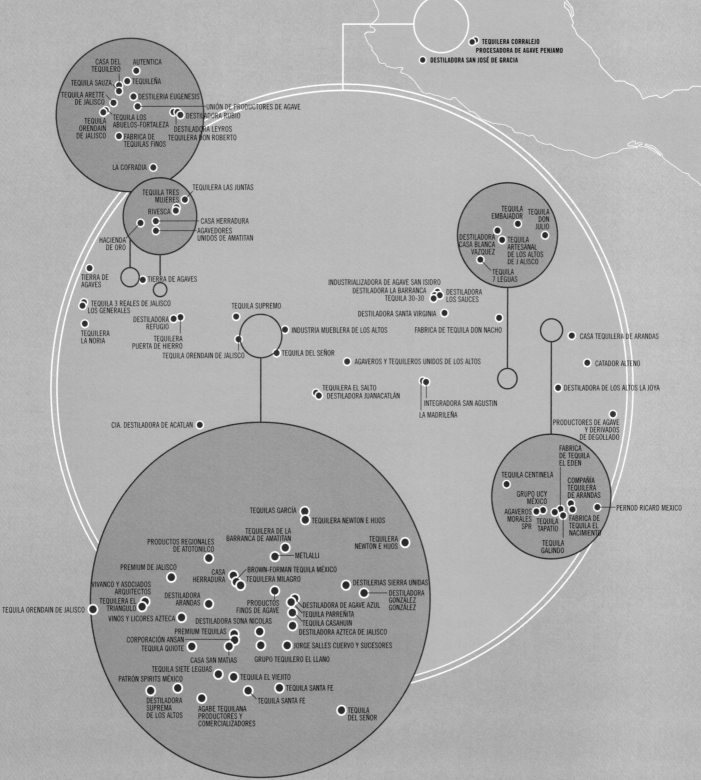

LA GONZALEÑA

TEQUILERA LA GONZALEDA

TEQUILERA CORRALEJO
PROCESADORA DE AGAVE PENJAMO

DESTILADORA SAN JOSÉ DE GRACIA

CASA DEL TEQUILERO
AUTENTICA
TEQUILA SAUZA
TEQUILEÑA
TEQUILA ARETTE DE JALISCO
DESTILERIA EUGENESIS
UNIÓN DE PRODUCTORES DE AGAVE
DESTILADORA RUBIO
TEQUILA LOS ABUELOS-FORTALEZA
DESTILADORA LEYROS
TEQUILA ORENDAIN DE JALISCO
TEQUILERA DON ROBERTO
FABRICA DE TEQUILAS FINOS

LA COFRADIA

TEQUILA TRES MUJERES
TEQUILERA LAS JUNTAS
RIVESCA
CASA HERRADURA
AGAVEDORES UNIDOS DE AMATITAN
HACIENDA DE ORO

TIERRA DE AGAVES
TIERRA DE AGAVES

TEQUILA 3 REALES DE JALISCO
LOS GENERALES
DESTILADORA REFUGIO
TEQUILERA LA NORIA
TEQUILERA PUERTA DE HIERRO
TEQUILA ORENDAIN DE JALISCO

TEQUILA SUPREMO
INDUSTRIA MUEBLERA DE LOS ALTOS
TEQUILA DEL SEÑOR

INDUSTRIALIZADORA DE AGAVE SAN ISIDRO
DESTILADORA LA BARRANCA
TEQUILA 30-30
DESTILADORA LOS SAUCES
DESTILADORA SANTA VIRGINIA
FABRICA DE TEQUILA DON NACHO

TEQUILA EMBAJADOR
TEQUILA DON JULIO
DESTILADORA CASA BLANCA VAZQUEZ
TEQUILA ARTESANAL DE LOS ALTOS DE J ALISCO
TEQUILA 7 LEGUAS

CASA TEQUILERA DE ARANDAS

CATADOR ALTENO

AGAVEROS Y TEQUILEROS UNIDOS DE LOS ALTOS
DESTILADORA DE LOS ALTOS LA JOYA

TEQUILERA EL SALTO
DESTILADORA JUANACATLÁN
INTEGRADORA SAN AGUSTIN
LA MADRILEÑA

CIA. DESTILADORA DE ACATLAN

PRODUCTORES DE AGAVE Y DERIVADOS DE DEGOLLADO

FABRICA DE TEQUILA EL EDEN
TEQUILA CENTINELA
GRUPO UCY MÉXICO
COMPAÑÍA TEQUILERA DE ARANDAS
PERNOD RICARD MEXICO
AGAVEROS MORALES SPR
TEQUILA TAPATIO
FABRICA DE TEQUILA EL NACIMIENTO
TEQUILA GÁLINDO

TEQUILAS GARCÍA
TEQUILERA NEWTON E HIJOS
PRODUCTOS REGIONALES DE ATOTONILCO
TEQUILERA DE LA BARRANCA DE AMATITAN
METLALLI
TEQUILERA NEWTON E HIJOS
PREMIUM DE JALISCO
CASA HERRADURA
BROWN-FORMAN TEQUILA MÉXICO
TEQUILERA MILAGRO
VIVANCO Y ASOCIADOS ARQUITECTOS
TEQUILERA EL TRIANGULO
DESTILADORA ARANDAS
DESTILERIAS SIERRA UNIDAS
DESTILADORA GONZÁLEZ GONZÁLEZ
TEQUILA ORENDAIN DE JALISCO
PRODUCTOS FINOS DE AGAVE
DESTILADORA DE AGAVE AZUL
VINOS Y LICORES AZTECA
TEQUILA PARREÑITA
DESTILADORA SONA NICOLAS
TEQUILA CASAHUIN
PREMIUM TEQUILAS
DESTILADORA AZTECA DE JALISCO
CORPORACIÓN ANSAN
TEQUILA QUIOTE
JORGE SALLES CUERVO Y SUCESORES
CASA SAN MATIAS
GRUPO TEQUILERO EL LLANO
TEQUILA SIETE LEGUAS
TEQUILA EL VIEJITO
PATRÓN SPIRITS MÉXICO
TEQUILA SANTA FE
DESTILADORA SUPREMA DE LOS ALTOS
TEQUILA SANTA FE
AGABE TEQUILANA PRODUCTORES Y COMERCIALIZADORES
TEQUILA DEL SEÑOR

Tequila Styles

There are five main classifications of tequila, and for the most part, they are based on age. Joven/Gold is the exception—it refers to a tequila that may be blended and/or has had additional colorings and flavorants added before being bottled.

BLANCO/SILVER

- Jose Cuervo Platino
- Inocente Platinum
- Astral
- Gran Patrón Platinum
- Milagro Select Barrel Reserve Silver
- Casamigos Blanco
- El Tesoro Platinum
- Arette Blanco Suave
- Avión Silver
- Casa Noble Blanco
- Patrón Silver
- Calle 23 Blanco
- Siete Leguas Blanco
- Partida Blanco
- 1921 Blanco
- Corzo Silver
- 1800 Reserva Silver
- Don Julio Blanco
- Siembra Azul Blanco
- Charbay
- Hornitos Plata
- Tres Generaciones Plata
- Cabo Wabo Blanco
- Herradura Silver
- Tequila Ocho Plata
- 4 Copas Blanco
- Agave Dos Mil Blanco
- Azuñia Platinum Blanco
- Don Valente Blanco
- 5150 Blanco
- Fortaleza Blanco
- La Piñata Plata
- Republic Plata
- Gran Dovejo Blanco
- PaQuí Silvera
- Artá Silver
- Sol Azul Silver
- Casa de Luna Blanco
- Corrido Blanco
- Puro Verde Silver
- Voodoo Tiki Platinum
- Mejor Tequila Blanco
- 88 Blanco
- Riazul Silver
- Teteo Blanco
- Kah Blanco
- El Viejito Silver
- Don Modesto Blanco
- Vida Tequila Blanco
- Revolucion 100 Proof Silver
- El Reformador Blanco
- 1921 Blanco
- Comisario Blanco
- Aha Toro Blanco
- YEYO Silver
- El Gran Jubileo Blanco
- El Jimador Blanco
- Hotel California Blanco
- Talero Silver
- Abreojos Silver

REPOSADO

- Jose Cuervo Tradicional
- Olmeca Altos Reposado
- Siete Leguas Reposado
- Partida Reposado
- Maestro Dobel
- Milagro Select Barrel Reserve Reposado
- El Tesoro de Don Felipe Reposado
- Herradura Reposado
- Chinaco Reposado
- Casa Noble Reposado
- Frida Kahlo Reposado
- Corazón de Agave Reposado
- Gran Centenario Reposado
- Cabo Wabo Reposado
- Reserva de Don Julio Reposado
- Siembra Azul Reposado
- Muchote Reposado
- Agave Dos Mil Reposado
- Gran Dovejo Reposado
- Marquez de Valencia
- Republic Reposado
- 374 Reposado
- Don Valente Reposado
- 4 Copas Reposado
- Corrido Reposado
- 3 Amigos Reposado
- 5150 Reposado
- Kah Reposado
- Mejor Tequila Reposado
- Trago Reposado
- El Viejito Reposado
- Sol de Mexico Reposado
- Aha Toro Reposado
- Señor Rio Reposado
- Dulce Vida Reposado
- Azuñia Reposado
- Puro Verde Reposado
- Artá Reposado
- Riazul Reposado
- El Rey y Yo Reposado
- Voodoo Tiki Reposado
- El Gran Jubileo Reposado
- Peligroso Reposado
- CRUZ Reposado
- Vida Tequila Reposado
- Sol Azul Reposado
- El Relingo Reposado
- 88 Reposado
- La Piñata Reposado
- Aeroplano Reposado
- Casa de Luna Reposado
- 123 Organic Reposado
- Espolón Reposado
- Lunazul Reposado
- Los Azulejos Reposado
- Chamucos Reposado
- Piedra Azul Reposado
- Montejima Reposado

AÑEJO

- Avión Añejo
- Cazadores Añejo
- Corazón de Agave Añejo
- Herradura Añejo
- Tres Generaciones Añejo
- Luna Nueva Añejo
- Voodoo Tiki Añejo
- Casa Noble Añejo
- Gran Centenario Añejo
- Tres Agaves Añejo
- El Tesoro De Don Felipe Añejo
- Kah Añejo
- Suavecito Añejo
- Cabo Wabo Añejo
- 1800 Tequila Reserva Añejo
- Hornitos Añejo
- El Jimador Añejo
- Milagro Añejo
- Partida Añejo
- Tapatio Añejo
- Don Julio 1942
- Chinaco Añejo
- 4 Copas Añejo
- Riazul Añejo
- Dulce Vida Añejo
- Corrido Añejo
- Peligroso Añejo
- Republic Añejo
- Agave Dos Mil Añejo Grand Reserve
- XQ Gran Reserva Añejo
- Artá Añejo
- Azuñia Añejo
- Aha Toro Añejo
- Comisario Añejo
- Don Jose Lopez Portillo Añejo
- Señor Rio Añejo
- Don Valente Añejo
- La Piñata Añejo
- El Relingo Añejo
- El Viejito Añejo
- Capaz Añejo
- 5150 Añejo
- 374 Añejo
- Tequila II 55 Añejo
- 3 Amigos Añejo
- Ambhar Añejo
- Oro de Jalisco Añejo
- Gran Dovejo Añejo
- Sol de Mexico Añejo
- El Charro Añejo
- Don Modesto Añejo
- Vida Tequila Añejo
- 88 Añejo
- Gran Patrón Burdeos
- U4Rick Añejo

JOVEN/GOLD

- Casa Dragones
- Agavales Gold
- Casa Noble Joven
- La Cava de los Morales Gold
- XXX Siglo Treinta Gold
- Margaritaville Gold
- Sauza Gold
- Olmeca Gold
- Pepe Lopez Gold
- Jose Cuervo Especial Gold
- Cesar Monterrey Gold Reserva
- Zafarrancho Gold
- Milagro Unico

EXTRA AÑEJO

- Don Julio Real
- Jose Cuervo Reserva de la Familia
- Qui Platinum Extra Añejo
- San Matias Gran Reserva
- Gran Centenario Leyenda
- AsomBroso 11 Year Añejo
- Crótalo Extra Añejo
- Casa Noble Single Barrel Extra Añejo
- Chinaco Negro Extra Añejo
- Herradura Seleccion Suprema
- Corrido Extra Añejo
- Toro de Lidia Extra Añejo
- Siete Leguas D'Antaño
- San Matias Rey Sol
- Tonala Suprema Reserva
- Partida Elegante
- Centinela Extra Añejo
- El Gran Jubileo Seleccion Suprema
- Herencia Historico
- Arette Gran Clase

Tequila Cocktails

Many tequila cocktails simply substitute tequila for another spirit in a cocktail, such as the punnily named Juan Collins and Tegroni, but the best tequila drinks, such as the famed Margarita, utilize the unique taste profile of the liquor.

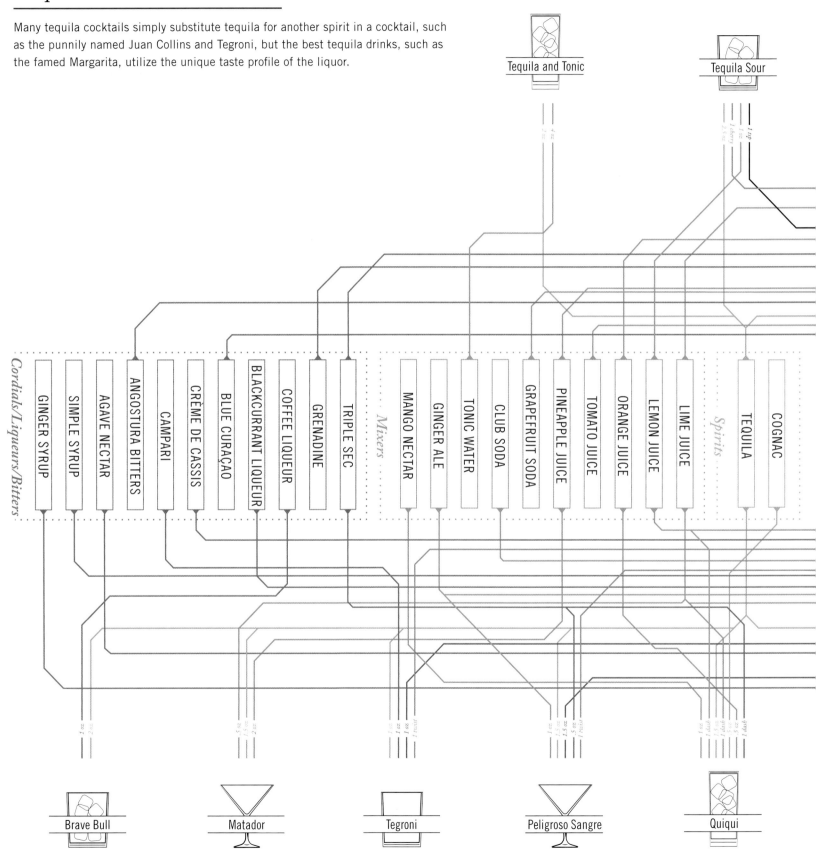

Tequila and Tonic

Tequila Sour

Cordials/Liqueurs/Bitters

GINGER SYRUP

SIMPLE SYRUP

AGAVE NECTAR

ANGOSTURA BITTERS

CAMPARI

CRÈME DE CASSIS

BLUE CURAÇAO

BLACKCURRANT LIQUEUR

COFFEE LIQUEUR

GRENADINE

TRIPLE SEC

Mixers

MANGO NECTAR

GINGER ALE

TONIC WATER

CLUB SODA

GRAPEFRUIT SODA

PINEAPPLE JUICE

TOMATO JUICE

ORANGE JUICE

LEMON JUICE

LIME JUICE

Spirits

TEQUILA

COGNAC

Brave Bull

Matador

Tegroni

Peligroso Sangre

Quiqui

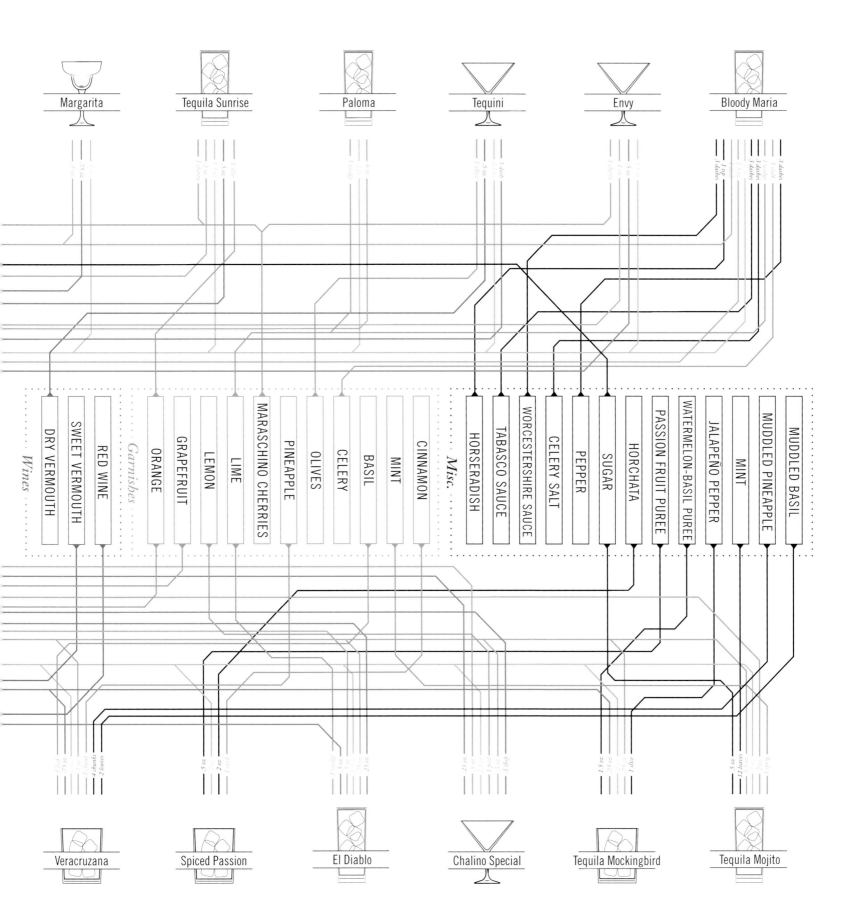

Margarita

Tequila Sunrise

Paloma

Tequini

Envy

Bloody Maria

Wines

DRY VERMOUTH

SWEET VERMOUTH

RED WINE

Garnishes

ORANGE

GRAPEFRUIT

LEMON

LIME

MARASCHINO CHERRIES

PINEAPPLE

OLIVES

CELERY

BASIL

MINT

CINNAMON

Misc.

HORSERADISH

TABASCO SAUCE

WORCESTERSHIRE SAUCE

CELERY SALT

PEPPER

SUGAR

HORCHATA

PASSION FRUIT PUREE

WATERMELON-BASIL PUREE

JALAPEÑO PEPPER

MINT

MUDDLED PINEAPPLE

MUDDLED BASIL

Veracruzana

Spiced Passion

El Diablo

Chalino Special

Tequila Mockingbird

Tequila Mojito

Brandy Styles & Regions

Simply put, brandy is distilled wine. Usually consumed as a digestif (i.e., post-meal), it contains 35% to 60% alcohol by volume and is drunk from a specialized glass referred to as a snifter. Pomace brandies, for their part, are distilled from the solid remains of grapes employed in the wine-making process. Both are produced around the world, but the most notable examples of each are found in Europe and South America.

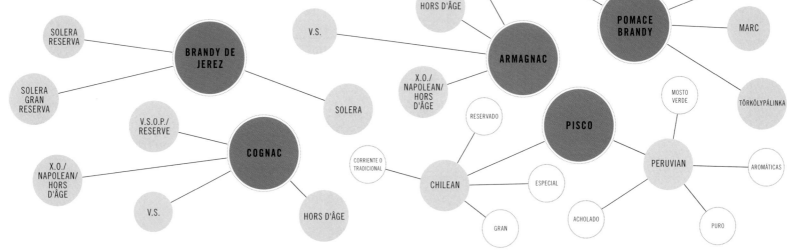

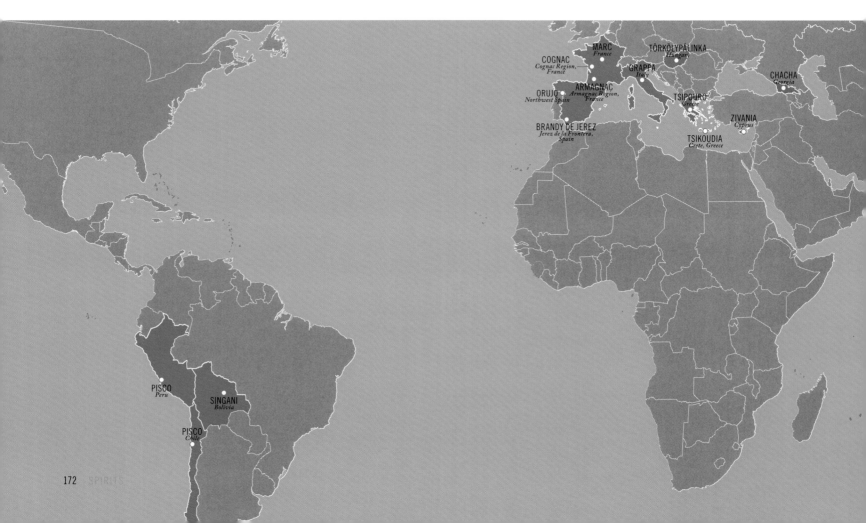

The Cognac-Making Process

Cognac is arguably the most famous—
and highest-quality—type of brandy.
Like Champagne, it has its own AOC that
defines not only its geographic origin in
France but also its unique and laborious
method of production.

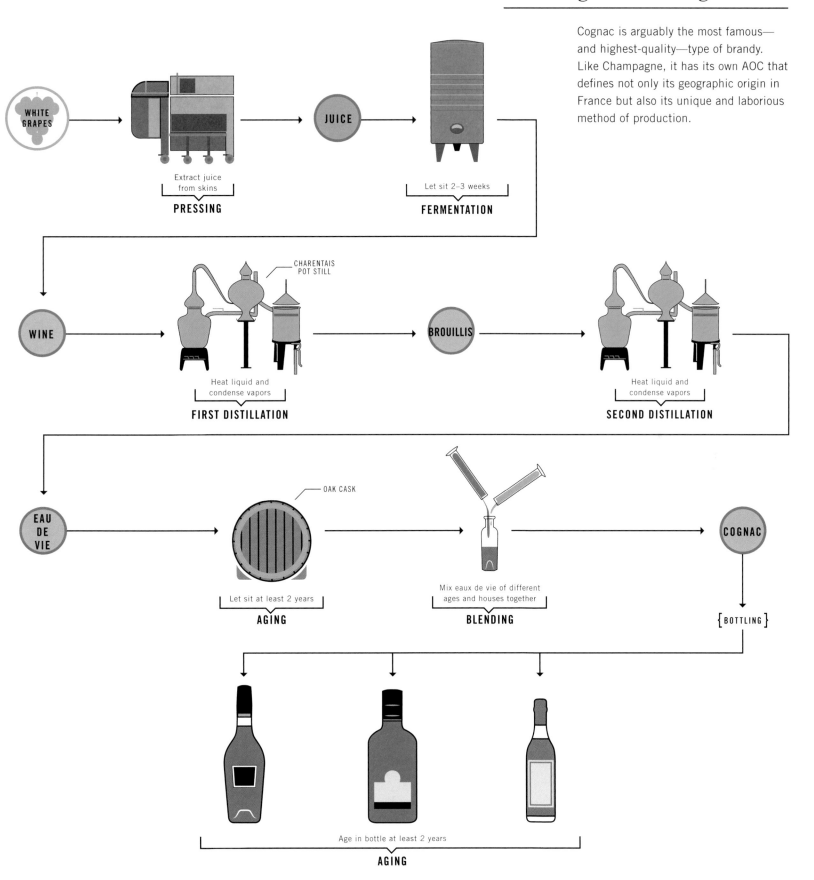

WHITE GRAPES

Extract juice
from skins

PRESSING

JUICE

Let sit 2–3 weeks

FERMENTATION

CHARENTAIS
POT STILL

WINE

Heat liquid and
condense vapors

FIRST DISTILLATION

BROUILLIS

Heat liquid and
condense vapors

SECOND DISTILLATION

OAK CASK

EAU DE VIE

Let sit at least 2 years

AGING

Mix eaux de vie of different
ages and houses together

BLENDING

COGNAC

{ BOTTLING }

Age in bottle at least 2 years

AGING

Brandy Cocktails

Many brandy cocktails date back to the nineteenth century, such as the Tom and Jerry. A brandy, rum, and warm milk concoction, it is the quintessential cold-weather cocktail.

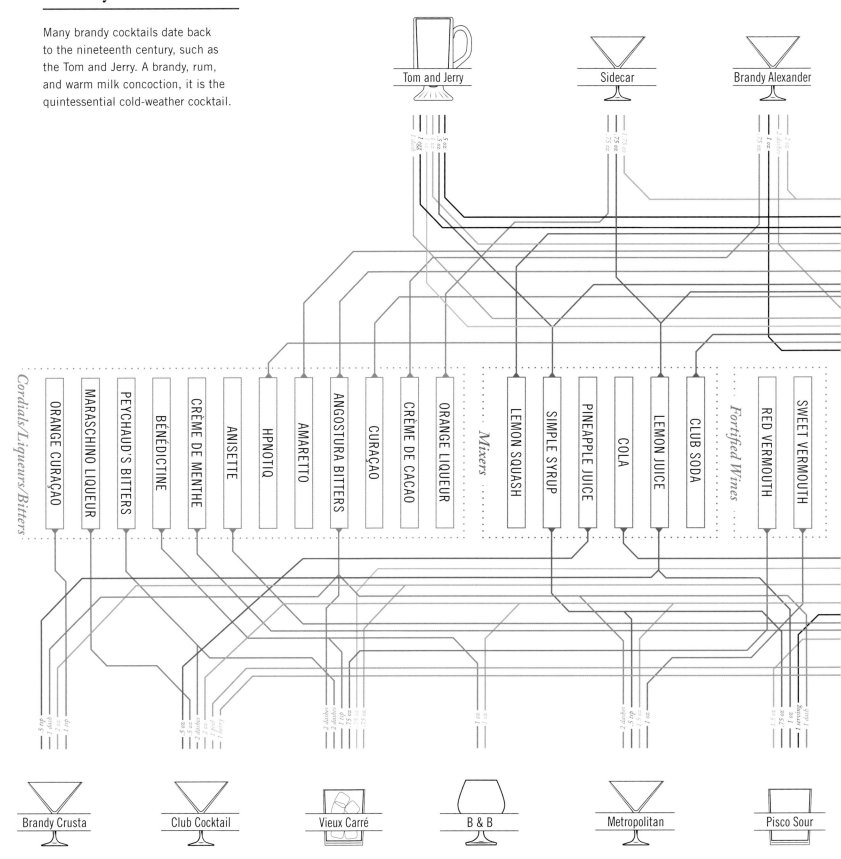

Tom and Jerry

Sidecar

Brandy Alexander

Cordials/Liqueurs/Bitters

ORANGE CURAÇAO
MARASCHINO LIQUEUR
PEYCHAUD'S BITTERS
BÉNÉDICTINE
CRÈME DE MENTHE
ANISETTE
HPNOTIQ
AMARETTO
ANGOSTURA BITTERS
CURAÇAO
CRÈME DE CACAO
ORANGE LIQUEUR

Mixers

LEMON SQUASH
SIMPLE SYRUP
PINEAPPLE JUICE
COLA
LEMON JUICE
CLUB SODA

Fortified Wines

RED VERMOUTH
SWEET VERMOUTH

Brandy Crusta

Club Cocktail

Vieux Carré

B & B

Metropolitan

Pisco Sour

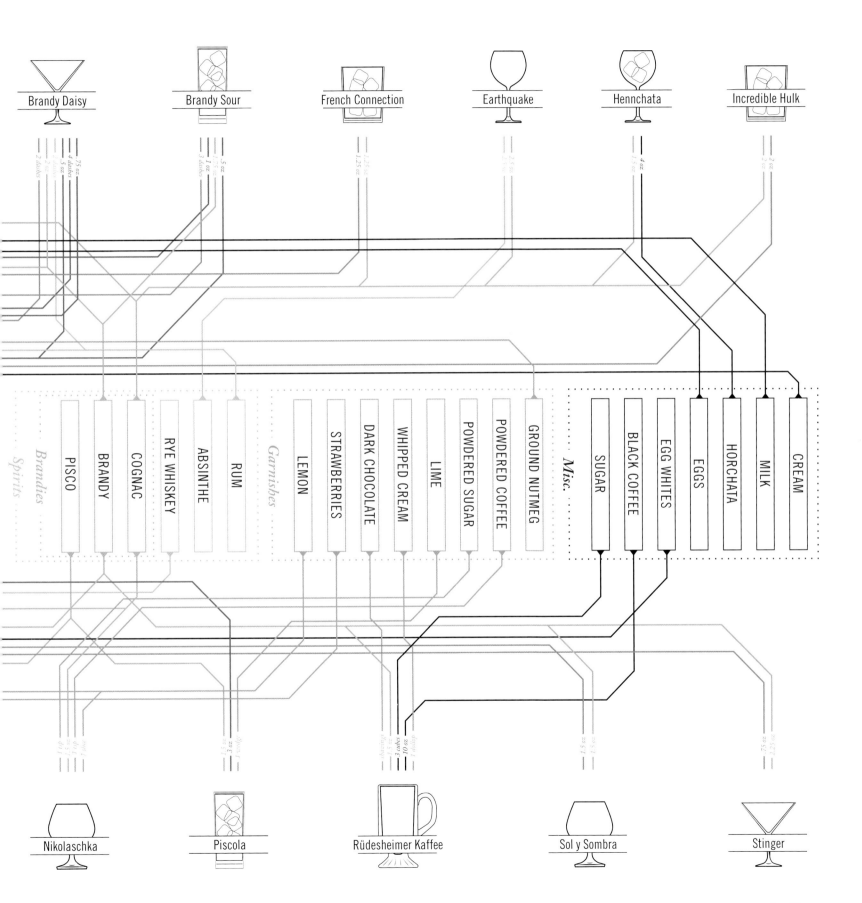

Brandy Daisy

Brandy Sour

French Connection

Earthquake

Hennchata

Incredible Hulk

Spirits

Brandies

PISCO

BRANDY

COGNAC

RYE WHISKEY

ABSINTHE

RUM

Garnishes

LEMON

STRAWBERRIES

DARK CHOCOLATE

WHIPPED CREAM

LIME

POWDERED SUGAR

POWDERED COFFEE

GROUND NUTMEG

Misc.

SUGAR

BLACK COFFEE

EGG WHITES

EGGS

HORCHATA

MILK

CREAM

Nikolaschka

Piscola

Rüdesheimer Kaffee

Sol y Sombra

Stinger

Liqueurs & Bitters

Typically, a liqueur will consist of a distilled alcohol, some sort of flavoring, and an added sweetening agent such as sugar. Along with bitters, which are alcoholic preparations noted for their distinctive botanical flavors, these drinks serve as an essential component of a multitude of different cocktails.

PEACH
- Mathilde
- Southern Comfort

COCONUT
- Batida de Coco
- Kalani
- Cocoribe
- Malibu

PEAR/POIRE WILLIAM
- Xanté
- Marie Brizard Poire William
- Mathilde Poire

MELON
- BOLS Melon
- Dolce Cilento Meloncello
- Midori

FRUIT
- PAMA Pomegranate
- Kuemmerling
- Jägermeister
- Schonauer Apple

KRÄUTER-LIKÖR

MARASCHINO
- Stock
- Drioli
- Luxardo
- Maraska

CHERRY
- Clear Creek
- Berentzen Wild Cherry

LEMON/LIMONCELLO
- Pallini
- Luxardo
- Sovrano

GRAPEFRUIT
- Combier Pamplemousse
- Tapaus Licor de Pomelo
- Giffard Crème de Pamplemousse

ORANGE/CITRUS
- KWV Van der Hum
- Aurum
- Pimm's No. 1 Cup
- Grand Marnier

ELDERFLOWER
- St-Germain
- The Bitter Truth

CHAMOMILE
- Marolo Milla
- J. Witty

JASMINE
- Greenbar Fruitlab Organic Jasmine

FLOWER

LIME
- Monin Original
- Velvet Falernum

TRIPLE SEC
- Stirrings
- Cointreau
- Pierre Ferrand

SAMBUCA
- Lazzaroni
- Antica
- Luxardo
- Averna

CURAÇAO
- Senior Curaçao
- Mandarine Napoléon

PASTIS
- Pernod Ricard Pastis 51
- Berger
- Pastis Henri Bardouin

ANISE
- Goldwasser
- Galliano

ANISETTE
- Meletti
- Marie Brizard
- KIS

HERBAL
- Damiana
- Bénédictine
- Liqueur Herbert
- Chartreuse
- Strega
- Becherovka
- Suze
- Agwa de Bolivia

LEMON VERBENA
- Verveine du Velay
- Sidetrack

LIQUEUR
- Glayva

HAZELNUT
- Frangelico
- Fratello
- Tamborine Mountain Choc Hazelnut

TOBACCO
- Sabra
- Perique Liqueur de Tebac
- Historias y Sabores

BITTERS
- Aperol
- St. Vitus
- Regan's Orange
- Peychaud's
- Underberg
- Campari
- Angostura

AMARO
- Fernet Branca
- Averna
- Ramazzotti

CHOCOLATE
- Godiva
- Mozart

176 SPIRITS

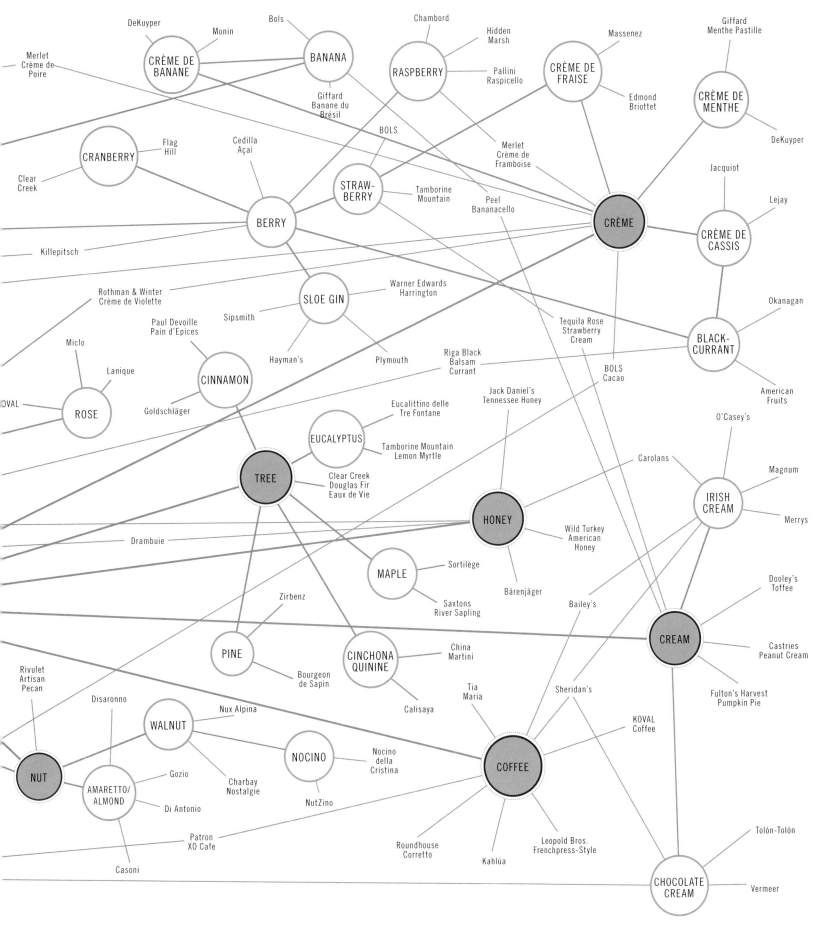

Merlet Crème de Poire

DeKuyper — CRÈME DE BANANE — Monin

Bols — BANANA

Chambord — RASPBERRY — Hidden Marsh

Pallini Raspicello

Massenez — CRÈME DE FRAISE

Giffard Menthe Pastille — CRÈME DE MENTHE

Edmond Briottet

DeKuyper

Giffard Banane du Brésil

BOLS

Flag Hill

CRANBERRY

Cedilla Açai

Clear Creek

STRAW-BERRY

Tamborine Mountain

Merlet Crème de Framboise

CRÈME

Jacquiot

Lejay

CRÈME DE CASSIS

BERRY

Peel Bananacello

Killepitsch

Okanagan

BLACK-CURRANT

American Fruits

Rothman & Winter Crème de Violette

Warner Edwards Harrington

SLOE GIN

Tequila Rose Strawberry Cream

Sipsmith

Riga Black Balsam Currant

BOLS Cacao

O'Casey's

Paul Devoille Pain d'Epices

Hayman's

Plymouth

Jack Daniel's Tennessee Honey

Miclo

CINNAMON

Carolans

Magnum

Lanique

Eucalittino delle Tre Fontane

IRISH CREAM

ROSE

EUCALYPTUS

Merrys

Goldschläger

Tamborine Mountain Lemon Myrtle

OVAL

TREE

Clear Creek Douglas Fir Eaux de Vie

HONEY

Wild Turkey American Honey

Dooley's Toffee

Drambuie

MAPLE — Sortilège

CREAM

Castries Peanut Cream

Zirbenz

Bärenjäger

Bailey's

Rivulet Artisan Pecan

PINE

CINCHONA QUININE

China Martini

Sheridan's

Fulton's Harvest Pumpkin Pie

Bourgeon de Sapin

Calisaya

Tia Maria

KOVAL Coffee

Disaronno

WALNUT

Nux Alpina

Nocino della Cristina

NOCINO

NUT

Gozio

Charbay Nostalgie

COFFEE

Tolón-Tolón

AMARETTO/ ALMOND

Di Antonio

NutZino

Leopold Bros. Frenchpress-Style

Patron XO Cafe

Roundhouse Corretto

Casoni

Kahlúa

CHOCOLATE CREAM — Vermeer

Celebrity Spirits

Celebrities have long been happy to lend their names to small-batch liquor, wine, and beer. In the past such ventures were mostly a matter of vanity, but successes such as Jay Z's investment in Ace of Spades Champagne have made it clear that there's real money to be made in celebrity alcohols.

Cabo Wabo Tequila

SAMMY HAGAR
Musician

Danny DeVito's Limoncello

DANNY DeVITO
Actor

Skinnygirl

BETHENNY FRANKEL
Entrepreneur

Myx Moscato

NICKI MINAJ
Rapper

Miraval Rosé

BRAD PITT
Actor

ANGELINA JOLIE
Actress

Haig Club Single Grain Scotch Whisky

DAVID BECKHAM
Athlete

Aviation American Gin

JOE MONTANA
Athlete

Dreaming Tree Wines

DAVE MATTHEWS
Musician

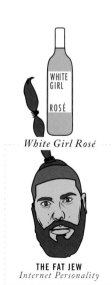

White Girl Rosé

THE FAT JEW
Internet Personality

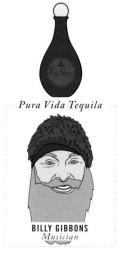

Pura Vida Tequila

BILLY GIBBONS
Musician

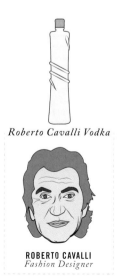

Roberto Cavalli Vodka

ROBERTO CAVALLI
Fashion Designer

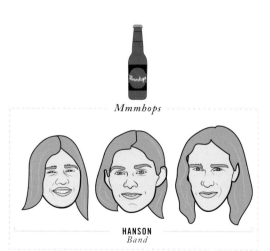

Mmmhops

HANSON
Band

Old Whiskey River Bourbon

WILLIE NELSON
Musician

Mangria

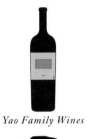

ADAM CAROLLA
Comedian

Sauza 901 Tequila

JUSTIN TIMBERLAKE
Singer, Actor

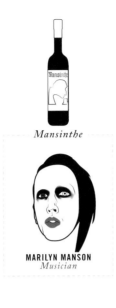

Conjure Cognac

LUDACRIS
Rapper, Actor

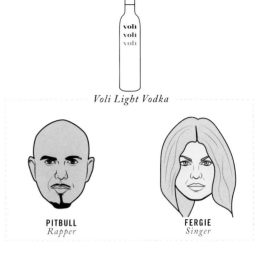

Mansinthe

MARILYN MANSON
Musician

Voli Light Vodka

PITBULL
Rapper

FERGIE
Singer

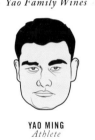

Yao Family Wines

YAO MING
Athlete

Barrymore Pinot Grigio

DREW BARRYMORE
Actress

Ron de Jeremy Rum

RON JEREMY
Adult Entertainer

Francis Ford Coppola Wine

FRANCIS FORD COPPOLA
Director

Ace of Spades
(Armand de Brignac Champagne)

JAY-Z
Business, man

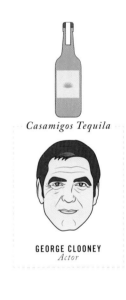

Casamigos Tequila

GEORGE CLOONEY
Actor

DeLeón Tequila

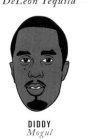

DIDDY
Mogul

Jeff Gordon Wine

JEFF GORDON
Race Car Driver

Tenuta Il Palagio Wine

STING
Musician

Crystal Head Vodka

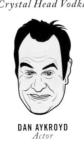

DAN AYKROYD
Actor

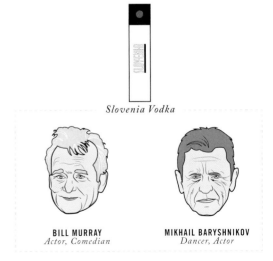

Slovenia Vodka

BILL MURRAY
Actor, Comedian

MIKHAIL BARYSHNIKOV
Dancer, Actor

Drinks from Film & Literature

From James Bond's famous martini to the White Russians favored by
The Dude to Philip Marlowe's gin gimlet, characters from film, TV, and
literature have both popularized existing cocktails and added all new
ones to the public's consciousness.

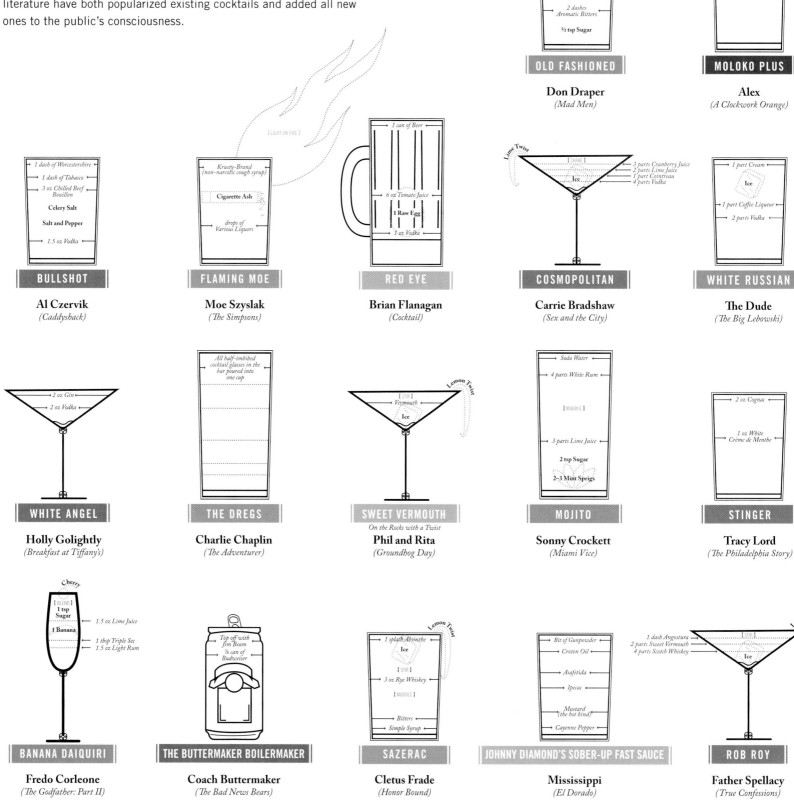

OLD FASHIONED

Don Draper
(Mad Men)

Lemon Wedge
1.5 oz Bourbon
Ice
[MUDDLE]
1 dash Soda Water
2 dashes Aromatic Bitters
½ tsp Sugar
1 Maraschino Cherry
Orange Slice

MOLOKO PLUS

Alex
(A Clockwork Orange)

Barbiturates
(Vellocet, Synthemesc, or Drencrom)
Milk

BULLSHOT

Al Czervik
(Caddyshack)

1 dash of Worcestershire
1 dash of Tabasco
3 oz Chilled Beef Bouillon
Celery Salt
Salt and Pepper
1.5 oz Vodka

FLAMING MOE

Moe Szyslak
(The Simpsons)

{ LIGHT ON FIRE }
Krusty-Brand (non-narcotic cough syrup)
Cigarette Ash
drops of Various Liquors

RED EYE

Brian Flanagan
(Cocktail)

1 can of Beer
6 oz Tomato Juice
1 Raw Egg
1 oz Vodka

COSMOPOLITAN

Carrie Bradshaw
(Sex and the City)

Lime Twist
[SHAKE]
Ice
3 parts Cranberry Juice
2 parts Lime Juice
1 part Cointreau
4 parts Vodka

WHITE RUSSIAN

The Dude
(The Big Lebowski)

1 part Cream
Ice
1 part Coffee Liqueur
2 parts Vodka

WHITE ANGEL

Holly Golightly
(Breakfast at Tiffany's)

2 oz Gin
2 oz Vodka

THE DREGS

Charlie Chaplin
(The Adventurer)

All half-imbibed cocktail glasses in the bar poured into one cup

SWEET VERMOUTH
On the Rocks with a Twist

Phil and Rita
(Groundhog Day)

[STIR]
Vermouth
Ice
Lemon Twist

MOJITO

Sonny Crockett
(Miami Vice)

Soda Water
4 parts White Rum
[MUDDLE]
3 parts Lime Juice
2 tsp Sugar
2–3 Mint Sprigs

STINGER

Tracy Lord
(The Philadelphia Story)

2 oz Cognac
1 oz White Crème de Menthe

BANANA DAIQUIRI

Fredo Corleone
(The Godfather: Part II)

Cherry
[BLEND]
1 tsp Sugar
1 Banana
1.5 oz Lime Juice
1 tbsp Triple Sec
1.5 oz Light Rum

THE BUTTERMAKER BOILERMAKER

Coach Buttermaker
(The Bad News Bears)

Top off with Jim Beam
⅞ can of Budweiser

SAZERAC

Cletus Frade
(Honor Bound)

1 splash Absinthe
Ice
[STIR]
3 oz Rye Whiskey
[MUDDLE]
Bitters
Simple Syrup
Lemon Twist

JOHNNY DIAMOND'S SOBER-UP FAST SAUCE

Mississippi
(El Dorado)

Bit of Gunpowder
Croton Oil
Asafetida
Ipecac
Mustard (the hot kind)
Cayenne Pepper

ROB ROY

Father Spellacy
(True Confessions)

1 dash Angostura
2 parts Sweet Vermouth
4 parts Scotch Whiskey
[STIR]
Ice
Lemon

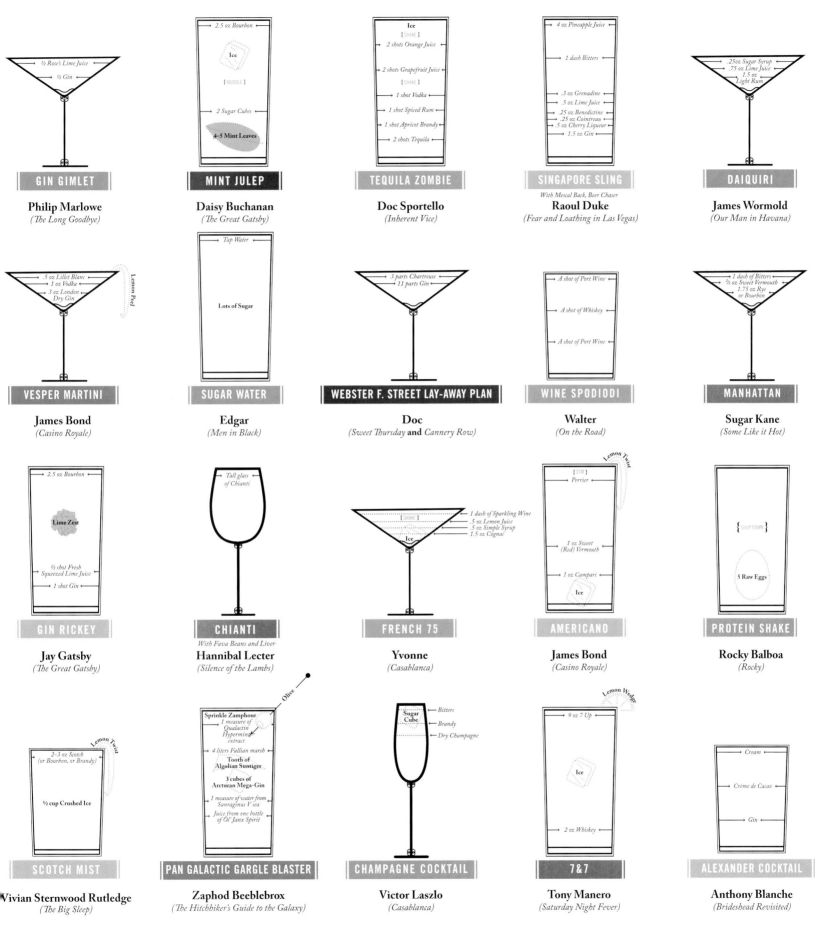

GIN GIMLET
½ Rose's Lime Juice
½ Gin

Philip Marlowe
(The Long Goodbye)

MINT JULEP
2.5 oz Bourbon
Ice
[MUDDLE]
2 Sugar Cubes
4–5 Mint Leaves

Daisy Buchanan
(The Great Gatsby)

TEQUILA ZOMBIE
Ice
[SHAKE]
2 shots Orange Juice
2 shots Grapefruit Juice
[SHAKE]
1 shot Vodka
1 shot Spiced Rum
1 shot Apricot Brandy
2 shots Tequila

Doc Sportello
(Inherent Vice)

SINGAPORE SLING
4 oz Pineapple Juice
1 dash Bitters
.3 oz Grenadine
.5 oz Lime Juice
.25 oz Benedictine
.25 oz Cointreau
.5 oz Cherry Liqueur
1.5 oz Gin

Raoul Duke
With Mescal Back, Beer Chaser
(Fear and Loathing in Las Vegas)

DAIQUIRI
.25oz Sugar Syrup
.75 oz Lime Juice
1.5 oz Light Rum

James Wormold
(Our Man in Havana)

VESPER MARTINI
.5 oz Lillet Blanc
1 oz Vodka
3 oz London Dry Gin
Lemon Peel

James Bond
(Casino Royale)

SUGAR WATER
Tap Water
Lots of Sugar

Edgar
(Men in Black)

WEBSTER F. STREET LAY-AWAY PLAN
3 parts Chartreuse
11 parts Gin

Doc
(Sweet Thursday and Cannery Row)

WINE SPODIODI
A shot of Port Wine
A shot of Whiskey
A shot of Port Wine

Walter
(On the Road)

MANHATTAN
1 dash of Bitters
⅔ oz Sweet Vermouth
1.75 oz Rye or Bourbon

Sugar Kane
(Some Like it Hot)

GIN RICKEY
2.5 oz Bourbon
Lime Zest
½ shot Fresh Squeezed Lime Juice
1 shot Gin

Jay Gatsby
(The Great Gatsby)

CHIANTI
Tall glass of Chianti

Hannibal Lecter
With Fava Beans and Liver
(Silence of the Lambs)

FRENCH 75
1 dash of Sparkling Wine
.5 oz Lemon Juice
.5 oz Simple Syrup
1.5 oz Cognac
[SHAKE]
Ice

Yvonne
(Casablanca)

AMERICANO
[STIR]
Perrier
Lemon Twist
1 oz Sweet (Red) Vermouth
1 oz Campari
Ice

James Bond
(Casino Royale)

PROTEIN SHAKE
{ GULP DOWN }
5 Raw Eggs

Rocky Balboa
(Rocky)

SCOTCH MIST
2–3 oz Scotch (or Bourbon, or Brandy)
Lemon Twist
½ cup Crushed Ice

Vivian Sternwood Rutledge
(The Big Sleep)

PAN GALACTIC GARGLE BLASTER
Olive
Sprinkle Zamphour
1 measure of Qualactin Hypermint extract
4 liters Fallian marsh
Tooth of Algolian Suntiger
3 cubes of Arcturan Mega-Gin
1 measure of water from Sanraginus V sea
Juice from one bottle of Ol' Janx Spirit

Zaphod Beeblebrox
(The Hitchhiker's Guide to the Galaxy)

CHAMPAGNE COCKTAIL
Sugar Cube
Bitters
Brandy
Dry Champagne

Victor Laszlo
(Casablanca)

7&7
Lemon Wedge
9 oz 7 Up
Ice
2 oz Whiskey

Tony Manero
(Saturday Night Fever)

ALEXANDER COCKTAIL
Cream
Crème de Cacao
Gin

Anthony Blanche
(Brideshead Revisited)

Alcohol in Popular Music

Booze has provided an embarrassment of riches for music writing—dating back, it would seem, to the strumming of the very first note. Whether the subject of adoration, regret, or simply the means of inspiration by which to put melody over chords, alcohol has infused the lyrics and temperaments of nearly every musical genre, from old folk ballads to country hits to modern rock and pop sensations.

SPIRITS & MISC

WHISKEY/MOONSHINE

LET ME GO HOME WHISKEY, *Amos Milburn*

BAD, BAD WHISKEY, *Amos Milburn*

LAST CALL, *Lee Ann Womack*

JOCKEY FULL OF BOURBON, *Tom Waits*

MOONSHINER, *The Clancy Brothers*

ALABAMA SONG, *Bertolt Brecht/The Doors*

CHEERS (DRINK TO THAT), *Rihanna*

MOONSHINE, *Savage*

NO NO SONG, *Ringo Starr*

SNORTIN' WHISKEY, *Pat Travers Band*

GOOD GOOD WHISKEY, *Amos Milburn*

THAT SMELL, *Lynyrd Skynyrd*

AMERICAN PIE, *Don McClean*

A GOODBYE RYE, *Richard Buckner*

RYE WHISKEY, *Punch Brothers*

WHISKEY GIRL, *Toby Keith*

WHISKEY HANGOVER, *Godsmack*

WHISKEY IN A JAR, *The Dubliners*

WHISKEY RIVER, *Johnny Bush*

WHITE LIGHTNING, *The Big Bopper*

GOOD OLD MOUNTAIN DEW, *Bascom Lamar Lunsford and Scotty Wiseman*

ACQUIRED TASTES

SIPPIN' CIDER THROUGH A STRAW, *Collins and Harlan (CIDER)*

PASS THE COURVOISIER, *Busta Rhymes (COGNAC)*

EISGEKÜHLTER BOMMERLUNDER, *Unknown (SCHNAPPS)*

GIN

GIN HOUSE BLUES, *Bessie Smith*

GIN AND JUICE, *Snoop Dogg*

COLD GIN, *Kiss*

TEQUILA

JOSÉ CUERVO, *Cindy Jordan*

STRAIGHT TEQUILA NIGHT, *John Anderson*

TEQUILA, *The Champs*

COCKTAILS

RUM AND COCA-COLA, *The Andrews Sisters*

BRASS MONKEY, *Beastie Boys*

FUNKY COLD MEDINA, *Tone-Lōc*

ONE MINT JULEP, *The Clovers*

ESCAPE (THE PIÑA COLADA SONG), *Rupert Holmes*

MARGARITAVILLE, *Jimmy Buffett*

BEER & WHISKEY

ONE BOURBON, ONE SCOTCH, ONE BEER, *Amos Milburn*

JOHN BARLEYCORN, *Unknown*

THE JUICE OF THE BARLEY, *Unknown*

I DRINK ALONE, *George Thorogood and the Destroyers*

THE WILD ROVER, *Unknown*

TEMPERANCE

THE PIG GOT UP AND SLOWLY WALKED AWAY, *Fozzie Bear*

REHAB, *Amy Winehouse*

BOOZE *(IN GENERAL)*

COCKTAILS FOR TWO, *Duke Ellington*

ONE FOR MY BABY (AND ONE MORE FOR THE ROAD), *Frank Sinatra*

BRUCES' PHILOSOPHERS SONG, *Monty Python*

DRINKIN' MY BABY GOODBYE, *Charles Daniels Band*

GET MY DRINK ON, *Toby Keith*

I THINK I'LL JUST STAY HERE AND DRINK, *Merle Haggard*

LONGNECK BOTTLE, *Garth Brooks*

THE PIANO HAS BEEN DRINKING, *Tom Waits*

LITTLE BROWN JUG, *Glenn Miller and His Orchestra*

MONKS OF THE SCREW, *Curran/Monks of the Screw*

SEVEN DRUNKEN NIGHTS, *The Dubliners*

DROBNA DRABNITSA, *Unknown*

DRINKING AGAIN, *Frank Sinatra*

ONE MORE DRINK FOR THE FOUR OF US, *Unknown*

THE NIGHT PADDY MURPHY DIED, *Johnny Burke*

SHOW ME THE WAY TO GO HOME, *Irving King*

BUY U A DRANK (SHAWTY SNAPPIN'), *T-Pain*

CRACK A BOTTLE, *Eminem*

ONE MORE DRINK, *Ludacris*

CIGARETTES AND ALCOHOL, *Oasis*

HAPPY HOUR, *The Housemartins*

NIGHTTRAIN, *Guns N' Roses*

PAINT BOX, *Pink Floyd*

FAIRYTALE OF NEW YORK, *The Pogues*

DRUNKEN SAILOR, *Unknown*

HELAN GÅR, *Unknown*

SHOTS, *LMFAO*

SWIMMING POOLS (DRANK), *Kendrick Lamar*

TIPSY, *J-Kwon*

TOO DRUNK TO F*CK, *Dead Kennedys*

TUBTHUMPING, *Chumbawamba*

VIENS BOIRE UN P'TIT COUP À LA MAISON, *License IV*

WASTED, *Carrie Underwood*

KISS ME, I'M SHITFACED, *Dropkick Murphys*

HIGH 'N' DRY (SATURDAY NIGHT), *Def Leppard*

BEER

CORONA, *The Minutemen*

BEEF AND BUTT BEER, *Unknown*

BAR ROOM BUDDIES, *Merle Haggard and Clint Eastwood*

BEER FOR MY HORSES, *Toby Keith and Willie Nelson*

BEER IN MEXICO, *Kenny Chesney*

BEERS AGO, *Toby Keith*

CHARLIE MOPPS, *Unknown*

I LIKE GIRLS THAT DRINK BEER, *Toby Keith*

REDNECKS, WHITE SOCKS AND BLUE RIBBON BEER, *Johnny Russell*

BEER BARREL POLKA, *Liberace*

IM HIMMEL GIBT'S KEIN BIER (IN HEAVEN THERE IS NO BEER), *Ernest Neubach*

ES GIBT KEIN BIER AUF HAWAII, *Paul Kuhn*

ROADHOUSE BLUES, *The Doors*

SAY IT AIN'T SO, *Weezer*

99 BOTTLES OF BEER, *Unknown*

THERE'S A TEAR IN MY BEER, *Hank Williams*

'TIS MONEY MAKES A MAN: OR, THE GOOD-FELLOWS FOLLY, *John Wade*

WHAT'S MADE MILWAUKEE FAMOUS (HAS MADE A LOSER OUT OF ME), *Glen Sutton*

WIGGLE IT, *2 in a Room*

WINE

HAVE SOME MADEIRA M'DEAR, *Flanders and Swann*

THE BOTTLE LET ME DOWN, *Merle Haggard*

DRINKING CHAMPAGNE, *Cal Smith*

DAYS OF WINE AND ROSES, *Henry Mancini*

RED RED WINE, *UB40/Neil Diamond*

BOTTLE OF WINE, *The Fireballs*

ELDERBERRY WINE, *Elton John*

LILAC WINE, *Elkie Brooks*

GUBBEN NOAK CARL, *Michael Bellman*

SO HAPPY I COULD DIE, *Lady Gaga*

SPILL THE WINE, *War*

SCENES FROM AN ITALIAN RESTAURANT, *Billy Joel*

YESTERDAY'S WINE, *Willie Nelson*

NORWEGIAN WOOD, *The Beatles*

How to Order a Drink

The multiform drink styles make different uses of ice, glass size, mixers, and garnishes to cater to drinkers of all dispositions—if you want unadulterated alcohol, ask for your drink "neat"; if you're partial to a club soda chaser, try ordering your spirit with a "back"; if you like piña coladas, well . . . just say so.

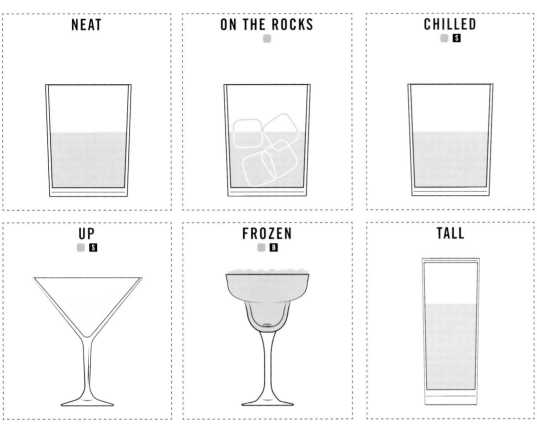

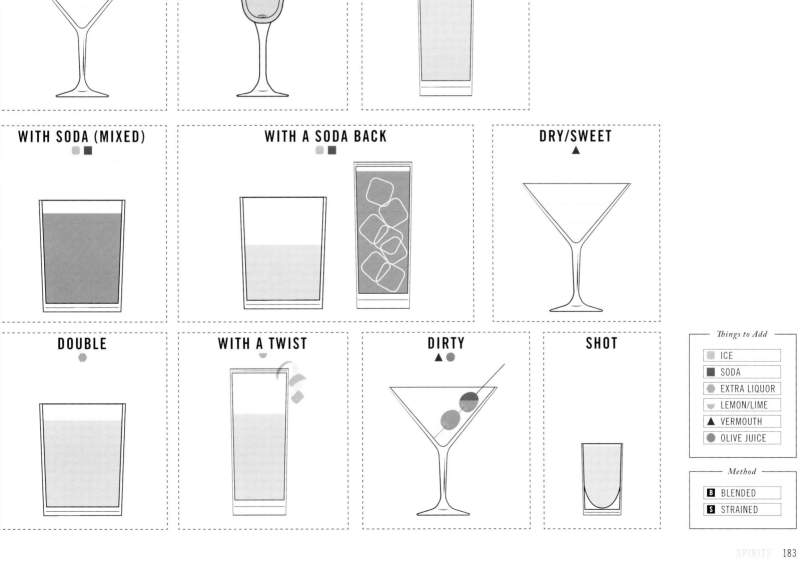

NEAT

ON THE ROCKS

CHILLED

UP

FROZEN

TALL

WITH SODA (MIXED)

WITH A SODA BACK

DRY/SWEET

DOUBLE

WITH A TWIST

DIRTY

SHOT

Things to Add

ICE
SODA
EXTRA LIQUOR
LEMON/LIME
VERMOUTH
OLIVE JUICE

Method

B BLENDED
S STRAINED

Heading 1: Adobe Caslon Pro Size 18

SUBHEADING2

SUBHEADING3

SUBHEADING4

Body Copy. Trade Gothic LT Std Regular Size 9, Leading 12. All alcoholic beverages are fermented—the aforementioned process whereby yeast creates alcohol—but fermented beverages can then be distilled, which concentrates the alcohol.

ARROWS AND RULES

PRIMARY PALETTE

SECONDARY PALETTE

Taxonomical elements use a combination of size, colors, strokes, and dots to differentiate hierarchy from one another.

Illustrations are generally line art and technical in style, aiming to accurately convey dimensions and proportions.

Labels and titles were treated in a variety of containers to illustrate hierarchy and to best suit the form of the chart.

BACTERIA

SUGAR WATER

BITTERING HOPS

Sources

Listed below are general sources that we came back to again and again in our research process.

ALCOHOL GENERALLY

World Maps of Köppen-Geiger climate classification: http://koeppen-geiger.vu-wien.ac.at/

Malt: http://malt-review.com/

USDA Agricultural Research Service: http://www.ars.usda.gov

Master of Malt: https://www.masterofmalt.com/

National Institute on Alcohol Abuse and Alcoholism: http://www.niaaa.nih.gov/

World Health Organization: http://www.who.int/en/

Name that Plant: http://www.namethatplant.net

Plants for a Future: http://pfaf.org/user/Default.aspx

Plant Systematics: http://plantsystematics.org/

Society for Historical Archaeology: http://www.sha.org/

BEER

The Oxford Companion to Beer (Garret Oliver, editor) was our bible for this section, particularly for sorting out the often confusing history of beer styles, along with Joshua M. Bernstein's *The Complete Beer Course*. We made extensive use of the databases on BeerAdvocate.com in coming up with example beers in each section, and the Beer Judge Certification Program (BJCP.com) was the final word in SRM, ABV, and other quantifiers for beer styles. These websites were also consulted:

Beer Legends: http://beerlegends.com/

RateBeer: http://www.ratebeer.com/

Beer Pulse: http://beerpulse.com/

Hopunion: http://hopunion.com/

Beer Me!: http://beerme.com/index.php

Brew Wiki: http://brewwiki.com/

Brew York: http://brewyorknewyork.com/

Yakima Chief: http://yakimachief.com/

The Beer Connoisseur: https://www.beerconnoisseur.com/

Beer History: http://beerhistory.com/

Michael Jackson, Beer Hunter: http://beerhunter.com/

Brewers Association: https://www.brewersassociation.org/

American Homebrewers Association: https://www.homebrewersassociation.org/

Immigrant Entrepreneurship: http://www.immigrantentrepreneurship.org/index.php

Germany: The Travel Destination: http://www.germany.travel/en/index.html

Liquid Bread: http://www.liquidbreadmag.com/

MoreBeer: http://www.morebeer.com/

San Francisco Brewers Guild: http://sfbrewersguild.org/

Northern Brewer: http://www.northernbrewer.com/

Portland Beer: http://www.portlandbeer.org/

True Beer: http://www.truebeer.com/

Slohops: http://slohops.com/

Beer Taps: http://www.beertaps.com/

40oz Malt Liquor: http://www.40ozmaltliquor.com/

WINE

We're greatly indebted to three wine books, all edited by Jancis Robinson: *The Oxford Companion to Wine*, *The World Atlas of Wine*, and *Wine Grapes*. All wine genealogy data was compiled using both Wine Grapes and the wine cultivar database at VIVC.de. In addition to these, we used:

Wine Enthusiast Magazine: http://www.winemag.com/

Wine Spectator: http://www.winespectator.com/

Andalucia.com: http://andalucia.com/

Sussex-Lisbon Area Historical Society: http://slahs.org/

Sonoma Valley Visitors' Bureau: http://www.sonomavalley.com/

Total Wine & More: http://www.totalwine.com/

The Wine Anorak: http://www.wineanorak.com/

Winerist: http://www.winerist.com/

Freshops: http://freshops.com/

Visit Portugal: https://www.visitportugal.com/en

Austrian Wine: http://www.austrianwine.com

New Wines of Greece: http://www.newwinesofgreece.com/home/

Vino Italiano: http://www.vinoitaliano.com/

Food & Wine Magazine: www.foodandwine.com

Comité Champagne: http://www.champagne.fr/

Champagne Guide: http://www.champagneguide.net/

New Zealand Wine: http://www.nzwine.com/

Italian Wine Central: http://italianwinecentral.com/

Chianti and Tuscany Wine Grape Varieties: http://www.chianti-chianti.info/

Made in Italy: http://www.made-in-italy.com/

WineCountry.it: http://www.winecountry.it/

Argentina Wine Guide: http://www.argentinawineguide.com/index.htm

Bourgogne Wines: http://www.bourgogne-wines.com/

Cellar Tours: http://www.cellartours.com/

Rhone Wines: http://www.rhone-wines.com/

Terroir France: http://www.terroir-france.com/

Alsace Wines: http://www.vinsalsace.com/en/

The Wine Cellar Insider: http://www.thewinecellarinsider.com/

The Vintner's Vault: http://www.thevintnervault.com/

WineMaker: https://winemakermag.com/

WineFrog: https://www.winefrog.com/

WineEducation.com: http://www.wineeducation.com/

The Alchemist's Wine Perspective: http://www.wineperspective.com/

Wines of Argentina: http://www.winesofargentina.org

The Wine Web: http://www.wineweb.com/

Cognac Expert: https://www.cognac-expert.com/

Winetitles Media: http://winebiz.com.au/

Wines of South Africa: http://www.winesofsa.co.sa/

Winophilia: http://www.winophilia.com/

All About Cognac: http://www.bnic.fr/cognac/_en/2_cognac/index.aspx

Sherry.org: www.sherry.org

Discover Douro Valley: http://www.discoverdourovalley.com/

SherryNotes: http://www.sherrynotes.com/

SPIRITS

An amazing little book called *The Drunken Botanist* by Amy Stewart helped us discover all manner of obscure drinks. *The Ultimate Encyclopedia of Wine, Beer, Spirits & Liqueurs* by Stuart Walton and Brian Glover provided us a base-level orientation before we delved into these sites:

Serious Eats: Drinks: http://drinks.seriouseats.com/

Home Distillation of Alcohol: http://homedistiller.org/

Quartz: http://qz.com/

AlcoholReviews.com: http://alcoholreviews.com/

Spirits Review: http://spiritsreview.com/

Whiskies R Us: http://whiskiesrus.blogspot.com/

Whisky Science: http://whiskyscience.blogspot.com/

Distiller: https://drinkdistiller.com/

Proof66: http://www.proof66.com/

ScotchBlog: http://www.scotchblog.ca/scotch_blog/blog/

WhiskyBase: https://www.whiskybase.com/

Artisan Distiller: http://artisan-distiller.net/

Belarusian Beverages: http://belarusvodka.lv

Craft Distillers: http://www.craftdistillers.com/

Difford's Guide: http://www.diffordsguide.com/

drinkFind: http://drinkfind.com/

The Drink Shop: https://www.thedrinkshop.com/

Liquor.com: http://liquor.com/

Vermouth 101: http://vermouth101.com/

The Drinks Business: http://www.thedrinksbusiness.com/

Tequila.net: http://www.tequila.net/

Malt Madness: http://www.maltmadness.com/index.html

Tequila: In Search of the Blue Agave: http://www.ianchadwick.com/tequila/

Visit Scotland: http://www.visitscotland.com/en-us/

World Whiskies Awards: http://www.worldwhiskiesawards.com/

Scotland: Whisky and Distilleries: http://www.whisky-distilleries.info/index.htm

Whisky for Everyone: http://www.whiskyforeveryone.com/index.html

The Webtender: http://www.webtender.com/

The Wormwood Society: http://www.wormwoodsociety.org/

The Whisky Exchange: https://www.thewhiskyexchange.com/

Acknowledgments

When we started Pop Chart Lab back in 2010, we had no idea where our little chart-making company would go, and we're still a bit in disbelief that we've grown from two people to twenty people and a few little designs to well over one hundred products for sale. So thank you first to all those who've bought a print from us, as you've allowed two accidental entrepreneurs to live the proverbial dream.

We ask our team to manage a huge workflow, and when we took on this book project, we committed to an aggressive turnaround schedule. Everyone at Pop Chart Lab had to manage the research and design of this book alongside their substantial list of other duties, so thanks to Ashley Walker, Becky Joy, Will Prince, and Alex Fernbach for making this happen. And thank you to Rachel Mansfield, Allison Laskin, Galvin Chow, and Sam Peterson for picking up the slack and handling the daily running of the business on the many days when the rest of us were deep into book work.

Thanks to Lauren Marino at Penguin for convincing us to write this book, to Brian Tart for his enthusiasm for it, and to Emily Wunderlich for her feedback on some very ugly early drafts. Thanks to Gigi Campo and Megan Newman for hopping in midstream and bringing it across the finish line, and for their patience with some tardy chartists. Thanks to Anne Kosmoski and Casey Maloney for making us look cool with their publicity work, and thanks to Justin Thrift and Bob Wojciechowski in the production department for making sure the book actually got printed.

—Ben & Patrick

POP CHART LAB
A Visual Guide to Drink Team

PATRICK MULLIGAN
COFOUNDER,
Editorial

BEN GIBSON
COFOUNDER,
Design

ASHLEY WALKER
Design

BECKY JOY
Design

WILL PRINCE
Research

ALEX FERNBACH
Research